PAC-MAN™

Birth of an ICON

Arjan Terpstra Tim Lapetino

パックマン：アイコンの誕生

Published by Titan Books, London, in 2021.
Originally published by Cook and Becker (2021).

©Cook and Becker, 2021
PAC-MAN ™ &©BANDAI NAMCO Entertainment Inc.
PAC-MAN ®

TITAN BOOKS

A division of Titan Publishing Group Ltd
144 Southwark Street
London SE1 0UP
www.titanbooks.com

Find us on Facebook: www.facebook.com/titanbooks
Follow us on Twitter: @TitanBooks

Published by arrangement with Cook and Becker, Lange Koestraat 41, 3511 RM
Utrecht, The Netherlands.
Visit the Cook and Becker website at cookandbecker.com

A CIP catalogue record for this title is available from the British Library.

ISBN: 9781789099393

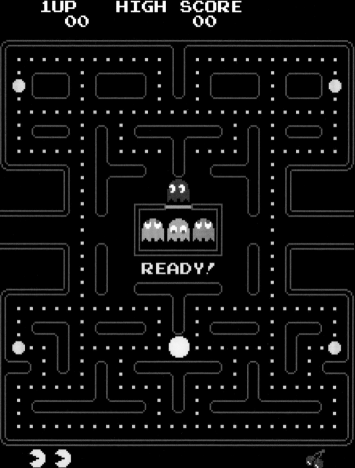

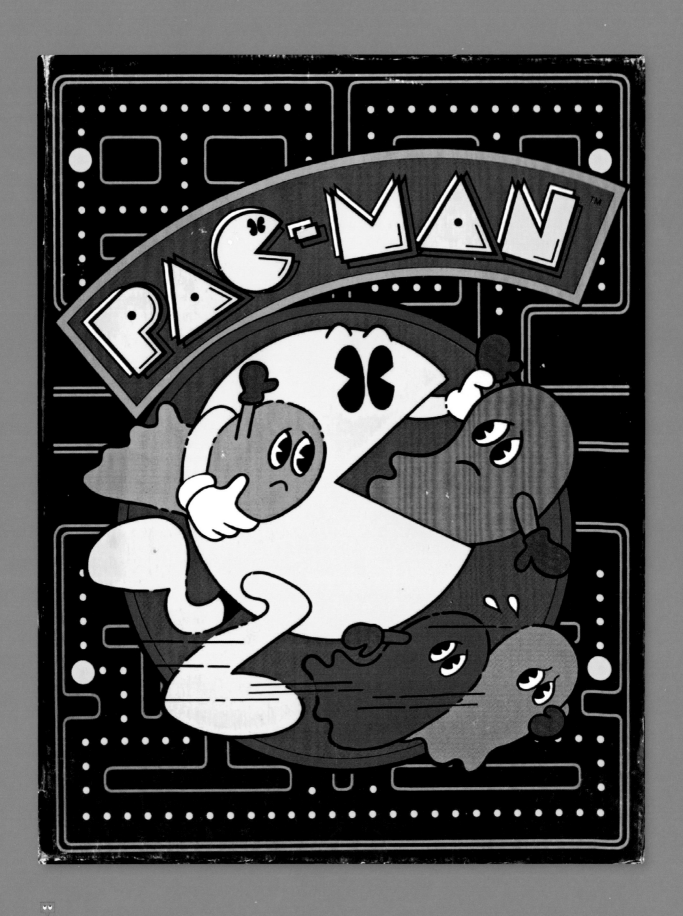

Pac-Man artwork originally created by artist Don
Mastri for Midway promotional uses in 1980.

About this book

Dear Reader,

It is our pleasure to finally introduce this book. *Pac-Man: Birth of an Icon* is a massive collection of video game history complemented by beautiful design. It comes from a fantastic team of writers and researchers who set out to create the definitive work on the iconic yellow dot muncher, and we are proud of the final results.

And what a history it is! Pac-Man's story spans decades and oceans, and touches video games, popular culture, and our world today. It was a privilege to spend time with so many people who had a hand in bringing Pac-Man to life, and an honor for us to be able to share their stories.

We hope this beautiful volume will entertain and inspire the generations of fans who have called Pac-Man their own.

Team Cook and Becker
Utrecht, The Netherlands
May, 2021

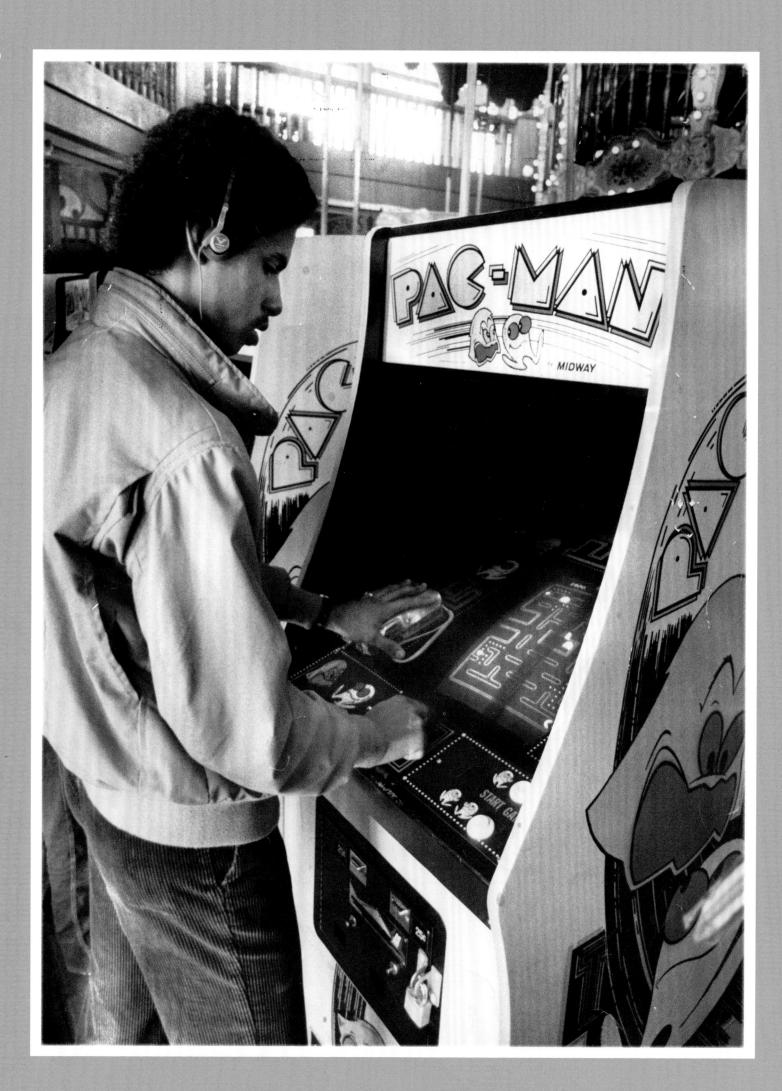

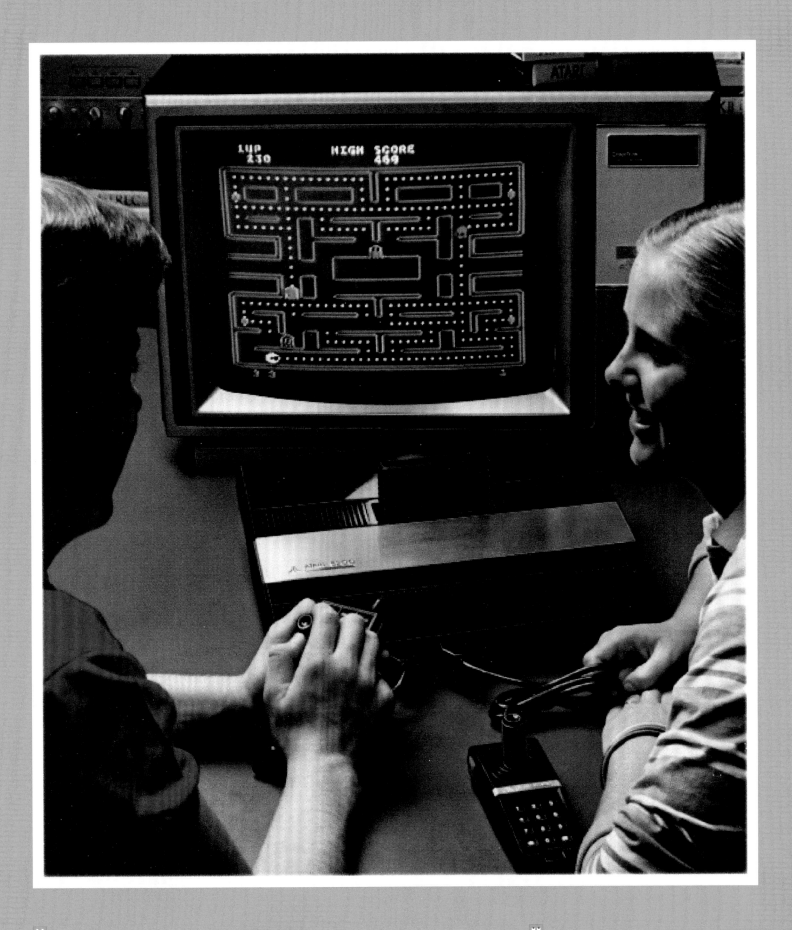

Brian Allen, 17, listens to his Walkman while playing
Pac-Man at the Pier 39 arcade in San Francisco on
March 16, 1982.

Detail of a promotional brochure for the Atari 5200
video game console, and one of its signature games,
Pac-Man. This 1982 translation of the game boasted
gameplay and graphics quite faithful to the original
arcade game.

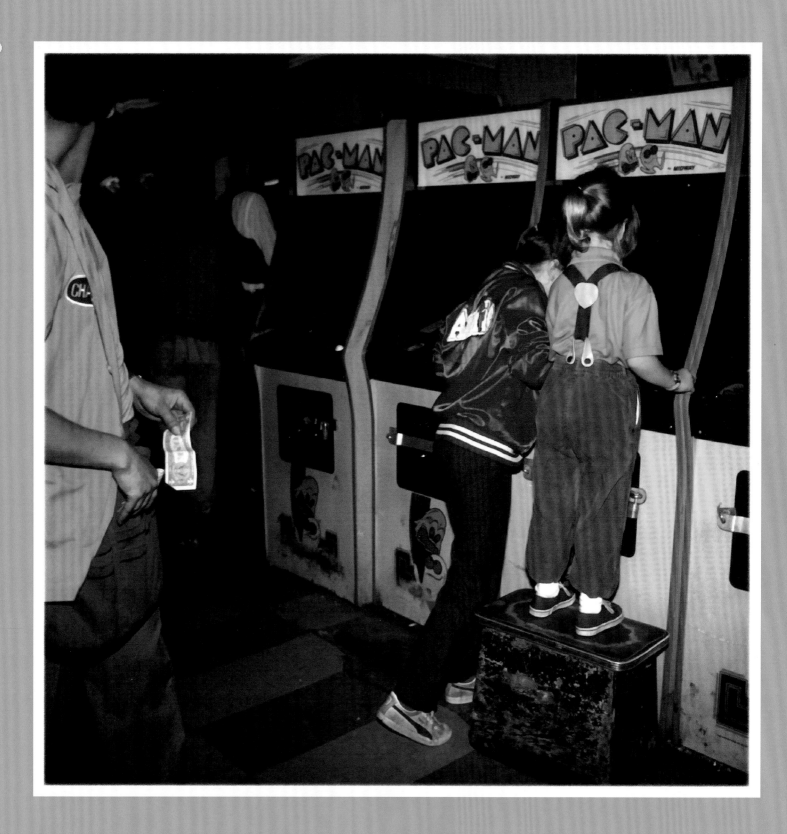

Young girls playing side-by-side at a row of *Pac-Man* machines at an arcade in Times Square, New York City, June 1, 1982.

A teenager plays a *Pac-Man* cocktail cabinet in Scheveningen, the Netherlands, in 1985. *Pac-Man* would continue to be an arcade staple long after the game launched in 1980.

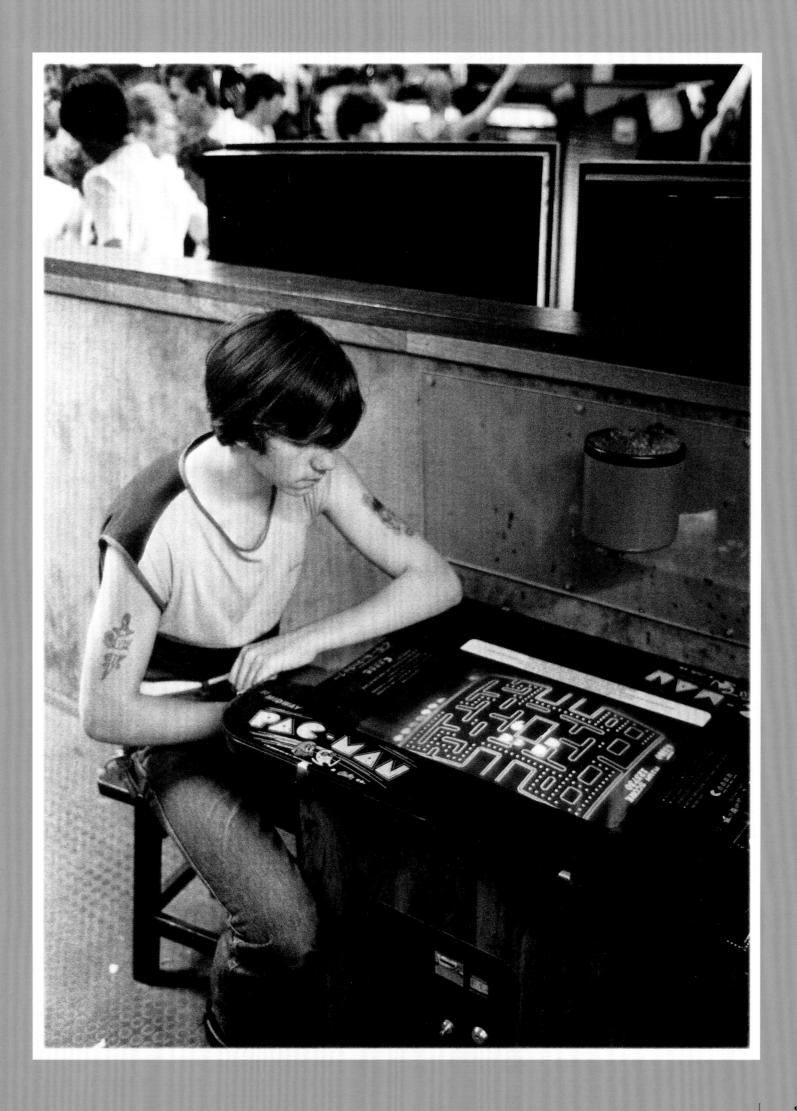

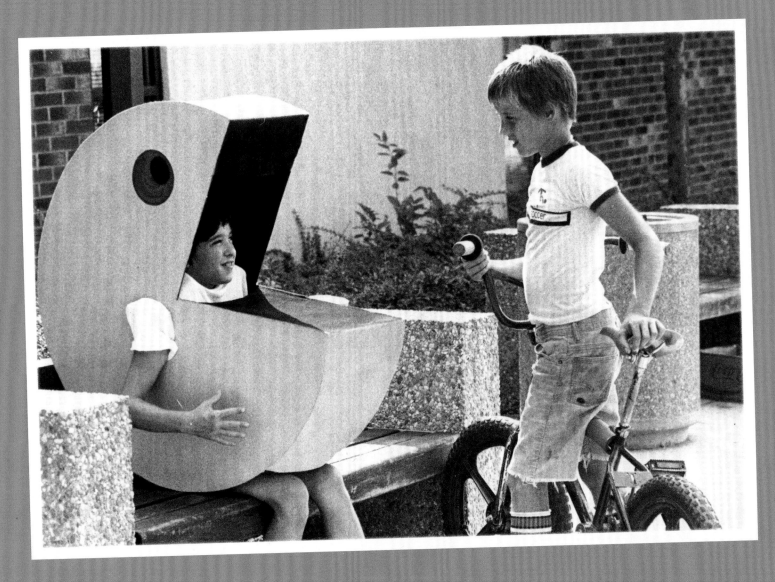

Young Michael Ward is cosplaying for a cause, collecting donations for muscular dystrophy in a home-made Pac-Man costume, captured in a vintage news photo from September 5, 1983.

Matt Henzel's mother Marla threw him a Pac-Man-themed 11th birthday party in 1983, in Saratoga Springs, New York, serving a homemade Pac-Man cake on Pac-Man napkins, and prepared goodie bags for all guests.

A handful of kids seem to be waiting in anticipation for a slice of Pac-Man birthday cake for Levar's birthday in this undated photo.

Brian Corley poses proudly in his Pac-Man shirt. His parents were hooked on the Atari 2600, and Corley spent his earliest days watching from his crib, mesmerized by their gameplay.

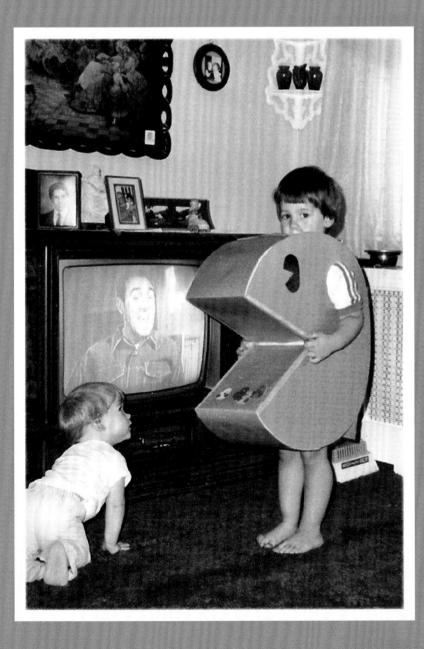

Three-year-old Rob Wanenchak displays a Pac-Man costume made by his mother (complete with ghosts ready to be chomped) leading up to Halloween in 1984.

Contents

CHAPTER 1

Birth of
an Icon

アイコンの誕生

The Story of Pac-Man

On a chilly Thursday morning in January of 1983, Jennifer Allen burrowed in her purse for more quarters. Standing in a steamy laundromat at Broadway and 78th Street, this magazine writer waited for her turn to step up to a large, yellow arcade machine tucked inside the cleaners. The others in line were all boys—teenagers and children. As she wrote in her 'Private Lives' column for *New York* magazine, Allen felt like the chaperone of a party, feeling awkward about her daily engagement with this arcade cabinet, sometimes even stealing quarters from her boyfriend's desk to feed her obsession. "Shouldn't you be in school?" she asked one of the boys, hoping to weed out the line a bit. "Shouldn't you be at work?" the boy answered. Her experience wasn't that unusual.

Like an invading force, canary yellow arcade cabinets suddenly appeared everywhere, embedding themselves in the fabric of everyday life of the early 1980s. Bars, arcades, bodegas, grocery stores, dentist waiting rooms. With a wave of beeps, blips, and the unmistakable "waka-waka-waka" sound, the game laid claim to passionate players, fans, detractors, and pundits. Part of a mushrooming "video craze," *Pac-Man* had arrived.

The game was released in Japan in 1980 by Namco Ltd., making waves there before being licensed to Midway Manufacturing Company in the United States. This Chicago-based video game company had not only imported an arcade game, but also a particular style of character-driven Japanese design, known as *kawaii*. The game's "cute" style of bright, colorful video game graphics were simple, approachable—and adorable. Coupled with distinctive gameplay, *Pac-Man's* presentation was key to unlocking much broader appeal for the arcade game—and video games as a whole. Its graphics were an effective way to work within the limitations of that era's computing power, while also remaining singularly engaging. Soon, players of all ages were grabbing *Pac-Man* arcade joysticks. The game crossed over from niche fascination to mainstream appeal, eventually selling more than 96,000 units in its initial run, breaking industry records and preconceived notions of the kind of video games the public wanted. *Pac-Man* would remain an arcade mainstay during its first decade, selling nearly 200,000 more arcade cabinets in the years to come, a world record.[1]

"Pac-Man quickly crossed over from niche fascination to mainstream appeal."

The game also helped lead a revolution in computing technology. "It not only showed what could be done with very little processing power," wrote tech consultant Dave Hawksett, "but it also brought computer technology to the attention of many young people." Its mastery of the coin-operated video game industry would only be part of *Pac-Man's* success story, though. Pac-Man's appeal as a character transcended arcades and moved into the wider realm of popular culture. A hit record graced the airwaves. A Saturday morning cartoon entertained young people as they pored over their sugary breakfast cereals. Pac-Man and his ghostly pursuers became a licensing dream, appearing on everything from pajamas to alarm clocks, from sleeping bags to popsicles (lemon ice flavor, naturally), establishing Pac-Man as the first video game mascot to reach near-universal recognition.

Ongoing Appeal

The crushing wave of Pac-Man merchandise would eventually slow to a trickle, but the decline did nothing to diminish the immense impact Pac-Man had (and continues to have) on pop culture in general, and on the public acceptance of video games in particular. Before *Pac-Man*, video games were largely the domain of teenage boys and kids, who played competitive and aggressive-looking games in arcades and other amusement spaces. But when *Pac-Man* arrived on the scene, the rulebook for successful games went out the window, swapping conflict-laden imagery for cuteness, and competitive shooting of aliens for dot munching. As a result, girls and women arrived en masse, making their presence felt in the industry, voting with their quarters.

"Pac-Man's influence continued as video games evolved."

But Pac-Man's appeal and impact wasn't limited to the decade of hairspray, heavy metal, and Reaganomics. The original game's influence continued as video games evolved, both in arcade machines and home consoles. Despite its age, Pac-Man appeared every time a new gaming technology reared its head, from virtual reality to geolocation to artificial intelligence, the game's increasingly simple architecture mapped onto new modes and styles of play—serving as a bellwether for change.

A million stories have spawned from the signature blue neon maze. For more than 40 years, Pac-Man has spun cultural yarns, and more tales than we can chronicle here. Instead, our international team focused on the creation and introduction of *Pac-Man*—in its twin cities of Tokyo and Chicago. In many ways, the game received a rebirth with its introduction to American pop culture, and the results were surprising. This book seeks to unveil the complete origin of the game, its evolution, and the creative teams that spun computer code into reality. Talented programmers, savvy marketers, powerful executives, pioneering lawyers, and engineering students all contributed significant pieces to the greater puzzle of Pac-Man.

The video game industry owes *Pac-Man* a great debt. Its simple, addictive gameplay and signature characters held players captive, game after game, in a way that transcended gender, age, and class. Somehow, the game hit a coveted sweet spot, soaring into the collective consciousness like no game before it.

Japan & the Rise of Video Games

日本とビデオゲームの台頭

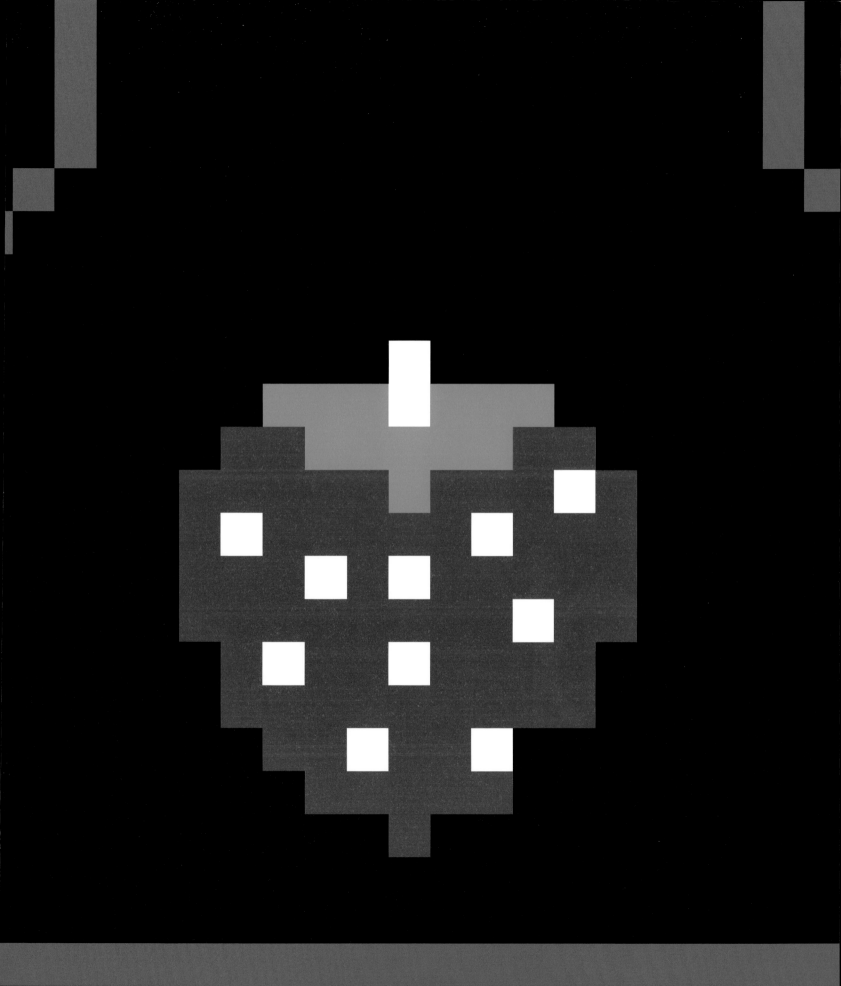

The Pinball Designer

Japan in the 1960s and '70s saw the coming-of-age of its postwar generation. With it came a strong cultural shift: the values and tastes of earlier generations were being challenged, creating a youth culture obsessed with liberation from (real and perceived) restraints. Taking cues from youth culture elsewhere, the country shared most of the international trends, from fashion and music tastes to leftist political philosophies. The former led to Japanese teens adopting Western clothing and musical styles, the latter to the amplification of pacifist, Marxist and anarchist philosophies. A growing frustration with Japan's outdated structures and conservative ruling class, combined with a lack of economic perspective for young people in the frugal postwar decades, often led to social unrest, with student movements clashing violently with authorities on many occasions.

Swept up in all this was one Toru Iwatani. Born in 1955 in Meguro Ward, Tokyo, his family relocated a couple of times during his youth to accommodate his father's job as an engineer for a broadcasting studio. For some time, the family settled in Akita, a rural place in northwest Japan with plenty of room for kids to venture out and discover nature. Looking back on his youth, Iwatani remembered the enjoyment he found in outdoor activities like hiking, catching crawfish and pranking his friends.[2] During the cold winters he enjoyed building igloos and designing horse racing games on pieces of paper, making up the rules and playing the games with friends. When his family returned to Tokyo after a decade, they found a city in dramatic transition, in complete opposition to the tranquil countryside.

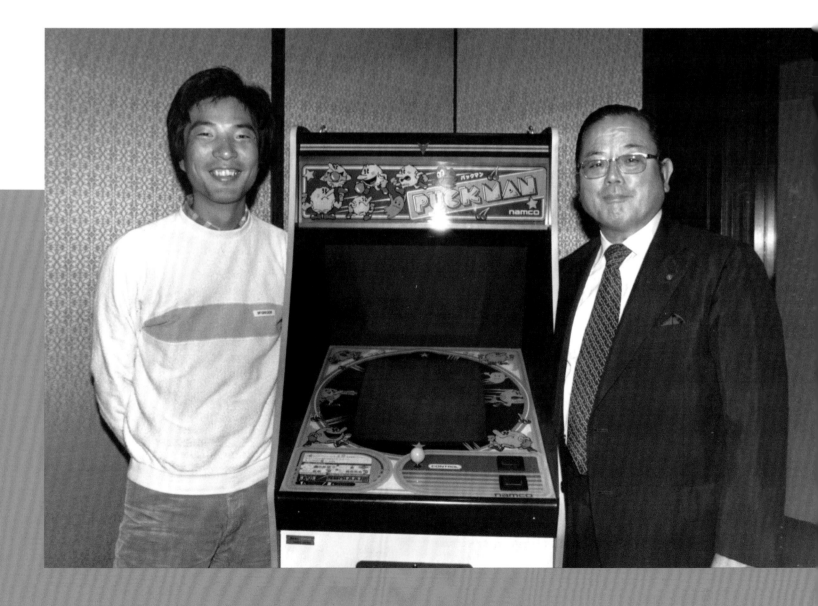

Of his kindergarten years, Iwatani remembered a Tokyo "before the crazy land specu-lation, before the economic boom," he wrote. "Roads were still gravel, utility poles were merely logs coated with asphalt." It was a city in a state of recovery from the devastation of World War II, a difficult phase that ended—symbolically, at least—with the 1964 Summer Olympics and the modernist building spree associated with it. On his return to the capitol, asphalt-log Tokyo was rapidly becoming urbanized, replacing old and war-torn Tokyo with the concrete-and-neon Tokyo of today, the bustling metropolis of millions.

"I learned to embrace the machine with both hands, with an illusion as if I were dancing with the machine."

Toru Iwatani, Namco game designer

The impressionable and observant Iwatani soaked it all in. In 1970, at age fifteen, he enrolled in the Tokyo Metropolitan University high school, where Marxist and other left-leaning student groups tried to influence the school's policies and practices, using strikes, marches and boycotts as tools. To little avail, as, in Iwatani's words, "they influenced the school culture, but barely reformed it." Still, the long-haired rebels were interesting enough for Iwatani, and for a while he joined their ranks. "High school and college students of Japanese society during that time seriously believed that their movement would 'make the world a better place.' I believed that, too. So I joined student movements and attended demonstration marches, but I mainly saw them as a kind of festival, as a place for the young to divert their energy. [Also] when classes were on lockout due to student strikes, we would go to the rock café in Shibuya at 11AM and drink while listening to loud rock."[3] That music was a diet of Western hard rock, with bands like Cream, Led Zeppelin, and Deep Purple among Iwatani's favorites.

Another hobby of his was pinball. During his college years and subsequent four years spent at the Tokyo University School of Engineering, Iwatani was a regular in rooftop amusement centers with pinball machines. Life at the university wasn't as carefree as his high school years, so to wind down from the rigorous school days, he would play any machine he could get his hands on. "I became crazed about it," he wrote. "I was fascinated when I first saw pinball, with its American pop design at the bowling alley. The peculiar art design on the large glass in front made me think of a painting exhibition, with all the various targets on the playfield melding together. There was something the machine portrayed that drew me in. Once I played, I was addicted to the sharp move-ments, the speed of the ball, the fun in the various features, and the depth of the game. The more I played, the better I would be able to manipulate the ball. As I took my stance, I learned to embrace the machine with both hands, with an illusion as if I were dancing with the machine."[4]

Pac-Man creator Toru Iwatani (left) and Namco president Masaya Nakamura proudly pose with their brainchild, *Puck Man*, ca. 1981.

In 1977, in the final stages of University, students were required to start looking for jobs, and Iwatani found a recruitment book that advertised companies seeking new talent. While flipping through the pages, one advertisement's tagline grabbed him: "Creation of Play," it read. The ad, from a company called Namco Ltd, seemed to promise something different from other firms—something more creative. At least, that's how it felt to Iwatani. "Honestly, this was the first page in which I felt something. When I saw the phrase, it dawned on me that this was a place where I could do something."[5]

His other reason to apply was a bit more prosaic. "It is embarrassing to talk about it now, but at the time when Namco was in the Ōta ward, Yaguchi-no-watashi station, [so] one of the reasons I chose this job was because I was able to take one train line to commute to work," he said. In a sprawling city where daily train commutes could easily take two to three hours, the prospect of a short ride was incredibly tempting.

Namco: Creators of Play

Founded in 1955 as Nakamura Seisakusho Ltd. by Masaya Nakamura, Namco would eventually grow to become a major player in the world of video games.[6] But the company certainly began modestly. Nakamura graduated from the Yokohama Higher School of Technology with a degree in shipbuilding in 1948, but was unable to find employment in an industry crippled by the war. Instead, he worked in his father's gun repair shop located at a Matsuya department store in Tokyo, learning the trade from the ground up—starting by sweeping floors and riding his bike through town in the evenings to distribute advertising posters. Over time, stricter gun laws adversely affected the business, and the shop switched to selling air rifles and children's pop guns. As young Nakamura busied himself purchasing goods for the shop, the young shipbuilding engineer—probably much to his own surprise—suddenly found himself exploring the world of toys and kids' entertainment.

Soon, Nakamura learned of the resurgence of rooftop amusement spaces. Before World War II, these kinds of entertainment areas dotted the roofs of department stores in Japan's cities, but the war had nearly wiped them out. Sensing a business opportunity, he borrowed some money and bought two mechanical horse rides, launching Nakamura Seisakusho Ltd. as a company in 1955. In interviews, he emphasized the company's humble origins. "I talked a department store into allowing me to set them up in its roof garden," he said in 2001. "I operated the rides myself. I refurbished the machines myself. I would polish them and clean them every day, and I was there to welcome the mothers of the children as they arrived."[7]

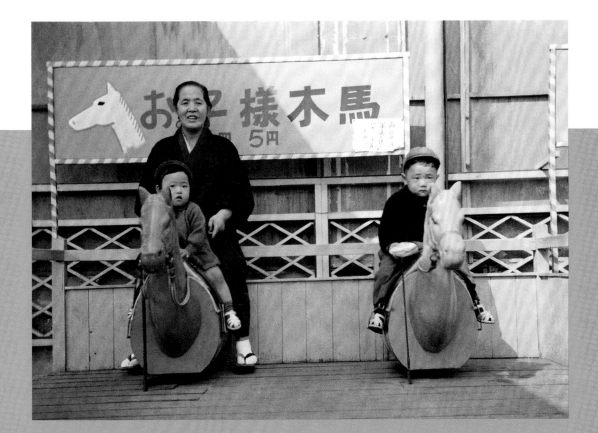

Kids enjoying Nakamura's crank-operated wooden horse rides.

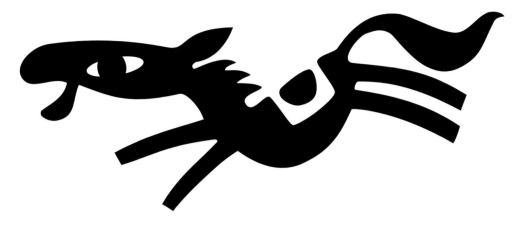

As the Japanese economy experienced a slow but steady growth over the coming years, demand for entertainment grew with it. For Nakamura, this meant he could gradually expand his number of rides and amusement locations. His decade-long, hands-on experience of operating rides and other attractions (including things like "3-D sound and picture" machines showing 3-D slides, a Ferris wheel, and once even a goldfish pond where children could scoop out new pets) gave him invaluable insights into the leisure market, and he was quick to seize opportunities when they presented themselves. Facing stiff competition from companies with contracts for better sites, Nakamura secured a coveted Disney license in 1966, which allowed him to model his kiddie rides after popular Disney characters.[8] About the same time, he ramped up production by opening up a large, new manufacturing plant—up to that point, he had used his in-laws' garage as a makeshift factory, making repairs and painting the rocking horses there.[9] The combined expansion in manufacturing and licensing brought the company toe-to-toe with other competitors in coin-operated amusement machines. These rivals included Sega and Taito, who, like Namco, would be household names for gamers worldwide in the years to come.

As the '60s gave way to the 1970s, the Japanese leisure industry was positively booming, with entertainment companies' growth rates approaching 30 to 50% annually. Increased consumer demand led to new growth in hotels, bowling alleys, supermarkets and bars. It created an environment where companies like Nakamura Manufacturing Co., Ltd. and its competitors were ideally suited to take on the challenge of launching video games in Japan. As Nakamura's Disney deal illustrated, the amusement industries in the U.S. and Japan were connected in a myriad of ways. This had been the case, in fits and starts, since the U.S.-led Allied occupation of postwar Japan, and in the post-occupation era that began in 1952. Postwar agreements ensured a large American presence on Japanese soil, with the U.S. leasing military bases throughout Japan. These would be the ideal point of entry for Western forms of entertainment that were new to the country.

Japan had a strong history of amusement machines dating back to the popularization of Pachinko ball-and-pins games in the 1930s.[10] These wall-mounted skill games, which remain commonplace in Japan to this day, require players to launch a stream of tiny metal balls into the playing field, aiming to shoot the balls into receptacles yielding more balls. After play, the yield is exchanged for prizes or cash—effectively making it a gambling game, a practice which authorities have always turned a blind eye towards. Japanese consumers were seasoned users of vending machines, photo booths and the like, as well as electro-mechanical shooting games and other novelties.

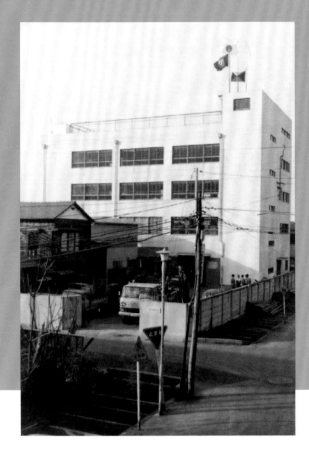

Namco's HQ around the time of *Puck Man*'s development, situated in Tamagawa, in Ota-ku, Tokyo. The company would move to larger offices in 1985, also in Ota-ku.

Undated photo of a young Masaya Nakamura, founder of Namco.

So when Western companies arrived, offering new forms of coin-operated entertainment, a healthy market already existed. Jukeboxes, electromechanical shooting games, and bowling (with automated pin-setters) were either introduced by American companies (such as Rosen Enterprises) with strong ties to U.S. military bases in Japan. (This included Service Games of Japan, which merged with Rosen under the new name Sega Enterprises in 1965), or by Japanese companies with close connections to the U.S. industry, like Taito. Importantly, this wasn't a one-way affair, as Japanese companies made inroads into the American markets too, introducing electro-mechanical game classics like *Periscope* and *Indy 500* (known as *Speedway* in the U.S.) to American audiences.

With that in mind, it's clear why Japan would be among the first countries in the world to adopt video games. Through their American industry contacts, Japanese businesses soon learned of *Pong* and its incredible success in the coin-op market in 1972. Atari's *Pong* wasn't the first coin-operated video game—that honor goes to Atari's *Computer Space*, a year earlier—but it was surely the first time a video-based arcade game proved commercially successful. During Atari's rise to prominence in the early 1970s, Namco was busy developing crane games, kiddie rides, and what its small group of mechanical designers called "effect games." These electro-mechanical games were built around a certain effect they achieved in an audience, like the popular racing game *Racer* (modified and re-released as *Formula-X*, and finally as *F1* in the U.S., by Atari). These games used a complex array of sound and lighting effects to project a car speeding through a race course on a screen in front of the player.

Players would sit in a realistic-looking car cabin, steering and shifting gears to mechanically affect the race. Another popular game, *Submarine*, had players launch torpedoes at projected ships while looking through a periscope. But the most popular game was *Shoot Away*, said Kiyoshi Sarukawa, Namco's head of domestic sales at the time. This lightgun-based skeet shooting simulation launched in 1977, to great success. "It was an amazing product," Sarukawa said. "Customers who drank a lot in [entertainment district] Kabukicho would easily spend 1,000 yen or 2,000 yen on it! [Laughter]. That is because there is a real thrill in that game."

Over time, Namco's "effect games" would find their footing in the Japanese entertainment market—with *Shoot Away* reaching U.S. markets, too—and yet Nakamura and his sales staff felt something was missing. Sarukawa recalled, "The champion of arcade products [in Japan] was clearly pinball, and in those days, only Taito and Sega imported them. The feeling was, we couldn't really do without them." Another concern was the complex nature of these effect games. They required a lot of maintenance due to all the moving parts and sophisticated electronic wiring. Growing the company's electro-mechanical portfolio with outstanding products was one thing, but servicing them was quite another.

So when video games arrived on the scene, with their use of microchips, Namco was quick to grasp that the future of electronic entertainment was here. These new designs meant there were fewer moving parts, and when something broke, workers simply switched out an arcade board to get the machine running again. "Although [switching to video games] required funding and skilled labor, it was something we had to do in order to keep up with the times," recalled designer Akira Osugi. "There were manufacturers who didn't, and they ended up going away. [Also] video games were more fun. Why? Because video games expanded the possibility of ideas. You could do anything in video games, and it was *interesting*."[11]

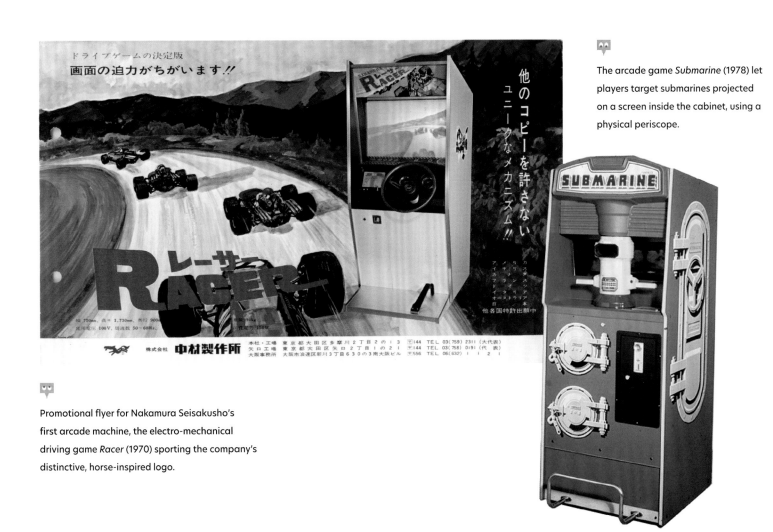

The arcade game *Submarine* (1978) let players target submarines projected on a screen inside the cabinet, using a physical periscope.

Promotional flyer for Nakamura Seisakusho's first arcade machine, the electro-mechanical driving game *Racer* (1970) sporting the company's distinctive, horse-inspired logo.

Japan's video game history began in early 1973, less than nine months after the first *Pong* cabinet was installed in the United States. Backed by the enthusiasm of his engineers, Nakamura moved to license *Pong* from Atari, and started manufacturing them in Japan. At the same time, Taito and Sega released their own takes on the game, launching *Elepong* (Taito) and *Pong Tron* (Sega) through their distribution channels, while Nakamura distributed the authorized Atari game to others.[12] Meanwhile, Atari itself was keeping a close watch on developments in Japan.

After *Pong*, the California-based company released a slew of arcade titles *(Space Race, Rebound, Gran Trak 10)* to such acclaim that it had trouble ramping up production enough to satisfy demand. Atari's stellar growth and the near-universal appeal of its product warranted international expansion. In August, 1973, Atari Japan was established. However, this short-lived subsidiary was doomed from the start; the company failed to understand the intricacies of the Japanese amusement markets, running into all kinds of problems—sometimes it could not even clear its own imported arcade machines at customs.[13] Soon, selling the Japanese company seemed the only option to salvage something from the disaster. Market leaders Taito and Sega were approached, but both declined the offer, unconvinced by Atari Japan's poor showing.

"Atari's machines kept coming in, overflowing our capacity."

Katsutoshi Endo, Namco location manager

Nakamura saw things differently. A close relationship with the leading U.S. company could only be beneficial to understanding the challenges of the budding video game markets. So, in July, 1974, he bought Atari Japan, now owning what was ostensibly an in-house video game import division—and a direct link to the best video game makers in the world. It was a bold move, but one that didn't truly pay off for years. At first, things seemed rosy, and the obstacles to success merely logistical, said Katsutoshi Endo, who was tasked with location hunting for the Atari machines. Endo: "I remember scouting new warehouse space around the Tsukiji area [in Tokyo] for a full week, because when we bought Atari Japan, we had a lot of stock. Their machines kept coming in, overflowing our capacity."

It also meant the number of repairs needed ramped up considerably. It was one of the technical challenges brought about by Namco's pivot to video games. Manufacturing evolved to work with microchips, but only gradually. Yoichi Haraguchi, who was charged with procuring semiconductors, remembered the step-by-step changes. "Electro-mechanical games didn't use ICs (integrated circuits) or transistors, and were made with relays. Only after we were able to make video games ourselves, we started to use circuit boards—for the electromechanical games, as well as for video games." After Atari's stockpiled machines were sold, a new reality set in—one where Atari couldn't satisfy Nakamura's demand for his Japanese market. Infrequent shipments from the U.S. gave Nakamura serious headaches, as his company was often left without enough cabinets to supply their amusement center customers.

But if inventory was one concern, the ascendance of a domestic Japanese video game industry certainly was another. Taito in 1974 released two titles that could compete with Atari's, also on Atari's home turf: *Basketball* (*TV Basketball* in the U.S.) and *Speed Race* were among the first games to cross the Pacific. Sega followed in Taito's footsteps by releasing *Man TT* in 1976, a motor racing arcade game rebranded as *The Fonz* for North America, to tie in with the popular *Happy Days* television series.

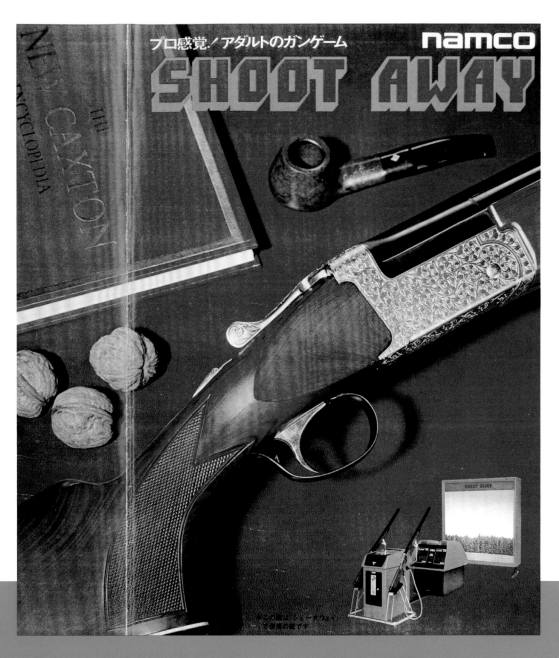

Promotional flyer for light gun shooter game *Shoot Away* (1977), Namco's first arcade product sold outside of Japan. An electro-mechanical success, the skeet shooting simulation was lauded for its realistic feel and atmosphere.

Flyer for Nakamura Seisakusho's *Formula-X* racing game (1975). The massive cabinet design was downsized considerably for the follow-up title *F-1* (1976). A licensed version was released for North America by Atari the same year, with Namco credited on the cabinet marquee.

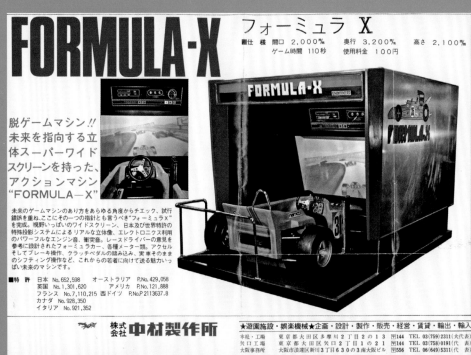

namco

THE NAME THAT BRINGS YOU MOST PROFITABLE AND RELIABLE GAMES.

Masaya Nakamura
PRESIDENT

THE CREATOR AND MANUFACTURER OF THE F·1 TAKES GREAT PLEASURE IN ANNOUNCING IT'S NEW NAME.
CALL US NAMCO!!

NAMCO
THE NAME THAT
YOU CAN
DEPEND UPON

(FORMERLY NAKAMURA SEISAKUSHO CO., LTD.)
NAMCO LIMITED

2-8-5, TAMAGAWA, OTA-KU, TOKYO, 146, JAPAN
PHONE: TOKYO (03) 759-2311
CABLE: GAMECREATER TOKYO
TELEX: 246-8521

Slowly but surely, a winning business strategy emerged for the key players in Japanese markets: a combination of domestic distribution of imported (American) games, and the development, sales and licensing of home-grown Japanese arcade machines.

The Young Apprentice

Nakamura Manufacturing was renamed Namco Limited early in 1977, adopting a trade name that was around since 1971. When Iwatani joined the company a few months before the name change, he was in for a surprise. At a party to welcome new employees, he introduced himself and expressed his desire "to design a pinball machine that will make the world proud." Much to his dismay, Iwatani's elder co-workers pointed out that the company didn't make pinball machines. "A lack of research on my part," Iwatani admitted. "I just figured they would be making them. When I spoke to some of the mechanics, they told me Namco wasn't able to make anything that complicated. Pins are just very intricate machines and are riddled with patents. I looked them up—the patents for things like the covering of the top glass plate with a see-through film so that it wouldn't be damaged— and soon figured out it would be very difficult to work around them."

Iwatani's first job at Namco was to work in the development department, alongside 25 to 30 staff, which included mechanics, designers, and electronics specialists. Their department was both a production line and repair shop, with heavy machinery like sheet metal cutters dominating the scene. The small factory was located in the middle of the city, a loud and crowded space without air conditioning. In summers, it could get very hot. It was also a relatively informal environment, with staff dressed in t-shirts and jeans instead of the suits and ties worn in the rest of the company. "I remember how you could just try all these machines at your leisure," Iwatani said. "Electro-mechanical games were very fun to make! I tried my hands on a few of the machines, working on prototypes. One time I tried to operate this machine which stamped out shapes of sheet metal, without knowing anything about the way it was supposed to be used. I just guessed how to place the metal, adjusting it with both hands, and when I pressed the pedal to stamp it out, the shaft that pressed the metal came down and landed a hair away from my fingernails. Just a little bit off, and my fingers would have been flattened."

Like most young new hires, Iwatani was assigned to service the Atari arcade games, switching out circuit boards, broken joysticks, and buttons. "Those were the days of the 'one board, one game' era," Iwatani said. "You could change games by replacing the software on the circuit boards. I'd check the boards returned to us by vendors who claimed they weren't in good condition, spraying integrated circuits that appeared to be broken with cooling spray and fixing them up."[14]

Beyond that, he kept himself busy playing video games most of the time. Samples of new Atari games would show up at the workshop, and it fell to Iwatani to decipher them. "Of course, back then the instructions of Atari games would be in English, and we had to translate them into Japanese, and I was mainly in charge of that," he said. "The staff familiar with electro-mechanical games didn't know video games well, so young me was put in charge of playing Atari's sample games, understanding the contents, and writing the instructions."[15]

"Simple jobs," he mused. "But come to think of it, I believe that between test play during repairs and creating documents for new hardware, I absorbed a lot of game ideas."[16] Other young hires followed similar paths, and consequently a growing group of young people emerged from the work floor well-versed in the intricacies of video game design, computer technology, and everything else needed to build arcade cabinets. Working for the development team (which moved to a larger, air-conditioned factory in 1978) did not preclude running errands for other departments.

Nakamura Seisakusho became Namco in 1977. This name change was advertised in U.S. video game industry magazines, telegraphing the company's international ambitions.

At one point, the 22-year-old Iwatani was asked to assist the department that handled intellectual property rights at Namco. Illegal copying of arcade machines was rampant in Japan, but copyright protection measures were still in their infancy. This meant that Namco couldn't do much about it without legal action. Removing a bootleg version of your own machine still meant going head-to-head with the manufacturer in court, and without strong copyright laws, judges required irrefutable evidence of the alleged copying.

So when Namco received a tip that a company in Kanagawa prefecture (southwest of Tokyo) was manufacturing copies of its *F-1* racing game in a Yasuda warehouse, Iwatani accompanied two older colleagues there to get photographic evidence. "It was exactly on the day The Allman Brothers Band performed in Japan," Iwatani remembered.[17] They found the warehouse, located the unauthorized machines, and snapped some pictures until warehouse security personnel confronted them and called the police. "Within minutes, we heard police sirens sound off and along came the patrol cars," said Iwatani. "In a couple of hours, we were being interviewed at the Isehara Police Station. We had legitimate arguments regarding the copied products, but they would not listen to us. Instead, we were arrested for trespassing. They secured our fingerprints and took front and side profile photos as we held on to numbered signage. It was the worst day of my life."[18] Later that day, Namco's lawyers phoned and explained the situation, after which Iwatani's mother was allowed to pick him up from the station. "Of course, I couldn't go to the Allman Brothers show. I was supposed to meet with my then-girlfriend there, who had the tickets to the show, but I couldn't make it, and she ended up dumping me."

The charges against Namco's employees were eventually dropped, and the *F-1* court case was later settled. But the story still illustrates the Wild West mentality of the Japanese amusement businesses in the late 1970s. Manufacturers openly riffed on successful themes or gameplay, sometimes copying machines *in toto*, or slightly changing the designs to avoid legal problems. It was a headache for Nakamura, who saw his business strategies undercut by copycats of all shapes and sizes.

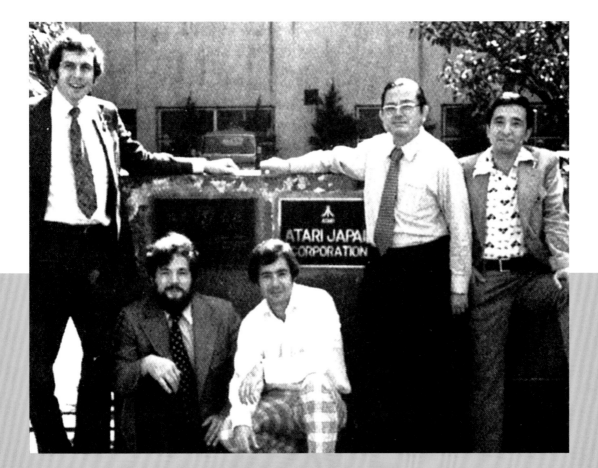

Atari's Nolan Bushnell (far left) and Masaya Nakamura (second from right) pose outside the Atari Japan offices in Tokyo. Hideyuki Nakajima (left of Nakamura) was president of Atari Japan and vice-president of Nakamura Seisakusho Ltd., and would play a pivotal role in establishing Namco's international trade relations.

His line of officially licensed Atari arcade games was particularly threatened by it, with imitations and clones of its new *Breakout* game appearing before Namco could even supply the originals. A new firm called the Universal Sales Company released a *Breakout* clone called *Scratch* in 1977, and Taito launched a popular 'table-top' model (comparable to U.S. "cocktail style" cabinets) called *T.T. Block* that same year. But those were only the companies that showed some creativity in their adaptations. "All of a sudden we encountered a great number of copies in the Japanese market," said Nakamura. "And we saw more copies than the original game that we were trying to distribute. It was to the detriment of our business."[19]

Also complicating matters was the involvement of the Yakuza—Japanese gangsters—in the production and sales of black market copied machines, which led to scenarios more dangerous than Iwatani's. The Yakuza traditionally had vested interests in pachinko parlors, but kept an eye out for other cash-operated machinery as well, including video games. "We knew exactly where these copies were being manufactured," said Nakamura, "and I instructed my staff to go to these factories for surveillance. They [the Yakuza gangsters] would watch from their car, then they would notice a car approaching them from the front, making their car immobile. They would come out of their cars and make threats."[20]

Nakamura asked Atari CEO Nolan Bushnell to send him more *Breakout* machines to resolve the matter, but Atari wasn't very cooperative. Frustrated, Nakamura and his VP and international marketing director Hideyuki Nakajima flew to London to meet with Bushnell at a trade show, to discuss what had become an impossible situation, to no avail. Nakamura said, "Hide and I went to see [Bushnell] one morning to lodge a very strong claim against the copies in Japan and to ask for his assistance...to counter the copies in Japan and do something about it. Unfortunately, when we met him, it was the morning after apparently a very long night of partying on the part of Nolan Bushnell and he obviously had a hangover. He was in no physical condition to concentrate on our very serious claim. He took it very lightly. For that reason and for the sake of self-defense in terms of business, we decided to start manufacturing the game ourselves."[21]

Something Is Buzzing

Nakamura's decision, which he didn't share with Atari, would be a fateful one. It violated the conditions of Namco's licensing agreement with Atari, because the company had not been granted manufacturing rights. Yet to Nakamura it seemed the only way out: to keep ahead of the competition, including illegal bootleggers, pushing his own machines felt like the final recourse. Once Bushnell found out, he filed a lawsuit against Namco. The lawsuit would eventually be settled, but at the time it nearly sank the relationship with Atari. However, in the short term, it did help Namco, freeing them to finally supply *Breakout* machines in numbers befitting the huge national demand. Suddenly, Namco was on par with other Japanese amusement companies in terms of large-scale game manufacturing. Emboldened by the move, their next step was to break away from Atari altogether, producing games in-house that could compete on their home turf and beyond.

Namco's development teams happily accepted the new circumstances. Staff discussed their eventual move into video game development as a foregone conclusion. Their work on Atari's games gave Namco intimate knowledge of the engineering and design behind arcade systems, and also yielded some early ideas for Namco's own games. "Video games with new concepts were coming in all the time," Iwatani said about this. "I was surprised at how amazing Atari's ideas were as a video game maker. Internally we on the staff thought, 'We want to make them, too!'"[22]

One early enthusiast was Shigeichi Ishimura, a promising engineer who joined Namco a year before Iwatani and would later become its president in 2005. "I was put in charge of the maintenance of Atari machines," he said. "They used to break pretty often. I think it was partially thanks to this that I became known as 'that guy who's great with electronic circuits.' I anticipated that video games would be the next big thing, so around the second year after I joined the company [in 1976], I was writing papers about video games and filing written applications to buy development equipment for video games, among other things."[23]

"I had a strong concept about what a game designer is– someone who designs projects to make people happy."

Toru Iwatani, *Namco game designer*

Ishimura's activities would be critical to Namco's future, Akira Osugi recalled. "I think that Namco became able to make video games, not because of the acquisition of Atari, but rather because of Ishimura-san's joining of Namco. Nakamura-san told me at the time that video games would soon be at the core of the company's business, and that we had to make them at all costs. Well, at the beginning there was no one who could make such games, but Ishimura-san, although I didn't know him very well at the time, had an air about him that made it seem possible."

One of Ishimura's notes pushed the idea of utilizing computer CPUs (central processing units) to move away from the solid-state electronics used in electro-mechanical games. This led to the purchase of single-board TK-80 microcomputers and PDA-80 developer kits from NEC, and a handful of engineers assigned to study the system's potential to create video games.[24] "The NEC TK-80 was a great computer," said programmer and sound designer Toshio Kai. "I think the development staff bought a number of them. I remember watching it from the side, and decided to try them out myself."

Several game development projects began with this small engineering team, with Iwatani assigned as a designer on one of them, and Ishimura overseeing the computer board design and programming for all projects. It might seem odd that the company put new, inexperienced hires on key game development tasks, considering that Namco had many other seasoned electro-mechanical engineers on-hand. But it made total sense for Namco in the grand scheme of things, considering that the company still relied heavily on electro-mechanical games and kiddie amusements for its profits. Iwatani elaborated on that: "At the time, the video game industry was nothing but a possibility, so the development was left up to the younger employees. We made the [first] game with a team of three people. When you include the people in charge of designing the cabinet, it took seven or eight of us a year to finish. Outfitting the development environment lasted quite a while."[25]

Yet Nakamura was confident these youngsters—those who played video games and repaired the Atari machines—could pull it off. Years of experience in a creative industry taught him that energy and curiosity went a long way, and he cultivated a free-thinking environment where everyone could introduce new ideas rather than top-down management. Ishimura recalled: "Nakamura-san used to ask employees, 'Are you serious about this?'; 'How far are you willing to go?'; 'Are you going to take responsibility?' [and so on], very often."

"He had no need for plans which people were so eager to give up on. 'I have no need for analytical arguments; show me some passion!', is what it came down to. If someone were to show their unrivaled passion for their idea from the start, they might not have been rejected, I think. I talk about rejection, but this all transpired in a very informal and free setting."[26] As someone with decades of experience in creating "play," Nakamura knew what to look for in the people he hired—individuality, inquisitiveness, and personality. "The entrance exam emphasized the interview more than a written exam," Iwatani wrote later. "I remember that the president Masaya Nakamura and Yusuke Yokomizo were the interviewers. My direct boss, Yokomizo, later mentioned, 'This kid is really different from the others.'"[27]

At the beginning, Iwatani felt lucky just to make it into Namco. Reflecting on his early career, he mused, "I had no special training at all; I am completely self-taught. I don't fit the mold of a visual arts designer or a graphic designer. I just had a strong concept about what a game designer is–someone who designs projects to make people happy. That's his purpose."[28]

Taito's *T.T. Space Invaders*—the "T.T." standing for "table-top"—helped popularize the horizontal, table-style arcade cabinets. These games were known as "cocktail tables" in the U.S. market because they allowed players to put drinks (and ashtrays) on the flat top surface. The model would be an industry staple for years to come.

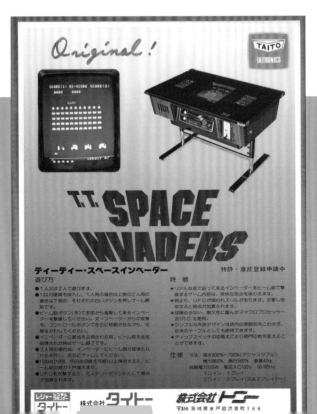

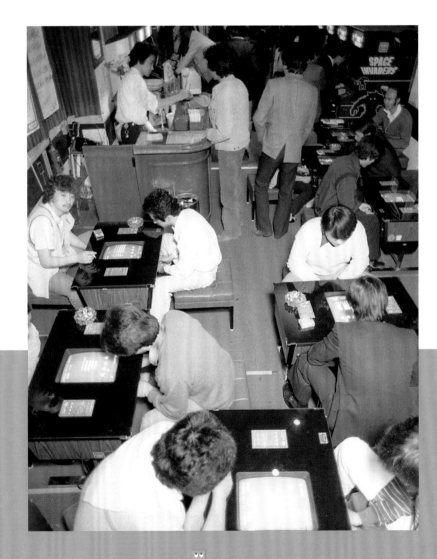

Players crowding an "Invader room" or "Invader house" in Japan on April 10th, 1979. These dedicated spaces housed only *Space Invaders* games in Japan, because of the game's outrageous popularity. Note how the arrangement of cocktail tables and upright

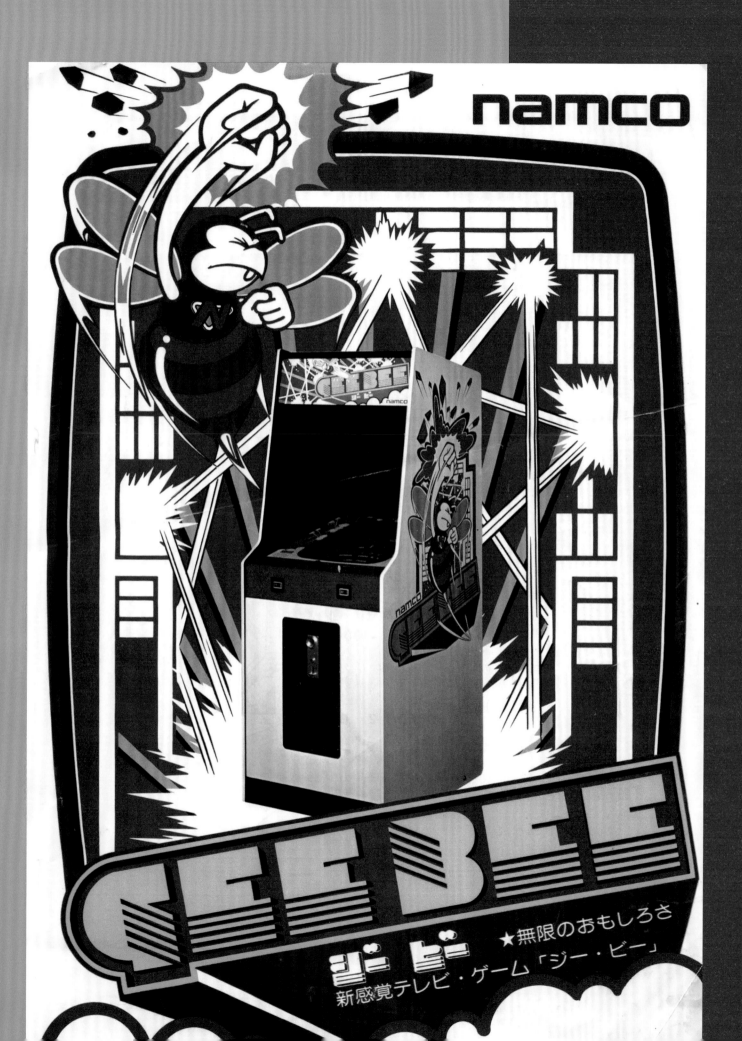

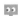

Gee Bee (1978) combined the popular block-breaking mechanics from Atari's *Breakout* (1976) with pinball elements like paddles, spinners, and pop bumpers.

Still, Iwatani should not have worried about his background, because "different" was exactly what Nakamura was searching for. In a 1985 profile of Nakamura in the *Journal of Japanese Trade & Industry*, the writer honed in on the company tagline: "Asobi wo Create suru", or "Creation of Play." He wrote: "In Japanese society, which is often criticized for putting too much emphasis on work, 'play' has a negative value. In such a society, Nakamura's attitude of making 'play' a source of business is unique. Most companies try to hire students with excellent scholastic records, but Namco is different. Namco does not want stereotypical honor students. It wants young men with unique ideas. Nakamura believes that technical innovations will create market after market, and that enterprises must have employees with diversified talents and capabilities to respond nimbly to future change."[29]

From the moment Iwatani was asked to brainstorm a possible Namco video game, he advocated for what he considered the best possible theme: pinball. "Of course, there was a personal impulse, as I really wanted to make a pinball game. But in addition, there was a strong conviction [amongst my colleagues] that pinball game features could be applied in video games as well."[30] Besides pinball, he was also inspired by Atari's *Breakout*, which led to a hybrid game design in which the player used (digital) paddles and bumpers to clear rows of blocks, with the ball ricocheting like a pinball. In the summer of 1978, his vision, *Gee Bee*, was completed, representing the very first video game developed by Namco.

Whatever hopes Namco had for *Gee Bee*'s success would soon be dashed, however, by the arrival of a new Taito game that dominated the market in the wake of its June 1978 release: *Space Invaders*. Designer Tomohiro Nishikado's iconic game featured aliens descending towards Earth, with players firing laser cannons to ward off the invasion. Shooting moving targets was a novelty for games of that era, and so was the ability to save a high score on the machine—a feature that would grow to define arcade gaming for years to come.[31] Nishikado's appealing, pixelated alien designs did the rest. Soon Japan was completely hooked on the game, with players waiting in long lines for a turn to play, returning again and again to attack the high scores on machines.[32] Amusement centers swiftly adjusted to the craze, sometimes clearing out entire game lineups to accommodate more *Space Invaders* cabinets. Taito reportedly sold 300,000 machines in 1978 and 1979, making it the first-ever Japanese-made blockbuster game. It would go on to sell some 65,000 machines in the U.S. market, setting the stage for more Japanese games to follow.[33]

"We heard stories of Gee Bee machines piled up while still inside their boxes, or machines being used as room partitions."

Shigeichi Ishimura, Namco game engineer

The unprecedented success of *Space Invaders* undoubtedly hurt *Gee Bee*'s reception. Introducing new games to the market was a practical process of convincing amusement site owners to try new arcade machines over the ones they already knew. Ishimura said, "Sales to game centers and cafés took the form of the rental of space. We would take a set of the game and put it at the location with the request to the proprietor to take care of just the electrical fees. The proceeds from the machines would be split between the proprietor and Namco. This being the case, being a shop-owner, rather than getting around 1,000 yen a day, you would obviously prefer a machine which rakes in 10,000 yen a day. When we showed someone *Gee Bee*, we often got told, 'I don't need that, bring me *Space Invaders*!' Plenty of units were sold, but we heard stories of (*Gee Bee*) machines piled up while still inside their boxes, or machines being used as room partitions."[34]

Stories about *Gee Bee*'s bleak prospects reached the development teams, too. "Since we failed badly, we had quite a lot of stock [of the machines] left," said Iwatani. Namco's sales people came over to the developer department, saying things like, 'Well, what are we going to do about all these machines that are sitting here?' somewhat in a threatening manner. We understood their frustration, of course, but this definitely was not a nice experience for us." Fortunately, not all the news out of Namco was bad. *Gee Bee* eventually sold 10,000 units, and U.S. company Gremlin Industries took an interest in the game and licensed it for North American markets, where it launched late in 1978. In 1979 Namco released two sequels, *Bomb Bee* and *Cutie Q*.[35] Both designed by Iwatani, they further explored the dual pinball/block breaker theme with improved visuals and stronger gameplay. Still, interest in these "paddle games"—which used pinball-style flippers or paddles to launch projectiles—tapered off quickly, and not just because of the *Space Invaders* competition. *Gee Bee* was a very difficult game, Iwatani later admitted, which required considerable skill to chalk up a respectable high score. It taught Iwatani valuable lessons about the delicate relationship between game design, player expectations, and difficulty settings—lessons he would take to heart in his next video game project, *Puck Man*.

Promotional material for Namco's *Bomb Bee*, the sequel to *Gee Bee*. While the game didn't impress Japanese gamers, it did lead to a notable cooperation with Nintendo, who re-released the game as *Bomb Bee-N* in 1979—the "N" indicating this version was Nintendo's. It would be one of the first examples of a "third party game release" on Nintendo hardware.

CHAPTER 3

Finding Puck Man

パックマンを探して

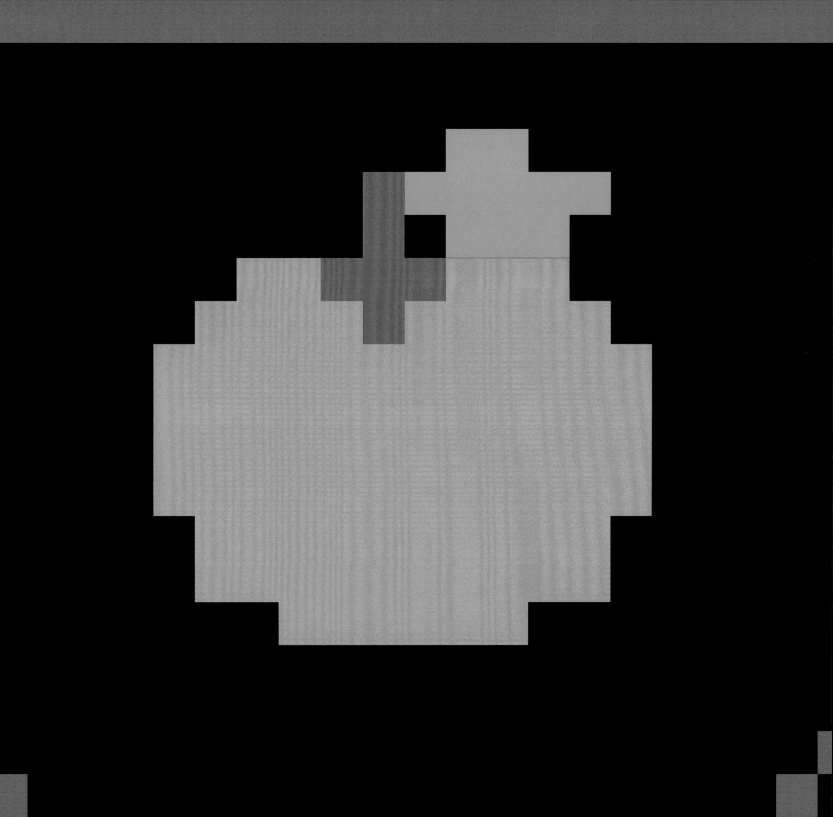

profoundly changed the relationship between players and games, and the role games could play in the wider realm of popular culture. The game brought new types of players to video games, introduced iconic character designs that transcended arcade screens, and launched a trend of cute, casual games that continues today.

> **"Making a game combines everything that's hard about building a bridge with everything that's hard about composing an opera."**
>
> **Frank Lantz**, Game designer

In addition, it's crucial to understand how *Pac-Man*'s many merits tie directly into Iwatani's original game design. The introduction of new players (women, children, businessmen) sprang directly from Iwatani's thoughts on the role of games and the state of arcades. The iconic status of *Pac-Man* and its four ghost characters grew out of his desire to draw players into a story by making a likeable comic character the "face" of a video game. The ongoing lineage of "casual" games owes a debt to its forerunner in *Puck Man*; the style of games would undoubtedly be different if not for Iwatani's efforts to design a game that would be attractive to new audiences.

In hindsight, the throughline seems so clear: the game is the natural fruit of Iwatani's intention to build approachable, appealing games. However, this simplistic narrative doesn't account for the creative and technological struggle of video game design. As any game designer will attest, making a video game is a herculean task, and making a successful one—a game that does everything right—eludes many development studios. There's technology that will or won't yield the required effects, a business context that may or may not affect a game's success in the market, and cultural elements (the game story, but also the cultural context informing the makers and the games) that may or may not work for or against design ideas. Game designer Frank Lantz, Director of the New York University Game Center, summed up the (im)possibilities best: "Making a game combines everything that's hard about building a bridge with everything that's hard about composing an opera. Games are basically operas made out of bridges."[36]

Iwatani and his peers at Namco succeeded in composing something truly timeless, which led to a game that resonates with every player—whoever he or she may be, and whenever he or she will play it.

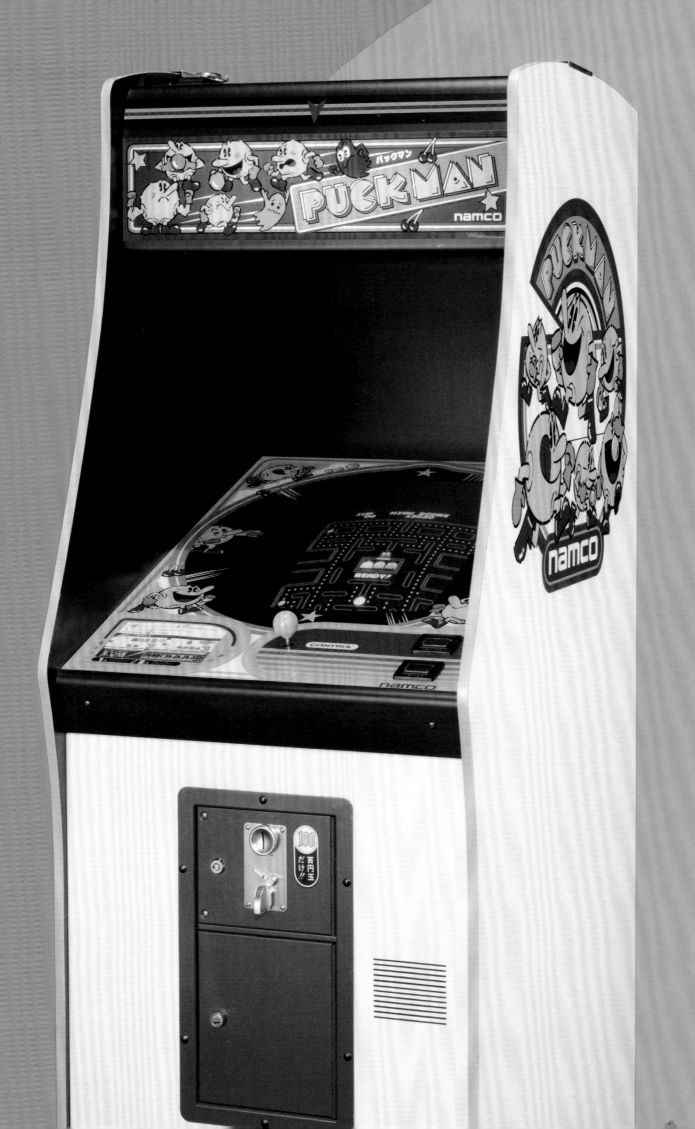

⋮ Star Wars

The development of *Puck Man* began in April, 1979, just before *Bomb Bee* and *Cutie Q* were finished and shipped. By then, Namco had grown to nearly 750 full-time employees and was a force to be reckoned with in the Japanese amusement industry. Roughly a third of those workers were engaged in the development, design, manufacturing, and marketing of video games, with almost 40 of them directly responsible for game development.[37] The bulk of the workforce centered around Namco's amusement locations, working as game center clerks, operators, or location managers. "Namco's biggest source of funds was still from these locations, where the daily money came in," said location manager Akiyoshi Sarukawa. "That's why the number of people in marketing and development was still relatively low. Later, as video games became mainstream and the market grew, the number of employees there increased rapidly."

Gee Bee, *Bomb Bee*, and *Cutie Q* did well enough to sustain the creation of new video games, and the small development teams had clearly found their groove, creatively. One of those teams—whose core included lead designer Kazunori Sawano and programmers Shigeichi Ishimura and Toshio Kai—would soon launch a title that outperformed Namco's paddle games by a wide margin: *Galaxian*. Released while the shooter craze was in full swing, the game appeared to be Namco's attempt to simply copy a successful formula.[38] While there is truth to that perspective, Sawano's work on this space shooter began before *Space Invaders* hit the market. *Galaxian* had other parentage, too.

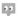

Galaxian compared favorably to other space shooters of the era. Its enemy vessels actually appeared in waves visually, with individual ships breaking formation and dive-bombing the player's ship. These movements resembled the movement of *Star Wars'* TIE Fighters.

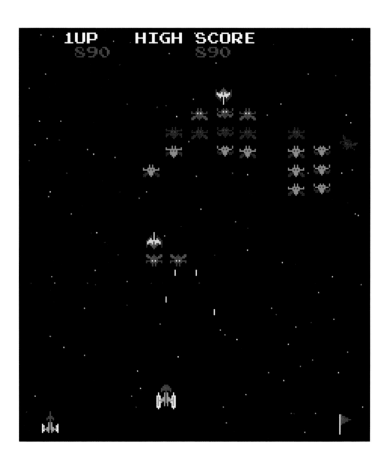

The original *Star Wars* film, released in 1977, had an enormous impact on entertainment industries worldwide. Its popularity seemed to have no limits, and soon other science fiction and space fantasy films flooded televisions and movie theatres. Other related properties rushed in to fill the vacuum of space content, from a resurrected *Star Trek* to television series like *Battlestar Galactica* and *Buck Rogers in the 25th Century*. Video game manufacturers were in on the space race too, with Cinematronics launching an arcade game called *Space Wars* (1977) and Atari debuting its first-person space shooter *Starship 1* in arcades that same year. In Japan, *Star Wars* influenced the design concept for *Space Invaders*—before settling on the iconic theme of space aliens, designer Nishikado had experimented with everything from humans to tanks to airplanes, to little satisfaction.

Namco's original *Galaxian* arcade cabinet.

"We were actually in the middle of developing Galaxian when Space Invaders came out."

Kazunori Sawano, Namco game designer

Namco's Sawano was equally inspired by *Star Wars* for his first video game title. Planning a game set in open space (and not a planet's surface, like *Space Invaders*) he envisioned ships executing the types of maneuvers associated with dogfighting airplanes, before he was corrected by Nakamura.[39] Sawano recalled, "We were actually in the middle of developing *Galaxian* when *Space Invaders* came out, and the president of Namco told us, in no uncertain terms, that *Galaxian* had to be the 'post-*Invaders*' game. It was a tremendous amount of pressure. Naturally, we took a lot of cues from *Space Invaders* while making *Galaxian*."[40]

Despite this, *Galaxian* was much more than a riff on Taito's game. Sawano's ideas about dogfights ended up becoming the swooping attack patterns *Galaxian* is known for—a huge leap from *Space Invaders'* mechanically descending rows of aliens. But perhaps more important was the use of color. *Galaxian* was among the first arcade games to use a multi-colored display, raising the bar for any other contenders in the video game industry. Since *Pong*, most video games had utilized black-and-white monitors, with color effects sometimes achieved by using transparent, colored overlays on the screen—the descending aliens in *Space Invaders* were created using white graphics on a black screen, but the static, colored overlays tinted the characters each time a row of aliens moved down. *Galaxian*, in comparison, utilized multi-colored alien sprites, a scrolling starfield background that suggested depth of field, and enemies that flew in parabolic arcs instead of static rows.

With these innovations, the game greatly expanded the creative possibilities in video games and kicked off what Iwatani called "Namco's expressive gaming style," a combination of colorful graphics and "playful" gameplay that, with each release, moved closer to satisfying an even wider audience.[41] *Galaxian* also gave Namco's coffers a boost, according to location officer Katsutoshi Endo. "The first prototype was put in at 4pm for a location test, and it was stolen around 10pm. So, I called President Nakamura and told him of the theft. The president said, 'Well, if it was stolen in such a short time, then it will be a big hit!' After the incident, the popularity of *Galaxian* exploded, and I remember that the office safe was literally overflowing with yen coins and notes. Sales at our locations doubled at once! That gave us a lot of confidence."

Taking it Easy

While working on the paddle style games, Iwatani had been jotting notes for his next project, and he kept returning to two things. The first was the idea that *Gee Bee* had been too hard to play, leading to its disappointing performance in the market. In hindsight, the team recognized they had fallen victim to a trap specific to video game development. Iwatani explained, "The reason *Gee Bee* became that difficult is that the designers spent a lot of time playing their game during the development process. Because they got better and better at playing the game, they also increased the difficulty to match this." Any new game, Iwatani realized, would need to be much easier to pick up initially, if it was going to have greater commercial success.

The second idea was born while roaming the game centers of Tokyo. By the middle of 1979, the space battle trend was running on overdrive. Amusement spaces were flush with shooter video games, with many venues advertising themselves as "Invader houses" that only offered *Space Invaders* and drinks. Many of these locations were open 24/7, thick with cigarette smoke and stale sweat. Targeted at an adult audience, they also gained a reputation as hangouts for kids skipping school and shadowy underground figures. Whether this image was deserved or not, it led to a strong backlash around the country. Officials voiced their concerns about the moral corruption of Japan's video gaming youth, and Japan's major amusement trade organization, the Japan Amusement-Trade Association (or the JAA), felt compelled to issue strict guidelines for game centers to prevent heavier measures from the government.[42] These concerns would be mirrored overseas in legislation aimed at U.S. pinball games and the reputations of arcade parlors.

"I figured that a game based around the verb "to eat" could be fun."

Toru Iwatani, Namco game designer

While the JAA's concerns differed from Iwatani's, he also felt uncomfortable with the state of the industry, specifically the lack of game variety. Space battle games appealed mostly to young men, and other groups that had previously visited the typically family-friendly amusement spaces were increasingly seeking other forms of entertainment. "Game amusement centers were saturated with games where killing aliens was the main objective," Iwatani said. "These types of games had a rather brutal image and a largely male audience. Lots of these games had great concepts that were fun to play, but I felt that none of these were equally accessible to women."[43] Apart from the ruthless nature of the games themselves, the arcades also felt increasingly dark and gritty—a stark contrast to Iwatani's days playing pinball. Arcades at that time were "for men," Iwatani recalled. "It wasn't fashionable at all. When women would go out, they'd go out in a group of friends or with a boyfriend as a couple. And I realized that if women and couples were going to come to game centers, they had to be cheerful places."[44]

Hardware designer Shigeichi Ishimura discussed Iwatani's thoughts with him at the time. "I think it was in Yokohama, on the way back from a drink or something," he said, "and I remember Iwatani-san saying that he wanted to make a game like that while watching a group of girls happily giggling at a game center." A simple, lighthearted game would make all the difference, they thought, and this required a game idea that would appeal to this specific audience.[45] Ticking off activities that he associated with young women, Iwatani looked into subjects like fashion, fortune telling, dating, and eating.

("I didn't spend a lot of time seeking their opinion on the ideas," he later admitted.)[46] At the Namco offices, he would spar with colleagues in the development department, including designer Toshio Kai, programmer Shigeo Funaki, and Ishimura. "When it came time to figure out what sort of game I could do, I suggested basing it around a particular verb," Iwatani said. "I thought up a variety of verbs, such as 'grab' and 'surround.' [In the end] I figured that a game made in the image of a culinary environment and based around the verb 'to eat' could be fun."[47]

Soon, Iwatani developed his basic idea about a game where the player gathered food—and not much else. "In my initial design, I had put the player in the midst of food all over the screen," Iwatani said about this early phase of development. "As I thought about it, I realized the player wouldn't know exactly what to do; the purpose of the game would be obscure. So, I created a maze and put the food in it. Then whoever played the game would have some structure by moving through the maze."[48] Ishimura assisted by making a maze on *Galaxian* hardware—a prototype that would function until the team had a better idea of what the game would look like.

For further inspiration, colleagues contributed ideas, chatting about other games that employed eating or food as a theme. They explored casino slot machines and their use of iconic fruits and bell images in the reels, which they considered distinctly "American" and, by definition, "cool design." What began as a bit of fun eventually turned into the well-known bonus items of their game, with the fruits, bell, and key later found in consecutive levels of the game. Iwatani recalled, laughing: "Once we began running out of ideas, we even put in things like Galaxians."[49]

Next came the game's character design, which, as lore has it, was inspired by one of Iwatani's meals. Out on a lunch break one day, Iwatani ordered a pizza at an American restaurant chain called Shakey's Pizza. He finished one slice of it, and left on his plate were the makings of a singular video game character. Back at the office, he sketched his idea on graph paper—a circular character with a missing wedge for a mouth, which Funaki translated into computer code. The player would be able to steer the chomping character through the maze, its mouth opening and closing as it moved. The team now had a munching character who could clear a maze filled with food dots. Iwatani named them "esa" (Japanese for "food") in his design documents, though this word would be lost in translation once the West embraced the idea of dots.

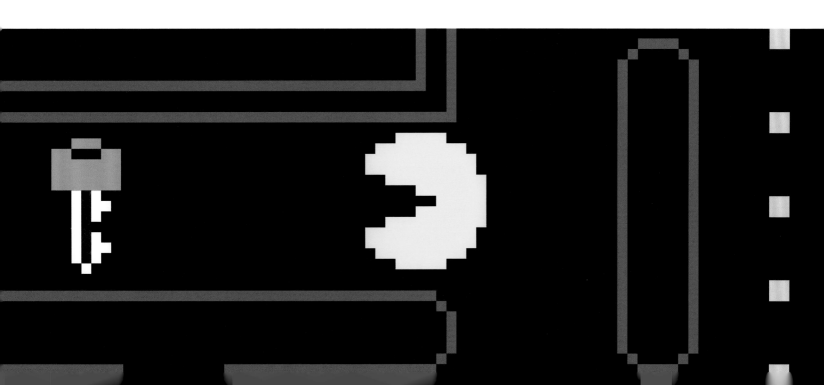

A LUNCH TO REMEMBER

The legend of Pac-Man's origin is almost as famous as the dot muncher himself. Repeated in the press whenever the character is discussed, Toru Iwatani's "pizza story" has taken on something of a mythical quality over the decades. Reportedly, Iwatani was having lunch by himself one day, removed a slice of pizza from the pie on his plate, and saw his game's character in what remained of his meal. As appealing as the story is, it also comes loaded with questions. After all these years, it still isn't clear if the tale is true, half-true, or simply a bit of excellent corporate storytelling.

The source of the story is Toru Iwatani himself. From the earliest interviews, pizza was an interview staple for reporters, with Iwatani gladly feeding them versions of inspiration found in his lunch. "The idea for Pac-Man came by chance," wrote the *Journal of Japanese Trade & Industry* in a feature called "Namco, Maker of the Video Age," in 1985. "On a balmy spring afternoon when the cherry blossoms were in full bloom, Iwatani was having a small pizza for lunch at a snack bar. Casually, he thrust his fork into one of the six slices of the pizza and lifted it to his mouth. Suddenly he noticed that removing the segment had created what appeared to be a gap-ing mouth on the plate. From there on, his imagination took wing."

The story itself certainly took flight. It was repeated again and again, in increasing detail. In the 1988 publication *Denshi Yūgi Taizen (The Complete Book of Video Games)* for instance, Iwatani is quoted: "I happened to come up with a hint during lunch one day. As you know, pizza is cut into several fan shapes."

"I took one of the slices to eat. When I saw the shape of the rest of the pizza, it hit me. I thought, 'This can be used for game design!' So, I immediately drew a sketch." In December 2005, he confirmed the story in a contribution to *Game Developer* magazine: "I was at a restaurant and noticed a pizza with a slice missing. I thought, 'This is it!' This was the inspiration, and it became the shape and general concept for *Pac-Man*." The story would be repeated to *The Times of London* in 2005, where Iwatani added a location for the story—a local restaurant of the American chain in Japan called Shakey's Pizza.

But a second strain of interviews tell a slightly different story. In June 1982, Iwatani told an *International Herald Tribune* reporter: "I wish I could say I had pizza pie for lunch. But I don't remember what I ate." Four years later, Susan Lammers interviewed Iwatani for her *Programmers at Work* series, and asked point blank if the pizza story was true. "Well, it's half true," Iwatani answered. "In Japanese the character for mouth (kuchi) is a square shape.

It's not circular like the pizza, but I decided to round it out." Tristan Donovan, author of the 2010 book *Replay: The History of Video Games*, also questioned Iwatani about his circuitous stories. Iwatani relayed a version of the tale where he had "researched" a "keyword" related to eating: "When I did the research I came across the image of a pizza with a slice taken out of it and had that eureka moment."

So, what is the real story? Did he truly bite into mozzarella inspiration? Iwatani's love of practical jokes is well-known. Could this be one extended prank pulled on a long line of reporters? Or was it simply a nuance of language, with Iwatani explaining himself honestly to English-speakers, only to have something essential lost in translation? In the end, it could simply be a convenient story, originally concocted in jest, but now sustained over decades of repetition. In 2000, Iwatani shared his thoughts with Hidekuni Shida and Yuuki Matsui for their book, *Game Maestro Volume 1: Producers and Directors*. Video game journalist Chris Kohler translated his statement: "It's already passed into legend, so I'm going to stick with this: I took one slice out of a pizza and saw Pac-Man."

Removing a slice or two from a pizza immediately brings to mind the story of Pac-Man's origin, as told by creator Toru Iwatani.

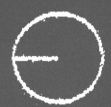

Iwatani's original Puck Man design sketches on graph paper were used to plot the pixels on a 16x16 pixel grid.

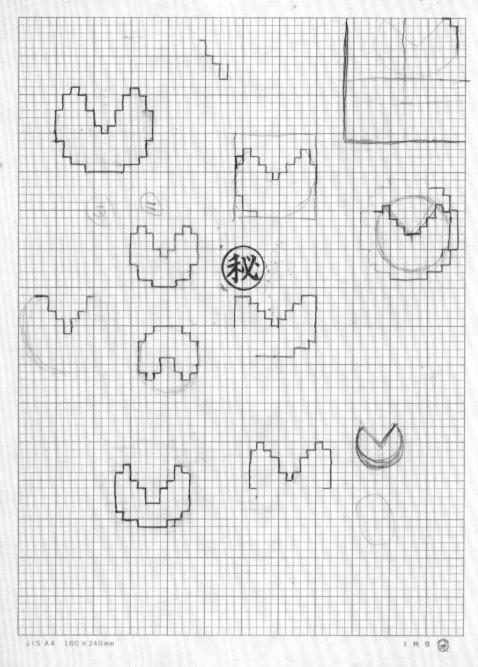

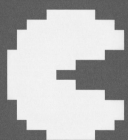

Friendly Enemies

On its own, eating dots in a maze didn't make for fun, compelling gameplay, Iwatani realized. For this reason, he started considering enemies who could stand between the player and the food.[50] Aliens or spaceships were non-starters for this game, so he looked for inspiration elsewhere. Eventually he created a group of enemy monsters that referenced characters like Casper the Friendly Ghost and the popular Japanese manga/anime, *Little Ghost Q-Taro (Obake no Kyutarō)*. "Q-Taro came out when I was in primary school, and I liked drawing [the ghost] as a kid, since its shape was really simple," Iwatani said. "So, when I designed the monsters, I drew them with Q-Taro in mind. With their round heads and big eyes, the monsters weren't scary, but rather cute. Q-Taro is supposed to be a friend who lives in your house and is always close by, so they are indeed similar in that sense."

"There was the temptation to make the Pac-Man shape less simple."

Toru Iwatani, Namco game designer

With these four monsters roaming the maze, the player would have a harder time getting at the food, needing more strategy to navigate the playfield. Satisfied with the basic game concept—a mouth-figure eating dots in a maze while chased by monsters—Iwatani formally filed a proposal to develop the idea further. After the proposal was approved, a three-man project team was created to execute it, with Iwatani joined by programmers Toshio Kai and Shigeo Funaki. Next came a full year of development and fine tuning the game's details. The team explored new features as they moved along, without a deadline or specific budget set by management. "It was totally up to the developers," Iwatani said. "Sales people or management [at that time were] not that familiar with the game development process; they depended on the young developers."

"Without there being a deadline for *Pac-Man* and [the *Galaxian* sequel] *Galaga*, we were pleased to continue the development without this pressure."[51] Working in a small team had its benefits. "There really was not a lot of stress involved," Iwatani said. "When you work on a project with a lot of people, it's important to align your ideas and discuss concepts. That wasn't the case with *Pac-Man*. At times it almost felt like a DIY project." Subsequently, the team worked freely on the game until they were completely satisfied with the results.

Each iteration of the game was spawned by trial-and-error. Features were added and dropped, tested and retested, tweaked and implemented—anything that didn't work was eliminated. The warp tunnels on the left and right sides of the screen were added along with the "ghost pen" or "ghost nest," the square spawning unit in the middle of the screen. Initially, the pen sported a sliding door which released a ghost after a specific number of dots were eaten by the player, but that feature didn't last.

Another idea that didn't make it was to give the player the ability to shoot at the enemies. "Some people felt like the continuous 'running away' of the game needed some variety, or was lacking a bit of thrill. So, the idea of adding an extra attack button to make Pac-Man shoot projectiles to defeat the ghosts did come up. But we soon decided this wouldn't work, so we dropped it."[52] Also, the team revisited the sprite design of the main character, who was still without a name.

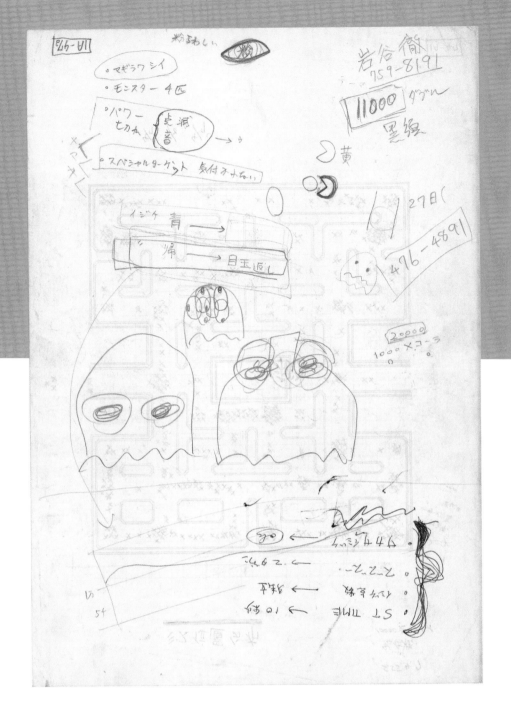

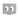 Little Ghost Q-Taro on the cover of a pop-up book, 1972.

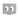 Some of Iwatani's original sketches of the ghosts explore aspects like positioning of the eyes.

"There was the temptation to make the shape less simple," Iwatani said in a 1986 interview. "While I was designing this game, someone suggested we add eyes. But we eventually discarded that idea because once we added eyes, we would want to add glasses and maybe a moustache. There would just be no end to it."[53]

A desire for simplicity soon drove every design decision. For player input, the team eventually settled on a four-way joystick, without burdening new players with an array of buttons, levers, or knobs to decipher. Getting the most out of the 16-color circuitry and color monitor, they chose contrasting colors for all of the on-screen elements. The maze was created with bright blue outlines on a stark, black background, with the player character traversing the screen in radiant yellow, a color Iwatani considered "neutral, peaceful" and "which neither represents friend or foe."[54] The four ghosts were tinted in pastel shades of red, blue, pink, and orange—"friendly" colors chosen because Iwatani thought women might like them—with large white eyes and blue pupils that would point in the direction of travel.

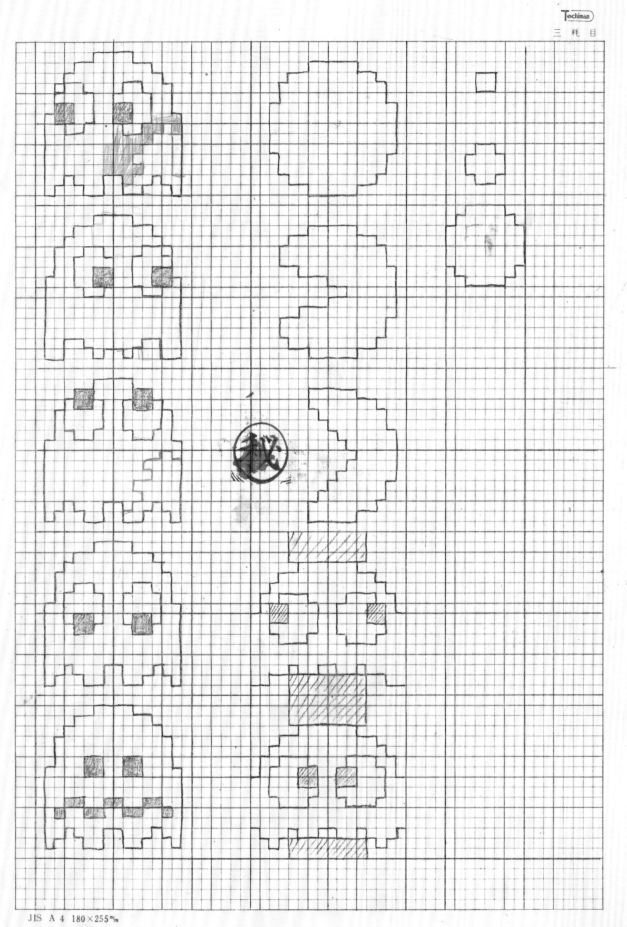

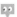

A size comparison chart for Pac-Man, ghosts, and (power) pellets.

"I distinctly remember that we looked at the colors in Sanrio characters for the ghosts, to add to the 'cuteness' of the game," Iwatani said. Since the launch of a cat character known as Hello Kitty in March 1975, the company Sanrio had become synonymous with everything "kawaii" or "cute," an almost child-like aesthetic centered on adorable characters with rounded features and (often) disproportionately large heads and outsized eyes.[55] This popular aesthetic dominated Japanese media like manga (comics) and anime (animation) from the 1970s onward, but was also seen in company mascots and public signboards. Soon, this Japanese "cult of cute" would become part of the global design language, with Sanrio—dealing in small gifts like stationery, school supplies, and trinkets—its largest purveyor and retailer. Before the decade was out, Hello Kitty was one of the most successful marketing brands in Japan, and a design icon in her own right.[56] Iwatani, like most Japanese, was smitten by the brightly colored, delightful-looking Sanrio characters. "That's why I decided on one ghost being pink. I even remember saying, 'Make it Sanrio pink!'"

This "cute" color palette provided a striking contrast to the black and blue maze, and also helped the colorful characters, dots, and bonus items stand out from the playfield during the game.

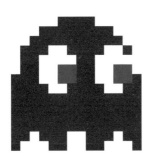

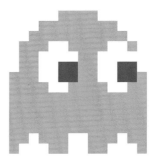

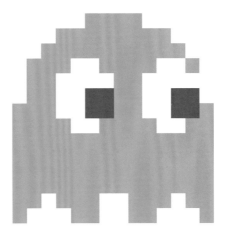

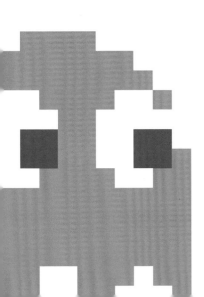

WHAT'S IN A NAME

Do you want in on a little secret? Sometimes a name is more than just a name, and with *Pac-Man*, this certainly is the case. Most players know his four ghostly pursuers as Blinky, Pinky, Inky, and Clyde, but it's their "real" names that are worth paying attention to. These alternative character names subtly clue gamers into the behavior of the multi-colored adversaries. Shadow (Blinky) pursues Pac-Man, living up to his name by shadowing him; Speedy (Pinky) tries to cut him off by taking an intercepting route through the maze; Bashful (Inky) tends to shy away from the action; and Pokey (Clyde) just dawdles without actively pursuing Pac-Man.

These demonstrative names are there by design. Creator Toru Iwatani and his team wanted to entice novice players to embrace *Puck Man* and its cute design. To lure gamers in, the developers at Namco used the game's "attract mode" to show off these subtle clues. The first thing players see is not the maze or the way Pac-Man utilizes power pills, but the ghost names, rolling slowly into view, one by one—practically sharing an instruction manual on the ghosts' behavioral patterns before a single coin is inserted.

Of course, in the original Japanese *Puck Man*, the names were different—but those original monikers have the same indicative qualities as the U.S. versions. Blinky's Japanese name "Oikake," for instance, means "to run down or pursue," and "Machibuse" (Pinky) translates to "ambusher." Another set of nicknames merely served as indicators of their respective colors (Blinky's "Akabei" means "Red guy," for instance), with the exception of Clyde's "Guzuta," a word that roughly translates to "slow" or "unsettled guy."

Completionists will like the fact that there is also a third set of names, besides the Japanese and U.S. name sets. A different set of English names were developed by Iwatani, as part of the "*Puck Man*, final specifications" document. These are illustrative of an alternate history, in which we would guide Pac-Man away from Urchin, Romp, Stylist, and Crybaby, who were respectively nick-named Macky, Micky, Mucky, and Mocky.

	Japanese Name	Japanese Nickname	American Name	American Nickname
	Oikake - 追いかけ (Pursuer)	Akabei - アカベイ (Red guy)	Shadow	Blinky
	Machibuse - 待ち伏せ (Ambusher)	Pinky - ピンキー (Pinky)	Speedy	Pinky
	Kimagure - 気まぐれ (Fickle one)	Aosuke - アオスケ (Blue guy)	Bashful	Inky
	Otoboke - お惚け (Dopey one)	Guzuta - グズタ (Dawdling, slow, unsettled guy)	Pokey	Clyde

This June 30, 1980 document, titled "Puck Man, final specifications," includes two lists of ghost names. The first list was used in the Japanese *Puck Man* arcade game, while the second ("For foreign countries") indicates that Namco considzered exporting the game to other territories. A handwritten note by Toru Iwatani shows how several variations were considered before finalizing the last two sets. Of course, later that year, Midway would create their own American names and nicknames.

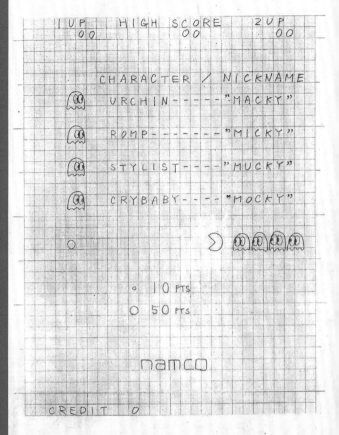

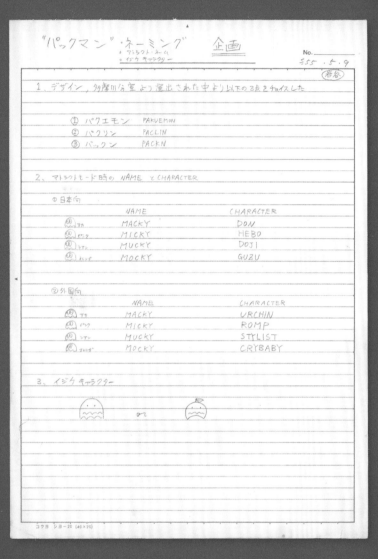

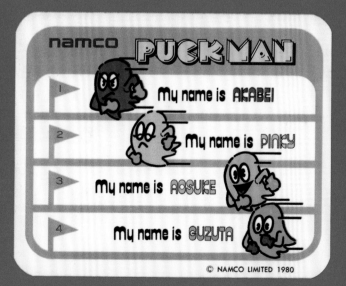

Waka-Waka!

The colorful designs were complemented by Toshio Kai's audio design for the game. Kai was one of the first Namco employees to use the TK-80 computers and had worked alongside Sawano on *Galaxian* as a programmer. Previously, Namco had developed a custom sound chip that allowed sound designers to combine up to three sounds at any moment, controlling each channel's volume, frequency, and waveform.[57] While three notes are enough to play (almost) any chord, the hardware setup was quite spartan in practice, greatly reducing the possibilities for sound effects. Configurations for individual sounds were coded directly onto the chip, while the underlying files were stored in the game's memory, along with all the other elements needed to run the game. This meant that every sound occupied bytes that could also be used for generating movement or colors, so an economical approach to programming sound was essential.

But Kai was up for the challenge. As a trained musician with a background in jazz guitar, the programmer was ideally suited to tackle the daunting task of creating exciting music with limited technology. "At the time, I was interested in microcomputers," Kai said. "I bought one and it made sounds, so I played around with it in my spare time."

Working in tandem, Iwatani and Kai exchanged ideas on how the new game should sound. Kai started building his first ideas on guitar, recording ideas for playback to his colleagues.[58] Inspiration flowed from several directions. Kai: "Back then, there was a jazz guitarist named Gábor Szabó, and what he did was so interesting. In Japan it was the norm to use a single melody in a song over certain chords and play it repeatedly, but Szabó shifts the chords in his songs, so I thought, 'Let's do that!' I experimented with melodies, and shifted the chords, and added things like drums or stomping sounds." This experimental approach eventually yielded the opening theme for *Pac-Man*, a short, jazzy melody in the tradition of those found in Looney Tunes or Disney cartoons. To Kai, the Szabó influence is still audible. "To me," he remarked, "the tune has a bit of a gypsy music feel to it, which isn't surprising, as Szabó is Hungarian."

Musical score for Toshio Kai's opening theme for *Pac-Man*.

Besides working on the musical theme, Kai designed the rest of the game's audio, too, including the sound effects and notes played during various stages of the game. To further embellish the game's eating theme, Kai and Iwatani looked for sounds associated with eating, like swallowing, munching, or biting. To explain the desired results, Iwatani happily served as voice actor. "I described the 'swallow' sound effect that I wanted to Kai-san by eating fruit, and by making actual gurgling sounds."[59] This process eventually led to the now-famous "waka-waka" sound Pac-Man makes after eating a dot—a sound that echoes the words "paku paku," Japanese slang for munching, much like the English "chomp chomp."

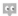

Animation sketches for each of Pac-Man's character states. Iwatani's famous "death" animation was meant to resemble an explosion of fireworks.

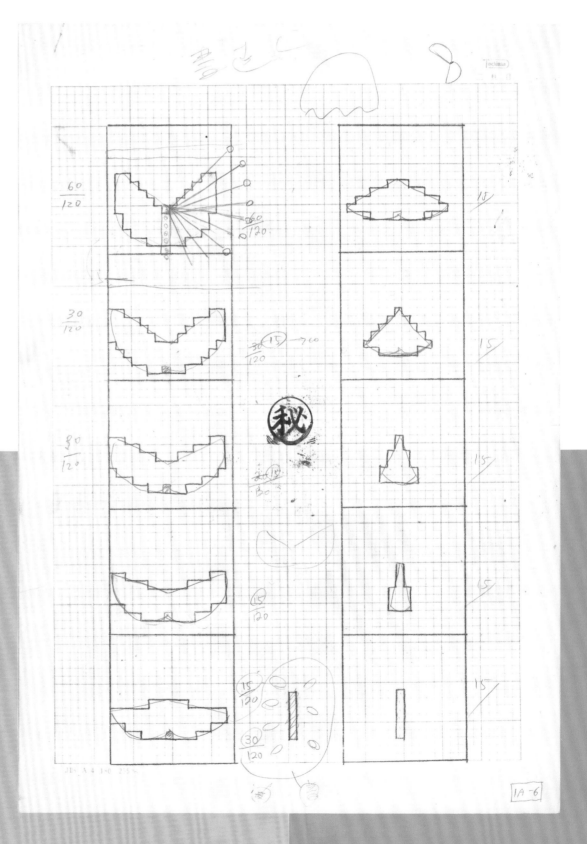

1. ゲームストーリー
・迷路上に置れたエサ：□を モンスター：👻に
つかまらない様に パックマン：ᗧ をコントロール
して食べていく。

1-1 エサ
・得点（食べると消えてスコアに加算される）
　□ ： 5点
　□ ： 10点 ｝モンスターが1匹の場合
　□ ： 15点

モンスターが画面上に2匹以上（モンスター参照）現れた時
表1

エサ ＼ WHEN	👻	👻👻	👻👻👻	👻👻👻👻
□	5	5×2	5×3	5×4
□	10	10×2	10×3	10×4
□	15	15×2	15×3	15×4

・パックマンがエサを食べる時に要する時間は エサの
大きさにより異なる。
　□ ： 1クチ（パク）
　□ ： 2クチ（パクパク）
　□ ： 3クチ（パクパクパク）

・パワーエサ
画面上のエサ群の中に6個の点滅しているパワーエサ
がある。
パックマンがそれを食べると、モンスターとの立場（追いかける⟷逃げる）
がしばらく逆転する。

This and following spread: Various design documents describing the movement, speed, and positioning of ghosts relative to the maze structure. Worth noting is how the maze design evolved over time as the team adjusted it based on play testing during development.

1-3 モンスター
・常に点滅しており、足をヒラヒラ動かし、進む方向に
目を向けている。
・エサの上を通過して移動する。
・壁、シャッターに当った時にそこで停止する。
・パックマンがパワーエサを食べたと同時に、点滅がなく
なり、イジケ顔：👻になる。その時点滅パックマンに
追われると逃げる。
パックマンにかじられると一目散に帰巣する。
・シャッターに押え込まれて動けなくなることもある。
・巣の中には常に3匹のモンスターが動めいており、
パックマンがしばらくエサを食べないでいると、巣の
扉が開いてくる。完全に開いてしまうと、1匹外に
出ていく。
・動き
　・パックマンを追いかける具合は、残りのエサの数が
　少なくなる程シビアになる。（パックマンも出置検索の
　タイミングを早くしていく。）

1-4 シャッター
・画面上に、通路をふさぐ様にシャッターが開閉している。
・シャッターの真下にいるパックマン、モンスターを押え込む
ミとがある。
・シャッターの具合は、アタリ社製「ガッチャ」のメイスと似ている。

1-5 クリア
・すべてのエサを食べ終えると再び初期の状態に戻る。
・クリア毎に、モンスターの動き、数等で難局度を増していく。

2. 検討
・パックマン、モンスターの動き、スピード、数設定等は
実験により、都度設定していく。

—3—

1-2 パックマン
・常に進む方向にクチをパクパクさせている。
・進む方向にクチがあって、エサと一致した時に
それを食べる。
・壁、シャッター、エサにクチ以外の所で当った時 パックマン
はそこで停止する。
・エサを食べ始めたら、それを食べ終えるまで動けない。
・パワーエサ（点滅）を食べると、エサ食べ終えた時点から
パックマンは点滅し（モンスターの点滅はなくなり、
イジケ顔：👻になる）逃げる立場から違う立場
に逆転する。
点滅が徐々に速くなり、5～7秒後に点滅が終り、
同時にモンスターが点滅しはじめ、元に戻る。
パックマンが点滅している間は、エサを食べるに要する
時間は通常より早くなり、モンスターをかじることができる。
（モンスターの得点は300点。）
・シャッターに押え込まれて動けなくなることがある。
・プレーヤー操作により上下左右の4方向に移動する。
・スピード（移動速度）

速い　V1 — パワー ᗧ　　帰巣 👻
　↑　V2 — なし
　　　V3 — 　　　　パワー 👻
遅い　V4 — イジケ 👻

・一足スピード以下方向すると向きだけを変える事ができる。
・進行方向と逆に操作するとブレーキがかかる。
・ニュートラブで停止。
・モンスターにつかまると消滅する。

—2—

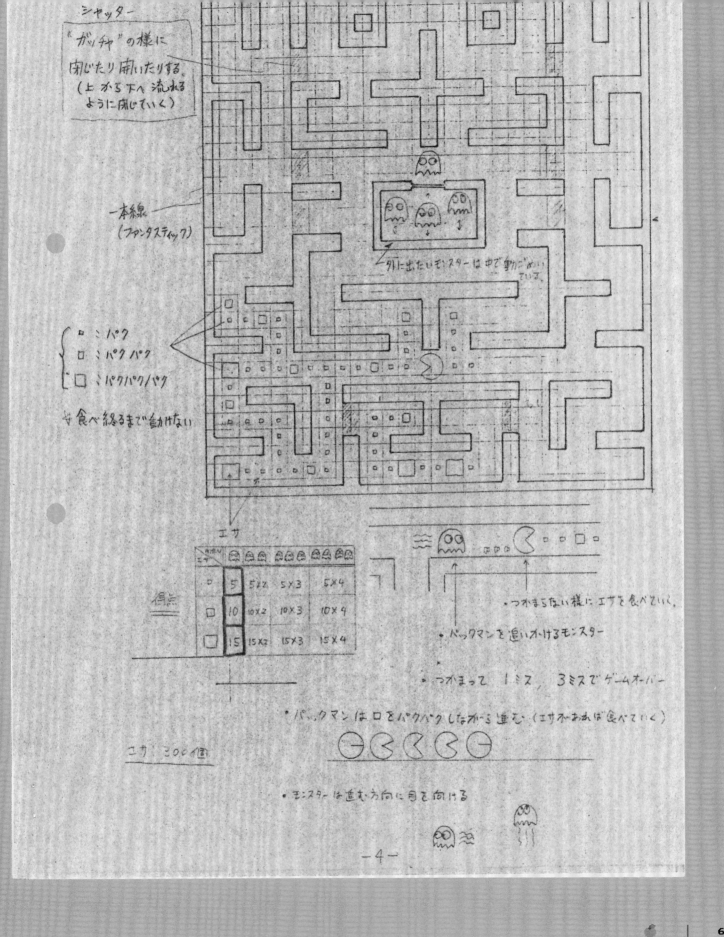

シャッター

"ガッチャ"の様に
閉じたり開いたりする。
(上から下へ流れる
ように閉じていく)

―本線
(ファンタスティック)

外に出たいモンスターは中で動きまわっている

□ ニ パク
□ ニ パクパク
□ ニ パクパクパク

└ 食べ終るまで動けない

エサ

得点

エサ	🐙	🐙🐙	🐙🐙🐙	🐙🐙🐙🐙
□	5	5×2	5×3	5×4
□	10	10×2	10×3	10×4
□	15	15×2	15×3	15×4

・つかまらない様にエサを食べていく

・パックマンを追いかけるモンスター

・つかまって 1ミス、 3ミスでゲームオーバー

・パックマンは口をパクパクしながら進む(エサがあれば食べていく)

エサ ニ00個

・モンスターは進む方向に角を向ける

—4—

63

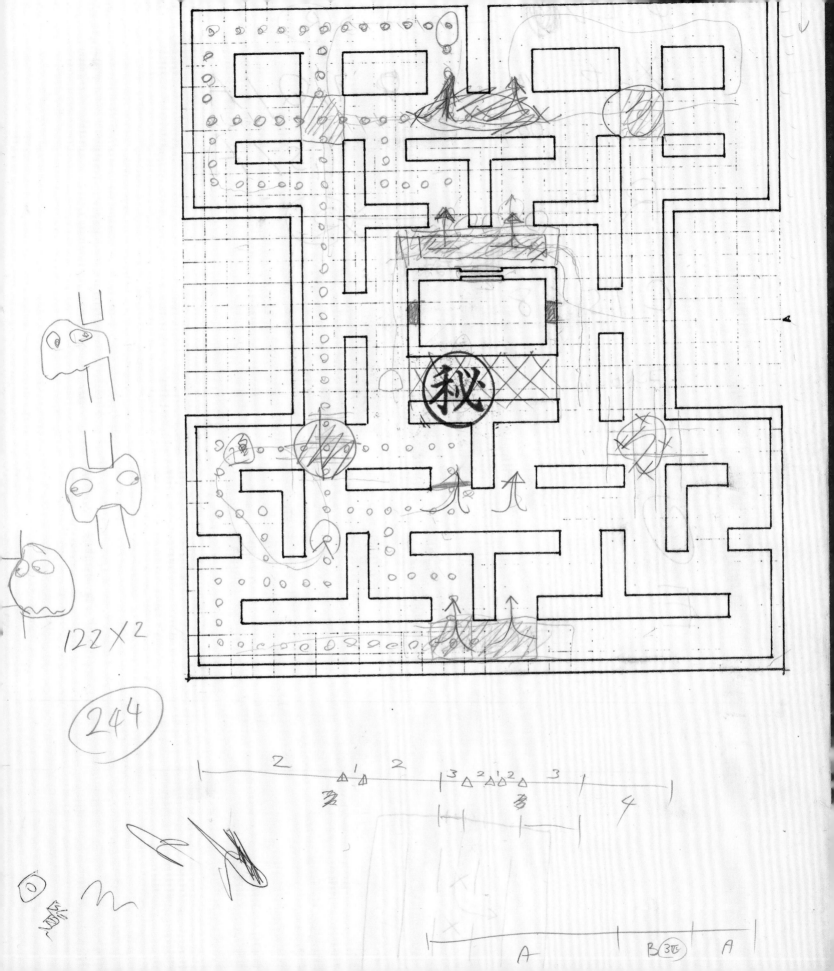

秘

122X²

244

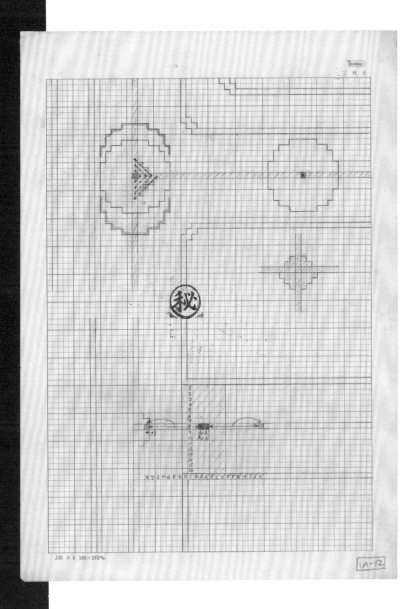

Fabulous Algorithms

Most of the development team's time was spent on what Iwatani proudly called "the heart of the game," the complex behavior of the ghosts. Everything he envisioned about the new game—its appeal to women, and its comical, light-hearted qualities—depended on how accessible and fun the gameplay would be. Many of the popular space shooting games had one thing in common that struck Iwatani as odd: they were relentless. Waves of enemies would descend on the player, and only continuous firing would keep them alive. Any mistake would quickly be punished, as enemies were programmed to mercilessly home in on the player. Namco's game needed to be different. "To give the game some tension, I wanted the ghosts to surround Pac-Man at some stage of the game," Iwatani said. But I felt it would be too stressful [for players] to be continually surrounded and hunted down. So, we made the ghosts' invasions come in waves. They'd attack and then retreat. As time went by, they would regroup, attack, and disperse again. It seemed more natural than having constant attacks."

"When a human being is constantly under attack like this, he becomes discouraged," Iwatani mused. "So, we developed the wave-patterned attack. Gradually the peaks and valleys in the curve of the wave become less pronounced so that the ghosts attack more frequently."[60]

This pattern would be pivotal to *Pac-Man*'s success with novice players: players weren't chased down and attacked at *every* moment. Additionally, a game would begin by having the first two ghosts leave the ghost pen and, instead of attacking the player, they would move away from Pac-Man, each to their own designated corner. Next, they would move into chase mode for about 20 seconds, before flipping around and heading toward their corners again—a state known as "scatter mode." Players were now offered a respite to regroup and plan where to go before the next attack started. This design satisfied Iwatani's desire to make a game that wasn't exceedingly difficult at the outset, even though *Pac-Man* (especially in its later stages) is very hard to truly master.

"I wanted each ghostly enemy to have a specific character and its own particular movements."

Toru Iwatani, Namco game designer

It also met Iwatani's need to create a game that felt 'fair' to players. Iwatani explained this in detail to Maurice Molyneaux, an American game designer who, as head producer and Director of Production for Namco Networks U.S., led the development of various Pac-Man games for mobile devices: "He explained to me he didn't like how games like *Space Invaders* were so relentless and always tried to kill you," Molyneaux said. "He wanted to make his game a little lighter, a little cuter—and the psychology behind it is interesting. There are moments in the game where you're caught in a corner and the ghosts are about to kill you, and it happens to be right at the moment when they flip directions and you're spared. Iwatani said to me, 'And so you live when you should have died, and therefore, the game feels inherently fair. It doesn't feel like it's always trying to rip a quarter out of your pocket.' That psychology really stuck with me—that the game feels inherently fair because of this type of interaction."

The idea behind the wave-patterned attacks would be echoed in the rest of the game, especially in the ghosts' "chase mode" behavior. Today, the algorithm behind the movement of the ghosts and their responses to Pac-Man is entry-level knowledge for budding game coders, but it was groundbreaking at the time. Iwatani and his team were the first to look at individually coded enemy patterns in this way. However, most of the heavy lifting in code wasn't created by Iwatani, but by programmer Shigeo Funaki. Funaki left Namco shortly after their game was released, and he fell off the radar without sharing Iwatani's notoriety—but he certainly deserves the credit for creating a "fabulous algorithm" based on Iwatani's minimal instructions: "Please have the monsters chase the player from all sides instead of simply following from behind like a string of beads."[61]

This spartan request led to one of the most fascinating aspects of *Pac-Man*: each ghost has an individual personality and its own behavior, all because of the game's programming.[62] The game hardware sees the maze as a collection of tiles that serve as markers for the code that controls the enemy characters. The game's algorithm knows which tile Pac-Man rests on at any moment, and calculates which target tile the four ghosts should head to—with each ghost aiming for its own designated tile on the board. Iwatani elaborated: "I wanted each ghostly enemy to have a specific character and its own particular movements, so they weren't all just chasing after Pac-Man in single file, which would have been tiresome and flat. One of them, the red one called Blinky, did chase directly after Pac-Man. The second ghost [Pinky] targets a point a few dots in front of Pac-Man's mouth. If Pac-Man is in the center, then Monster A and Monster B are equidistant from him, but each moves independently, almost 'sandwiching' him."

```
36        FEDCBA9876543210        37        FEDCBA9876543210
0360: 0000,0000                   0370: 0000,0000
0361: 0380,0380                   0371: 01C0,01C0
0362: 03C0,03C0                   0372: 01E0,01E0
0363: 03E0,03E0                   0373: 01E0,01E0
0364: 01E0,01E0                   0374: 01F0,01F0
0365: 01F0,01F0                   0375: 00F0,00F0
0366: 01F0,01F0                   0376: 00F0,00F0
0367: 00F0,00F0                   0377: 00F0,00F0
0368: 00E0,00E0                   0378: 00F0,00F0
0369: 00E0,00E0                   0379: 00F0,00F0
036A: 01F0,01F0                   037A: 00F0,00F0
036B: 03E0,03E0                   037B: 00F0,00F0
036C: 01E0,01E0                   037C: 01F0,01F0
036D: 03E0,03E0                   037D: 01E0,01E0
036E: 03C0,03C0                   037E: 01E0,01E0
036F: 0380,0380                   037F: 01C0,01C0

38        FEDCBA9876543210        39        FEDCBA9876543210
0380: 0000,0000                   0390: 0000,0000
0381: 0060,0060                   0391: 0010,0010
0382: 0070,0070                   0392: 0038,0038
0383: 0070,0070                   0393: 0038,0038
0384: 0078,0078                   0394: 003C,003C
0385: 00F8,00F8                   0395: 007C,007C
0386: 00F8,00F8                   0396: 007C,007C
0387: 00F8,00F8                   0397: 00F8,00F8
0388: 00F0,00F0                   0398: 00F0,00F0
0389: 00F8,00F8                   0399: 00F8,00F8
038A: 00F8,00F8                   039A: 007C,007C
038B: 00F8,00F8                   039B: 007C,007C
038C: 0078,0078                   039C: 003C,003C
038D: 0070,0070                   039D: 0038,0038
038E: 0070,0070                   039E: 0038,0038
038F: 0060,0060                   039F: 0010,0010

3A        FEDCBA9876543210        3B        FEDCBA9876543210
03A0: 0000,0000                   03B0: 0000,0000
03A1: 000C,000C                   03B1: 0000,0000
03A2: 000E,000E                   03B2: 0000,0000
03A3: 000E,000E                   03B3: 0000,0000
03A4: 001E,001E                   03B4: 0004,0004
03A5: 003E,003E                   03B5: 000E,000E
03A6: 003E,003E                   03B6: 003E,003E
03A7: 007C,007C                   03B7: 007E,007E
03A8: 007C,007C                   03B8: 00FC,00FC
03A9: 007C,007C                   03B9: 007E,007E
03AA: 003E,003E                   03BA: 003E,003E
03AB: 003E,003E                   03BB: 000E,000E
03AC: 001E,001E                   03BC: 0004,0004
03AD: 000E,000E                   03BD: 0000,0000
03AE: 000C,000C                   03BE: 0000,0000
03AF: 0000,0000                   03BF: 0000,0000
```

PAGE 10

```
          FEDCBA9876543210        31        FEDCBA9876543210
0: 0000,0000                      0310: 1001,0000
1: 0000,0000                      0311: 0802,0000
2: 07C0,07C0                      0312: 0704,0000
3: 1FF0,1FF0                      0313: 08BC,0700
4: 3FF8,3FF8                      0314: 9A58,0FB0
5: 3FF8,3FF8                      0315: 55A4,0FE8
6: 7FFC,7FFC                      0316: 3A74,0E78
7: 7FFC,7FFC                      0317: 0B28,0730
8: 7FFC,7FFC                      0318: 0628,0270
9: 7FFC,7FFC                      0319: 1D64,05E8
A: 7FFC,7FFC                      031A: 12C4,0BC8
B: 3FF8,3FF8                      031B: 1CC8,07F0
C: 3FF8,3FF8                      031C: 373C,00E0
D: 1FF0,1FF0                      031D: 40E4,0000
E: 07C0,07C0                      031E: 8002,0000
F: 0000,0000                      031F: 0001,0000

2         FEDCBA9876543210        33        FEDCBA9876543210
20: 0000,0000                     0330: 0000,0000
21: 0100,0106                     0331: 0100,0106
22: 0F00,0FF6                     0332: 0F00,0FF6
23: 1F80,03FE                     0333: 1D80,11FE
24: 0FD0,01FE                     0334: 3CD0,20FE
25: 0FF8,01FE                     0335: 3FF8,20FE
26: 7FFC,63FC                     0336: 7FFC,71FC
27: 7FF8,7FF8                     0337: 7FF8,7FF8
28: 7FF8,7FF8                     0338: 7FF8,7FF8
29: 7FFE,63FE                     0339: 7DFE,71FE
2A: 0FFE,01FE                     033A: 3CFE,20FE
2B: 0FFC,01FC                     033B: 3FFC,20FC
2C: 1FF8,03F8                     033C: 1FF8,11F8
2D: 0FFC,0FFC                     033D: 0FFC,0FFC
2E: 01FE,01FE                     033E: 01FE,01FE
2F: 0000,0000                     033F: 0000,0000

4         FEDCBA9876543210        35        FEDCBA9876543210
40: 0000,0000                     0350: 0000,0000
41: 0000,0000                     0351: 0700,0700
42: 1F00,1F00                     0352: 0FC0,0FC0
43: 1FC0,1FC0                     0353: 07E0,07E0
44: 0FE0,0FE0                     0354: 07E0,07E0
45: 07E0,07E0                     0355: 03F0,03F0
46: 03F0,03F0                     0356: 01F0,01F0
47: 01F0,01F0                     0357: 01F0,01F0
48: 00F0,00F0                     0358: 00E0,00E0
49: 01F0,01F0                     0359: 01F0,01F0
4A: 03F0,03F0                     035A: 01F0,01F0
4B: 07E0,07E0                     035B: 03F0,03F0
4C: 0FE0,0FE0                     035C: 07E0,07E0
4D: 1FC0,1FC0                     035D: 07E0,07E0
4E: 1F00,1F00                     035E: 0FC0,0FC0
4F: 0000,0000                     035F: 0700,0700
```

PAGE 9

These pages and the following:
Various printouts of Pac-Man's
source code.

```
70CD A900    1273:  TIME/2S  LDA   I /0
70CF 8DF623  1274:           STA   A :TIMER/L
70D2 ADF623  1275:  TIME*2S  LDA   A :TIMER/L
70D5 C93F    1276:           CMP   I /3FH
70D7 30FB    1277:           BMI   R :TIME*2S
70D9 60      1278:           RTS
             1279:  ;
             1280:  ;
70DA A513    1281:  WAKUI    LDA   Z :FLAG.2
70DC 2920    1282:           AND   I /20H
70DE F006    1283:           BEQ   R :WAKUA
70E0 20956C  1284:           JSR   A :WAKU/2
70E3 60      1285:           RTS
70E4 20626B  1286:  WAKUA    JSR   A :WAKU/1
70E7 60      1287:           RTS
             1288:  ;
             1289:  ;
70E8 F8      1290:  INCR     SED
70E9 18      1291:           CLC
70EA A901    1292:           LDA   I /1
70EC 6539    1293:           ADC   Z :CREDIT
70EE 8539    1294:           STA   Z :CREDIT
70F0 D8      1295:           CLD
70F1 60      1296:           RTS
             1297:  ;
             1298:  ;
             1299:  ;  NMI PROGRAM
             1300:  ;
70F2 EA      1301:  NMI      NOP
70F3 8D600C  1302:           STA   A /C60H
70F6 8D500C  1303:           STA   A /C50H
70F9 48      1304:           PHA
70FA 98      1305:           TYA
70FB 48      1306:           PHA
70FC 8A      1307:           TXA
70FD 48      1308:           PHA
70FE ADF323  1309:           LDA   A :FLAG.6
7101 D031    1310:           BNE   R :END/B
7103 A524    1311:           LDA   Z :FLAG.3
7105 2901    1312:           AND   I /1
7107 D02B    1313:           BNE   R :END/B
7109 AD000C  1314:           LDA   A /C00H
710C 8516    1315:           STA   Z :POINT1/L
710E A513    1316:           LDA   Z :FLAG.2
7110 2904    1317:           AND   I /4
7112 F020    1318:           BEQ   R :END/B
7114 ADF623  1319:           LDA   A :TIMER/L
7117 2907    1320:           AND   I /7
7119 C903    1321:           CMP   I /3
711B D017    1322:           BNE   R :END/B
711D EEFF23  1323:           INC   A :C/AAA
7120 ADFF23  1324:           LDA   A :C/AAA
7123 2907    1325:           AND   I /7
```

```
7125 D005    1326:           BNE   R :TTTTT1
7127 20DC70  1327:           JSR   A :WAKUI
712A A513    1328:  TTTTT1   LDA   Z :FLAG.2
712C 2920    1329:           AND   I /20H
712E D007    1330:           BNE   R :2PLY/B
7130 F073    1331:           BEQ   R :1PLY/A
7132 4CF975  1332:  END/B    JMP   A :END/A
7135 4CD173  1333:  2PLY/B   JMP   A :2PLY/A
7138 A000    1334:  MENT     LDY   I /0
713A A904    1335:           LDA   I /4
713C 8532    1336:           STA   Z :POINT6/H
713E A91D    1337:           LDA   I /1DH
7140 8531    1338:           STA   Z :POINT6/L
7142 20D46F  1339:  YOSHI/3  JSR   A :SPINTOU
7145 C8      1340:           INY
7146 20D46F  1341:           JSR   A :SPINTOU    →JSR  A:SUZUKI
7149 88      1342:           DEY
714A 20656C  1343:           JSR   A :PO6(20)
714D A532    1344:           LDA   Z :POINT6/H
714F C907    1345:           CMP   I /7
7151 D0F1    1346:           BNE   R :YOSHI/3
7153 A000    1347:           LDY   I /0
7155 A904    1348:           LDA   I /4
7157 8532    1349:           STA   Z :POINT6/H
7159 8531    1350:           STA   Z :POINT6/L
715B 20D46F  1351:  YOSHI/M  JSR   A :SPINTOU
715E A020    1352:           LDY   I /20H
7160 20D46F  1353:           JSR   A :SPINTOU    →JSR  A:RYOESAN
7163 A000    1354:           LDY   I /0
7165 20836C  1355:           JSR   A :PO6(1)
7168 A531    1356:           LDA   Z :POINT6/L
716A C919    1357:           CMP   I /19H
716C D0EF    1358:           BNE   R :YOSHI/M
716E A907    1359:           LDA   I /7
7170 8532    1360:           STA   Z :POINT6/H
7172 A944    1361:           LDA   I /44H
7174 8531    1362:           STA   Z :POINT6/L
7176 20D46F  1363:  YOSHI/N  JSR   A :SPINTOU
7179 A020    1364:           LDY   I /20H
717B 20D46F  1365:           JSR   A :SPINTOU    →JSR  A:RYOESAN
717E A000    1366:           LDY   I /0
7180 20836C  1367:           JSR   A :PO6(1)
7183 A531    1368:           LDA   Z :POINT6/L
7185 C959    1369:           CMP   I /59H
7187 D0EF    1370:           BNE   R :YOSHI/N
7189 A904    1371:           LDA   I /4
718B 8532    1372:           STA   Z :POINT6/H
718D A941    1373:           LDA   I /41H
718F 8531    1374:           STA   Z :POINT6/L
7191 20D46F  1375:  YOSHI/Q  JSR   A :SPINTOU
7194 C8      1376:           INY
7195 20D46F  1377:           JSR   A :SPINTOU    →JSR  A:SUZUKI
7198 88      1378:           DEY
```

```
7199 20656C  1379:          JSR   A :PO6(20)
719C A532    1380:          LDA   Z :POINT6/H
719E C907    1381:          CMP   I /7
71A0 D0F1    1382:          BNE   R :YOSHI/Q
71A2 60      1383:          RTS
             1384:
71A3 203A71  1385: 1PLY/A   JSR   A :MENT
71A6 A516    1386:          LDA   Z :POINT1/L
71A8 29C0    1387:          AND   I /COH
71AA F009    1388:          BEQ   R :MIGI
71AC C9C0    1389:          CMP   I /COH
71AE F024    1390:          BEQ   R :HIDARI/N
71B0 4CF975  1391:          JMP   A :END/A
71B3 8D800C  1392: MIGI     STA   A :C80H
71B6 A51F    1393:          LDA   Z :COUNT/1
71B8 C901    1394:          CMP   I /1
71BA F040    1395:          BEQ   R :MIGI(1)
71BC C902    1396:          CMP   I /2
71BE F011    1397:          BEQ   R :MIGI<2>
71C0 A620    1398:          LDX   Z :COUNT/2
71C2 E8      1399:          INX
71C3 8620    1400:          STX   Z :COUNT/2
71C5 E019    1401:          CPX   I /19H
71C7 D00E    1402:          BNE   R :SFT/UE1
71C9 CA      1403:          DEX
71CA 8620    1404:          STX   Z :COUNT/2
71CC 4CF975  1405:          JMP   A :END/A
71CF 4C6572  1406: MIGI<2>  JMP   A :MIGI(2)
71D2 4CC472  1407: HIDARI/N JMP   A :HIDARI
71D5 A204    1408: SFT/UE1  LDX   I /4
71D7 BD0104  1409: MADA/A1  LDA   AX/401H
71DA 9D0004  1410:          STA   AX/400H
71DD E8      1411:          INX
71DE E01E    1412:          CPX   I /1EH
71E0 D0F7    1413:          BNE   R :MADA/A1
71E2 A204    1414:          LDX   I /4
71E4 BD2104  1415: MADA/A2  LDA   AX/421H
71E7 9D2004  1416:          STA   AX/420H
71EA E8      1417:          INX
71EB E01E    1418:          CPX   I /1EH
71ED D0F7    1419:          BNE   R :MADA/A2
71EF A522    1420:          LDA   Z :BPH
71F1 18      1421:          CLC
71F2 D8      1422:          CLD
71F3 6908    1423:          ADC   I /8
71F5 8522    1424:          STA   Z :BPH
71F7 4CF975  1425:          JMP   A :END/A
71FA A620    1426: MIGI(1)  LDX   Z :COUNT/2
71FC CA      1427:          DEX
71FD 8620    1428:          STX   Z :COUNT/2
71FF E000    1429:          CPX   I /0
7201 F027    1430:          BEQ   R :NEXT/EA
7203 A21C    1431:          LDX   I /1CH
```

```
7205 BD4007  1432: MADA/A3  LDA   AX/740H
7208 9D4107  1433:          STA   AX/741H
720B CA      1434:          DEX
720C E002    1435:          CPX   I /2
720E D0F7    1436:          BNE   R :MADA/A3
7210 A522    1437:          LDA   Z :BPH
7212 38      1438:          SEC
7213 D8      1439:          CLD
7214 E908    1440:          SBC   I /8
7216 8522    1441:          STA   Z :BPH
7218 A21C    1442:          LDX   I /1CH
721A BD6007  1443: MADA/A4  LDA   AX/760H
721D 9D6107  1444:          STA   AX/761H
7220 CA      1445:          DEX
7221 E002    1446:          CPX   I /2
7223 D0F7    1447:          BNE   R :MADA/A4
7225 4CF975  1448:          JMP   A :END/A
7228 A286    1449: NEXT/EA  LDX   I /86H
722A 8E1D07  1450:          STX   A :71DH
722D E8      1451:          INX
722E 8E1E07  1452:          STX   A :71EH
7231 E8      1453:          INX
7232 8E3D07  1454:          STX   A :73DH
7235 E8      1455:          INX
7236 8E3E07  1456:          STX   A :73EH
7239 E8      1457:          INX
723A 8E5D07  1458:          STX   A :75DH
723D E8      1459:          INX
723E 8E5E07  1460:          STX   A :75EH
7241 A940    1461:          LDA   I :SP
7243 8D5C07  1462:          STA   A :75CH
7246 8D5B07  1463:          STA   A :75BH
7249 8D7B07  1464:          STA   A :77BH
724C 8D7C07  1465:          STA   A :77CH
724F 8D7D07  1466:          STA   A :77DH
7252 20CD67  1467:          JSR   A :HM13
7255 20B567  1468:          JSR   A :VP12
7258 A902    1469:          LDA   I /2
725A 851F    1470:          STA   Z :COUNT/1
725C A901    1471:          LDA   I /1
725E 8520    1472:          STA   Z :COUNT/2
7260 4CF975  1473:          JMP   A :END/A
7263 A620    1474: MIGI(2)  LDX   Z :COUNT/2
7265 E8      1475:          INX
7266 8620    1476:          STX   Z :COUNT/2
7268 E019    1477:          CPX   I /19H
726A F01D    1478:          BEQ   R :NEXT19
726C 20926E  1479:          JSR   A :POINTS/O
726F 20A86E  1480:          JSR   A :SIFT/O
7272 20926E  1481:          JSR   A :POINTS/O
7275 E627    1482:          INC   Z :POINT2/L
7277 E616    1483:          INC   Z :POINT1/L
7279 20A86E  1484:          JSR   A :SIFT/O
```

Beating Bluto

On top of the chase and scatter modes, the team added a third mode—a genius stroke of game design. After eating a "power food," the roles of Pac-Man and the ghosts are suddenly reversed, with the player now chasing the ghosts—who race off frightened and colored blue—to chomp them for bonus points. The role reversal was a novelty for games, but was firmly rooted in slapstick comedy and children's cartoons. Iwatani was the first to admit the alternating pattern of chasing and being chased were inspired by the cartoon characters Tom and Jerry. However, the larger idea originated from a show that was very popular in Iwatani's youth—the American cartoon, *Popeye the Sailor*. "In his normal state, [Popeye] is a delicate character who always loses to [his enemy] Bluto," Iwatani said. "However, once Popeye eats a can of spinach, his position turns around and he unleashes superpowers to throw the big man Bluto. Pac-Man and his power treats are basically Popeye's spinach."[63]

player and the game's enemies. While Pac-Man's position and the game modes chiefly determine the ghost behavior, a player's movement and the maze structure impact their paths too, all adding up to situations that seem unique. The ghosts feel like they have lives of their own, "deciding" which routes they will take to get somewhere.[64]

This concept was further enhanced by the many tweaks Iwatani's team made to the speed of Pac-Man and his enemies. In chase mode, Blinky is not as fast as Pac-Man, and thus unable to overtake him. Yet eating a dot causes Pac-Man to slow down, literally stopping for one animated frame—or 1/60th of a second—so eating a row of dots gives Blinky an opportunity to catch up on the player. In contrast, Pac-Man is able to navigate corners slightly faster than the ghosts. This strategy—known as "cornering" by players— is just one of many speed-related tweaks in play. Navigating the game's side warp tunnels cuts the speed of ghosts in half, for instance. In their frightened mode, the ghosts slow down and Pac-Man speeds up, but only after freezing for three frames. Many of these quirks are nearly imperceptible, but they greatly add to the tension, balance, and excitement of the overall game.[65]

Popeye the Sailor Man first appeared in a *Thimble Theatre* comic in 1929. Popeye gained increased strength and power after eating spinach, a gimmick that came to define the character and also inspired Pac-Man's "power up" state after eating a power pellet. In a pair of stills from a 1935 animated episode, Popeye beats his chief rival, Bluto, after eating a can of spinach.

With the game's development at its midpoint, other hands at Namco worked on visual design elements beyond the monitor. The name came first, as Namco's marketing team needed it to brand both the game and character, promoting them on items like sales flyers, advertisements, and the game cabinet itself. Having lived with a chomping character for months, a name wasn't too hard for the team to find: the name came from "an eating sound, as often seen in cartoons, 'Paku Paku,'" Iwatani told an interviewer. "Other options also came up, including 'Pakkuri,'" he said. "We had meetings on this, but the name was finalized as Puck Man pretty quickly."[66]

Before Namco's licensing deal with Midway Manufacturing in the United States, *Puck Man* was the game's official name (though that moniker would also remain for some territories beyond Midway's North American licensing agreement, including the UK, West Germany, Italy and other countries). After settling the discussion, the team looked into the name's availability, checking against known trademarks and patents, and found that toy company Tomy had already claimed the title for future use. Iwatani contacted them (as he was personally charged with handling copyright matters for their game in Japan) to negotiate for the right to use the name. After Namco paid Tomy a one-time usage fee, the matter was settled, though they had alternate names at the ready if Tomy had not agreed. "In that case, the game was going to be called *Paku-emon*," Iwatani said. "We would be using the *-emon* extension used in 'old-fashioned' Japanese, similar to [comic character] Doraemon's name."[67]

Left page: This promotional sticker highlights Puck Man's dynamism, emphasized by dotted lines Tadashi Yamashita used in the first illustrations of the character.

Right page: The arcade flyer for Namco's *Puck Man* introduced the game's eating theme, not only by illustrating a hungry Puck Man, but also in marketing copy that read "Watch out! Eat the blinking power food!"

★パックマン★

PUCK MAN

危い！
点滅する
パワーエサを食え！

1UP　　HIGH SCORE　　2UP
980　　　19800　　　　800

PUCK MAN

パワーエサをいつ食べるか、それがポイント

パク、パク、パク……。迷路に並んだ"エサ"をどんどん食べる黄色いパックマン。それをジャマする4匹のモンスターとの手に汗握る追撃戦。追い込まれた！万事休す！！しかし、あわててはいけない。点滅する"パワーエサ"を食べてパワーアップ。一気に立場が逆転。逆にモンスターをやっつける事ができる。待ち伏せして戦うか、おもいきり引き寄せて4匹まとめてやっつけるか、それは作戦しだい。ユーモラスな動き、楽しい音響効果、かわいいキャラクターのパックマンショーもあって訴求効果満点！！
一度やるともうあなたはゲーム・フリーク。ナムコ「パックマン」はそれほどホットなゲーム。

●ハイスコア
栄光の最高得点を鮮やかに表示。

●スコア
左1stプレイヤー、右2ndプレイヤーの得点。最高999,990点。

●モンスター
4匹それぞれ違った性格をもっていて、パックマンを追いかけてくる。

●パックマン
食べ始めたら止まらないワンパク坊や。モンスターにつかまらないようにうまくコントロール。

●残りのパックマン数

●パワーエサ〔50点〕
これを食べるとパワーアップ！モンスターをやっつけられる。

●エサ〔10点〕

●ワープトンネル
モンスターに追いつめられたら、ここに逃げ込め！反対側にワープして脱出することができる。

●フルーツターゲット
1画面に2回出現、食べるとボーナス得点。

●クリア数
クリアした数をフルーツで表示。

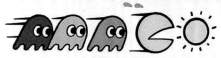

逆襲して高得点を・・・・・・・・・

1 危い！点滅するパワーエサを食え！！

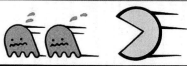

2 パワーアップ！！ モンスターが…

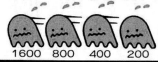

イジケ… パワーアップ

3 チャンス！！ 逆にかみつけ！！

4 連続してかみつくと得点倍増！

1600 800 400 200

フルーツターゲットを食べてボーナス得点

モンスターの巣の下に現われる色々なフルーツ。これを食べると 🍒（100点）🍓（300点）🍊（500点）から最高5,000点までのボーナス得点が得られます。

仕　様

- ●高さ　600mm　調整可〔＋100mm〕
- ●横幅　860mm　●縦幅　560mm
- ●重量　54kg
- ●使用電源　AC100V±10V　50/60Hz
- ●消費電力　82W
- ●1人1ゲーム　100円
　（料金、ゲーム制限等調整可）

「遊び」をクリエイトする
株式会社 ナムコ

本　社　〒146　東京都大田区多摩川2－8－5　TEL 03(759)2311(大代)
大阪事業所　〒556　大阪市浪速区新川3-630-3　南大阪ビル　TEL 06(649)5311(代)
★遊園施設・娯楽機械★　企画・設計・製作・販売・経営・賃貸・輸出・輸入
★各種イベント★　企画・制作・実施

Backside of the *Puck Man* flyer, explaining the gameplay in detail.

The final name was then passed down to an in-house design team led by experienced character designer Tadashi Yamashita. Less celebrated than the more well-known Iwatani, Yamashita has proven to be one of the key figures in Namco's arcade history. His portfolio includes graphic design work for nearly every game made by Namco since 1970, including logos and designs for *30 Test* (an electro-mechanical numerical testing game), *Formula-X*, *F-1*, *Shoot Away*, and *Submarine*. He also lent his clear, colorful, tightly rendered design sensibility to a slew of Namco video games like *Gee Bee*, *Bomb Bee*, *Galaxian*, and *Cutie Q*.

"At a certain point I was asked to do artwork designs on a new video game," Yamashita said. "So I visited Iwatani-san to have a look. When I saw the game, he showed me a screen of a simple circle shape that opened and closed its mouth. After that, I went back to my desk and started sketching." In the hands of Yamashita, the simple shape quickly came to life. "It took me just a short time to arrive at the final form, a round shape with arms and legs. Yet I felt [the character] lacked notable features, so I added some accents to his eyes—a retro flavor—to make them look bigger."[68] Stretching the *Puck Man* shape vertically, he created two black eyes that echoed the character's original silhouette. "They're called pie-eyes, aren't they? When I tried it, it was quite interesting, so I decided to use it." Yamashita's "pie-eyes" could certainly be classified as "retro." That style had a long tradition in American cartoons, dating back to pre-war cartoon characters Betty Boop and Bimbo coming out of the Fleischer Studios, or even the early version of Mickey Mouse seen in the 1929 animated short, *The Jazz Fool*.

"I put together a typography that I later learned looks a bit old-fashioned in the U.S."

Tadashi Yamashita, Namco character designer

Soon, a fully fleshed-out cartoon character emerged, with large black pie-eyes, elongated nose, omnipresent mouth, and spindly arms and legs. "I thought it was very interesting when I first saw [the design]," Toshio Kai said. "At that time, Iwatani-kun often said he wanted to keep the designs for the game simple, cutting out everything unnecessary. And Yamashita-kun just drew just that." Yamashita's character design was submitted ("there wasn't much time to propose alternatives," he said) and quickly approved.[69] Next, the larger design team—Akira Osugi, Kunio Sato, Hiroshi Ono, and Yamashita himself— worked on designing the full cabinet. Ono was the junior member. "I joined the company in 1979, which was right around the time the development of *Puck Man* began," he said. "Yamashita-san drew the [initial] character, and later, when we were making the cabinets, we split up and drew the characters on the top signboard and side panels. I remember I couldn't draw them as neatly as he did. He says it's a quite easy, simple, and straightforward design, but I thought it was very sophisticated! The curves are quite beautiful."

The *Puck Man* logo and the instantly recognizable *Pac-Man* typography were designed by Yamashita—again, an obvious choice, as he was responsible for designing nearly all the logos for Namco's games. "I put together a retro style that I later learned looks a bit 'old-fashioned' in the United States, but one that matched the character design," he said. Yamashita was inspired by the colors of the titular character, but his lettering was influenced by typography they had gathered in their studio. "At that time, we were collecting advertising signs," Toshio Kai remembered. "Various American things came in, so we used them as references as we went along."

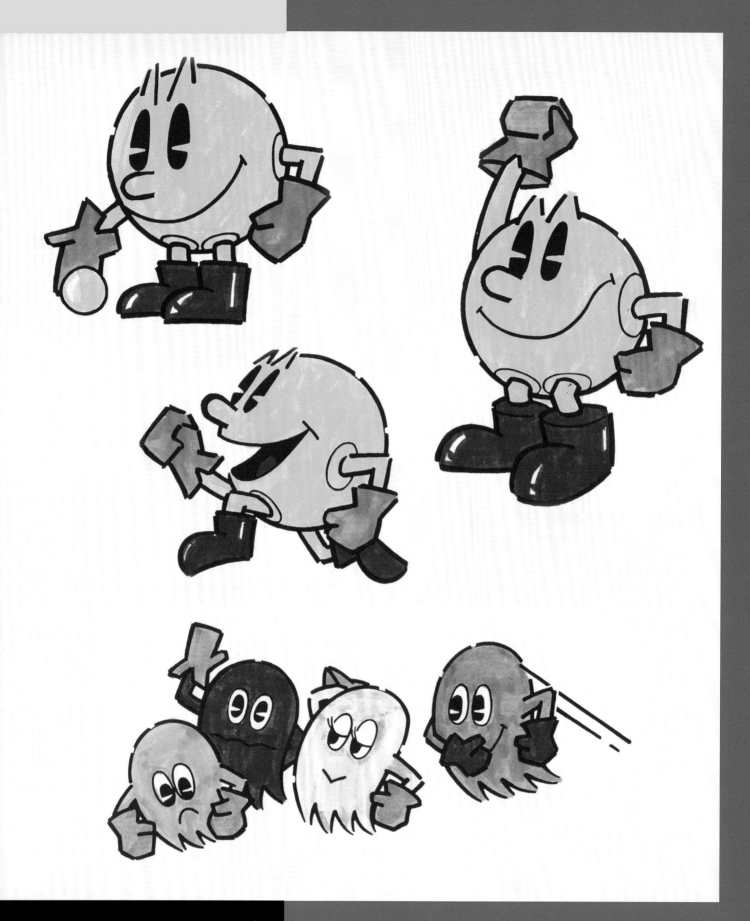

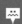
Original Pac-Man drawings by Tadashi Yamashita. Yamashita brought a lighthearted personality to the character who was nearly abstract in his on-screen debut.

Namco artist Tadashi Yamashita discussed his Pac-Man illustration work in an interview aired on December 17th, 2020. While Toru Iwatani has served as the public face of the *Pac-Man* team over the decades, Yamashita was rightfully honored for his significant contributions during the San Diego Comic Con Character Hall of Fame induction of *Pac-Man*.

DRAWING ON INSPIRATION

Across the decades, Namco artist and designer Tadashi Yamashita quietly created scores of powerful logos and evocative illustrations for some of Namco's most iconic arcade games.

He also had a significant impact on Pac-Man, translating 111 yellow, chomping, on-screen pixels into a grinning, effusive character who took pop culture by storm. Yamashita used his design and illustration skills to bring energy and personality to *Pac-Man*, even without an accompanying narrative or clear background for its title character. Yet, his illustrated version of Puck Man, gracing the sides of the original Japanese arcade cabinet, became the bedrock upon which nearly all other incarnations of the character were built. Yamashita's contribution was not limited to character art, either. He also designed striking logos for a host of early and classic Namco games, including *F-1, Shoot Away, Gee Bee, Galaxian, Rally-X, Galaga, Pole Position, Xevious*, and many more.

MAKING HIS MARK

Yamashita joined Namco in 1970 and continued his artistic output there into the late 1980s. His approach to creating logos and typography for such a diverse set of games began by focusing on the games themselves. "When I get an offer to create logos," he said, "I check games with my own eyes. Then, I listen to the game designers, play the games by myself, watch someone else's

gameplay, and get the feel of the world." Those pixelated graphics served as the jumping-off point for Yamashita's initial designs. He began projects by creating rough visual concepts, working through multiple versions until landing on a design he felt was "unique and impressive."

DRAWING ON EXPERIENCE

Yamashita recalled his first encounter with *Puck Man*, and the assignment to depict the character for the arcade cabinet side art. "I was asked to do artwork designs for a new video game," he said. "So I visited Mr. Toru Iwatani, the game designer, to have a look. When I looked at the screen, a yellow circle was moving around, up and down, left and right, running away from enemies or beating them. It was impressive. The element on the screen was simple— a yellow circle."

"I went back to my desk and started designing it," Yamashita recalled, "and the character you see now came to life immediately. There wasn't much time to propose alternatives, but I submitted the design, and it was approved." Though Iwatani, for his part, wasn't immediately charmed by the liberties taken with the game's pixelated character design. "At first, I didn't really like the picture with the arms and legs," he told Japanese researchers in an interview in 2019. "I thought, 'What? That's not right!'"

However, Yamashita's design prevailed. Without a detailed brief or design direction, the artist drew on his own feelings and inspiration for the character designs. "In the game, it is just a yellow circle without arms and legs," he said. "So, I added arms and legs to the globe. However, when I also added fingers, it looked too graphic and unsuitable as a character. Therefore, I put it on the mittens and boots to remove such graphicness. Since Pac-Man is just a round shape with arms and legs, I felt he lacked notable features. So I added some accent to his eyes—a retro flavor—to make them look bigger. Actually, I put some thought into it."

Yamashita drew on comics and animation of the past, including early versions of Mickey Mouse and the popular street sweeper character Rerere no Oji-san, who both sported pie-shaped eyes popular in classic animation—which just happened to be perfect for Puck Man. Those "pie eyes" echoed the flat design of Pac-Man and created a stronger emotional connection with the character. "I think the expression of the eyes is important for humans and animals to read their minds or to impress on others, so I made them big," Yamashita said.

His depictions of the gang of ghosts were inspired by Q-Taro, the main character of *Obake no Kyutarō*, the Japanese manga series. Yamashita worked to design each ghost around the behavior/character personalities that Iwatani provided.

LETTING LETTERS TELL THE STORY

While Yamashita has created many typographic logos in his career, the lettering for *Puck Man* might be his most recognizable. He crafted the distinctive Pac-styled letterforms shortly after watching *Puck Man's* gameplay. "I went back to my worktable and started sketching, and that typeface popped into my head. I had an impression that it was like a title of American comics. However, there were no specific examples, and I drew it as it came to my mind." The various shadows and outlines surrounding the logotype also provided a 1950s style that seemed to accentuate both the motion and cuteness of Puck Man himself.

While other similar street sign lettering and typefaces pre-dated Yamashita's *Puck Man* logotype (like designer Milton Glaser's Baby Teeth lettering from 1966), he was not aware of these similar geometric designs. In fact, Yamashita said he was most likely inspired by alphabet-shaped biscuits and snacks. After *Puck Man's* name change to *Pac-Man* for American audiences, Yamashita updated his logo with the new spelling. But his version was not used by Midway, who created their own version of the Pac-Man logo typography, which Yamashita doesn't like. For his own sequel logos, Yamashita "tried to remain consistent with the English letters of the logos and to differentiate each logo by adding decorations around the letters."

Somewhat surprising for a portfolio filled with bespoke typography, Yamashita admitted he is not typically concerned with legibility. "I am not saying readability is unnecessary," he explained, "but I think the logo is a part of the artwork. I designed the logos so that they would express the world of the games visually and still be impressive." His influence on the Pac-Man franchise did not end there, however. Yamashita continued creating logos for other Namco Pac-sequels, including *Super Pac-Man*, *Pac & Pal*, and *Pac-Land*.

Today, Yamashita's *Pac-Man* lettering is unmistakable and has transcended the video game environment to become arguably one of the most recognizable typefaces in pop culture. Yamashita was surprised that his creation has spawned many popular fonts and homages. His artistic legacy with Pac-Man lives on, both in its impact on video games, and for Yamashita himself. "Even today when I draw Pac-Man, he continues to bring me happiness and cheers me up inside. When drawing Pac-Man, a carefree and happy character, I feel carefree as well."

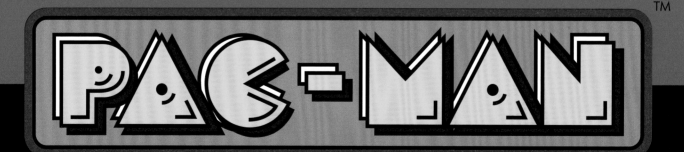

Yamashita's logo designs for Namco arcade games often make use of three-dimensional effects, large container shapes, and lighting effects of various sorts. The designs are colorful and bold, perfect for capturing a player's attention from across a crowded arcade.

The Pursuit of Innocence

With Pac-Man now visualized in the cabinet art, the overall game experience began to take shape. Without realizing it, the design team was writing history—*Puck Man* would become the first video game to lean so heavily on character design, introducing a mascot who could be utilized outside the game or even beyond the confines of the industry. Eventually, it would have an enormous impact on *Pac-Man*'s success and the absorption of video games into popular culture.

Importantly, the *Puck Man* character and cabinet designs were informed by Iwatani's sense of the dot muncher's personality. Iwatani made it clear to Yamashita that his creation should be portrayed as a "simple, shy guy." Yamashita himself described his final renderings as happy-go-lucky; "a character with no worries." Iwatani elaborated: "Pac-Man's character is difficult to explain even to the Japanese," he said. "He is an innocent character. He hasn't been educated to discern between good and evil. He acts more like a small child than a grown-up person."[70] In other places he elaborated on this. "I imagined Pac-Man as a mischievous boy who eats everything evil in the world," he told reporters. "The fruit is his dessert."[71]

The team's effort to include some subtle storytelling would lead to another first for video games: the inclusion of animated cutscenes or intermissions, which the development team called "coffee breaks." The game graphics were "quite comical," said Iwatani. "So, we wanted to use things like animation. But since doing this for the entire game would be impossible; using it as an intermission was the perfect solution." In his writings, Iwatani confessed that he worried the gameplay might be too intense for new players. "With chasing at the heart of gameplay," he wrote, "the game had long stretches of nervous moments.

Scenes from *Pac-Man*'s first intermission or "coffee break," also the very first animated cutscene in video games. Pac-Man is chased by Blinky, then the chase reverses, eventually leaving Blinky with a torn costume.

To take the nerves away from players for a moment—as well as to learn a bit about the worldview of the character—we suggested to put in animations between the [game] stages. However, Mr. Funaki was strongly opposed to this. His reasoning was, 'If it doesn't relate to the game, I don't want to program it.'" "Now, I did not know how to program," Iwatani continued, "so there was no way I could make demo animations. So I tried to convince [Funaki-san] the animations were essential to understand the character's view of the world, and we [also] kept hearing over and over that [using video was] beneficial in the marketplace, so we managed to coax Mr. Funaki into creating them."[72] Iwatani also championed empathy and consideration for players, keeping their perspective in mind throughout the game development process. "They would want to take a break during play," he said. "And because of the variety of coffee break cutscenes, they would also serve as another bit of fun for the player, making them go, 'Did you see that one yet?' to their friends. Seeing the coffee breaks would become a goal for the players in itself. I convinced him that these facts would make the players want to play more, and thus spend more money on the game."

In the end, three simple, comical interludes played after the second, fifth, and ninth levels, with Pac-Man and the ghosts "performing" in the short scenes. Toshio Kai provided music for the interludes, riffing on his jazz-styled opening theme.[73] As Iwatani predicted, reaching the animations would soon be an additional challenge to players, as well as a recognizable marker for their progress.

Acting on Iwatani's hunch, Funaki single-handedly created the first video game cutscenes, supported by Kai's and Ishimura's groovy tunes. It would be Shigeo Funaki's final contribution to video games; after *Puck Man* was completed, he left Namco to pursue other interests.

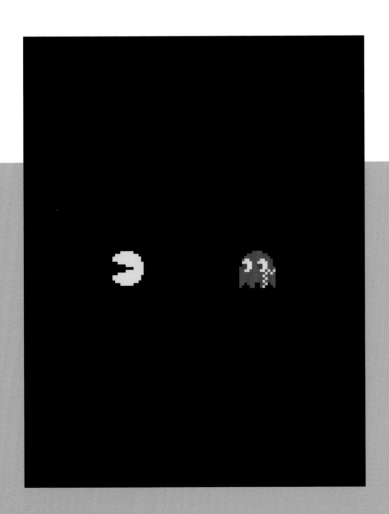

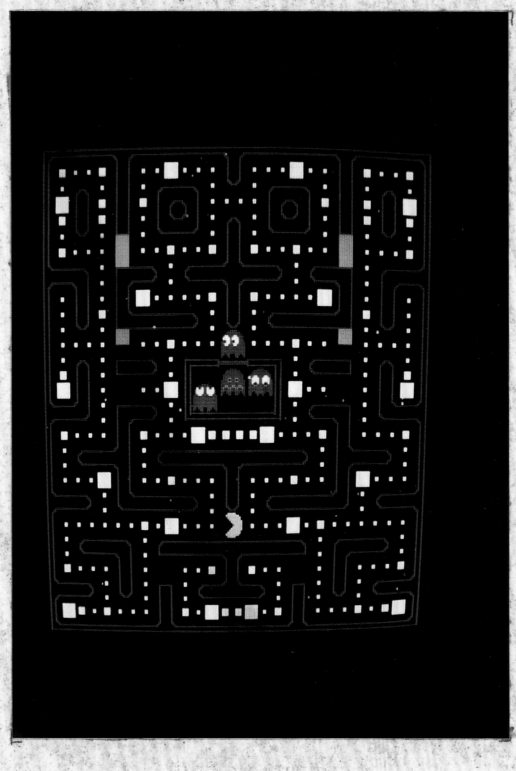

ブラウン管表示例

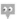

Almost Ready

While Namco management favored a hands-off approach with their young programmers, it didn't mean that their work wasn't scrutinized. With *Puck Man* nearing completion, it had to pass muster with Nakamura before the game would be considered for release. For those involved in the production, the presidential trial play in this "presentation to the president" was, as Iwatani wrote, "a ceremony with a bit of pressure." He recalled the scene: "When President Nakamura began, he played for a few hours. I remember him getting passionate while he played," Iwatani said, "to the point that he would even make the cabinets shake!"[74]

"Suddenly, while playing *Puck Man* [at the trial play], seeing the four colorful ghosts, he started yelling, 'Which colors are the enemy?!' at us. And when we would explain to him all of the ghosts were enemies, he'd say, 'No, tell me which ones are the enemy!'" After a brief moment, Nakamura delivered his judgment: as he didn't know who the enemies were, he ordered the team to simply "make them red." Iwatani objected, but Nakamura wasn't interested and walked out.[75] Stymied, the team consulted how to counter their boss without looking too disobedient. Iwatani proposed to survey the younger members of the development team, to show Nakamura which was the better option: four red ghosts or four different colors.

Iwatani: "The results were about 40 or 50 for the colorful ones, against zero for the red ones. We introduced the survey to the president, telling him the results were 40-0. He stared at the paper for quite a while, and finally gave us his approval. 'I see', he said. 'You can do what you want then.'"

While Nakamura was an experienced player and a veteran of the amusement business, he could still be persuaded to accept design input from creatives at the lowest levels of his company. This open-handedness was a hallmark of his approach. Still, the team had to work hard to get their point across, as Iwatani explained in a 1985 interview. "When you're trying to bring a new idea to life," he said, "you often encounter the following problem: even though you may convince your bosses of the basic idea quickly enough, it can take a long time to convince them of the parts they've deemed 'extraneous.' You have to persuade them that those ideas are only unnecessary when viewed in isolation. Once it's part of a game that's out there in the world, the players who love that game won't see it as 'extraneous.'"

"Honestly, finding the words to convince management of this is a whole other side of the job," Iwatani continued. "When I made *Pac-Man*, I strongly believed that the time had come for video games to become more than they were, and I wanted to express that in my new game. But the newer your ideas, the more work it takes to make others see your vision, and that really took up a lot of my time and energy."[76]

Location Testing

Nakamura's approval meant the game would go into production soon, and would be included in sales pitches to amusement spaces. "From a sales point of view, we thought *Puck Man* would be able to turn locations upside down," location manager Katsutoshi Endo said. "It looked like this machine could compete with [machines from] Sega and Taito. I remember thinking if we could get into coffee shops, it would do great!" The development team was absorbed in tying up the loose ends—a line of code here, a difficulty adjustment there. While playing through the final version of *Puck Man*, a nagging doubt plagued Iwatani. Was this the game that would "make it" in the game rooms? The game played well, was challenging enough, and its "waka-waka" sounds would surely grab the attention of players.

But Iwatani wondered if it would be enough to woo existing players, let alone draw in new player groups. "I was somewhat frustrated with the play speed, but had come to accept it, more or less. Yet when we played the game at double speed to test some work efficiencies, the frustration I felt disappeared completely!"[77] The team decided to keep the double speed, adding one final major design change at the very last minute. "I still think about what would have happened if we had shipped the slower version."

At twice the speed, the game proved to be great fun for everyone at Namco. Even at its launch date, *Puck Man* still had its skeptics within the company, said Hideyuki Nakajima, Namco's vice president. "It was the first video game with so much strategy and no fighting, but the more people in the company tried the game, the more they became addicted."[78] This included President Nakamura himself. "I remember bringing a final test version of *Puck Man* to the president's office when most of the company was on break due to [the Japanese national holiday of] Golden Week or some other holiday," hardware designer Shigeichi Ishimura said. "The president's approval of the final features was needed, of course. I think I asked President Nakumura something along the lines of: 'Could you please try the prototype of *Puck Man*?' Since the president was a person who preferred being at the office rather than at home, he apparently spent the whole holiday at the office playing *Puck Man*. When I asked him how it had been after the holiday ended, he responded, laughing: 'It was so much fun, I developed tendonitis! What have you done to me?!' He liked it, apparently!"[79]

"Players were giggling and laughing, making noise and having fun in general."

Toru Iwatani, Namco game designer

On May 22 1980, *Puck Man* rolled out to a test location in Shibuya, Tokyo, then and now the undisputed youth epicenter of the city, and was installed at an amusement center atop the Tokyo Bunka Kaikan building.[80] Iwatani: "It was a thin, chimney-shaped building with seven or eight floors, consisting of several movie theaters. On the top floor, there was a very long, narrow room where couples, having just seen movies, would hang out a little before they returned home. So, they weren't necessarily gamers."[81]

Importantly, the event was documented in detail, as the Agency of Cultural Affairs demanded a strict recording of the "first day of announcement," the date a new product is first shown to the public. Iwatani continued: "We were there the whole day, as the development team had to absolutely be present during location testing, quietly taking notes throughout the day, watching people playing, et cetera." The first response from these moviegoers—including, crucially, many women—could not have been better. "Women and couples made up the majority of the public during the location testing. They were giggling and laughing, making noise and having fun in general, so we thought to ourselves, 'This is going according to plan!' It confirmed that our concept was working."

ミス位置分布

4/7, 4/8, 4/9

Hitting the Market

ゲーム市場への進出

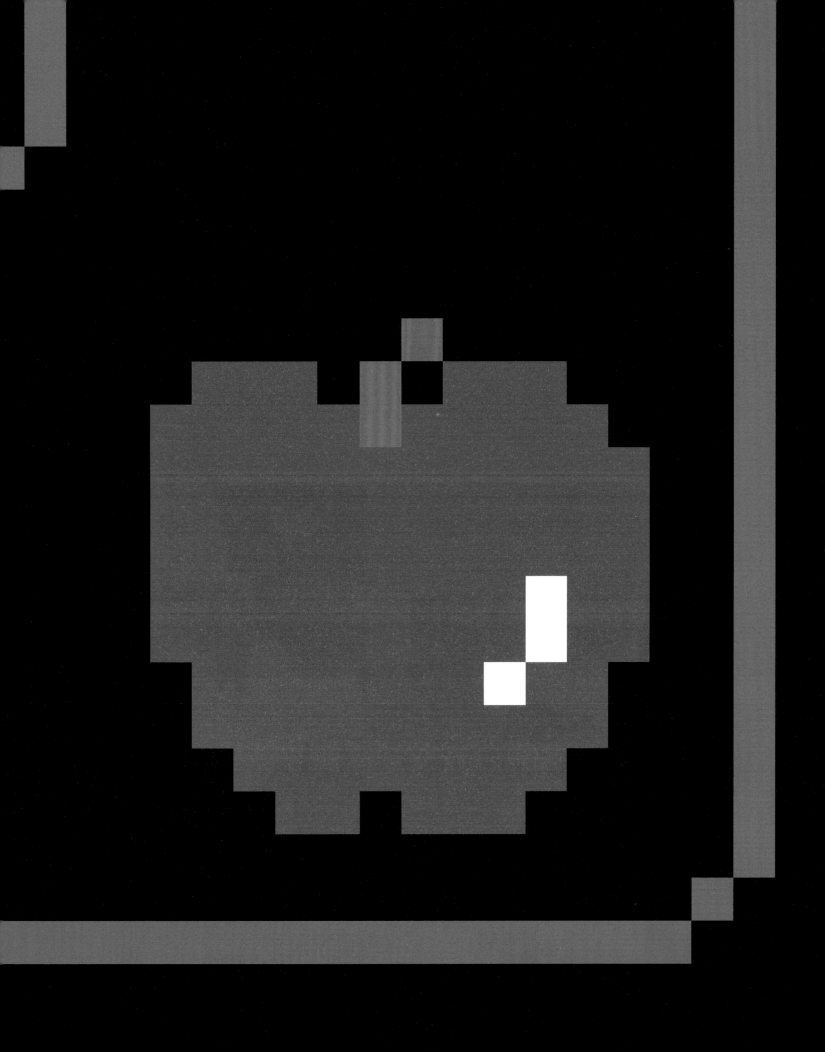

Production and Marketing

After the location test in May 1980, *Puck Man* went into production in two models: a black and woodgrain tabletop (or "cocktail") version, and a white upright cabinet. Production of the machines was outsourced to other companies. In the production of Namco's earlier electromechanical machines, everything was done in-house. "People from development used to come to [the designers] from the prototype stage onward," said Yoichi Haraguchi, who led the production teams at the time. "But this was all done in a very tumultuous atmosphere, with people talking and arguing over things all the time. After that, we had to outsource because we couldn't mass-produce with that method and we needed a plating company and a board company to make the boards. So [with *Puck Man*] we only made the prototypes within the company, and everything else was outsourced."

That summer, the marketing campaign to distributors and arcade operators kicked in. Sales, it was advertised, would start from August onwards, for a retail price of 580,000 yen for the table version and 680,000 yen for the upright version.[82] The first advertisements in *Game Machine* magazine read: "Gobbling up the dots in the maze, it's *Puck Man*! Four monsters coming in for the attack. Counterattacking by eating a power food, it's a TV game console which requires you to play with your brain!"[83]

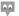

Masaya Nakamura poses with the *Puck Man* game and Pac-Man merchandise, 1982.

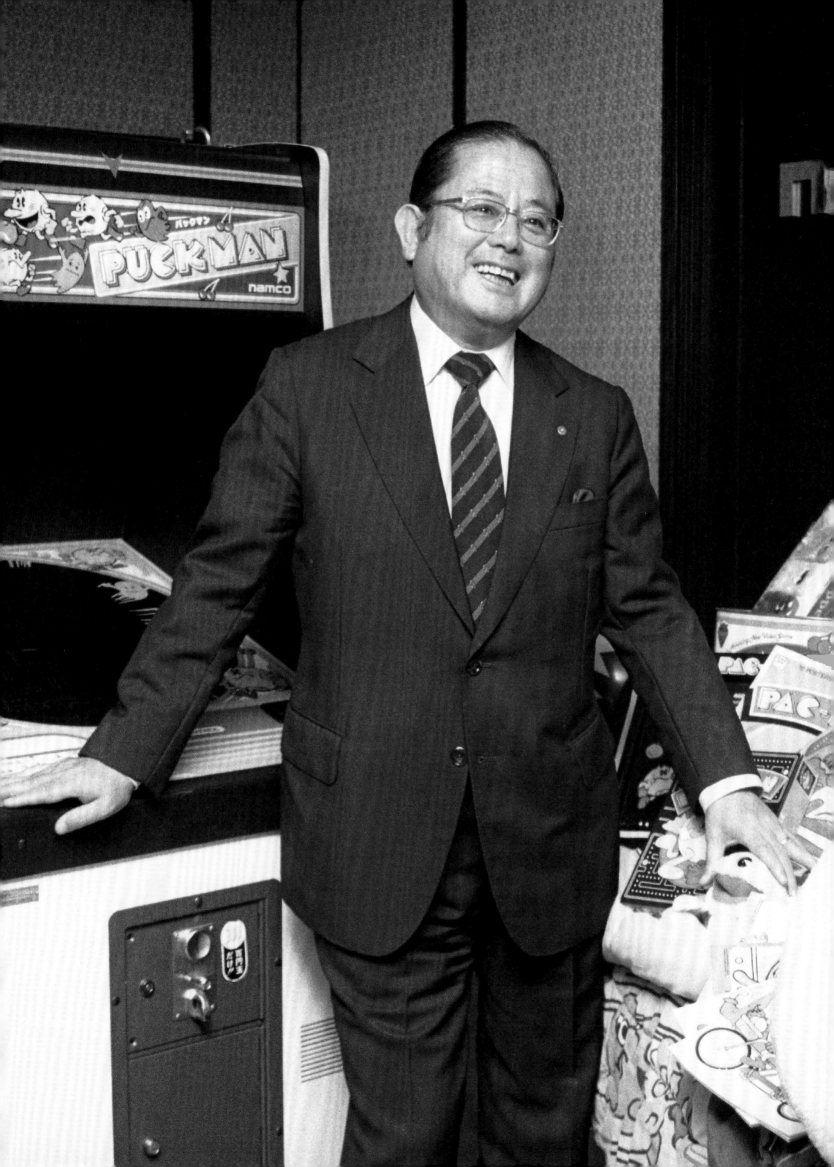

The game was soon featured at industry events like the massive 18th Amusement Machine Show held in Tokyo, from October 8-10. The convention, hosted by the Japan Amusement-Trade Association (JAA), was a key event for the industry, with more than 70 exhibitors displaying a wide range of amusement equipment including video and arcade pieces as well as things like kiddie rides, jukeboxes, sing-along music tape players and more.[84]

But Namco promoted its new game at smaller events too, such as novelty private shows for vendors and traders. "In July, we had a private show only for *Puck Man* at a hotel," said domestic sales manager Kiyoshi Sarukawa. These types of exclusive events were an important barometer for gauging interest in new products. "These events were rare in those days, and to feature just one game was a first for us, too. I remember the response of the vendors and traders was not too enthusiastic. After all, they were used to looking at shooting and racing games, and then a very different *Puck Man* came out, so I guess they were probably a bit unsure."

Sarukawa admitted to not "feeling the passion" during the event, with one notable exception. "There was a vendor from Hokkaido, an elderly person who didn't usually play games, but he played *Puck Man* from the start of the event until we wrapped up," Surakawa remembers. "When I saw that, I strongly felt this game could be played by a wide range of people, including those who don't usually play games." Katsutoshi Endo felt similarly when he toured installation sites in Tokyo. "Up to that point, you would not see women playing games on their own in places like coffee shops, you know? However, I witnessed such a scene several times when the tabletop *Puck Man* appeared in these locations, so I really felt the game could be accepted by women as well."

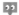

The first Japanese advertisements for *Puck Man* explained the gameplay and its emphasis on strategy. "Gobbling up the dots in the maze, it's *Puck Man*! Four Monsters coming in for the attack. Counterattacking by eating the Power Food, it's a TV game console which requires you to play with your brain."

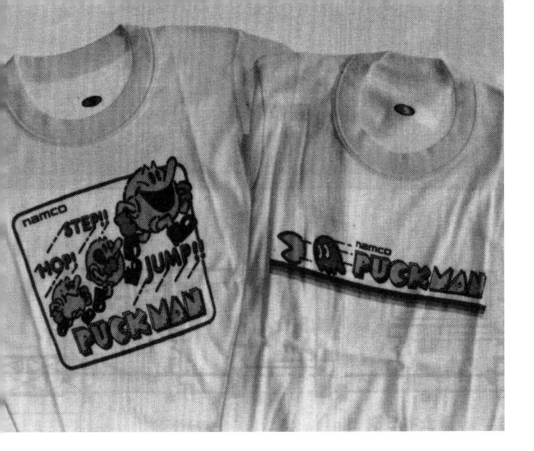

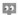

A Rough Launch

The vendors' reluctance to insta-buy *Puck Man* was mirrored at other events, which led to meager initial sales. But soon after, sales suddenly picked up. "The numbers increased drastically 40 to 50 days after we shipped the first machines," Sarukawa reflected. "By then it was obvious the game's popularity was sustainable, and that a wide range of people liked to play it. From then on, *Puck Man* sales would be quite stable and total sales would be very good." One indicator was the increase of the number of games installed in coffee shops: a whopping 1,000 venues scattered around Tokyo soon operated one or more cabinets.

Soon, Namco's manufacturing department was charged with producing up to 30,000 *Puck Man* machines—a tall order for a company that typically produced 2,000 cabinets a month. Production levels increased as they streamlined their outsourcing, but Namco staff soon faced a new problem. The incredible domestic success of *Space Invaders* had created a domino effect in the industry—both Japanese manufacturers and their U.S. partners had entered the fray, launching one video game after another. Nintendo offered *Space Firebird*, *Monkey Magic*, and *Sheriff* in rapid succession, and Irem launched both *Andromeda SS* and *Green Beret*. Taito offered Atari's *Missile Command*, Sega/Gremlin released *Space Tactics* and *Digger*, and Nichibutsu debuted *Moon Cresta* and *Crazy Climber*—the list of novel arcade game releases seemed like it would never end.

As the national amusement industry soared on the back of the video game craze, it became difficult to source the electronic components used in arcade machines. Namco's manufacturing staff was soon struggling to find enough semiconductors, boards, and color monitors, said Yoichi Haraguchi. "We got some parts from overseas companies like Raytheon and Intel, but most were from domestic suppliers. When we placed our orders with them, they would give us delivery dates, but almost no supplier would keep them, since they couldn't keep up with demand. Or we would receive parts that were wildly different from what we wanted, which led to us reselling those to other companies."

Semiconductor factories were soon stretched to the breaking point, and became selective in choosing clients. Namco's staff would run into challenging negotiations, as traditional electronics manufacturers were wary of large orders from new, unknown companies, and demanded large up-front payments. After *Space Invaders*, the sales of EPROMs (programmable memory chips) soared overnight, for instance, raising eyebrows with producing companies. "These manufacturers were very reluctant to do business with us," Iwatani said, "so our team had to use every trick in the book to convince them."

One of these "tricks" was to ask distributors to send surplus goods straight to Namco. When orders bounced with other companies, Namco would buy them, saving the distributor money on logistics and storage. Another was to simply pay more than the competition, Shigeichi Ishimura said. "We were in a race against imitations and copy products, so it was tremendously important to make and sell the product quickly."

Even so, Namco had trouble fulfilling all its orders. "Customers wanted the machines as fast as possible," Iwatani said. "At the time, there were a lot of popular games being made, so if you couldn't keep up with demand during the initial release of your video game, they would just buy different machines. And that's logical, isn't it? If you had to tell them that it would take half a year for them to receive their machine, you couldn't do any business at all."

In the end, *Puck Man* sold nearly 15,000 games in Japan—sales worthy of Namco's investment, but hardly another *Space Invaders*. In addition, a number of *Puck Man* units were also sold under license in a variety of other countries and territories like the UK, Thailand, Italy, West Germany, France, and Spain, resulting in a range of cabinet designs bearing the *Puck Man* moniker. Between domestic sales and those abroad, *Puck Man* likely sold between 17,000 and 20,000 units. It was considered a reasonable success in the market, but those results would soon be dwarfed by what happened when a new, U.S.-based licensee knocked on Namco's door.

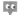

A *Puck Man* upright cabinet awaits players in Shinbashi Gameland, an amusement center in the Shinbashi area in Tokyo. *Game Machine* likely was the first magazine to publish photos of *Puck Man* in its natural habitat on October 15th, 1980.

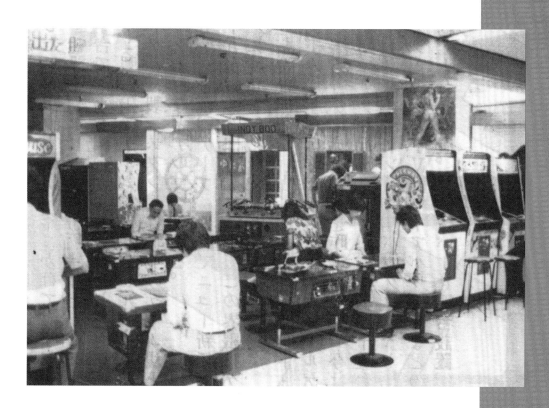

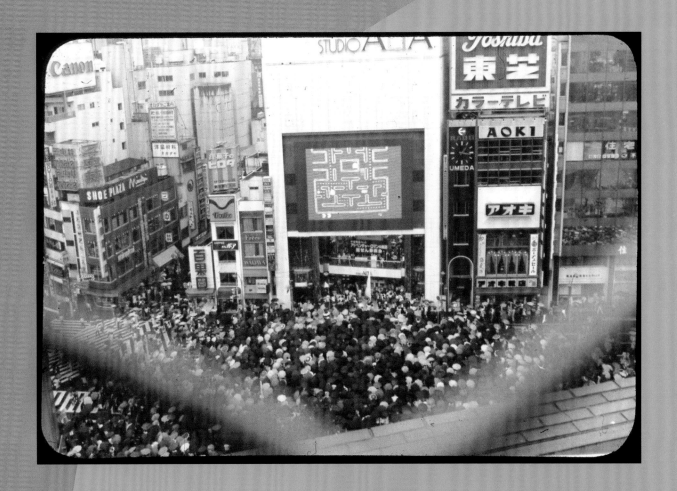

 Puck Man is shown on the giant advertising monitor on the Studio Alta building, June 29th, 1980. Namco had a close relationship with the warehouse and television studio in the popular Shinjuku, Tokyo area, holding *Rally-X* tournaments in the building, although the crowd in this picture is unrelated to any Namco event. The large screen, installed in April of that year, was a novelty and would soon be a popular meeting point.

Early promotion for Namco's new "TV game," in industry magazine *Game Machine,* advertising *Puck Man* as "the game everybody's talking about." The magazine explained that sales would begin in early August, 1980, and the retail price for the cocktail version was 580,000 yen, while the upright version sold for 680,000 yen.

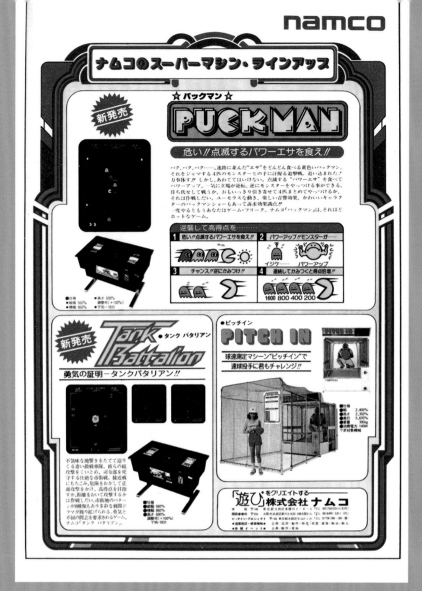

Full color Namco advertisement, *Game Machine*, October 15th, 1980. The ad showcases *Puck Man*, as well as *Tank Battalion* and an expansive baseball themed game, *Pitch In*.

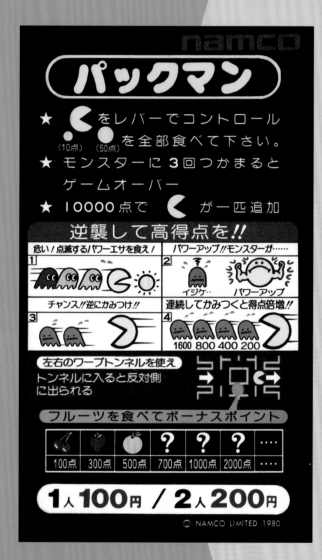

Puck Man cabinet instructions.

This lyrical German flyer announced the new, Namco-licensed game for the (West) German market, making the most out of the German word "packend" ("gripping"). Europeans would be exposed to *Pac-Man* from different avenues. Before a steady stream of imported Midway *Pac-Man* cabinets filled the arcades, European players relied either on Namco imports, licensed iterations, or on one of the many, many bootlegged versions of the game.

René Pierre, an established French manufacturer of billiard and foosball tables, released its own version of Namco's *Puck Man* as *Crock-Man* in 1980 ("croquer" means "to bite").

Flyer for the licensed Spanish version, *Pacuman*, made by Recreativos Franco, S.A., a Madrid-based operation still in business today. The translation of *Puck Man* didn't stop at the title, either; the game proudly introduces "Espia," "Tramposo," "Estilista," and "Lloron" as the ghosts, together with their nicknames "Tomate," "Dientes," "Racky," and "Mocky."

MYSTIC·MAN

1 eller 2 spillere

1	Undgå at blive fanget
2	10 10 10 10 10
3	50 50

4	200 400 800 1600
5	100 300 500
6	Over 10.000 point giver ekstra runde

Vægmodel 14"	
Bredde	57 cm.
Dybde	43 cm.
Højde	73 cm.

compu-game a/s

elektronik

MALERVEJ · 6700 ESBJERG · (05) 15 07 88

Flyer for a Danish bootleg version of *Puck Man* called *Mystic Man*, which appears to be in a unique, tabletop configuration, with a shorter base and coin slot at the top.

CHAPTER 5

Coming to America

パックマン、アメリカへ！

The U.S. Video Craze

The video game boom in Japan was mirrored in the United States, with that country's own surge in companies, amusement spaces, players, and new video games. A mere decade after Atari's Nolan Bushnell first experimented with connecting coin slots to video games with *Computer Space* (1971) and *Pong* (1972), arcade video games were hitting the mainstream. In June 1981, industry pundit David Rosen of Sega Enterprises told an audience of arcade machine distributors they were now part of a $5 billion industry—easily topping the $2.7 billion the 1980 domestic movie box office revenue, or the $3.7 billion reported by the music industry.[85]

In what was colloquially known as "the video craze," games moved out of the shadows and arcades and into the spotlight, multiplying like rabbits. The mania that began in the late 1970s gained steam as games started moving into the fabric of everyday life, showing up in hotel lobbies, gas stations, convenience stores, pizza joints, and more. This nationwide surge in new locations inflated sales numbers, Rosen told his audience, leading to "a grand total of 700,000 video game machines deployed." Each machine earned the owner an average of $5,000 per year, Rosen said, "and it's common in today's market for new 'hot' games to earn $10,000-15,000 during their first 8-12 months on location. That's really quite something."[86] That stratospheric success was fueled, in large part, by the efforts to bring *Puck Man* to America.

The Chicago Scene

Chicago, IL, also known as the "Windy City," became the epicenter of the U.S. coin-operated industry, beginning in the 1920s and '30s. Nicknamed both for its blowhard politicians and cold Lake Michigan winds, Chicago was also considered the "Detroit of the coin-op industry." The city and near suburbs grew to serve as the beating heart of production, manufacturing, and distribution for some of the largest manufacturers in the pinball, jukebox, and electro-mechanical world, including Bally, Midway, Williams Electronics, Chicago Coin, Gottlieb, Stern Electronics, Seeburg, and many others.

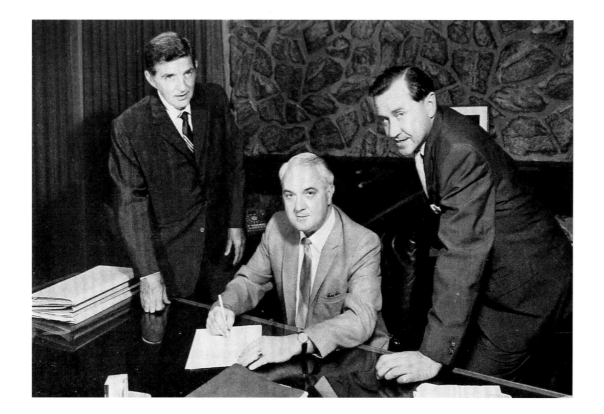

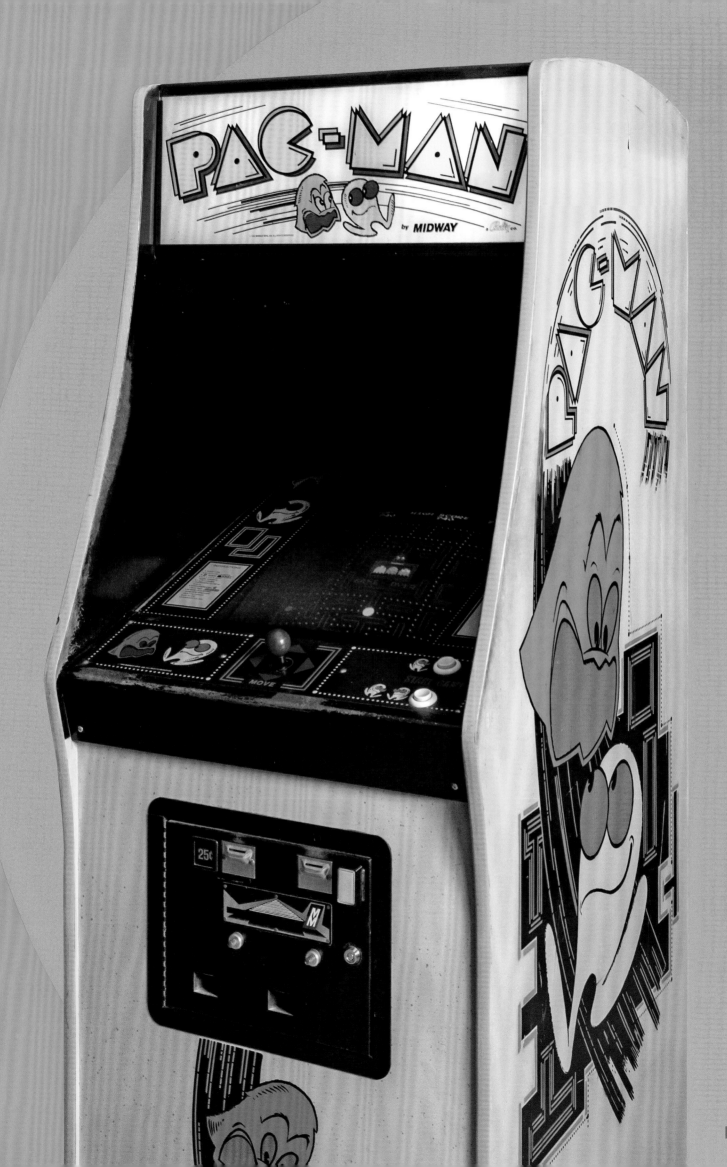

Many of the industry's stalwarts and pioneers grew up in the city's fertile industrial soil. Gottlieb was founded in Chicago by David Gottlieb in 1927, and evolved from pinball manufacturing to other electro-mechanical games. It was also home to the first successful coin-operated pinball machine, *Baffle Ball*, in 1931. Bally Manufacturing took its name from its breakout game, 1932's *Ballyhoo*, and expanded into a juggernaut that would come to dominate casinos and the slot machine world. The Williams Manufacturing Company was the brainchild of Harry E. Williams, who kicked off his company while World War II was raging in 1943. The Seeburg Corporation dominated jukebox sales and manufacturing in the 1950s and '60s. As electromechanical games, slot machines, jukeboxes, and pinball all collided in the Windy City, their makers formed a network of associated suppliers, manufacturers, and distributors that would intertwine as the industry evolved.

Into this environment came Midway Manufacturing Company. Formed in 1958 by founders Hank Ross and Marcine "Iggy" Wolverton, the company spun out of a long-running collaboration between the duo. Wolverton was a mechanical engineer by trade, designing aircraft ordnance during World War II. He entered the coin-operated market in Chicago, first working at Wurlitzer, the company best known for its popular jukeboxes. Wolverton then moved to electro-mechanical game maker United Manufacturing Company, where he met electrical engineer Hank Ross. The two worked together for 11 years at United, but eventually decided to leave and form their own concern in October of 1958, in Franklin Park, IL, a suburb just west of Chicago. They named their fledgling company after the nearby Midway Airport.[87] Ross told an industry magazine, "We feel that there is still plenty of room for growth in a small firm in the coin machine industry. Wolverton and I are very optimistic regarding Midway Manufacturing's future."[88]

"Midway was successful enough to be counted among the 'big five' manufacturers of coin-operated machines, all of which were based in the Chicago area."

With the intent to keep overhead low and prices competitive, Midway debuted in early 1959 with a coin-operated shuffleboard game called *Bumper Shuffle*, and followed it with a bingo-pinball game of sorts, *Red Ball*. The company produced a slew of successful electro-mechanical games, from rifle shooters to physical baseball simulations during the 1960s, surviving in a shrinking market—chiefly on the strength of their clever game designs and high-quality manufacturing. But the company specifically avoided pinball manufacturing, both because of the crowded market, and because pinball operation was still illegal in many large U.S. cities, including Chicago.

In this climate of decline and consolidation, Midway was still successful enough to be counted among the "big five" manufacturers of coin-operated machines, all of which were based in the Chicago area: Gottlieb, Bally, Williams, Chicago Coin, and Midway. These companies made up the backbone of Chicago's coin-operated industry. These manufacturers—whether in jukeboxes, mechanical games, or vending machines—would sell their products to a lattice of distributors spread out in regions across the country. Distributors would handle multiple types of coin-operated machines and games, selling them to route operators and location owners.

The exterior of Midway's offices in the 1970s.

In these early days of the coin-operated game industry, distributors purchased games via exclusive relationships with manufacturers—meaning that only a single distributor could sell a company's games or types of games in a given region. Those close relationships kept alliances tight and operators tied to specific companies and their game releases. Operators purchased the games and then placed them in various locations (typically old-style arcades, taverns, and bowling alleys in that era) along a defined "route." These operators would maintain, repair, and rotate games on their coin routes, usually splitting the take of coins with a particular location 50/50.

Better With Bally

But the postwar prosperity of the 1950s had changed the calculus for coin-operated amusement. The inexpensive investment of a coin or two for a few moments of amusement was less popular at a time when many Americans could afford more lavish entertainment. By the end of the 1960s, that softening coin-op market and its effects hit Midway hard. The company found itself in financial trouble, and Ross and Wolverton decided to sell Midway to their peers and sometime-competitors at Bally in 1969. The deal was announced on July 21 of that year, in which Bally agreed to acquire the company for an undisclosed amount of stock. Wolverton and Ross continued to manage the company as a division of Bally.

Bally Manufacturing Corporation (a subsidiary of Lion Manufacturing) was founded by Raymond Moloney in 1932, to make pinball games, skill machines, and later, slot machines. The purchase of Midway was part of Bally's growth by acquisition strategy; and Midway, with its 28,000 square foot manufacturing plant, popular electro-mechanical games, and lucrative electronics component business, was an attractive target. Just three days earlier, Bally had also acquired coin-op cabinet maker Lenc-Smith Co., housed in nearby Cicero, IL, which would guarantee Bally and Midway access to the firm's machine cabinet skills. "The diversified line of popular Midway equipment will complement the current Bally line and greatly strengthen the position of distributors," said Bally president Bill O'Donnell. "This move is another major step in Bally's plans to expand its operations through the acquisition of well-managed, profitable companies in related product areas. This is in addition to continuing emphasis on our internal growth."[89]

While Midway joined the fold as part of the publicly traded Bally, the companies were still physically separate, operating just one town apart in the Chicago suburbs. Both Bally Pinball and Midway's games were managed separately under the greater Bally umbrella, and this division became even more stark as video games grew in popularity, as the '70s drew to a close. Bally's VP of marketing, Tom Nieman, said the two companies had "a competitive spirit but a common interest." He said that many on the pinball side "were still holding on to the idea that pinball was a good, strong, dominant product. But clearly, the trend was towards video."

This division—both physical and historical—was felt across the two companies. Jim Jarocki, who worked on Midway's promotions and advertising from 1982-1984, pointed to what he saw as a history of quiet disregard. Robert Mullane, the chain-smoking Harvard MBA and CEO of Bally, was reportedly not as interested in the smaller subsidiary. "We were always like a red-headed stepchild to them," Jarocki said. Midway had been part of the Bally family for more than a decade when Mullane became chairman of the board at Bally, so novelty was not the issue. The divide was likely part cultural and also technological: Mullane and Bally Pinball were often characterized as dollars-and-cents types closer to the parent company's corporate side, in contrast to Midway's home-grown, family operation. The technologies underpinning their core products probably also played a part, as the skillsets and traditions of pinball game design and production—solenoids, wires, bumpers—were markedly different than those used to create screen-based, electronic video games.

The Bally manufacturing line in the late 1950s.

Marofske, Midway President, Names Executive Committee

CHICAGO — David Marofske has been named president of Midway Mfg. Co. of Franklin Park, Ill., a wholly owned subsidiary of Bally Manufacturing Corporation of Chicago.

Marofske, a 20-year Midway veteran who served as vice president of manufacturing since 1972, succeeds president Marcine Wolverton, one of the founders of the coin-operated electronic games manufacturing firm.

Upon assuming his new post, Marofske announced the formation of an executive committee and named officers to serve on that committee.

Dr. Martin Keane, (Ph.D., Engineering) associated with Midway since 1976, joins the executive committee and continues in his capacity as vice president of engineering.

Paul Vesper, a 20-year Midway veteran most recently in charge of the Printed Circuit Department and Electronic Component Division, was promoted to vice president of manufacturing.

Stanley Jarocki, who has been Midway's director of marketing since 1977, was promoted to vice president of marketing.

Jack Hartman, who served as Midway treasurer since joining the firm in 1978, was promoted to vice president of finance.

Henry Ross and Marcine Wolverton, co-founders of the company, will both participate in policy matters assisting the executive committee.

Describing the newly formed executive

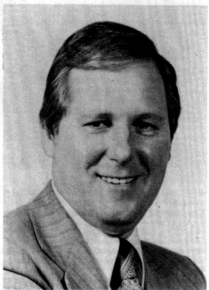

David Marofske

committee, Marofske said, "Midway's sales volume nearly tripled during the past three years, enhancing the company's position as one of the leaders in the coin operated amusement industry. Yet, we are just entering our greatest period of growth, and the executive committee will provide a formal structure for helping us realize our full potential in an expanding market."

Marofske explained that his optimistic

(continued on page 43)

David Marofske is named president of Midway Manufacturing in this industry trade article, February, 1980.

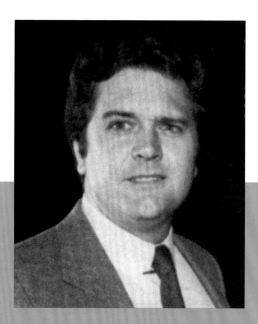

Tom Nieman served as vice president of marketing for Bally Pinball and helped spearhead the company's efforts to license popular personalities and properties to help sell its popular pinball games.

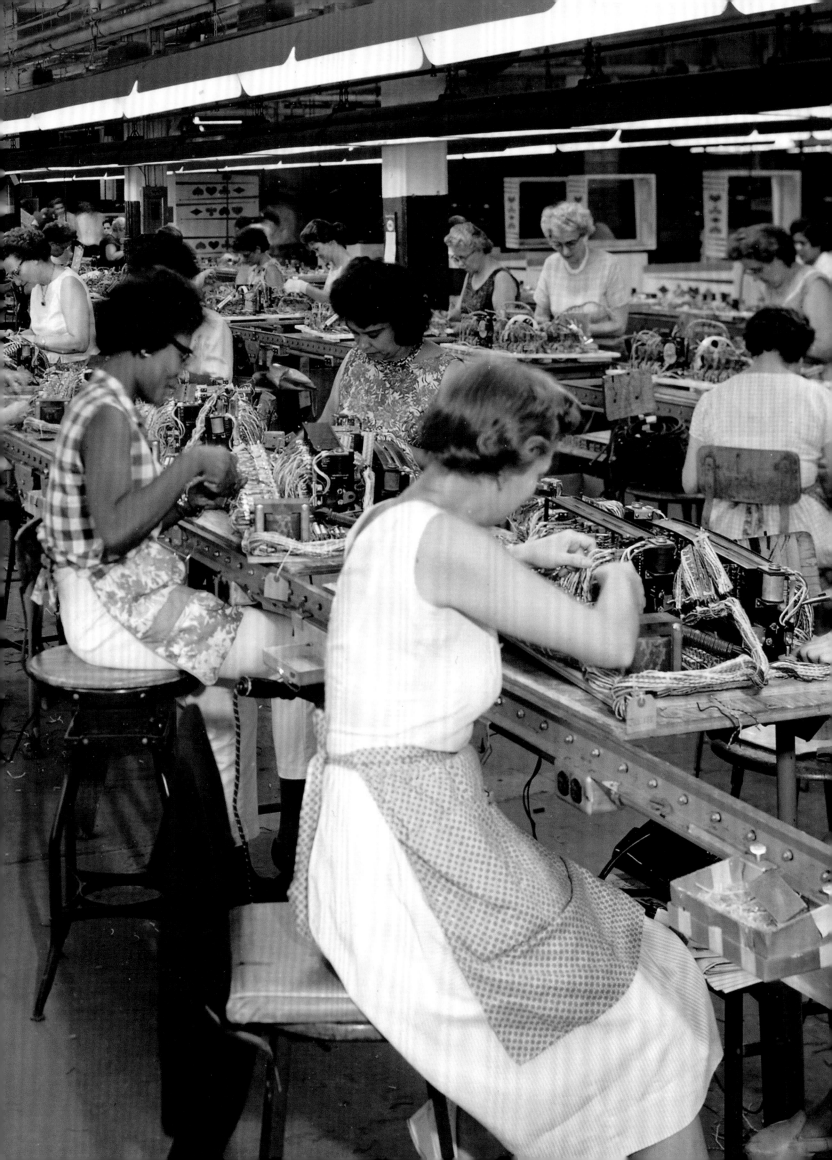

Still, Bally was undoubtedly a pillar of the coin-op industry. Well-capitalized and publicly held, the company had made its money and reputation chiefly on two things: slot machines and pinball games. Bally's pinball division was known for their strong manufacturing, beautiful artwork, and innovative use of licensing. Its introduction of new, electronic pinball machines in the late '70s, which replaced the older electromechanical models, boosted the company's sales.

"I mean, a pinball's a pinball—but Elton John brought it to life. Now it had a personality!"

Tom Nieman, Bally marketing VP

Bally also found great success in wrapping these state-of-the-art games in popular licensed celebrities and properties, like The Rolling Stones, *Star Trek*, Evel Knievel, and *Playboy*. Nieman pioneered this practice of creating licensed pinball machines, and that approach influenced the pinball division's direction—and likely the company's overall comfort with licensing, which would become important later on. "We always took a license," Nieman said. "We found that a brand would put personality into an inanimate object. I mean, a pinball's a pinball—but Elton John brought it to life. Now it had a personality!" But Nieman knew that licensing was only one part of the puzzle, because only great gameplay could ensure staying power, whether it was in pinball or video games. "What I said after our success is, 'I'll get the first quarter. The game's got to hold the next quarter.' So, you had to have good games, good content, and good flow to keep it going. If it had a branded name on it, it just blew everything else away in the room and got tremendous, early play. Then, if it was a good game, it stuck. You made money."

But despite these new ideas in pinball, change seemed to be in the air. Since the launch of Atari in 1972, coin-operated video games had gained steam and popularity. The company's *Computer Space*, *Pong*, and its sequels had demonstrated a greater appetite for video-based games—and also hinted that video games could have a life beyond the traditional pool alleys, arcades, and bars. Trailblazing manufacturers like Atari were pushing traditional coin-op manufacturers to think differently about their products. Nolan Bushnell, co-founder of Atari, told a trade magazine: "We're going to increase growth of the industry, not by competing with other manufacturers, but by leading the industry into new areas. Our first step is to provide machines placeable in locations where coin-op games have never been before."[90]

It was clear that the market for video-based games had grown, and Bally's pinball-based dominance was beginning to slip. This shift was happening chiefly within arcades, which occupied a strange netherworld in the 1970s. More and more video game cabinets were popping up in these haunts—called "video parlors" on the West Coast. They still carried a somewhat sleazy reputation, a holdover from decades of bad publicity and lasting associations with seedy elements and organized crime. Pinball games themselves were illegal in many places, including big cities like New York and Chicago. Evolving from earlier cash-payout pinball machines, these later games were often still seen as gambling devices rather than the "games of skill" that manufacturers touted. The companies at the heart of the Chicago-based pinball industry—Bally, Williams, Gottlieb, Chicago Coin, and others—couldn't even sell their pinball games within the Second City's borders.

One journalist called it "the equivalent of not being able to drive a car in Detroit or eat a peach in Georgia."[91] Chicago finally passed an ordinance that legalized the games

in January of 1977, as New York had done in 1976. But on the eve of the golden age of video games, this popular image of arcades still lingered—seedy dens of iniquity, where kids would spend their money and get into trouble. These hangouts—and the games within them—had not yet reached the mainstream.

Learning the Game of Video Games

In the early 1970s, Midway was still playing catch up with the new players in video games. While balancing its existing slate of electro-mechanical games like *Sea Rescue*, *Dune Buggy*, and *Mystery Score*, the company soon realized that video games would be an important part of its future. Midway would make huge strides in the following years, but the decade didn't begin in a promising way. Co-founder Hank Ross believed that Midway was "lowest on the totem pole" when the earliest video games were released in 1972. "Everyone else was ahead of us in terms of electronics," he said.[92] Months after the release of Atari's smash-hit, *Pong*, Midway jumped on the video game bandwagon in a very literal way. To capitalize on the *Pong* paddle game craze, Midway released its first video game, *Winner*, in March, 1973. The game was not original, but actually a licensed version of *Pong*, created in concert with Atari. While the game itself was basically *Pong*, it did bring a few original touches to the table.

Flyer for *Winner* (1973), Midway's very first video game, a licensed version of Atari's *Pong*.

MORE GAMES FROM MIDWAY.

18 WHEELER

4 PLAYER BOWLING ALLEY

SPACE INVADERS
Cocktail Table

4 PLAYER BOWLING ALLEY
Cocktail Table

 MIDWAY MFG. CO.
A BALLY COMPANY
10750 West Grand Avenue
Franklin Park, Illinois 60131
Phone: (312) 451-1360

For service information-call toll free 800-323-7182

©1979 Midway Mfg. Co.

PRINTED IN U.S.A.

Winner's cabinet was dressed heavily in wood veneer, and its marketing touted it as a "television skill game that fits the mood of any scene." The game was positioned for sales to more upscale locations like restaurants or bar-and-grills, which sales manager Larry Berke emphasized: "*Winner* lends itself to the sophisticated atmosphere of all locations." The game also contained "extra circuitry" that would connect it to a location's TV set, allowing the surrounding audience to view the gameplay in-progress.[93]

But Midway wasn't finished with playing catch-up in video games. Its next release, *Asteroid*,[94] was a licensed version of Atari's own second game, *Space Race*, both of which were unveiled in 1973. Midway continued with other paddle games, including the ironically titled *Leader*, and other *Pong* clone follow-ups, *Winner II*, and *Winner IV* in 1974.[95]

"Video game design and engineering were specialized skills owned by just a handful of technical teams."

Midway's internal design group was chiefly focused on production and engineering, and did very little of its video game design in-house. The company saw its creative need to cultivate and establish relationships with outside research and development (R&D) groups. Those groups eventually provided them with game designs, concepts, and prototypes that the company could turn into production-ready games. Firms like Arcade Engineering in Florida, Chicago-based Marvin Glass Associates, and Dave Nutting Associates in the nearby Chicago suburb of Arlington Heights, were instrumental in helping Midway bring fresh ideas and talent into a company that was better known for its production than its in-house creativity.[96] In these early days of the arcade era, video game design and engineering were specialized skills owned by just a handful of technical teams. Small clusters of game designers and engineers were contracted by various game manufacturers, while others ended up brought on as employees. Some of these small companies were even bought out by larger players. Midway would evaluate the prototypes developed by these partners—rejecting some and adapting others. The most intriguing ones would be turned into marketable, mass-producible games that looked and felt like "Midway games."

Midway also developed a close working relationship with Japanese video game maker Taito, and the two companies would license games to each other for distribution in their respective countries. Midway had imported games like *Wheels*, *Western Gun*, and *TV Basketball*, which gave the company some hard-won experience in modifying and re-imagining the marketing of Japanese games for American audiences. (Today, this process is referred to as "localization.")

But it was a trio of arcade games that raised Midway's profile and helped the company solidify its reputation as a legitimate player in the mid-'70s video game industry: its *Winner*, *Gun Fight* (licensed and adapted from Taito's *Western Gun*), and *Sea Wolf*, designed by Dave Nutting Associates. All three were considered quite successful for the time, selling more than 5,000 cabinets each. Still, Midway remained in the shadow of more prolific and successful companies. The company needed a huge hit, which came as part of the relationship with its collaborators at Taito—a game called *Space Invaders*, which had taken Japan by storm.

The Invasion Begins

Space Invaders became a bonafide sensation in Japan, setting off a national craze,[97] and its addictive gameplay and popularity carried over in the United States. Taito's Japanese creators wanted to handle the American release and distribution themselves through their Taito America Corp. in Elk Grove Village, IL, not far from Midway. But the factory wasn't ready for the level of production they anticipated after the Japanese onslaught. Former Taito America VP of R&D Keith Egging said, "After we saw the phenomenal earnings on test locations, we decided to license it to Midway Manufacturing."[98] And thus, the game came to Midway.

Taito's cautious approach paid off for Midway, since early indicators pointed to a breakout hit as soon as it was released in July, 1978. The company's representatives told industry magazine *Cash Box* that "location tests spanning 10 weeks prove *Space Invaders* to be out-of-this-world in breaking all-time collection records."[99] Midway's *Space Invaders* would go on to become the best-selling game in U.S. history at that point, with Midway reportedly producing 65,000 units during its run. Midway's George Gomez arrived at Midway that fall as a game designer, while the company was going full tilt on production of the hit game. "We made an awful lot of them," he said. "It wasn't small potatoes. The company was really going gangbusters during that time." Midway responded by following it up with a cocktail table version, as well as a sequel called *Deluxe Space Invaders* (1979), and a Bally pinball translation, *Space Invaders* (1980).

Midway's partnership with Taito worked well, no doubt in part because of the long-standing relationship between Midway marketing director Stan Jarocki and Mike Kogan, the Ukrainian-Jewish owner and founder of Taito. Kogan had settled in Tokyo by 1939, and started the Taito Trading Company in 1953. Jarocki knew him for many years while working at J.P. Seeburg, the Chicago-based jukebox manufacturer. Kogan's Taito had served as the exclusive Japanese distributor for Seeburg's coin-operated jukeboxes, making it one of the top jukebox companies in the country.

This historic success of *Space Invaders* birthed many significant changes for commercial, coin-op video games. First, it showed companies a viable alternative to Atari's model of creating home-grown games. Do-it-yourself game design was no longer the only trendy approach for game makers, and U.S. games weren't the only ones worth noticing. A distinctive stream of creative and innovative concepts were flowing out of Japan, too, and American companies quickly moved to dip into this well of foreign-born games from companies like Sega, Taito, Namco, and others. Some of these same companies would eventually set up their own manufacturing and distribution in the U.S., but Japanese game makers had already influenced the video game industry, even if they started doing so from across the Pacific.

Full Color Video Attraction From Midway

New Galaxian

New...exciting space wars 1 or 2 player video game featuring full color monitor. Engineered by Namco Ltd./ Manufactured by Midway.

SEE OTHER SIDE

MIDWAY MFG. CO.
A BALLY COMPANY
10750 W. Grand Ave.
Franklin Park, IL 60131
Phone: (312) 451-1360

For Service Information-
Call Toll Free: 800-323-7182

Specifications:
Height: 68½" (1740 mm)
Width: 25" (630 mm)
Depth: 31½" (800 mm)
Weight: 204 lbs. (92 Kg.)

Midway itself wanted more helpings of the success it had tasted with the imported *Space Invaders*. The game's incredible performance put the company on the map and set the stage for its growth, while also leaning on outside collaborators to develop other noteworthy games for the U.S. market. It released other successful titles like *Wizard of Wor* (1980) and *Gorf* (1981), both by Nutting Associates, as well as Arcade Engineering's *Omega Race* (1981). *Space Invaders'* 15-month production run[100] also affirmed what audiences worldwide wanted. On the whole, they craved explosive, fast-twitch shooting games, and the *Space Invaders* sensation brought on an avalanche of similarly themed shooters, to the point that industry commentators could see the game's "overwhelming influence" on the design of other machines released after it.[101] In the two years that followed, the industry's most popular games all seemed cut from the same cloth.

The most successful and popular games shared a similar motif—space shooting. Games like *Galaxian* (1979), *Lunar Lander* (1979), *Tail Gunner* (1979), *Starhawk* (1979), *Star Fire* (1979), and many others[102] featured spaceships or space-based shooting themes. When Midway released its own appropriately titled *Space Encounters* game in 1980, it was described as the "latest innovation in creative space games designed to continue in the winning tradition of our highly successful *Space Invaders* and *Galaxian* video coin-ops."[103] These fast-action, stress-inducing shooters kept coming, chasing both the cash box hopes of *Space Invaders* and the popularity of the *Star Wars* film in pop culture.

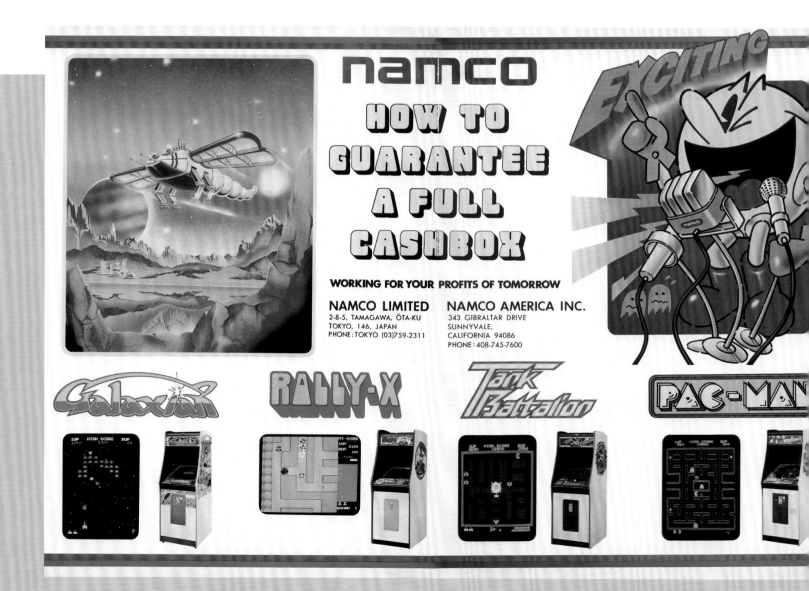

But this wasn't the first (or last) time that video game industry executives would indulge their lemming-like instincts. Atari's breakout arcade game, *Pong* (1972), basically created the commercial video game industry; but that same industry was nearly overwhelmed by similarly themed games—both knockoffs and copycats—which threatened to choke the early success and adoption of arcade games. Without strong copyright and patent security in place, *Pong* was often-imitated, shortening its lifespan and earning power for Atari. Success attracted copycats like a magnet as also-ran companies chased the latest game trends and player tastes. Like any other hits-focused business (the music and movie industries, for example), video games were not immune to this syndrome. Executives catching the scent of clinking quarters were often unable to look beyond the shallow pools of their industry backyard, or focus much beyond their traditional, assumed audience of men.

The myopic approach of designing and marketing to the same audiences with the same popular tactics meant that video games would remain a decidedly homogeneous industry. It wasn't merely focusing on the same players, either. Often, game leadership looked alike—white and male. Many of the video game makers were staffed with veterans of the coin-operated industries that predated video games, who brought their own biases to the table. While the stereotypical image of cigar-chomping executives and back-room deals spring to mind, the three-dimensional reality was more subtly biased. With the exception of newcomers like Atari, the tight-knit industry was often found recycling its own stale ideas or running from one trend to another. This short-sighted thinking about game themes, concepts, and audiences would persist—but in 1980, one game would forcefully break that mold.

Re-Made in the USA

While Midway and other video game manufacturers were looking across the Pacific Ocean for inspiration and games to import, only ideas (and code) could make the 6,000+ mile journey effectively. The arcade games themselves would have to be reinterpreted on many levels. First, simple economics ensured that manufacturing of these U.S.-released games would not happen overseas. At the time it was much more cost-effective to build arcade cabinets stateside rather than to send shipping containers filled with 200-pound arcade cabinets across the ocean.

But more importantly, Japanese design and manufacturing specifications were simply incompatible with those in the States—because of the metric system, of all things. Japanese arcade cabinets were drafted, fabricated, and built using metric-sized materials. Plywood thicknesses, shaft depths, and steering wheel dimensions were all drawn and planned with available, off-the-shelf metric materials, which had no easy equivalents for parts manufacturers in the United States. And it wasn't a simple substitution, because small differences in size, thicknesses, and tolerances meant cabinets and their array of wires, boards, switches, and monitors had to be re-envisioned from scratch, based on the needs and parts available in Western manufacturing.

Durability was also a concern. In Japan, games were placed in a narrower set of locations, like amusement spaces and coffee shops, whereas American arcade games could show up in any number of locations beyond a dimly-lit arcade. Bars, restaurants, bodegas, corner stores, supermarkets, theme parks, and even dentists' offices were all willing hosts to arcade games at the height of the video craze. This diversity of environments also meant that games in the United States would travel more and further than their Japanese counterparts. Operators would buy a set of arcade games and rotate them through a "route" of different locations—arcades, convenience stores, or shopping malls—to keep the games performing in the most appropriate locations, based on sales and the needs of location owners.

This 1980 flyer from Namco America Inc. showcases the company's 1980 Japanese lineup, while utilizing the American *Pac-Man* logo and name.

Cabinets would be shuttled from location to location, on and off trucks or moving vans, while also being subjected to the daily wear-and-tear of the typical American teenage audience. Midway designer George Gomez pointed out that "games had to be pretty rugged. Simply and honestly, when I look at some of the stuff that survived from that time, it survived because we built them really well and designed a lot of durability into them."

With Taito America transitioning to handling its own manufacturing and distribution in the Chicago suburbs in early 1980,[104] it no longer licensed games to Midway for manufacturing. Their partnership came to an end as Taito grew its U.S. presence, leaving Midway to look for other Japanese collaborators.

Midway found a willing partner when they agreed to license the next-generation space shooter from another Japanese company, Namco. As already seen in Japan, *Galaxian* was Namco's answer to *Space Invaders*, a direct shot across the bow of it's rival, Taito. "I must say that *Galaxian* was a far superior game," bragged Namco founder Masaya Nakamura. "The *Invader* game was black and white, and it had vertical and horizontal movements only, whereas *Galaxian* was in color and the enemies attacked from various directions. So, it was a significant improvement."[105] *Galaxian* had, in fact, ramped up the difficulty, graphic sophistication, and complexity of space attack games, while still remaining in the same mold as *Space Invaders*. Released in the U.S. in April 1980, *Galaxian* was a success for both Namco and Midway. "It's the natural follow-up to our highly successful *Space Invaders* game," said Stan Jarocki.[106]

While not nearly as popular as *Space Invaders*, *Galaxian* still went on to sell 45,000 units in the U.S., and was incredibly important as Namco's first major arcade hit. It also kept the industry's attention on Midway with another hit game. The sterling results proved an important first step in the relationship between Namco and Midway, because Namco had other games in its development pipeline that would soon need an American home.

Detail of a Midway *Pac-Man* PCB (printed circuit board) schematic.

Details of Midway's *Pac-Man* cabinet manual highlight the joystick assembly. Manuals like this one allowed Midway customers to repair and maintain their games, or order specific part numbers for replacement.

PAC-MAN - CONTROL ASSEMBLY

ORDER BY PART NUMBER ONLY

ITEM	PART Nº	DESCRIPTION
1	A921-00012-0000	SHAFT & BALL ASSY. - FIRST 3,000 GAMES
1	A932-00022-0000	SHAFT & BALL ASSY.
2	0017-00100-0025	1/4'' E-RING
3	0921-00702-0000	STOP SPACER
4	0921-00902-0000	SLIDE PLATE
5	A932-00011-00XF	SPOT WELD ASSY.
6	0017-00101-0713	#8-32 x 1'' SLT. FLAT HD. SCREW (4 REQ'D.)
7	0017-00103-0061	#8-32 HEX NUT W/SEMS (4 REQ'D.)
8	0932-00902-0000	GROMMET
9	0017-00101-0598	#8-32 x 5/16 SLT. HEX HD. M.S. (10 REQ'D.)
10	0921-00701-0000	SLEEVE
11	0017-00101-0528	#5-40 x 3/4 SLT. RND. HD. SCR. (8 REQ'D.)
12	0020-00202-0000	SWITCH PLATE (4 REQ'D.)
13	A932-00009-0000	SWITCH ASSEMBLY (4 REQ'D.)
14	A932-00012-00XF	STOP PLATE & SWITCH BRKT. ASSY.
15	0932-00904-0000	WEAR PLATE
16	0921-00700-0000	ACTUATOR
17	0017-00100-0115	7/16'' E-RING

TRAVEL OF PT. NO. 921-00700-0000 ACTUATOR IS APPROX. 1/8. SWITCH BLADE ASS'Y. SHOULD BE ADJUSTED TO MAKE CONTACT AT 1/16 OF ACTUATOR TRAVEL. TYPICAL 4.

0017-00101-0577
0020-00202-0000

0921-00700-0000

A932-00009-0000

MIDWAY MFG. CO.
A BALLY COMPANY

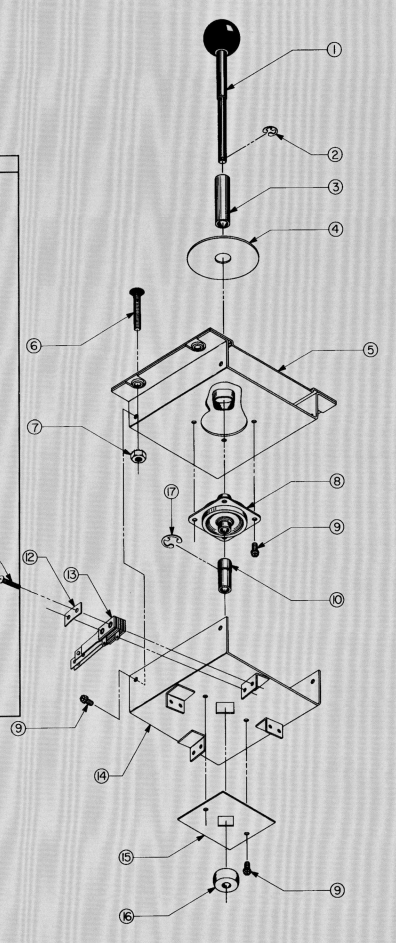

METHOD OF PLAY			
SW #1	SW #2		
OFF	ON	1 COIN	1 PLAY
ON	OFF	1 COIN	2 PLAY
OFF	OFF	2 COINS	1 PLAY
ON	ON		FREEPLAY

NUMBER OF PACKMEN PER GAME		
SW #3	SW #4	
ON	ON	1 PACKMAN
OFF	ON	2 PACKMEN
ON	OFF	3 PACKMEN
OFF	OFF	5 PACKMEN

BONUS PACKMEN		
SW #5	SW #6	
ON	ON	BONUS PACKMAN AT 10,000
OFF	ON	BONUS PACKMAN AT 15,000
ON	OFF	BONUS PACKMAN AT 20,000
OFF	OFF	NO BONUS

SW #7	SW #8	
OFF	OFF	PLAY MODE
ON	OFF	RACK TEST
OFF	ON	LOCKS PICTURE

M051-00932-A035

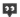

The manufacturer's nameplate found on the back of every *Pac-Man* cabinet produced by Midway in Franklin Park, just outside of Chicago, Illinois.

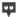

A paper guide stapled to the interior of a Pac-Man cabinet specifies which switches can be changed to adjust elements of the gameplay, including bonuses and lives per game.

The Chicago Way

In August of 1980,[107] Midway president Dave Marofske, VP of marketing Stan Jarocki, and co-founders Iggy Wolverton and Hank Ross boarded a flight at Chicago's O'Hare International Airport, bound for San Francisco. They planned to rendezvous with Satish Bhutani, who headed the emerging Namco America office on the West Coast, and then complete the final leg of their journey to Japan to view Namco's latest game offerings.

But a host of questions remained. What would the games be like? How would Namco's new games mesh with others planned by Midway's R&D teams? Together with Bhutani, the team took a plane to their final destination in Tokyo. Bhutani and Namco VP Hideyuki Nakajima each had earlier opportunities to show off the group of Namco games, but Bhutani wanted to reserve that privilege for Masaya Nakamura, so that the president of Namco could personally unveil them to his audience of Midwestern coin-op executives. But Midway was reportedly not Namco's first audience. The executives had already shown the games to other companies—most notably Atari, who had turned them down.[108] The suite of offerings included the racing title *Rally-X*, *Tank Battalion*, *King & Balloon*, and a game called *Puck Man*.

Rally-X was designed as a top-down racing game set within a maze. The player would drive a blue car through a multi-directional, scrolling maze, collecting all the racing flags in each level while being chased by a set of red cars. The game utilized a clever miniature "radar screen" that let players get a view of where flags and opponents were located on the sprawling maze, similar to other contemporary arcade games like *Defender*. *Tank Battalion* was another game in the set, which featured multi-directional tank battles, as the player sought to defend his tank base from waves of opposing tanks. The game was reminiscent of the 1974 Atari/Kee Games black-and-white game, *Tank!*.

"In those days, we were all a pretty close-knit group. Most deals were made on napkins in a bar somewhere."

Ken Anderson, Game Plan executive

Finally, the third game, *King & Balloon*, was a more conventional shooter, albeit with a unique take on characters. The player controlled a pair of people firing a cannon at waves of descending hot air balloons, defending their king from capture. The game was based on the *Galaxian* game hardware and shared some of its sounds as well. Intriguingly, it was one of the first to utilize in-game, audible speech, as the game exclaimed phrases like "Help!" and "Thank you!"

Dave Marofske of Midway recalled the details of Midway's initial meeting on the games: "[Namco] said they were not going to license all four to any one company, and in fact, they were leaning towards releasing them to four different companies. *Rally-X* seemed to be the one that kept getting touted, but we sort of thought there were two strong games and the other one was [*Puck Man*]. I don't think anyone on our side—and obviously nobody on their side at that time—knew which was going to be the stronger game, but we felt they both had strong potential."[109] Marofske seemed to lean towards *Rally-X* as the favorite.[110]

There were also other hands involved in dividing up these four Namco games. Ken Anderson was an industry veteran and a friend of Jarocki's who helped found a smaller video game company called Game Plan Inc., in Elk Grove Village, IL, in 1978.[111] Game Plan was also in the mix for some of Namco's offerings as well. But why would Midway allow a competitor—even a smaller one—to select some of the games it had access to? Anderson explained Midway's thinking: "Stan [Jarocki] was getting a bunch of games and they didn't have the capacity to produce them all," he said. "I picked *Tank Battalion*. I thought it was a much better game. So, it shows you how bright I am!" he laughed. "But somebody had to take it because Namco was going to sell it to somebody, and Midway wanted to control who it went to. Game Plan was less of a threat than Williams or some of the other people. So, better give it to me than one of them. We were a lot smaller. And so, why not? We were building our factory, and our capacity was a helluva lot less than if one of the other majors had it. They didn't want that to happen. And in those days, we were all a pretty close-knit group. Most deals were made on napkins in a bar somewhere." Game Plan eventually released both *Tank Battalion* and *King & Balloon*.[112]

Midway's 1979 product line included licensed games like Namco's *Submarine*, Taito's *Space Invaders*, and a slew of self-produced arcade games, like *Super Speed Race* and *Phantom II*.

Stan the Man

Stanley Jarocki grew up as a second-generation coin-op man in the Chicago area. His father, Stan Jarocki Sr., was a tool maker at the J.P. Seeburg Corporation, one of the earliest jukebox manufacturers in Chicago. Seeburg was the first company to release cutting-edge jukeboxes that could play both sides of a record. The company also introduced the first jukebox to play 45rpm records, and it dominated much of the industry throughout the '50s. The younger Jarocki started at Seeberg in 1950, sweeping floors in the holding dock while still in high school. He left to serve in the Korean War from 1951 to 1953, and then returned to Seeburg to work in sales and distributor relations.

Jarocki seemingly had a knack for the work, and kept advancing through the company, working in nearly every department. From the stockroom to the machine shop, to sales and marketing, he learned the minutiae of the coin-operated business at every level. Jarocki brought new ideas to his different roles, innovating as he went, and getting to know many influential players at the epicenter of Chicago's coin-op industry.

Stan Jarocki poses for the May 22, 1982 cover of *Cash Box* magazine.

As Seeburg's national promotion director in 1965, Jarocki introduced the company's Disco-theque Program, importing the French style of club music to bars and upscale restaurants. In an attempt to update the jukebox's tired 1950s image, Seeburg's Discotheque package included a jukebox that could be programmed to play exclusive, uninterrupted disco-theque-style music, lighting, printed banners, posters, illuminated window signs, speak-ers, and even a portable dance floor—a disco in a box. It made trade magazine headlines and burnished Jarocki's forward-thinking reputation. He worked his way up to senior vice president for sales and marketing at Seeburg. "I knew the industry," he said. "I knew the distributors. I knew how everything worked. I knew the product I was selling."

"I knew the industry. I knew the distributors. I knew how everything worked. I knew the product I was selling."

Stan Jarocki, Midway director of marketing

Jarocki then joined Electra Games as sales manager in May of 1975, and spent the next two years working as part of its video game division before being approached to join Midway. In September of 1977, he started as the newly minted director of marketing at Midway. With his tinted glasses, permed hair, and double-breasted suits, Jarocki was a standout figure. A flashy dresser with a confident demeanor, he left an impression—but his bold ideas and assuredness were even more noticeable.

Jarocki's ascent and 25 years at Seeburg yielded many lessons and an appreciation of the entire coin-op process from conception to production. He developed a taste for unique products, new technologies, and the chance to bring them to market. By the time he arrived at Midway, Jarocki knew virtually everyone in the industry's positions of power and influence. His son Jim put it this way: "He wasn't an egotist. He wasn't vain about it, but everybody knew Stan. All the distributors knew who he was, and probably most of the big operators in the country knew him personally. So, that was just him. He was a big personality." His personal connections didn't stop at the executive level, either. Jarocki's journey gave him an appreciation of all the hands needed to make a coin-op company work. He knew the names of the people in Midway's parts department and played on the company softball team, making a personal connection wherever he went.

Up in the Air

The ongoing courtship with Midway was not good news for Namco America VP Satish Bhutani. Bhutani had been lured to Namco to open up a domestic distribution network and its U.S. facility in California in June of 1978. But the move proved slow, and for six months Bhutani's home address in the Bay Area was the company's only U.S. address. It wasn't until later that the American branch of Namco would open a 10,000 square foot facility in Sunnyvale, CA.[113]

Bhutani had significant success with Namco's first major export, the electro-mechanical skeet shooting game *Shoot Away*. But after strong initial sales, supply problems cropped up, and Bhutani found himself without enough product to sell. *Puck Man* cabinets could potentially alleviate that problem, so Bhutani lobbied Namco president Masaya Nakamura to let the fledgling Namco America manufacture and distribute the game in the States, with Bhutani personally overseeing those efforts.

But Nakamura didn't want the headache of manufacturing the games across the ocean, so Namco considered U.S. partners—and Bally's Midway certainly fit the bill. Namco had many options for licensing its games in the West, but according to Bhutani, Bally made the most sense to leadership. Nakamura personally wanted to work with the company again after their successful release of *Galaxian* in the U.S. This decision would signal the beginning of the end for Bhutani at Namco, stymied as he was. Frustrated and listless, he left to join Japanese competitor Data East, opening their American office in 1980.

"We weren't the kind of company that would have supermodels in our booth to attract people."

Jim Jarocki, Midway advertising/sales manager

Nakamura's instincts weren't wrong. Midway (and its parent company, Bally) seemed like the perfect landing spot for *Puck Man* and other games in Namco's slate. They were no-nonsense and practical in their Midwestern way, and could handle the challenges of large-scale supply and manufacturing. Jim Jarocki, the company's advertising and sales promotion manager, said that Midway's low-key status was baked into the company. "I don't think we were ostentatious at Midway in how we did things," he said. "We weren't the kind that would have supermodels in our booth to attract people or anything like that. It was basically the product and the people. Right from the top, all of those guys came up from working class backgrounds. They had good business sense, and they got some good breaks. They were pretty lucky. But they also worked really hard and loved the people that worked there."

Through Bally, Midway had access to enormous manufacturing capacity, which put it ahead of many competitors. Bally occupied a sweet spot because the parent company's products were diversified—dealing not only in arcade machines, but also in pinball and slot machines. Bally had its own cabinet manufacturer in local subsidiary Lenc-Smith, and also owned the country's largest distributor, Empire Distributing, Inc., headquartered in Chicago.

After its successes with *Space Invaders* and *Galaxian*, Midway was seen by some in the industry as a company on the rise. After serving as VP of manufacturing for nearly a decade, Dave Marofske was named president of Midway in 1980, succeeding co-founder Marcine Wolverton. Marofske had risen through the ranks of Midway since 1959, long before the company was purchased by Bally. He told an industry trade publication that the company would undoubtedly continue its upward trajectory. "Midway's sales volume nearly tripled during the past three years," he said. "Yet, we are just entering our greatest period of growth."[114]

Midway's leadership team, many of whom were promoted upon Marofske's move to president, felt that its recent success would continue. In the background, Bally heads knew that the video game market was beginning to overtake its pinball sales, and the landscape was shifting. The future of both companies seemed to hinge on the increased success of Midway's video games.

Bringing It Home

Stan Jarocki was no stranger to trips to Japan, as he traveled there three or four times a year to scout games that Midway could potentially license. His journey to Tokyo with Dave Marofske, Wolverton, and Ross to view Namco's new lineup was emblematic of a larger strategy that several U.S. game manufacturers took. Neither Midway nor the other major video game companies had the internal capacity to develop enough games to satisfy the burgeoning market. In the early '80s, the demand for new arcade game products was so great that manufacturers were stretched thin just trying to keep the marketplace full. And companies had to diversify their releases, giving them a greater chance of success with a wide range of game styles and subjects—because not every game would be a success, and the hits needed to subsidize the flops. In a fickle market-place, grand-slam successes were elusive. Just because a game was fun to play didn't guarantee it would sell well.

But the results of this latest trip seemed to be different, at least to Jarocki. He saw something particular in *Puck Man* that encouraged him to bring it into the fold, and he was steadfast in championing the game. Jarocki hand-carried the PCBs (printed circuit boards) for their chosen titles—*Rally-X* and *Puck Man*—with him on the return flight from Japan, the potential keys to Midway's future stowed in the briefcase he carried through the bustling terminals of O'Hare International Airport. "I called the company in the morning and I said, 'I'm doing this,'" he recalled. "And they said, 'Bring it back and let's take a look.'"

After the team's arrival, Midway representatives took in the new games and discussed features, gameplay, and their initial impressions. They installed the boards Jarocki brought home in generic arcade cabinets and made their evaluations. But the first blush of the new games was not particularly rosy. Tom Nieman, VP of marketing for Bally, got a first look and was not impressed with *Puck Man*. He didn't think it aligned with the company's typical demographic, which was "overwhelmingly male." "I saw that *Puck Man* game with the little yellow dot," he said, "and I remember thinking, 'Oh my God, there's no teenage male who is ever going to get excited about this game!'" Nieman laughed. Apparently, he wasn't the only skeptical voice. Bally president Robert Mullane didn't see its appeal. "It's silly. Don't build it," he said after seeing the *Puck Man* prototype.[115]

Photo of a visit of Bally and Midway executive staff to Namco's in Tokyo, 1981. From left to right: Tadashi Manabe, Dave Marofske, Robert Mullane, Masaya Nakamura, John Britz, Hideyuki Nakajima, Stan Jarocki, Mr. Daira.

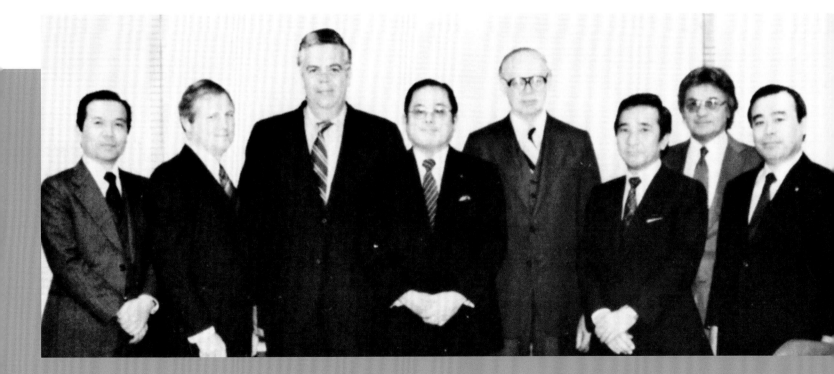

"He turned it down, plain and simple," Jarocki told one interviewer. Despite that, Jarocki urged Mullane to change his mind, and Midway's executive board overruled Mullane to make the deal with Namco."[116] But Mullane still didn't appreciate the game, later asking Jarocki, "What in the hell did you license that for?!" Nieman later called his own vocal opposition some of the "stupidest comments made in the industry."

"Remember, Space Invaders also got the old ho-hum. From then on, we just decided, 'Don't tell me it's bad until the players see the game.'"

Stan Jarocki, Midway director of marketing

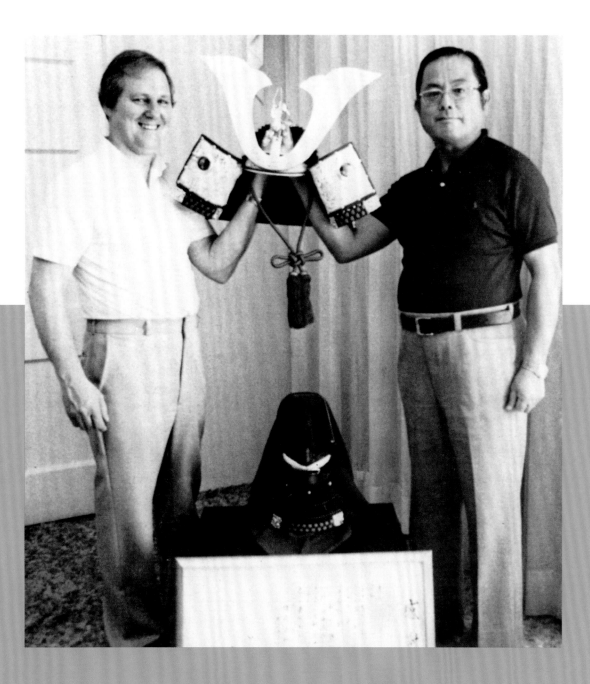

In June 1982, Namco president Nakamura gifted Bally Midway president Dave Marofske an ancient Japanese warrior helmet, a Kabuto. With it came a framed letter of appreciation, written in English and Japanese, "in acknowledgement and in a token of our gratitude."

But what was the issue with *Puck Man*, a game that Namco seemed quite proud of? Why did so many Midway executives shake their heads in disbelief at this Japanese creation? "They thought it was too simple," Jarocki recalled. "They thought it would go nowhere. But the simplicity of the game made it what it was—what it ended up being."

"You didn't need an instruction book to learn how to play it," recalled Jim Jarocki, Stan Jarocki's son and advertising and sales promotion manager for Midway. "Stan saw that. And when he decided to bring that in, everybody at Midway fought him. Everybody said, 'This will never work, Stan. We'll take a chance on it, but this is not going to be great.'" But the elder Jarocki stuck to his guns, confident that the game held promise.

Stan Jarocki seemed to be the lone voice supporting *Puck Man* upon its arrival. "I was really excited," he said. "I saw something that was so uniquely different that I felt it was the right thing to do. It was a very pleasant departure from the usual space, combat, and shooting games. Plus, it was totally simple to operate and easy to understand."[117] Jarocki had learned something important from Midway's previous import successes. "People thought that the cute-factor was going to nail us," he said. "But we had been through this kind of thing before. If you remember, *Space Invaders* also got the old ho-hum at the 1978 AMOA [the Amusement Machine Operators of America trade show]. From then on, we just decided, 'Don't tell me it's bad until the players see the game.'"[118] With that against-the-grain mentality, Jarocki was confident enough to push back against the conventional wisdom and groupthink that hung like a cloud around much of the video game industry—and his own leadership team at Midway. No one could foresee how that decision would play out, but the deal was finalized as Midway signed a licensing agreement on October 11, 1980. The little yellow dot muncher was about to come to America.

Mr. Masaya Nakamura
President
Namco, Limited

- Midway Manufacturing Co. fully understood and agreed
that the "ASSIGMENT OF COPYRIGHTS" for both [PAC-MAN]
and [RALLY-X] which were signed by Namco's representative
and granted to Midway Mfg Co. shall be governed and
restricted by the License Agreement of the above games.
The License Agreement above mentioned shall be finalized
no later than November 15, 1980.

Date *Oct 11, 1980*

By _____

> 99
>
> This signed page of the licensing agreement between Namco and Midway transferred rights for *Pac-Man* and *Rally-X* to Midway, signed by Midway president Dave Marofske.

CHAPTER 6

The Rise of Pac-Man

パックマンの台頭

Before *Puck Man* could be released into his newly-adopted home in the Midwest, changes needed to be made. The game was clearly very Japanese, in both its unique gameplay and overall visual presentation—at a time when that wasn't yet a positive selling point to Western audiences. But the game ended up being an early salvo in the impending era of imported Japanese dominance—with waves of electronics, affordable automobiles, pop culture, cute kawaii characters, and flawless design. While that shift was taking place, *Puck Man* needed a new name.

Toru Iwatani based his game on the Japanese phrase for gulping down food quickly, "paku paku taberu," and thus his Pakkuman character became Puck Man, and the original name of the arcade game. (In fact, the waka-waka-waka noise Pac-Man makes while eating dots is very similar to the sound of "paku-paku-paku" when spoken aloud.) But after Midway licensed the game and began the process of bringing it to market, a concern was raised. It was pointed out that hooligans and vandals could scratch off the middle of the 'P' in *Puck Man* to transform it into an 'F', making it an unmentionable four-letter word.

Namco American president Satish Bhutani claims to have been the first one to broach the subject of changing the name because of its potential for vandalism. Sitting in a restaurant in Madrid, Bhutani and Namco VP Hideyuki Nakajima discussed it with company president Masaya Nakamura. Bhutani said that it took "two months to convince Nakamura to change the name to *Pac-Man*." Nakamura had seemingly dug in on this creative issue, much like he had when arguing with his team about what color *Puck Man*'s ghosts should be. Midway co-founder Hank Ross told a trade magazine that their leadership submitted 10 alternate names that were all rejected by Namco, and that in a return memo, the Japanese company suggested "Pac."[119]

Some of the difference in approach to illustrating Pac-Man can be found in the opposing arcade marquees of Namco and Midway's respective cabinets. While Midway created their own version of Tadashi Yamashita's iconic *Puck Man* typography, the American designers eschewed the crowded, kinetic marquee Namco created. The Namco *Puck Man* cabinet shows the titular character racing across the game's logo, in a variety of emotive poses. In contrast, Midway's *Pac-Man* marquee choses simplicity over action, showcasing the logo and characters with a simpler color palette, focusing on the letterforms rather than the uniquely American character designs.

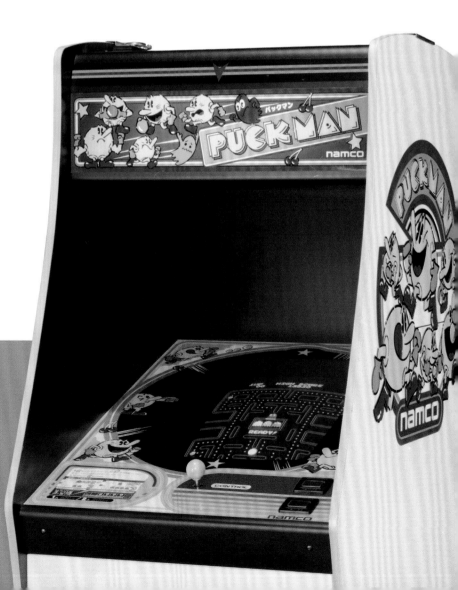

Midway VP of marketing Stan Jarocki said it was "strictly an American thing" and that the name was altered specifically with Midway's larger female audience in mind. "That thing was changed here for a specific reason. How would you like a woman playing a game with the dirty word on it? Our thoughts had to be, 'What will be accepted in the U.S. market?' and 'What won't be damaged in the U.S. market?' We demanded it be changed." In the end, the game received a new moniker and *Puck Man* became *Pac-Man*.

The initial reactions from Midway's team were mixed. Not only did it have an unusual visual appearance and overall gameplay theme, but its ethos also went against the grain of other popular video games of the time. While *Puck Man*'s gameplay would not be altered (except for a slight modification that made the game more difficult for American audiences),[120] it arrived in an atmosphere of reflexive cultural modification. It was just assumed that a licensing company would change the game's visual presentation—the cabinet art, marquee, game logo, instructions, photography, and marketing materials— for greater market acceptance. Midway had already done some of this with its successful release of Namco's *Galaxian*, making changes to the cabinet layout and re-imagining the original illustrations via its own artists. It was expected that any given game would diverge from its Japanese designs.

Made in Japan

Today, the West wholeheartedly embraces much of Japanese culture and design—and a significant portion of it has been absorbed, adopted, or remixed into mainstream visual culture. But 1980 was different. Matt Alt, an author and professional translator in Japan, believes that such changes to *Puck Man* were less overt racism and actually more complicated. Video games were "an inflection point for generational culture," he said. "It really was a kind of pivot, because up until that point, Japanese stuff was seen as chintzy, cheap, or alien. If you were marketing something to Americans in the '70s, saying it was from Japan wasn't a selling point. So, it isn't any surprise that the American side wanted to 'localize' *Pac-Man*'s name and cabinet art to something they thought would be more appealing to local audiences. Even the changing of the name, which might seem shocking today, was simply a matter of marketing—and canny marketing at that, I think, based on the results that followed."

Twenty-first century game and entertainment industries are far more globalized. Audiences raised on Japanese games, cartoons, and comics demand authenticity, while the internet keeps audiences on top of the latest international developments in real-time. Neither of these things were true when *Pac-Man* hit the scene. Midway's George Gomez explained that everything Midway did was dictated by the cash box—a machine's take in quarters. "It was about relating to an American audience," Gomez said. "So, you had to appeal to everybody. It just looked too Japanese, so they needed to change it."

"I think our sales and marketing guys just had a vision that they needed something different," he said. "So, they generated a lot of different concepts and they picked one and went with it. In some cases, it was a functional thing. The American vision was that this thing had to look like a giant toy. The character is yellow, so make the thing yellow. And so, 'I want art everywhere. I want art on the whole thing.'" So, Pac-Man was re-imagined with bright, red bug eyes, a knowing smirk, and rubbery, flipper-like feet built for running—emblazoned on the sides and front of Midway's arcade cabinets.

The original *Puck Man* cabinets were painted white. Gomez explained that the idea of a white cabinet was taboo for many U.S. owners and operators. Countless arcade cabinets were painted dark colors or black, and conventional wisdom held that this was in the service of operators. If a cabinet got scuffed or damaged it was an easy fix, "because every operator on the planet had a can of black spray paint in his toolbox," he said. "The feeling was that they were just going to get dirty. They were going to look like hell in a short period of time." Also, American games needed to grab attention and stand out—so white arcade cabinets were out, and bright, bold color was in. In anticipation of its debut, *Puck Man* received a facelift and a name change, while the gameplay remained fundamentally untouched. An army of bold, yellow arcade cabinets were built, each one calling out like a cheerful beacon in a crowded, dimly lit arcade

Reaction and Impact

When a game was ready, Midway would send cabinets out to test locations, a practice it used for every game it introduced. Midway placed the first games of a production run in some of its Aladdin's Castle locations, other local arcades, and also with key distributors like Los-Angeles based C.A. Robinson and Co., and Bally's own Empire Distributing.[121] There was added incentive for these locations, as they received early intel and generated great word-of-mouth for their customers. The owners also were allowed to keep 100% of the receipts from these games, which was a bonus, especially if the game proved to be popular.[122]

Midway's promotional flyer for *Pac-Man*, 1980. The beauty shots of the Midway arcade cabinets stand in stark contrast to the illustrations on the back side of the flyer (see next page), which use artwork from Yamashita's original *Puck Man* designs.

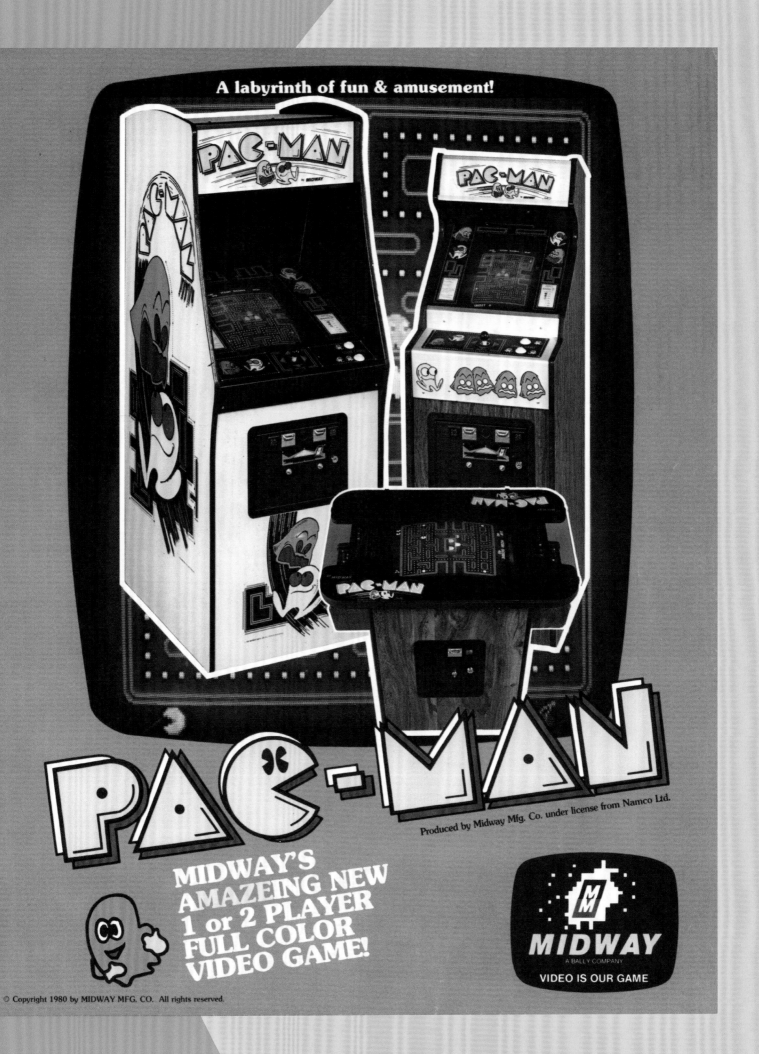

PAC-MAN

A sensational, full color video game for 1 or 2 players that tickles vision and challenges reflexes. Adding to the fun are musical refrains, chomping and action sounds along with amusing cartoon shows between racks.

The player, using a single handle control guides the PAC-MAN about the maze, scoring points by munching up the Dots in his path. Four Ghost Monsters—Inky, Blinky, Pinky and Clyde— chase after the PAC-MAN trying to capture and deflate him. The PAC-MAN can counterattack by eating the big, Power Capsule that enables him to overpower the Monsters for additional score. After all the Dots are gobbled up, the screen is cleared, and PAC-MAN continues for another round. Each rack features a special Fruit Target in the maze, which if eaten, earns Bonus Points. Players start with three PAC-MEN. An additional PAC-MAN is awarded for 10,000 points.

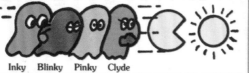

PAC-MAN REMAINING

HIGH SCORE — Retained and displayed daily.

PLAYERS' SCORE

DOTS — 10 Points Each.

POWER CAPSULE — 50 Points Each.

GHOST MONSTERS

PAC-MAN — The 'main' man.

ESCAPE 'Warp' TUNNEL — Out one side– reappear on other.

BONUS FRUIT TARGET — Appear below Monster's Den twice during each rack.

NUMBER OF SCREENS CLEARED — Fruit indicates how many times player has cleared the screen of dots.

Screen cleared once.
Screen cleared twice.
Screen cleared 3 times.
? Screen cleared 4 times.
? Screen cleared 5 times.
— etc. —

SCORE BIG ON THE COUNTERATTACK

1 Quick, eat the flashing Power Capsule.

Inky Blinky Pinky Clyde

2 When the PAC-MAN powers up, the Monsters start to run away.

3 Points double for each Monster caught.

1600 800 400 200

BONUS POINT FRUIT TARGETS!

The player is awarded extra Bonus Points for eating the Fruit Targets that appear in the maze.

100 Points

300 Points

500 Points

Or up to a maximum of 5,000 Bonus Points.

PAC-MAN is available in 3 Midway models: New Mini-Myte, Cocktail Table and Standard Arcade.

HEIGHT	WIDTH	DEPTH
58½″ 149 cm	19½″ 49.5 cm	24″ 61 cm
29″ 74 cm	32″ 81.25 cm	22″ 56 cm
73″ 185.5 cm	26½″ 67.25 cm	34″ 86.25 cm

MIDWAY MFG. CO.

A BALLY COMPANY
10750 West Grand Avenue
Franklin Park, Illinois 60131
Phone: (312) 451-1360
For service information—call toll free 800-323-7182

DISTRIBUTED BY:

Printed in U.S.A.

Oftentimes, if a game's appeal was uncertain, Midway would hedge its bets and produce 300-400 cabinets. If the early reception from those proved strong, a larger run would be manufactured. Testing also served as an important feedback loop for games not yet in production. Prototype cabinets would be placed in locations to glean feedback or insights that could be used to tweak or improve a game outside of the bubble of the game's developers. Midway even owned a storefront arcade, called Game Town, in the Chicago suburb of Crystal Lake. Jim Jarocki said that their teams were always seeking insights. "You observe the players, you interview the players," he said. "It wasn't scientific. It was mostly just face-to-face interviews. 'Well, what did you like? What didn't you like?'"

One of the first test cabinets was reportedly placed at Mother's Pinball in Mt. Prospect, Illinois, a popular suburban arcade well-known as an industry test location used by many video game companies.[123] While opinions were mixed on how the game would be received by audiences, initial results were strong enough to allow Midway to forge ahead. The newly re-christened *Pac-Man* was officially released in the U.S. in October of 1980. Midway's release called the game a "labyrinth of fun and amusement," and Stan Jarocki described it to the press this way: "*Pac-Man* is not only sensational, it's 'amazing!' It's a unique, full-color video attraction for one or two players that tickles vision and is a stimulating challenge to reflexes. Adding to the fun are musical refrains, chomping and action sounds, along with amusing cartoon shows between racks."[124]

Buoyed by strong word-of-mouth with players and industry insiders, the game emerged as a nearly instant, organic success. It was featured at the November AMOA Expo trade show in Chicago, an important industry show that let coin-op manufacturers show off their newest releases. The game was already generating positive industry buzz in trade magazines that same month. A note in *Cash Box*'s regular industry column, "Chicago Chatter," in January, said: "A tremendous seller at Empire Dist. Inc. is Midway's 'Pac-Man' which, at this point, seems to be breaking all existing sales records for a video game, according to the distrib's John Neville."[125] By February of 1981, video game distributors were already dubbing *Pac-Man* a "hit game."[126] Stan Jarocki said that sales were getting "stronger every week," and that Midway still "haven't even scratched the surface" of the game's sales potential.[127]

Midway released three different styles of *Pac-Man* arcade cabinets, diverging from the pair of games that Namco released in Japan. The game's U.S. marketing materials touted a full-size upright cabinet; a shorter, woodgrain-style "cabaret" version (the so-called *Pac-Man* "Mini-Myte", "a lowprofile unit with great profit potential," stated Stan Jarocki); and the sit-down-style cocktail cabinet.

Each varied in style and design from the Namco versions. The Namco cocktail cabinet had metal legs and feet, and its screen orientation meant that players would sit across from each other on the longer sides, with the joystick controller positioned below the screen, outward at lap level. Oddly enough, the joystick was designed to stick out horizontally from the cabinet, parallel to the floor. Midway's version of the cocktail cabinet, meanwhile, had more faux woodgrain and surfaces that reached all the way to the floor. Its joystick controllers sat at the shorter ends of the cabinet, installed on a small ledge that allowed players to rest their wrists there.

Midway manufactured an initial run of 5,000 games[128], which fed the initial flames of interest that continued to burn hot. That fall, operators surveyed said that *Pac-Man* rated as one of their biggest sellers and included it in lists of their highest-earning products.[129]

The Media's Growing Appetite

While *Pac-Man*'s legend was growing beyond arcades, the game still was relatively unknown to the mainstream media. Newspaper articles trickled in as reporters struggled to describe the environment—and the gameplay—of these new games. One article explained, "In *Pac-Man*, a yellow munching ball is moved around a maze to swallow up lined dots while evading a pack of roving munchers, capable of chomping the good guy."[130] Another described a 20-year-old college student "deftly guiding a round, yellow video ball with eyes around a dot-lined labyrinth, continually chased by three other balls."[131]

But even if the details were hazy, one thing was clear: playing *Pac-Man* was morphing from fad to mania. One news report intoned, "Video game fanatics, from kids to businessmen, are packing into the nation's arcades to play *Pac-Man*. It's the latest electronic toy, already more popular than *Space Invaders* or *Missile Command*. Pac-Man is a little, round yellow fellow with a big mouth."[132]

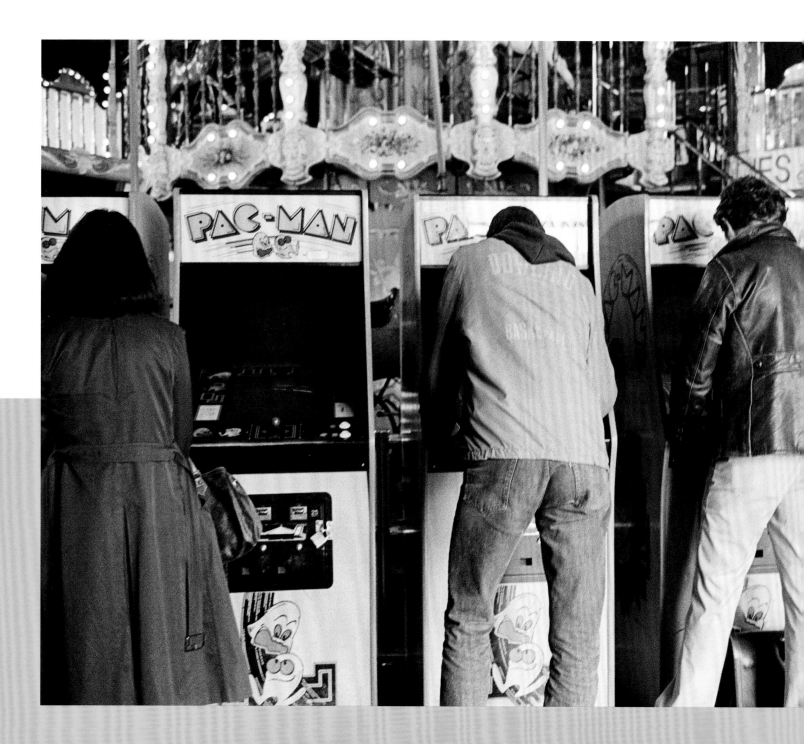

Players began flocking to the game's simple premise and were hooked by the difficulty in mastering it. Its approachable play and whimsical theme attracted both video game veterans and new players. Lines formed behind cabinets in arcades around the country. Location owners bought multiple machines to fulfill demand. The bright, canary-colored cabinets began infiltrating daily life outside of amusement centers, as they started appearing in corner stores, malls, and restaurants. International pop star Cher reportedly owned a *Pac-Man* cabinet, and had it written into her contract that she'd have a machine installed in her dressing room when she performed at Caesar's Palace in Las Vegas.[133] A *Pac-Man* cabinet was installed in the locker room of an international women's tennis tournament hosted in Chicago, and it was a big hit with players there in their downtime.[134] (Apparently it was difficult to stop athletes from competing at *something*.) The unprecedented adoption of *Pac-Man* by this much larger audience was a complete surprise. Midway seemed to have a hit on its hands. The company ramped up manufacturing, trying to meet the ballooning demand.

"I admire Pac-Man a lot. I think it's proved that you don't have to be lost in space to have a good time."

Dona Bailey, Atari Game designer

Even other video game programmers professed their admiration for the game. Atari programmer Dona Bailey, co-creator of the hit arcade game *Centipede*, appreciated the simplicity and approachability of *Pac-Man*: "I admire it a lot. I think it's proved that you don't have to be lost in space to have a good time." She also believed that the simple controls—rather than a slew of buttons—were the key to the game's acceptance with women. "I won't play buttons. I just don't think it's worth the trouble. I know plenty of other women who feel that way, too."[135]

TV reports, newspaper articles, and talking heads also used *Pac-Man* to discuss the emerging "video craze" that had germinated among teenagers and young people, and was suddenly noticeable to the world at large. Some pundits and news programs decried the fad, warning of the potential "anti-social" behaviors of solo game playing. In a review of a popular book on video games, one columnist shared his cranky opinion on their surge in popularity: "There is no defense against this latest assault on rational human behavior, this plague of shopping centers and convenience stores that now threatens to turn a man's home from his castle into a power company substation. There is nowhere one can hide from the incessant beeping, which already has rendered large portions of most metropolitan airports uninhabitable to all but the deaf or insensitive."[136] Teenager Nicole Baily was depicted as something of a *Pac-Man* addict in a news article, her obsession with the game portrayed as something akin to a drug habit. She told a reporter, "You can tell I'm really into it because I'll have one hand on the lever and one hand on the machine and somebody can be calling my name and I don't even hear them." She continued: "Hopefully when school starts, one of the stores around my high school will have it. If they don't, I'll request it. I *have* to have it."[137] A CBS News TV reporter commented, "Psychologists remind us that every younger generation has to have something to scare adults. Right now, all of this is certainly it."[138]

Not only was *Pac-Man* a growing success, but it also transformed the video game industry in several ways. It broadened the appeal of arcade games and dragged video game experiences out of an existence in dark arcades and smoky pool halls.

Players congregate at a row of *Pac-Man* machines near the carousel at Pier 39 at Fisherman's Wharf in San Francisco, CA, 1981.

Soon, video games (with *Pac-Man* as the bellwether) found their way into places that were not previously welcoming to the electronic sights and sounds of the blossoming medium—corner stores, restaurants, community centers, grocery stores, and more. A local dentist in Doylestown, Pennsylvania, reportedly "accomplished the near-impossible" by making his office a "popular attraction for children" after he installed a *Pac-Man* cabinet in his waiting room. "Patients who were usually reticent about visiting the dentist are literally flocking in, with or without toothaches—or appointments, in many cases," wrote *The Intelligencer*. "And it's not only the kids who love the machine," the dentist is quoted as saying, in the same article. "The parents love it too. They can play the machine while they wait for their appointments rather than read a magazine or watch television."[139] This type of exposure and press for the video game phenomenon, inquisitive and positive in tone, benefitted video games as a whole.

But what was it about *Pac-Man* that captured such attention, transforming it from passing trend to an arcade staple? The game's play began in a less frenetic manner, allowing the challenge to ramp up in a reasonable way. Its underlying structure allowed players to create—and understand—its consistent patterns. The game goal remained constant and clear—240 dots to eat on each level—with a clear way to accomplish the feat. But beneath the simplicity, the game held levels of complexity. Different modes of play unfold and swap during the game—chase or be chased, avoid or be aggressive. Follow dots or diverge for bonuses. Fight or flight. All of those activities could happen under the glowing marquee of a *Pac-Man* arcade game, and the moment-by-moment diversity of gameplay kept the challenge both fresh and rewarding.

The House That Pac Built

The symphony of millions of quarters dropping into coin slots across the country could almost be heard in Franklin Park, IL, just outside of Chicago. Midway was headquartered there, the nerve center for the company and a flurry of activity during the rise of *Pac-Man*. Midway's factory brimmed with new orders shipping out in short order. Demand for the game was so great that at its new Bensenville plant, Bally had workers running three shifts to keep up with orders, ramping up production from 350 cabinets daily[140] to nearly 1,200 games in a day.[141] Midway had so many standing orders for the arcade games that the company had vehicles parked and waiting inside the back of the factory, so that workers could just load games directly off the assembly line and onto the trucks going out for delivery.[142] At the peak of production, about 8,000 cabinets shipped in a month, and 96,000 games left the plant between 1980 and 1981."[143] In comparison, a more typical "hit" arcade game would sell between 8,000 and 10,000 cabinets during its entire lifespan. *Pac-Man* obliterated the standard expectations for what constituted arcade coin-op success.

Inside the halls of Midway and Bally, *Pac-Man*'s performance was a surprise to everyone—even those who had played the game. "We liked *Pac-Man*," said game designer George Gomez. "We were playing the heck out of it, you know? But I don't think anybody knew that we were going to make as many as we made." Bally art director Greg Freres was taken aback at the scale of *Pac-Man*'s success. "*Pac-Man* was the golden goose!" Freres said. "To go in the factory back then, to see all those games lined up! It's one thing to see pinball games lined up, but just the sheer volume they were cranking out of that factory!" At the peak of production, a *Pac-Man* cabinet could be assembled in 40 minutes,[144] and they sailed through the manufacturing line.

While the color *du jour* was clearly *Pac-Man* yellow, Midway's favorite shade might have been green. Revenues from both video game and pinball sales jumped by 90% from $229 million in 1980 to $435 million in 1982, and Bally's net income increased 72% to reach an all-time high of $91 million in 1982.

The groundbreaking ceremony for Bally Midway's new, multi-story office building in Franklin Park, Illinois, February 18th, 1982. From left to right: vice president Jack Hartman, Stan Jarocki, the mayor of Franklin Park Jack Williams, Midway president Dave Marofske, and Paul Vesper, vice president of Marketing for Bally Midway.

Video game sales—specifically *Pac-Man* and *Ms. Pac-Man*—were a huge part of that.[145] In 1981, *Pac-Man* arcade sales totaled nearly $200 million,[146] and according to figures reported by the *Chicago Tribune*, Bally's profits nearly tripled from 1978 to 1982, while revenues quadrupled to $1.29 billion during that five-year period."[147]

"I guess we could have made more," said Tom Nieman, Bally's VP of marketing. "But we made a lot! Everyone was really happy." Nieman said that the company made more than $500 million in sales based on the *Pac-Man* family of games. "That made us heroes of the corporation! We threw some incredible parties celebrating this. But we were all young and dumb! We had a great run. A great time." In no small boast, Stan Jarocki told *Time* magazine, "I think we have the Mickey Mouse of the 1980s."[148]

Namco management was also undoubtedly appreciative of *Pac-Man*'s warm welcome in the West, as the proud parent company shared the income from *Pac-Man* arcade game sales and licensing royalties 50-50.[149] The windfall from the partnership between Namco and Midway was apparently so strong that Bally purchased a small equity interest in Namco in 1982. Bally president Robert Mullane said the move "continues and strengthens Bally's long-standing association with Mr. Masaya Nakamura, president of Namco, Ltd., and his organization."[150]

In Japan, the *Pac-Man* royalty stream that was trickling back to Namco's coffers would become a flood, helping to usher the Japanese company into a new era. It not only led to record profits, but helped the company grow significantly. The profits provided the funds for new hires, new ideas, and another wave of fresh, unique games. Namco game audio designer Toshio Kai recalled, "The copyright fee came in, and we started to hire new employees, and those people got together and started making *Dig Dug* and other things. A lot of fresh, vigorous guys came in and I thought, 'Oh, things are changing.' Things changed a lot between 1982-1983 and the next 10 years."

Pac-Man's success didn't just expand the video game industry—it also changed Midway. The company was literally not big enough to handle the gigantic success of *Pac-Man*. Without access to today's modern supply chains and overseas manufacturing partners, Midway had to grow itself—more offices, greater production capacity, and warehouse space—to handle this meteoric rise. The needs were many, since nearly everything was built in-house. More wave soldering machines to manufacture the PCBs. Additional automatic mount machines for inserting electronic components. Assembly line workers and parts testers. When the *Pac-Man* production lines remained busy beyond expectations, Midway and Bally had to adapt. The company purchased a new warehouse and office space in Franklin Park in 1982. The 169,000 square foot building, built in 1967, had been previously owned by tire maker B.F. Goodrich. Where it once had manufactured tangible, practical *things*, the facility would now create *electronic experiences*—a paradigm shift that would eventually come to power much of the 21st century American economy. The building opened on March 22, 1983, and was quickly nicknamed "the house that Pac built."

Bally also merged its shrinking pinball division with Midway in 1982, forming the Bally Amusement Manufacturing Division. Investor Richard Reddock wrote, "This is an interesting and timely decision. The marketing engineering and production will now all be combined to take advantage of the economics of putting the two companies together."[151] This change was an outward reflection of the reality overtaking the coin-op industry since the late '70s—the demand for pinball had withered, and video was now king. For years Midway had used a tagline on posters, game flyers, and the coin doors of its arcade cabinets. "Video is our game." It had never been more true.

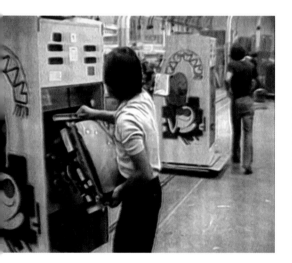

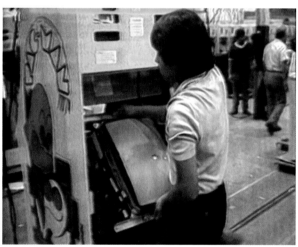

When NBC News visited Midway in March, 1982, production was in full swing. Stan Jarocki told reporters, "Five years ago our company produced around 50-60 machines a day, and today our production is well over 700 or 800 pieces a day."

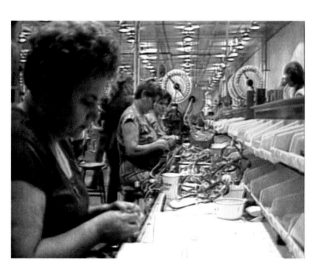

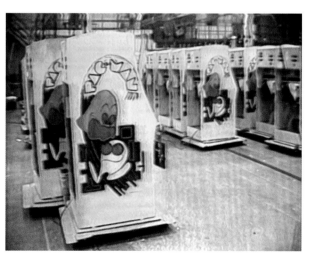

As Midway expanded in the wake of its success, the company had to hire many additional hands. Oftentimes, the fastest and most efficient way to do so (in the pre-internet age) was to hire locally. Prioritizing close connections meant that family members of existing employees got involved. Familiar last names graced the pages of the company's internal newsletter—husbands, wives, fathers, and more—and Midway's culture supported this tight-knit environment. Jim Jarocki, son of Stan Jarocki, was one of those familial hires.

"I had great personnel, on the ground training, hands-on. That's probably what led me to the success at Bally."

Stan Jarocki, Midway director of marketing

An advertising graduate from the University of Illinois, Jarocki began working at Midway after leaving his position as captain in the U.S. Air Force, having been stationed in Germany. Jarocki joined in March of 1982, managing advertising programs in industry magazines like *Cash Box* and *Replay*. He also worked with distributors and operator promotions.[152]

Jarocki also saw Midway's unique role in shepherding *Pac-Man* to greater U.S. as that of a helpful relative. "I think Midway was the foster parent that got the kid to Harvard," he said. "Midway got big. They got to be a billion-dollar company, but they still did it the old-fashioned way. They were playing the right way." Midway had taken a notable hit in Japan and transformed it into a sensation in the United States. But Stan Jarocki, who was instrumental in bringing *Pac-Man* to the U.S., said he rarely dwelled on the success while it was happening. "It was daily life," he said. "Wake up. Pac-Man. Go to bed. Pac-Man."

He also credited those accomplishments to a marketing team that he built, and the lessons learned in his decades at Seeburg and Electra. "Bally never had a marketing team like we had at Midway," he noted. "I had great personnel, on the ground training, hands-on. That's probably what led me to the success at Bally."

Even though parent company Bally was a very profitable, well-established business, *Pac-Man* introduced a kind of success that changed the way it approached games, informing its work in the nascent industry. "I think it changed the mentality of who was our audience, and that had a permanent effect," said Bally VP of marketing Tom Nieman. "I think that it expanded the horizons of what kind of content works, where we kind of had this myopic vision that you had to drive a car or shoot a gun or blow something up. *Pac-Man* just destroyed that paradigm! Basically, you're just delivering a form of entertainment—just like a TV show, just like a movie, just like any form of entertainment. By having a kid drop a quarter or two in, you have to deliver a short story. We had a limited view of what topics were relevant for that story before *Pac-Man*. After *Pac-Man*, it opened up the whole thought process—what could be entertaining for this audience."

SMALL CABINETS, BIG PROFITS

A month shy of *Pac-Man*'s North American launch in October 1980, Midway introduced a new concept. *Space Encounters* (a Midway riff on familiar space war themes) now came in two versions: the regular-sized "upright" cabinet and a smaller design called the "Mini-Myte," tailor-made for locations with limited space.

Measuring 19.5" wide by 24" deep and 58.5" high, the new cabinet was touted by Midway's Stan Jarocki as "a low profile unit with great profit potential" in *Cash Box* magazine (September 27, 1980). "With the installation of a Mini-Myte an otherwise vacant space becomes an income-producing area," he said. Location owners were told to expect to see more Mini-Myte versions of Midway games—and they delivered, as the *Pac-Man* Mini-Myte launched at the same time as the cocktail and upright versions.

Midway wasn't the only company toying with the idea of downsizing arcade machines to make them more attractive to smaller venues and those outside the traditional coin-operated haunts. These shrunken arcade games—sometimes called "cabaret-style" cabinets—were one more way that manufacturers tried to broaden their customer base, squeezing games into new places.

The 1979 hit game *Space Invaders* received a similar treatment from Taito America, re-launched in February 1981 as a "Trimline" cabinet. "It's maximum fun and profit per square foot!," a Taito advertisement read. "It's the go-anywhere, played-everywhere video from Taito." And Atari launched its own cabaret cabinets in November 1980, with *Battlezone* serving as its first title. "Floor space investment is less than four square feet," an Atari representative told *Cash Box*.

"Its smaller dimensions (54.24 high, 20.44 wide and 23.75 deep) and sophisticated appearance make it perfect for lounges, retail stores, convenience stores and restaurants, anywhere space is limited."

These smaller-profile cabinets emerged at the cusp of the arcade boom, showcasing an industry bent on diversifying their market penetration outside of traditional avenues. Also, these reduced-size cabinets were often designed in a different style. Many of them removed bold, colorful graphics, replacing them with "upscale" wood veneers or other, more "tasteful" imagery that could better fit into fancier restaurants or corporate environments. In fact, the legacy of these diminutive cabinets continues to this day. Smaller video game machines have become a popular consumer product, letting video game fans utilize space in their basements, spare rooms, and attics—to finally bring the arcade experience down to size.

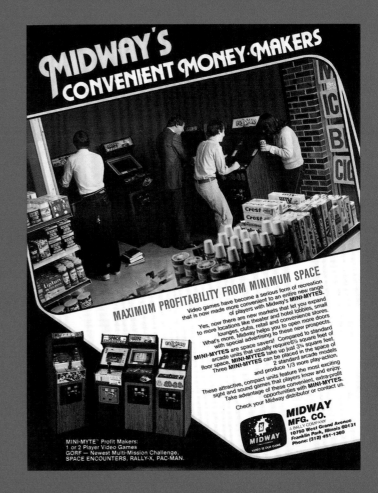

Two flyers for Midway's new "market openers." Hopes were high for these machines, but the market largely favored the upright arcade cabinets.

INTRODUCING **MIDWAY'S NEW**

mini myte™ VIDEO GAMES
SERIES

26½"

34"

STANDARD ARCADE MODEL

MINI-MYTE MODEL

73"

58½"

24"

19¼"

New SPACE SAVERS!

Just 3¼ sq. ft. of floor space – that's all these MINI-MYTES require. Ideal for locations where space is llimited.

New PROFIT MAKERS!

3 games in the space of 2 standard arcade models means 1/3 more play-action and profits with popular, exciting Midway games.

New MARKET OPENERS!

Now...expand to more locations and an entire new range of players!

Compact, attractive MINI-MYTE units are perfect for theater and hotel lobbies, restaurants, retail stores, lounges, clubs, waiting rooms, transportation centers—just about anywhere to entertain customers during waiting time.

SPACE ENCOUNTERS First of the MINI-MYTE Series!

A proved sure-fire attraction! Exciting space battle with a challenge that intrigues players. The mission is to guide an Assault Ship and score points destroying alien space ships, dodging enemy fire and avoiding contact with Space Channel walls. Requires skill, agility and concentration.

MIDWAY
MFG. CO.
A BALLY COMPANY
10750 West Grand Ave.
Franklin Park, IL 60131
Phone: (312) 451-1360

Colors on screen mechanically reproduced.

Growing the Pac-Man Frontier

Pac-Man's popularity was also felt within the walls of Bally/Midway. After moving into its larger headquarters, the company opened a mini-mart for employees there. Workers could shop an array of discounted Pac-Man merchandise there, and the mart also included other employee services like film developing and a ticket counter for local attractions like the Brookfield Zoo, the Six Flags Great America theme park, and theaters.[153]

And Midway wasn't finished using its own subsidiaries to install *Pac-Man* in a host of other venues. *Pac-Man* became a fixture in theme parks, when Midway's parent company, Bally, purchased the Six Flags corporation's six theme parks, two wax museums, and 40 "electronic game amusement centers" in 1981. They also acquired the Great America theme park in nearby Chicago suburb, Gurnee, from the Marriott Corporation.[154] These acquisitions showcased the economic might and diversification strategy of Bally, buoyed by the success of *Pac-Man*, *Ms. Pac-Man*, and the growth of Bally's slot machine manufacturing business. But it also signaled the company's intention to use an early form of brand synergy to capitalize on the popularity of the Pac-Man family of characters.

In 1974, Bally purchased Aladdin's Castle, a chain of family-focused arcades in malls and shopping centers—which, at its peak, grew to nearly 450 locations. As Pac-Man fever expanded, the company experimented with converting some of locations to a new format centered around Pac-Man. The company also opened "Pac-Man Palace" restaurants in Michigan and Indiana, which included a "limited fast-food menu" and a selection of Pac-Man games—*Pac-Man*, *Ms. Pac-Man*, *Mr. and Mrs. Pac-Man*, and more.

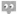

Midway's very own Mini Mart, offering Pac-Man merchandise to employees, part of the new Franklin Park offices that opened in 1982.

The Six Flags Over Georgia theme park in Atlanta introduced a "Pac-Man Play Fort" attraction to its site, a $1 million addition to the 331-acre park, envisioned by famed theme park designer Jack Pentes—with children specifically in mind. A park restaurant also showed Pac-Man cartoons and a live "Pac-Man Magic Show" was performed daily by Pac-Man and Ms. Pac-Man in a theater near the Fort.[155] The live versions of Pac-Man and Ms. Pac-Man didn't last particularly long, as pop culture eventually moved on, and the white-hot popularity of Pac-Man cooled. The theme parks also represented an overreach by Bally, as the company was eventually stretched too thin to succeed on so many fronts, leading to later financial troubles. Bally sold the Six Flags corporation for $600 million in 1987, and sold its pinball division to WMS Industries (Williams) in 1989.

A magician talks with a (somewhat) familiar yellow character as part of the "Pac-Man Magic Show" at the Six Flags Over Mid-America theme park in St. Louis, Missouri. After Midway parent company Bally purchased the theme park chain, it installed Pac-Man-themed attractions and games to build greater brand awareness.

Pac-Man was an essential part of many Six Flags theme park promotions, including this mention of the brand-new Pac-Man Land opening in the Texas park in 1983.

The world outside of video games also took notice. Pac-Man's adopted home city of Chicago declared October 19, 1981 "Bally Manufacturing Corporation Day." That same day, Bally president Robert Mullane presented mayor Jane Byrne with a *Pac-Man* cocktail-style arcade cabinet.[156] Ironic, considering that just a few years earlier, the company's chief product—pinball—could not be operated legally within the city.

Pac-Man (and his erstwhile "owners") became something like local royalty, invited to public events and promotions in the city. Chicago celebrated its 150th birthday on September 12, 1983, and Ms. Pac-Man and Pac-Man themselves (or, at least, costumed Midway employees) joined celebrities and dignitaries in celebrating the city's sesquicentennial, even presenting the city with a cake that exclaimed that Chicago was "Pac-Man's Kind of Town." Large, blue Pac-Man buttons were also distributed to the crowd, and the cake was planned to be donated to the Chicago Historical Society to be "plasticized" as a permanent artifact from the city's 150th birthday celebration.[157]

Midway's huge leaps underscored the incredible embrace of the Pac-Man brand in the U.S. and the company's ability to capitalize on it. Stan Jarocki had a custom gold ring made for himself, with Pac-Man emblazoned on it. Was it a reminder of the character that shaped their company? A memento of his success? A small glitter of good luck and fortune's capricious smile? Jim Jarocki said that it was just part of his father's big personality. "Stanley liked that stuff," the younger Jarocki recalled. "He wasn't vain about it, but he was a sales and marketing guy. He had the right kind of bounce in his step for stuff like that." The elder Jarocki's Pac-Man ring was made by a local jeweler, with a diamond for Pac-Man's eye, and his black mouth inlaid in the piece. "I gathered up all the old gold I could find, had it all melted down, and they made the ring," he said. "And you could hardly lift your hand off the table with it. I'm only kidding you. It wasn't *that* big."[158]

Bally Midway continued to expand in the '80s, and opened some of its own amusement centers with Pac-Man branding front and center. This Pac-Man Palace opened in Kalamazoo, Michigan, combining a large complement of arcade games and fast food.

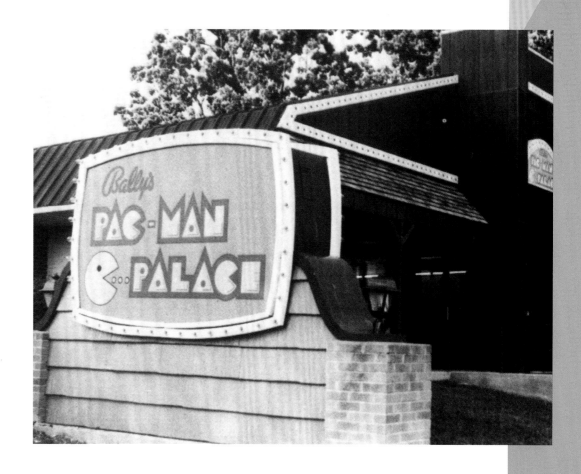

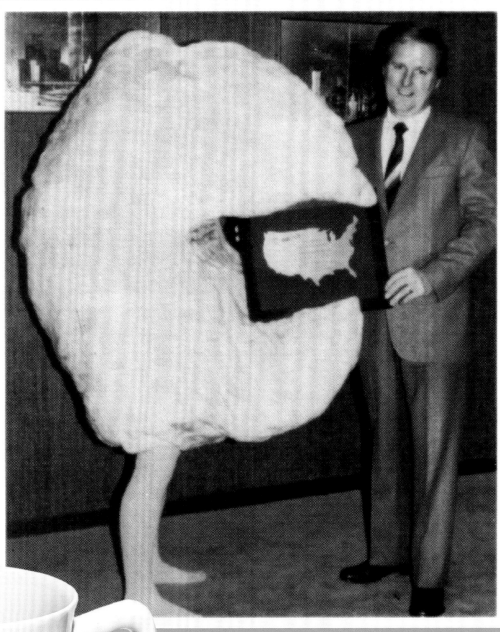

To celebrate one year of production and more than 90,000 games sold, Midway president David Marofske declared October 26, 1981 "Pac-Man Appreciation Day," and invited employees to celebrate during that workday. He also presented commemorative mugs to all members of the Midway team, which read, "I helped make Midway's record breaking *Pac-Man*." The company (via costumed Pac-Man) presented Marofske with a plaque congratulating him on the milestone.

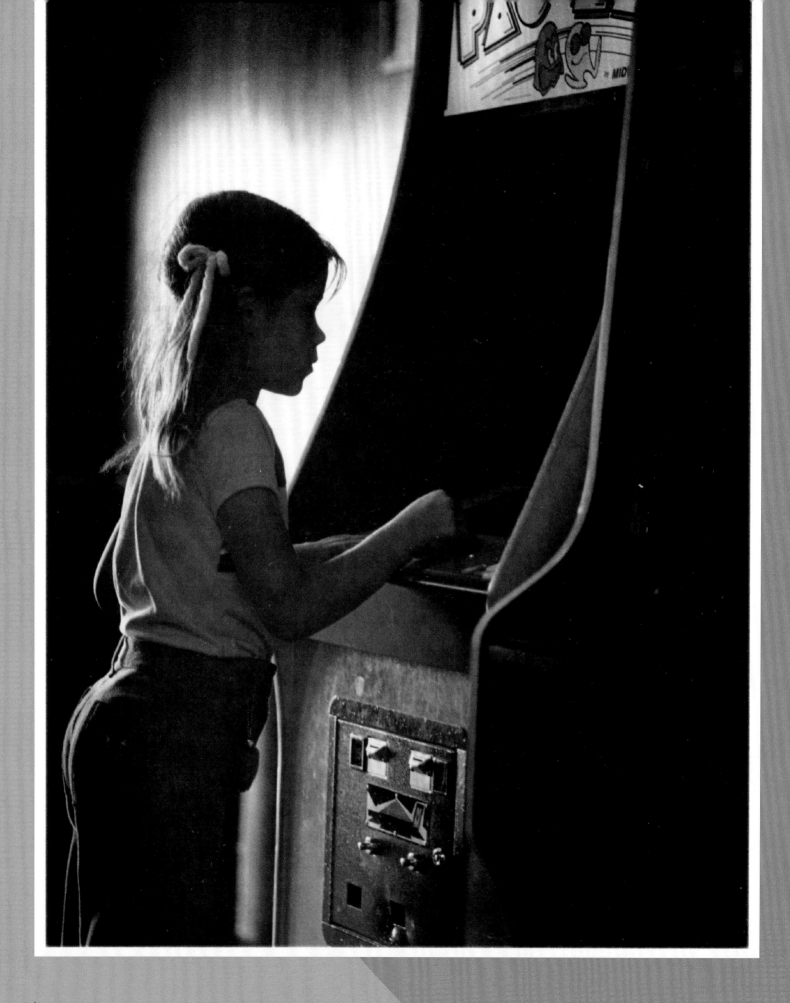

Sisters Are Doin' It For Themselves

One of the most obvious changes to the demographics of video games in the early 1980s was an influx of female players, who were something of a rare sight before the success of *Pac-Man*. A pair of women writers said that the arrival of "women—more than zaps, lights, or electronics—are the signal that the game has become respectable."[159] The statistics (and quarters) didn't lie, and publicly, Midway was very proud of its part in this trend. But occasionally, a hint of sexism and stereotypes escaped as Midway executives and pundits grappled with explaining their game's appeal to women. "Everybody plays *Pac-Man*," said Midway sales director Larry Berke. "This is the first time we've ever had so many females playing a game. I think it's because it's non-violent and non-caloric—they don't get fat eating all those dots."[160]

Many have offered explanations for why *Pac-Man* attracted women in a way that other games had not. Other highly-successful arcade games like *Missile Command* and *Asteroids* raked in the quarters, but they were more aggressive and militaristic, whereas *Pac-Man* was less directly confrontational and the characters cuter and more approachable. Even Pac-Man's adversaries, the ghosts, hardly seem like a threat. Midway's competitors and the entire industry had taken notice. Frank Ballouz, marketing VP of Atari said: "There's no question that games like *Pac-Man* and the cute or comical character games have brought the novice player around. Right now, we're concentrating a great deal of our effort into the ladies as they really seem to be a viable audience."[161]

And these games were soon released—whimsical, character-based affairs like *Lady Bug*, *Frogger*, Namco's *Dig Dug*, and others followed, with notable results. Industry press noted that "a growing number of non-combat, cute-type video games have been fast becoming popular—with Midway's historic *Pac-Man* setting the pace quite a while back. Many of the major factories have released this type of video and the games have generated an expanded player base and have had a particular impact on women players."[162]

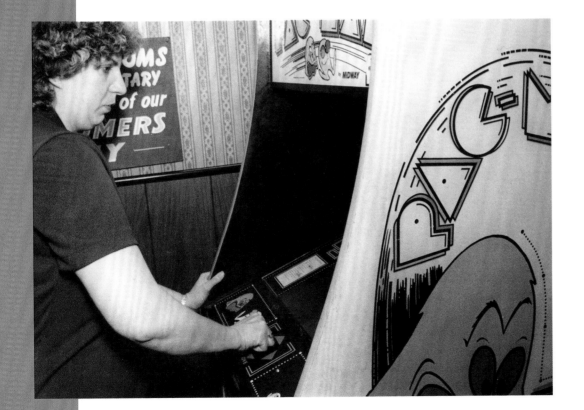

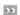

Far left: A young girl plays *Pac-Man* in this undated news photo.

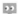

Gloria McCauley plays *Pac-Man* in Chittenango, New York, in 1984.

Even action-oriented themes were paired with cartoon-style graphics and characters, like Atari's *Centipede*: "Using vivid pastel shades and a pastoral theme of insects and mushrooms, *Centipede* attracted female players as well as men, and became [Atari's] second best-selling coin-op, clearing 50,000 units."[163]

Entertainment writer Jeffrey Ressner described the scene in early 1982: "While the average video game player continues to be the under-30 male, these new 'cute' games are attracting an ever-expanding player base comprised of parents, grandparents and even great-grandparents. But perhaps most importantly, these games are attracting more and more female players. In addition, locations that in the past resisted aggressive, explosion-oriented games are beginning to latch onto these cute games in vast numbers: cocktail lounges, supermarkets, hotel lobbies and other areas which traditionally shunned arcade games are now clamoring for them in great numbers."[164]

"I don't think it's a particularly feminine game—it just doesn't repel women."

John Condry, psychology professor at Cornell University

Joyce Worley, the pioneering video game critic and a founding editor of *Electronic Games* magazine, wrote about the rise of women in a male-dominated arcade culture, just as *Ms. Pac-Man* was about to be released: "Liberated ladies are rapidly discovering that electronic gaming is one activity in which the sexes can compete on absolutely even terms. The size and strength advantage which most men possess simply doesn't count here: Dexterity, finesse and quick thinking are the main ingredients of electronic gaming success." She also mentioned *Pac-Man*'s influence and importance in growing the female audience: "No discussion of women as electronic gamers would be complete without a deep bow in the direction of Midway's incomparable *Pac-Man*. The game's record-shattering success derives from its overwhelming popularity among female gamers."[165] Psychiatrists and researchers also had their own ideas about the game's appeal to women. Professor John Condry, a Ph.D. in psychology at Cornell University, was an early student of video games and their effects. "It attracts equal percentages of males and females," he said. "I don't think it's a particularly feminine game—it just doesn't *repel* women. It's hilariously cute! You see, if you build a video game with a fantasy structure that is equally attractive to both the sexes, you get both sexes to play it. That seems to be the case with *Pac-Man*."[166]

The game's appeal wasn't limited to women, though. *Pac-Man* helped make it socially acceptable for older audiences to embrace video game playing. No longer was a video game the sole domain of kids and teenagers. Older, more "grown up" generations also found a way to get their fix a quarter at a time. Men in suits could often be found crowded around arcade machines while on lunch breaks. Acid-washed jeans stood shoulder-to-shoulder with three-piece suits. *Pac-Man* truly was a democratic game, open to all comers. Midway's Stan Jarocki said that in 1982, their demographic studies showed that 42% of players were between 19-34 years old, compared to three years earlier, when 80% of them were aged 13-19 years old.[167] *InfoWorld* columnist Bill Freda provided his take on why *Pac-Man* was so enthralling: "The little Pac-Man creature is hungry; he wants to be fed. Think for a second of a child feeding biscuits to a puppy. Think of the bond that forms between them. Just as the puppy is dependent on his master, so is Pac-Man dependent on the player. Feeding energy dots to Pac-Man is a rewarding experience. Pac-Man is not perceived as an inanimate object, but as a friend in need."[168] [169]

Pac-Man made an impact—not just because it was a fad. Plenty of '80s hits, from jelly bracelets to crimped hairstyles to music videos, have faded into memory. But *Pac-Man* not only captured the zeitgeist of the era, it also popularized a kind of gameplay that seems to transcend the decades. Its simplicity and commitment to fun has weathered changes in technology and style better than many of its contemporaries, making it a legitimate classic.

"It's the reason that certain pieces of art and certain pieces of music are timeless," said Midway game designer George Gomez. "And I think that at the end of the day it sounds stupid, but it's a great, genre-defining game. It's always going to be significant because it's a work of art. It's a tremendous achievement. It appeals to all age groups. It appeals to all genders. It is easy to learn and hard to master, right? It's all of the things that anyone ever wishes a game could be. It's a significant step in the evolution of the genre. Of the medium."

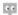

This Midway trade advertisement touted Pac-Man's profitability and earning power, quoting two of the industry's most well-known trade publications.

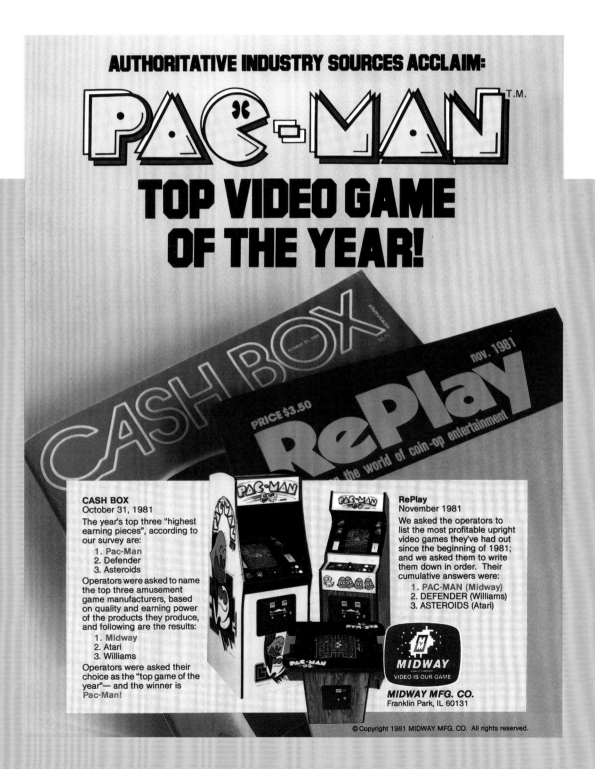

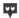

An unnamed Chuck E. Cheese employee poses in front of a row of *Pac-Man* arcade machines in San Mateo, CA, in 1981. His hat and uniform read "Pizza Time Theatre," the franchise's original name. His name tag says "Mongo."

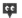

A group of teens crowd around a *Pac-Man* cabinet at an arcade on the Santa Cruz Boardwalk in California, 1981.

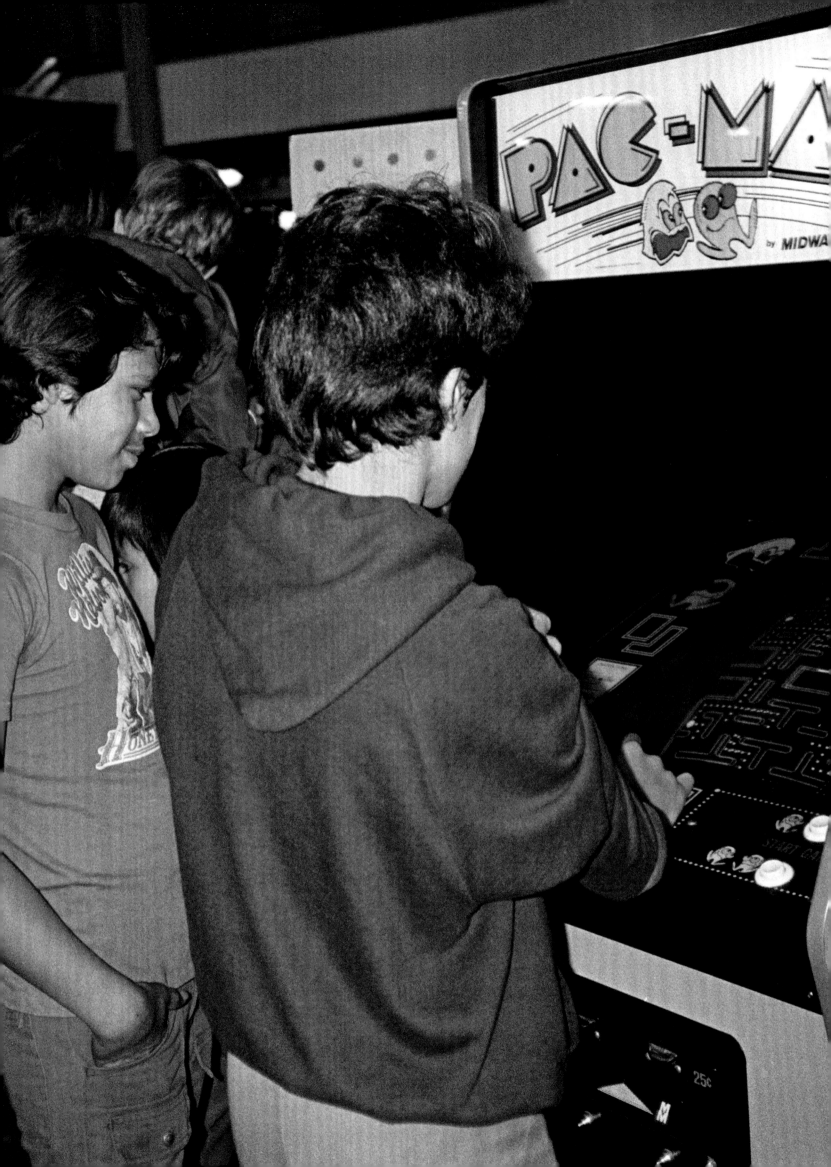

CHAPTER 7

We Are (Pac) Family

僕らはパックマン・ファミリー

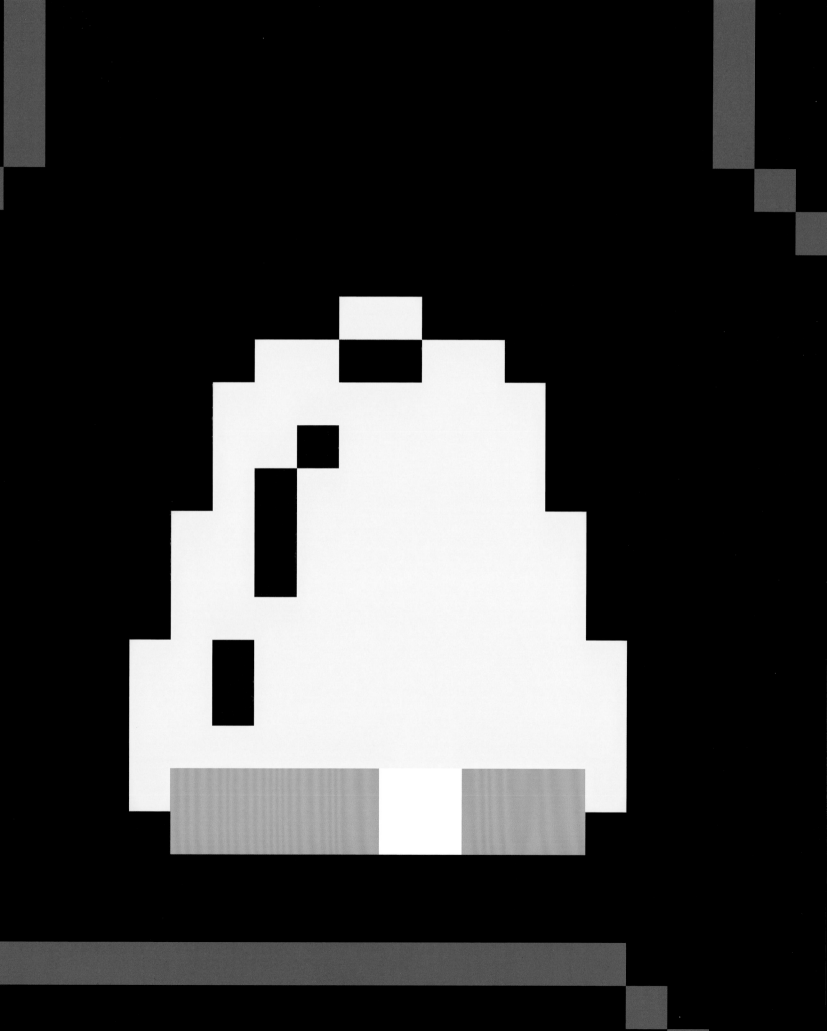

The Kids Are Alright

Namco's *Puck Man* had been a moderate success in Japan, but the game truly hit its stride in the United States, touching off a *Pac-Man* craze that reverberated through the mainstream, well beyond the confines of arcade culture. But this achievement begged the question: what to do for a second act? Namco created the hit game, but the company appeared unsure of how to tackle a sequel, especially since their game was a much bigger hit in another country. Namco took its time developing a follow-up game, with just hints trickling out in news sources. But like the continually hungry Pac-Man, the U.S. market seemed ravenous for more dot munching action—and fast. The first sequel, released nearly two years after *Puck Man*'s Japanese debut, began with the efforts of some savvy engineering students turned entrepreneurs. They capitalized on still-developing video game intellectual property law and teamed with Midway to put their own stamp on Pac-Man and video game history.

Also, Midway confirmed that its own success with *Pac-Man* was no fluke. The company showed that it had a finger on the pulse of U.S. video game players, marshaling its marketing savvy to deliver a game that truly connected with their newfound audience. Incredibly, Midway would also more than duplicate it's previous triumph with *Pac-Man*, showing their own creative perspective on how to follow up their shared megahit.

Kevin Curran and Doug Macrae sat in the office of Stan Jarocki, the VP of marketing at Midway Manufacturing. The pair of 22 year-olds, in suits and ties, made small talk with Jarocki as they waited for last-minute preparations of the game that brought them to Midway. It was October 9, 1981, but the young entrepreneurs were not enjoying the unseasonably warm day in Chicago. Instead, these wunderkind college dropouts were pitching an unusual video game to one of the hottest companies of the moment.

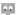

Kevin Curran (left) and Doug Macrae taking a moment during the development of *Super Missile Attack*, with Steve Golson (background).

Hardware lead Steve Golson working at a TRS-80 Model II computer in the middle of *Super Missile Attack* game development in 1981.

Chris Rode mugs for the camera at one of GCC's *Missile Command* cabinets, in the midst of the team's creation of the enhancement kit, *Super Missile Attack*.

The duo came to Midway one day after signing an agreement that ended their three-month court battle with video game giant, Atari, Inc. The lawsuit between Atari and their young company, General Computer Corporation, made waves and headlines in the burgeoning video game industry. Atari had sued GCC for $15 million, claiming that the small, Massachusetts outfit had violated its copyright and trademarks. But now, these young co-founders found themselves taking a meeting with coin-op veteran Stan Jarocki, brimming with confidence after emerging victorious from their legal skirmish with the well-financed Atari.

But that court conflict began brewing four years earlier—in a college dorm room at the Massachusetts Institute of Technology's Cambridge campus. Curran and Macrae met on that same floor of their MacGregor House dorm in the fall of 1977. The pair of engineering undergrads were talented, driven students who happened to connect by sharing adjoining rooms.

The group and their hallmates would pass the time playing an old pinball machine in the dorm. But one night, one of the machine's legs loosened and fell off, sending it crashing to the floor, shattering the playfield and back glass panels. The machine's angry owner vowed never to place another one of his machines in the dorms, which left the group without electromechanical entertainment.

So, in their sophomore year of 1978, Macrae "borrowed" his brother's Gottlieb *Pioneer* pinball game and placed it in the lobby of their MacGregor House dorm. He split the coin revenues with the residence hall, whose funds would go towards parties and social events. The game made money, and Macrae used the proceeds to expand his "coin route" after bringing Kevin Curran on as a 50/50 partner. The two used their profits to buy new arcade and pinball machines, placing them in other residence halls. Eventually, they owned nearly 20 machines in four different dorms on campus, bringing in a sizable income. "We ran it to a point that we could pretty much pay for tuition out of the quarters that were coming in," Macrae said. (MIT tuition was $4,700 per year in 1978.)

Details of the PCB (printed circuit
board) inside a *Pac-Man* cabinet.

Macrae was studying mechanical engineering and computer graphics. Growing up in the affluent town of Short Hills, New Jersey, his early interests in computer graphics were split between classes and projects in both computer aided design and architectural simulations, with his first job at a company called Computervision. He seemingly inherited some of his father's entrepreneurial drive. Donald A. Macrae had both an engineering bachelor's degree and a Harvard MBA, and formed several companies while working in construction, material science, and payroll processing. "He always took on the exciting and challenging parts of the new business, and often brought on a partner or two to complement his strengths," Doug Macrae said. "So, starting a company did not seem daunting to me." But this confidence was more than learning by example. "Some of it came from the brashness of a 20- or 21-year-old and saying, 'Yeah, I can take on the world.' Diving in and giving it a try."

"Let's take a popular, proven game that has player interest, and modify it so that we can bring these people back."

Kevin Curran, GCC programmer

His business partner, Kevin Curran, came to MIT after working on radar display graphics for F-14 fighter jets. Curran had been writing computer code since he was 13, so he came to MIT with a hefty amount of programming experience for those early computing days. Steve Golson, another suite-mate from their dorm, was studying in the earth sciences department. "My interest was in oil exploration geophysics, and that required a tremendous amount of computing," he said. "It was lots of digital signal processing and you were gathering enormous amounts of data, processing them in the computer, and interpreting what you got back."

GCC designed *Ms. Pac-Man* as an enhancement board that could be plugged into any existing *Pac-Man* cabinet. When they made their deal with Midway official, the hardware design remained the same—so all original *Ms. Pac-Man* cabinets contain the same basic configuration as a *Pac-Man* cabinet, ostensibly simplifying the game's production for Midway's manufacturing.

He then took an introductory electronics class at MIT, which fueled his curiosity. But it was a digital design lab Golson took alongside Curran that foreshadowed their future working relationship. "That was my big introduction into how digital electronics worked, and I just ate it up. I just thought this was the coolest thing ever!"

As part of their bevy of arcade games on campus, Macrae and Curran purchased three of Atari's *Missile Command* cabinets, and were amazed at the popularity of the game at its peak. Atari's apocalyptic missile defense game was released in July 1980 and proved to be incredibly popular, selling 20,000 cabinets in its initial run.[170] In it, players seek to prevent waves of ICBMs (intercontinental ballistic missiles) from decimating their planet's cities and bases—by blasting them out of the sky. Despite the player's best efforts, the game invariably ends with computer missile strikes overcoming the defenses and obliterating the player's cities. When the game is over, an ominous headline appears. The words "THE END" emerge from a final mushroom cloud of atomic destruction, a grim finale amidst increasing real-world Cold War tensions.

Curran and Macrae paid $2,500 each for their *Missile Command* games, and were thrilled that each one brought in $650 in the first week. At that rate, they figured to have the machines paid off in short order. But the following week brought a surprise—the overall take in quarters had dropped nearly $200 per machine. The next week the totals dipped even further. The budding entrepreneur operators had a problem. Their game players were getting much better at *Missile Command*, sometimes sitting at the machine for 30 minutes on a single quarter, reducing the duo's profits while monopolizing the machines. Other players just simply craved a different challenge at a time when new games regularly entered the market. By 1981, *Missile Command* had ceded its popularity to a new wave of games, and Macrae and Curran's own machines languished. They decided to do something about it.

Attack of the Missiles

Attacking the problem with the characteristic fervor of MIT engineers, they found it both an intriguing challenge and a practical matter to solve. After their experience operating a video game route between classes and homework, Macrae recalled an eye-opening notion: "We should actually try writing games as opposed to just operating them." Curran built on their growing ideas to improve the games they owned. "I focused very early on the idea of doing an enhancement kit," he said. "Let's take a popular, proven game that has player interest, and modify it so that we can bring these people back. Re-engage them. I thought it would be very useful to come up with new play patterns, new sounds, new graphics, and effectively do version two." The group looked squarely at one game in which they had invested a considerable sum—*Missile Command*.

Planning began in January 1981, and during their spring break that March, the group—now also consisting of Golson, John Tylko, Chris Rode, and Larry Dennison—began in earnest. Curran and Macrae had moved out of their dorm and into a rented house in Brookline, MA. Their shared mission: create an enhancement kit to alter *Missile Command*'s gameplay, refreshing it for fickle players. Just after starting work, Macrae and Curran incorporated as GCC—General Computer Corporation—on March 30, 1981. In an attempt to keep games like *Missile Command* fresh, other companies already sold "speed up kits," offered in the back pages of video game trade magazines or newspaper classifieds. Curran had investigated some, but found that most were relatively unsophisticated, just speeding up or "overclocking" a game's CPU (central processing unit), so that the action happened faster—if it didn't crash the original game code in the process.

Studying video hardware and software at MIT, Macrae and Curran figured they could come up with a better kit, selling it to other operators with issues similar to theirs. Golson, for his part, had proven that he could contribute a strong, working knowledge of hardware design to the growing team—so he became the team's hardware man. From the outset, it was important for Macrae to create a product that would truly also offer something new to players. "You want to understand everything so that you're not just changing constants, but you're writing some new routines that are going to do new things," he said. "We didn't want to just make it harder. We wanted to make it more interesting."

With a hefty $25,000 loan from Macrae's mother, they purchased a GenRad 6502 in-circuit emulator, which enabled them to copy, or "dump," the *Missile Command* machine's code, and analyze it line by line. To maximize the value of this expensive machine, the group worked on it in shifts, all day and throughout the night, nearly 24/7. It was an environment of hard work and fun, and some of them attended fewer and fewer classes as the experiment that was GCC took shape.

They also had foresight and savvy beyond their years in developing their *Missile Command* add-on, taking care to avoid creating anything that could be construed as appropriating Atari's proprietary game code or assets. "We took a step back and tried addressing intellectual property issues, which we felt were very important," said Macrae. "I was taking an intellectual property class at MIT at the time. We saw that if we were to take the code out of *Missile Command*—the Atari code, in fact—and modify it, and then sell that modified code, we'd be breaking copyright law, because we'd be selling their code in addition to ours, without permission. So, the hardware guys—particularly Steve Golson and Kevin Curran—came up with a solution that said, 'What if we overlay our code on top of the Atari code?' The best way to understand that is to picture buying a book from the original publisher, and then someone else creates some notes for the book. It might be an appendix or even overlays that you stick in that give additional information. The important part is, we're not selling the book, we're only selling the appendix." Curran also emphasized this idea and its primacy in their project: "When we sold somebody an enhancement kit, we included our software, but they had to have the original software from Atari—or the thing wouldn't work." This novel technique of switching between their original code and the untouched code of Atari's *Missile Command* was the key to their work, and would soon prove essential in their tussle with Atari.

Their expansion kit, dubbed *Super Missile Attack*, added a UFO with a laser cannon, unique sound effects, and sped up the overall gameplay. The kit, which cost $30 to build, contained a board that would plug into the existing ROM sockets of a *Missile Command* motherboard inside the cabinet, and it sold for $295. While not a small sum for arcade owners, it was far less than the cost of a brand-new machine, which typically ran between $2,500-3,000. The GCC team built the boards in the basement and shipped them out of the living room in May and June of 1981. Curran told an industry video game magazine, "We knew we had a winner when the final release version was first put on a test location in a large college dormitory. *Missile Command* fans were calling fellow fans from all over campus. The kit reduced the million-point player to a quick 50,000-80,000 points."[171]

That spring, rather than graduating, the team focused on fulfilling a deluge of orders that came in. The quality of their work (and the resulting updated game) garnered attention and a significant windfall. They sold roughly 1,000 units, netting them $250,000 in profit. Their engineering savvy had helped the team launch a potentially lucrative business, and had them considering what other popular game to target for upgrades next. It involved a little yellow dot muncher. But just as work began on that new project, *Super Missile Attack* drew the attention of Atari, who filed a lawsuit.

This ad for GCC's *Super Missile Attack* enhancement kit ran in *RePlay* magazine in June of 1981. The advertising, coupled with strong word-of-mouth, netted the team a good deal of cash, as well as the attention of Atari, the makers of *Missile Command*.

explosive profits

MISSILE SUPER ATTACK

It's here! The game enhancement you've been waiting for - SUPER MISSILE ATTACK.™ Designed by General Computer for your Atari MISSILE COMMAND™ Cabinet, it breathes new life into a proven winner.

The simple insertion of a plug-in circuit gives new dimensions to your MISSILE COMMAND™ Game. Increase excitement, difficulty, and your revenues.

SUPER MISSILE ATTACK™ is a software enhancement. All the characteristics that made MISSILE COMMAND™ a champion have been retained or improved.SUPER MISSILE ATTACK™ is a cashbox winner in test locations. Set the operator selectable difficulty levels and make it a winner in yours.

A General Computer Software Enhancement is your best equipment investment today. For about 10% of the price of a new game you can get your original investment in your MISSILE COMMAND™ working hard for you today.

Call 800·343·9500
for immediate delivery or further details.

In Mass. call collect 617·232·9220

General Computer Corp.

161

Tangling With Atari

While ramping up their work on this second enhancement kit, GCC looked to grow. The team moved their operation into a different rented house in nearby Wayland, owned by a professor away on sabbatical. But this shared, rented work/live space was no *Animal House*. "It was laid back," engineer Mike Horowitz recalled. "We weren't crushing beer cans on our heads. It was a pretty nerdy group, though we did have parties and we did drink alcohol. It wasn't unprofessional. Everyone was smart. Everyone wanted to do good work."

MIT student Phil Kaaret was hired in the summer of 1981, and did much of the programming work on the new kit. Mike Horowitz was one of the few original GCC team members who didn't attend MIT. He graduated from Cornell University in 1979 with a degree in industrial engineering, and his first job came as an engineer at Boston-based Computervision.

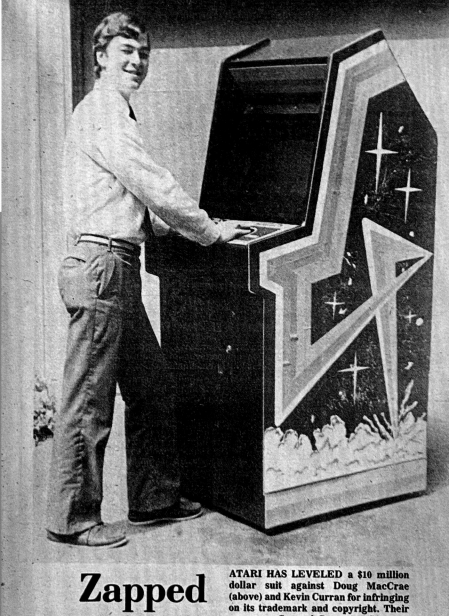

Zapped by Atari

ATARI HAS LEVELED a $10 million dollar suit against Doug MacCrae (above) and Kevin Curran for infringing on its trademark and copyright. Their company, General Computer Corporation in Wayland, has built an overlay circuit that "enhances" Atari's "Missile Command." Story on page 5.

"

The legal tussle between GCC and Atari made both local and national headlines for the Boston-area company. But GCC's young owners were confident in their legal standing and strategies in developing their first enhancement kit. The original caption is also incomplete—Atari actually sued GCC for $5 million, and Curran and Macrae for $5 million each, for a total of $15 million.

Early in his time there, he ended up sharing an office with a young intern named Doug Macrae, and the two struck up a friendship. Even though Macrae returned to MIT that summer, the two kept in touch. But after two years, Horowitz was itching for a different challenge—one that Macrae could potentially provide. "I realized that life in the big corporate thing wasn't really for me," Horowitz said. "It was kind of a shock—that big companies like that are just filled with mediocrity. It's just depressing."

"I saw Doug as a smart, capable, hardworking guy, and I was sort of drawn to that. He [Macrae] said, 'Do you want to come and join us to do games?'" Horowitz decided that he did, and rolled the dice, even though it meant no regular salary at the outset. "I wanted to work for a company where I was not embarrassed to explain what I do," he said. "It didn't have to be fixing the world's ills, but it had to be a net positive. So, making games seemed like a positive thing to add." Rather than a full salary, he would earn 10% of the profits on any game or product he worked on. But after Horowitz gave his notice at Computervision and readied to join, the landscape quickly shifted.

The week before he started at GCC, the lawsuit arrived from Atari, suing GCC for $5 million, and seeking $5 million each from both Macrae and Curran. Horowitz was surprised by his new colleagues' reactions. "'Mike! Mike! Atari sued us! We're not allowed to sell stuff anymore,'" he recalled them saying. "It was kind of a shock to me. But for them, it was exciting."

Doug Macrae also remembered Horowitz's incredulous response to their enthusiasm. "'Bring it on? What are you talking about?! We're being sued! We're going to be put out of business!'" Macrae said. "[Horowitz] took it a little more seriously than we did, I think." While the lawsuit might have shaken GCC's newest employee, he later realized that Macrae and Curran were quite sure of their legal position. "I truly wasn't surprised because Kevin and Doug ooze confidence," Horowitz said. "Especially Doug. I don't think he has ever approached anything where he thought he might lose."

The lawsuit was no surprise. GCC had been planning for the possibility of legal action from Atari, and had taken precautionary steps to protect their project at its inception. A local arcade distributor got wind of Atari's plan to sue, and told the young company. GCC went on the offensive, preemptively suing Atari and forcing a geographic change of venue that moved the legal battle to U.S. District Court in Massachusetts, their home turf. They sought a judgment that *Super Missile Attack* was an original work that didn't infringe on any of Atari's intellectual property. Atari countersued and requested a restraining order. Frank Ballouz, Atari's VP of Coin-Op Marketing, wrote in a statement: "They appear to our customers and to the public as Atari products, creating confusion and siphoning off legitimate returns from our investment in research and development." The game was on.

GCC engaged a young lawyer named Jerry Hosier to handle their case. "The story doesn't work without understanding Jerry Hosier," Curran said. "Jerry was and is a brilliant attorney in intellectual property. We hit it off. He found it to be a very interesting problem, intellectually. You could see the wheels turning in his head. He agreed to work with us, which was important because not everybody would work with a bunch of 20-year-olds out of MIT." Hosier would go on to break legal ground in this case, and made a name for himself in intellectual property law, garnering both success and criticism. In 2000, Forbes declared him the highest-paid lawyer in the country, with an annual income of $40 million. He was also later dubbed the "Babe Ruth of patent trolls."[172]

But back in 1981, he represented this young cadre of tech entrepreneurs as part of his law firm, Hosier, Niro, & Daleiden, Ltd. As the case dragged on, it dawned on Atari leadership that there was a chance they might lose to this scrappy startup.

"Several things started to happen," said Golson. "One, it was bad PR for Atari. If we had just gone away immediately, fine. They win. But we didn't go away. Secondly, our legal position started looking pretty good, and they really did not want a precedent set that it was legal to modify a game. So, it's turning into this painful thing. And the bottom line was that they really liked our kit, and they were impressed by what we had done. They couldn't figure out exactly how it worked and they were thinking, 'Wow, why don't we have these guys working for us?' That's what it came down to."

"Atari said, 'You're renewing the life of a game where we want to sell a brand-new cabinet. You are hurting us badly.'"

Doug Macrae, GCC game and graphics engineer

Atari executives also seemed to tire of having to appear in court across the country, and bosses at its parent company Warner Communications couldn't have appreciated media coverage of the suit as a David and Goliath story, with a multi-billion-dollar company taking on a scrappy band of kids. Atari's legal counsel, Skip Paul, finally sat down with the group and asked, "What do you want out of this?" Steve Golson recalled. And the answer was simple: GCC wanted to make games professionally for Atari. Atari responded by offering the company a lucrative game development contract—a guaranteed payment of $50,000 a month, for two years—totaling nearly $1.25 million. But the development deal didn't require the company to actually produce anything, and Atari had no expectation that GCC would do so. Atari saw this agreement as "go away" money that would get them out of a legal snarl that threatened to set a terrible legal precedent, while also costing them millions in potential lost revenue, bad press, and depressed stock prices.

Atari's lawyers probably figured the young engineers would cash their checks and return to school—or at least spend some extended time on the beach. Instead, GCC took their new development deal seriously, and quickly ramped up to start making video games for Atari. But before finalizing the Atari deal, GCC requested that some specific language be added to their contract. They were in the process of wrapping work on their enhancement kit for *Pac-Man*, and the team didn't want those months of work to be in vain.

GCC had made almost $250,000 on *Super Missile Attack*, and the install base of *Pac-Man* was potentially three or four times larger than that of *Missile Command*. They saw a potential $1 million payday on the horizon if they could find a way to legally produce the kit. "Atari had been very, very firm in saying, 'You realize no manufacturer ever wants to see an enhancement kit out there,'" said Macrae. "In private conversations they were saying, 'You understand that this planned obsolescence is part of our business. You're renewing the life of a game where we want to sell a brand-new cabinet. You are hurting us badly. You're hurting all of the game manufacturers.' So, we knew their position there, but we also had this enhancement kit for *Pac-Man* almost finished, trying to say, 'It's going to be very tough to swallow throwing that in the trash.'"

So, GCC requested that Atari's agreement would allow them to make other enhancement kits—*only* with the prior approval of the original game's manufacturer. Atari agreed to the amendment, but didn't believe any self-respecting game maker would open the door to this possibility. That decision left GCC with only one option, leading them to the offices of Pac-Man's American licensees at Midway.

Visiting Midway

After a flurry of calls to Midway, Kevin Curran was able to get president Dave Marofske on the phone. Curran, full of confidence from the results of the Atari case, asked for a face-to-face meeting to present their *Pac-Man* enhancement kit, now named *Crazy Otto*. But Marofske, aware of GCC and their litigation with Atari, reminded Curran that he was already in hot water for creating enhancement kits for other company's games. Curran pushed back. He recalled dropping a bombshell that had not been made public: "Well, Dave, I want to let you know that we settled our lawsuit with Atari," he told Marofske. "They dropped it with prejudice. And we're now selling the *Super Missile Attack* kits again. I'd like to work with you as opposed to against you, but we are prepared to move forward in either case."

Marofske, already fighting a slew of legal battles with bootleg *Pac-Man* games and unauthorized merchandise, seemed to welcome GCC's direct approach—even though he didn't know how weak Curran's poker hand actually was. An official deal with Midway was GCC's only avenue for their enhancement kit. If Midway demurred, they had no other alternatives, and their months of reverse engineering, programming, and design would be wasted. What the GCC team didn't know was that Midway was nearing the end of their *Pac-Man* production run. The game had sold nearly 100,000 cabinets in the U.S., and there was no sequel waiting in the wings. Namco was working on their own *Pac-Man* follow-up, but it wasn't ready yet, and Midway needed some other substantial games to keep their factory busy after months of record-setting production. Macrae, for his part, applauded Midway's negotiating: "I have to hand it to them—I think they probably played poker very well also. They did not sound desperate to us."

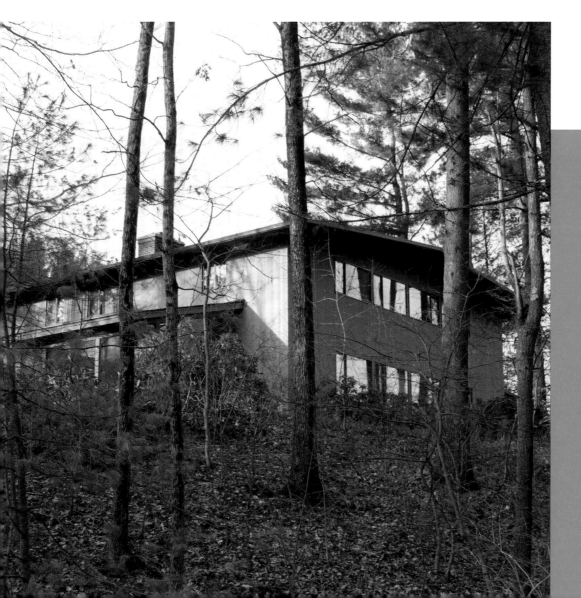

GCC's home office and headquarters in Wayland, Massachusetts, as seen in 2016.

GCC's *Pac-Man* enhancement kit made significant changes to the gameplay of *Pac-Man*. Its code and custom circuit board transformed the titular dot muncher into a character named Otto. Gone was the simple yellow disc of Pac-Man, replaced by a strutting, yellow sprite with long legs and blue eyes. Rather than chasing Blinky, Pinky, Inky, and Clyde, Otto now avoided Mad Dog, Killer, Brute, and Sam—nicknamed Plato, Darwin, Freud, and Newton, respectively. A visual departure from the original *Pac-Man* villains, these four sported dark blue shoes that matched their pupils, antennae, and furry, Muppet-like qualities. The game itself transformed the single *Pac-Man* maze into four different style boards, each with their own moving bonus fruits (cherries, strawberries, oranges, pretzels—Curran's favorite snack—apples, pears, and bananas), shapes, colors, and quirks—including a different number of dots on each screen. (The bonus items in *Pac-Man* originally contained some non-food items, like a *Galaxian* boss, a bell, and a key—inspiration from slot machines.)

All of these changes were tied to the overarching strategies GCC developed while knee-deep in the source code of *Missile Command*. "It became quite apparent to us that *Pac-Man* was the best candidate to work on for our next enhancement kit," Macrae said. "We started asking ourselves the same questions we did on *Super Missile Attack*, to really understand why the coin take had fallen on *Pac-Man*. Similar to *Missile Command*, people were playing there a very, very long time and were getting kind of bored with it. They were getting bored because there was one maze. They were playing a long time—not only because they had gotten good, but because they could learn patterns, and patterns could allow them to play forever—which is exactly what a coin operator did not want."

In development, Mike Horowitz and Phil Kaaret were tasked with altering the ghosts' behavior to better challenge players. It was crucial, Golson said, "to make the monster behavior random so that you could not play patterns anymore. Not just change it. If you changed it but it was still predictable, they'd figure it out. So, you wanted it to be truly random." Their solution was to randomize the ghost's "retreat state behavior," which changed a portion of their actions and made every game different while still ensuring the familiar ghost behavior and personalities remained intact. GCC also removed most of the "breather" moments of *Pac-Man* that Iwatani had introduced, where the ghosts retreat and give players a chance to regroup. The team's broad mandate was to recapture the excitement and challenge that new players felt upon first encountering *Pac-Man*, a novel video game experience that had mesmerized millions. Golson detailed some of the other alterations: "Changing the maze was obvious," he said. "There were [other] *Pac-Man* modification kits that people had come up with which had different mazes—and those were blatant copyright infringements. So, the idea of changing the maze was already thought of. We'd have more than one maze. Moving the bonus around was probably the other really big gameplay change."

The original game graphics (or "sprites") for the Crazy Otto character made use of all four directions he would travel. Otto was designed by Mike Horowitz to appear to run left, right, down, and up, showing his front and backside to the player.

Horowitz, engineer Chris Rode, and graphic artist Patty Goodson all contributed to the design concepts of Crazy Otto. Rode had sketched a hero character with feet and a mouth, and Goodson had named him Otto. While the team had some resources at their disposal, the tools of the era still didn't lend themselves to a streamlined visual design process. "Coming out with a good-looking character more sophisticated than Pac-Man—off of 14x14 pixels with three colors—was not easy," said Doug Macrae. With the design of Crazy Otto, Horowitz tried a more literal approach than what Namco had created in *Pac-Man*. He animated the character to visually look like Otto was climbing forward and backward in space while navigating up and down the maze. "I think [Mike] just felt that rather than a disk sliding around, it made more sense to walk," Macrae said.

Early *Crazy Otto* schematics drawn on yellow legal pads.

9-14

CRAZY OTTO

BREADBOARD DECODER #1

(pin diagram with inputs A3, A4, A5, A6, A7, A8, A9, A10, A11, GND and outputs Vcc, $\overline{P1}$, $\overline{P0}$, $\overline{P5}$, $\overline{P2}$, $\overline{P3}$, $\overline{P4}$, A12, \overline{F}, A13)

$$F = A8 \cdot \overline{P1} \cdot \overline{P2} \cdot \overline{P3} \cdot \overline{P4} \cdot \overline{P5} + P\phi$$

$$P\phi = \text{patch}_{00} + \text{patch}_{01} + \text{patch}_{02} + \dots + \text{patch}_{06}$$

$$\vdots$$

$$P5 = \text{patch}_{50} + \text{patch}_{51} + \dots + \text{patch}_{56}$$

BREADBOARD DECODER #2

(pin diagram with inputs A3, A4, A5, A6, A7, A8, $\overline{F4}$, $\overline{F5}$, $\overline{P2}$, GND and outputs Vcc, RA7, $\overline{P1}$, $\overline{P3}$, RA6, RA5, RA4, PATCH, RA3, $\overline{P3}$)

patch	$\overline{RA8}$	$\overline{RA7}$	$\overline{RA6}$
none	$\overline{A8}$	$\overline{A7}$	$\overline{A6}$
Pϕ	0	0	1
P1	0	0	0
P2	1	1	1
P3	1	1	0
P4	1	0	1
P5	1	0	0

$$\overline{PATCH} = \overline{P\phi} \cdot \overline{P1} \cdot \overline{P2} \cdot \overline{P3} \cdot \overline{P4} \cdot \overline{P5}$$

$$\overline{RA7} = \overline{A7} \cdot \overline{PATCH} + P2 + P3$$

$$\overline{RA6} = \overline{A6} \cdot \overline{PATCH} + P\phi + P2 + P4$$

$$\overline{RA5} = \overline{A5} \cdot \overline{PATCH} + PATCH \cdot$$

$$\overline{RA4} = \overline{A4} \cdot \overline{PATCH} + PATCH \cdot$$

$$\overline{RA3} = \overline{A3} \cdot \overline{PATCH} + PATCH \cdot$$

An early diagram of what would later
become a *Ms. Pac-Man* game maze.

Dealing With Midway

Back at GCC's first meeting with Midway, Steve Golson was busy installing the *Crazy Otto* prototype they brought from Boston. In a windowless conference room, Golson struggled with the hardware. He had plugged the handmade board into the CPU of a *Pac-Man* machine from Midway's production line, but it wasn't working. The game refused to boot up, costing precious, awkward minutes. While Curran and Macrae tried to kill time with Stan Jarocki across the hall, Golson sweated, thinking, "What the hell did I do?! Is there something that I broke?" The team hadn't done extensive testing on regular *Pac-Man* cabinets yet, and this particular prototype had only been completed the day before. Golson worried that something was wrong with their kit, which would not be a good way to kick off their presentation. Eventually, he gave in and asked for a different machine.

Midway techs delivered another *Pac-Man* cabinet from the production line, and with its *Crazy Otto* prototype firmly installed, it started up as planned. Both Marofske and Jarocki liked what they saw of the game, but also wanted a more seasoned player's opinion. They drafted a strong *Pac-Man* player from their manufacturing floor to try it, and he appreciated the challenge of the game.

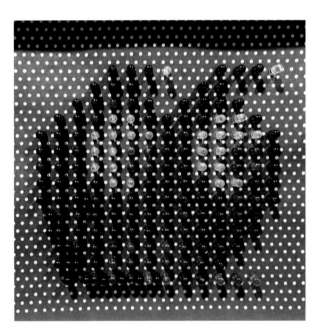

Without sophisticated development image creation tools, the GCC team relied on more low-tech methods to iterate on their character designs. They utilized a children's toy, the Lite Brite, to visualize design concepts. The glowing, colored pegs of the Lite Brite were used to simulate single pixels in a character sprite.

And with that, the GCC team made a handshake deal with Midway to place test cabinets (with the enhancement kits installed) out in local arcades, as soon as the initial hardware was complete. GCC had one *Crazy Otto* placed at Fun & Games Arcade in Framingham, Massachusetts, while Midway sent off a pair to Chicago area locations.

In an odds-defying twist, *Time* magazine reporters were working on a cover story about video games at the same time those three *Crazy Otto* prototypes were out at their testing locations. Photographer Dan McCoy inadvertently captured a picture of *Crazy Otto* (still housed in a *Pac-Man* cabinet) while visiting one of these arcades. The photo—complete with altered characters and maze designs—ran in the Jan 18, 1982 issue of *Time*, undoubtedly confusing many *Pac-Man* fans, since no sequel had been announced yet. *Crazy Otto* would not be seen in public again until after its transformation into a very different game. The source and origin of the *Time* photo flummoxed video game sleuths for decades, until GCC team members began discussing the game's development process in detail publicly in 2010.

Time magazine photographer Dan McCoy inadvertently photographed the unreleased *Crazy Otto* game while the unit was out at a testing location, thinking it was a typical *Pac-Man* machine. The image went to print in the magazine's feature story on video games, which undoubtedly confused video game fans.

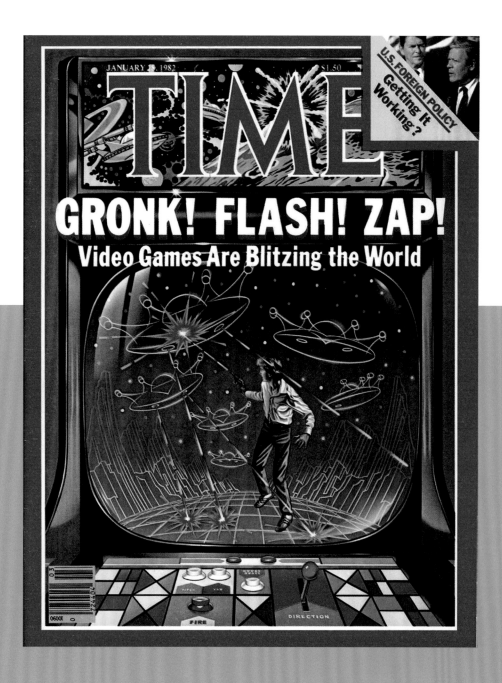

Pac Man scuttles about maze, eating dots

The First Lady

Three weeks after their initial Midway meeting, Curran met with president Dave Marofske for final negotiations in a suite at Chicago's historic Drake Hotel. On October 29, 1981, GCC signed a licensing agreement with Midway for the creation of enhancement kits and the option to produce full-size cabinets, but the details were slightly more complex. Curran noted that the agreement would pay GCC $150,000 up front and an additional royalty for each game sold. While the gameplay itself was mostly complete, *Crazy Otto* still went through some significant changes. After inking the deal with GCC, Midway needed Namco's final approval as it brought the Japanese company into the newly fashioned creative loop.

"Why not make it a game that says thanks to the lady players? Why don't we take the game and call it Ms. Pac-Man or Mrs. Pac-Man?"

Stan Jarocki, Midway director of marketing

GCC provided the impetus of the expansion kit itself, but Stan Jarocki and his Midway team brought their own contributions to the project. Jarocki finally decided that instead of selling it as a kit, Midway would release the game as a full-fledged sequel—with a new character taking center stage. In GCC's original version, Otto encounters a female counterpart during the animated sequences between levels—and in that brief storyline, they meet, fall in love, and a stork delivers a Baby Otto to the couple. Those three animated scenes (Namco nicknamed them "coffee breaks" in *Pac-Man*) ended up being crucial to the development of the character and final game. Unlike *Pac-Man*, the *Crazy Otto* intermissions told a linear story—an early, animated narrative that Mike Horowitz dreamt up during a long drive with his wife, Eileen. The couple were on their way to a friend's wedding, and perhaps impending thoughts of love and matrimony influenced him. But Horowitz claimed no spark of genius. It was "not ground-breaking, and maybe kind of obvious," he confessed. "I was given no direction. We didn't get together as a group and decide that we wanted this as a storyline. It was just 'Mike, go figure this out,' because they were off busy doing their own parts. We trusted each other to take care of what we were assigned to do."

Jarocki came up with the idea of elevating that female Otto (referred to as "Anna" in the game's source code) from love interest to leading lady in the new game—as she eventually became Ms. Pac-Man. His creativity and marketing savvy helped set the game apart from its predecessor, and gave Midway a story-driven hook for another wave of merchandise, sequels, and product tie-ins. He explained his rationale in an unaired television interview: "We wanted to perpetuate the *Pac-Man* trademark—and of course, the copyrighted characters," Jarocki said. "We thought, 'Why not make it a game that says thanks to the lady players? Why don't we take the game and call it *Ms. Pac-Man* or *Mrs. Pac-Man*?' But then someone came along and said, 'Hey, don't you feel that all those macho players out there aren't going to be interested in a game called *Ms. Pac-Man*?' I guess you might have called it a gamble. We put it out on the street and it turned out to be a winner."[173] Once it was settled that the game would center around the female protagonist, GCC got to work ironing out her visual details on screen. With input from both Namco and Midway, Mike Horowitz developed the game graphics and character sprites for *Ms. Pac-Man*. "I just came up with lots of different versions," he said.

His initial take had Ms. Pac-Man sporting long, red hair and a yellow bow—but this version was vetoed by Namco president Masaya Nakamura himself, who probably preferred a look that better harmonized with the spare, minimal design of Pac-Man. Macrae summed up Nakamura's comments: "He said, 'Love the concept, get rid of the hair.'"[174]

Horowitz continued iterating. "I also came up with the version as it is now—with the bow, beauty mark, and a little bit of lipstick," he said. "That was a huge, painstaking effort because there were no tools to do that. If I was to do that today, I would go to my computer and be able to make a very different version in just a few minutes, given the tools we have now." But Horowitz and the team had to rely on lo-fi development tools, including a repurposed Lite-Brite toy—with its colored, plastic pegs representing individual pixels. This allowed them to quickly visualize designs without laboriously programming them. Horowitz himself preferred using graph paper and colored pencils to develop his characters. "Working in the 14x14 [pixel] circle, there wasn't a whole lot you could add or take away," he said. Nonetheless, the team finally landed on designs approved both by Namco and Midway for the eventual game.

There was also another version of *Crazy Otto* crafted by GCC. Just before one of Curran's contract meetings with Dave Marofske, the rest of the team stayed up all night creating a variation that contained four intermission screens—one more than their previous builds. The standard game contained intermission scenes entitled "They Meet," "The Chase," and "Junior," where Otto met his match, fell in love, and had a baby delivered via stork. But this new version added a new third act that explained—somewhat explicitly—how the Baby character was conceived. As Curran headed to leave for his flight to Chicago, the team showed him the new scene. "They had intercourse!" Curran recalled. "When I woke up to go to the airport, they proudly showed me the new cartoon as they pressed the ROMs in my hand—and the third sequence was they had sexual intercourse, before the baby's born. They're like, 'Have a good trip, Kevin!' They did that to wind me up."

Aghast after seeing it, he said, "I hope that is not the version you put in my briefcase." All they gave Curran was a worrisome promise: "Well, you will know when you play it in Chicago," recalled Macrae. No one else ever saw that version. "Yes, we pranked him," said Steve Golson. "That was a one-off hack that Mikey did."

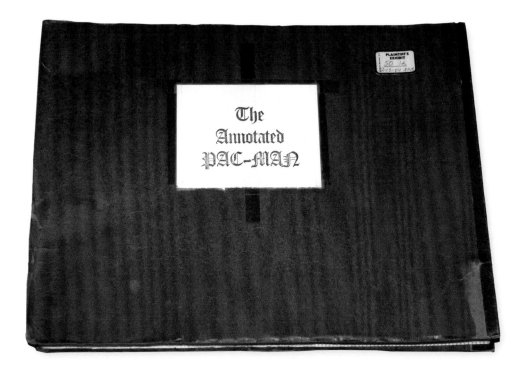

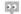

As part of their reverse-engineering efforts, GCC studied the source code of the original *Pac-Man* arcade game. This bound book contained a printed version of the code, which the team reviewed and made handwritten notes upon.

Pages from GCC's annotated Pac-Man source code with handwritten notes that highlight the character's death sequence.

After the actual final edits were made, Stan Jarocki sent a package to Nakamura in Japan on November 24, 1981. The parcel included a videotape of *Ms. Pac-Man* gameplay for final review. The approval process had moved swiftly, since *Crazy Otto* was nearly complete when GCC presented it to Midway, and most of the final pieces were in place barely a month later when Jarocki sent the video to Tokyo.

Because of its unusual development path, *Ms. Pac-Man* has been the subject of rumors and speculation over the years. Some stories have suggested that Midway and GCC launched the game (and subsequent sequels) without Namco's blessing, but that was simply not the case. While the initial *Crazy Otto* kit itself had been developed without a license, it was not marketed or sold until becoming an officially licensed game under Midway's deal with Namco. As per their ongoing agreement, Midway finalized the game in concert with GCC, with high-level representatives from their Japanese partners at Namco weighing in on creative decisions. "We worked under some pretty strict restrictions in the development of everything we did," said Stan Jarocki, "and we did it totally with the approval and blessings of Mr. Nakamura."

What's in A Name?

At its earliest stages, *Crazy Otto* was slated to be called *Super Pac-Man*, serving as a more conventional sequel, with Pac-Man once again headlining the game. (This name would later be used for a completely different game, developed and released by Namco—and licensed by Midway—in August, 1982.) But that initial idea didn't last long. When it came time to finalize the name of the yellow, female character, suggested names included Pac-Woman and Miss Pac-Man. Then Midway proposed Mrs. Pac-Man, since it was deemed improper for an unmarried character to have a baby with Pac-Man. But the wife of GCC developer Mike Horowitz, Ms. Eileen Mullarkey (who had insisted on keeping her own surname after marriage), believed that calling the character a Mrs. was an inappropriate choice. Instead, she proposed that the character—and game—should be called *Ms. Pac-Man*.

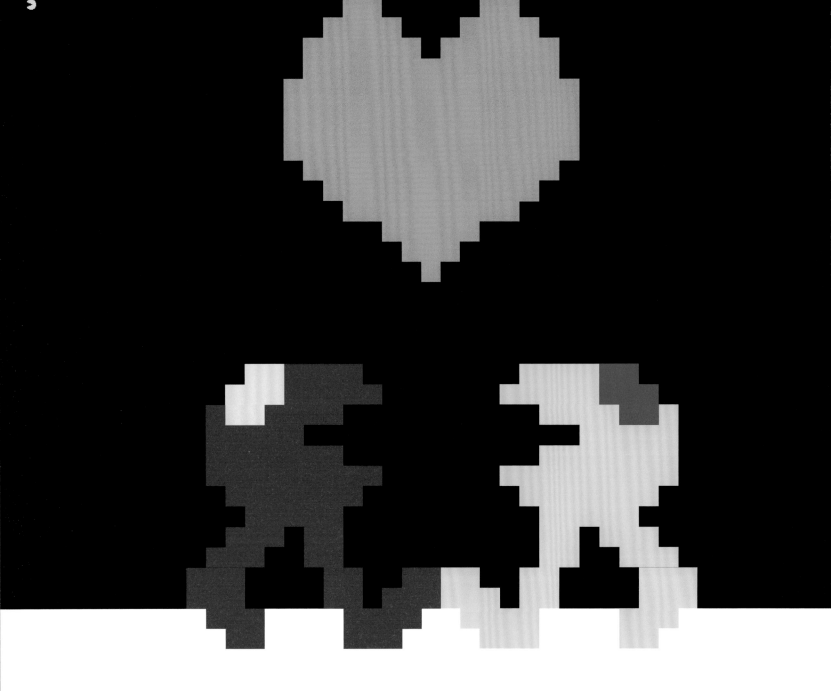

Part of a popular feminist movement of that era, the moniker *Ms.* had emerged in the American cultural discourse—because like the title Mr., it did not suggest a marital status. It gained notoriety after the launch of the influential *Ms.* magazine in 1972, the first issue adopting the usage "as a standard form of address by women who want to be recognized as individuals, rather than being identified by their relationship with a man."

The title also carried connotations of edgy, almost counter-cultural ideas about women's roles and gender. Mullarkey had raised the question of why the title Mrs. was necessary, re-framing the discussion about how the character would be presented. Horowitz said that their opinions just grew out of the surrounding culture. "That was the way we were living our lives," he said. "It just made sense—and most of our friends felt the same way. At that point, it became obvious that [calling it] *Ms. Pac-Man* was the right thing to do—and I think it's actually kind of crucial in its success. I don't think Miss Pac-Man, or Mrs. Pac-Man, or Pac-Woman would have been nearly as successful. She's more than Pac-Man with a bow. It was forward-thinking. She was a feminist. She was her own person."

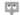

In one of the original "coffee break" animations for *Crazy Otto*, the titular character meets and falls in love with a red, female character, who was referred to as "Anna" in the game's source code. That character ended up taking center stage in the game, later being adapted into Ms. Pac-Man.

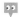

Mike Horowitz's original character designs for Ms. Pac-Man (then called Pac-Woman) sported long red locks and a yellow bow in her hair. Also, these sprites utilized the same four perspectives (views from front, left, right, and back) that he created for Crazy Otto.

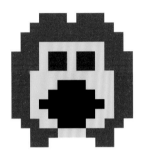 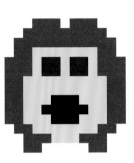

A Glamorous Arrival

Finally, *Ms. Pac-Man* debuted on February 3, 1982 during a press event held at the Sherman Oaks Castle Park game center outside of Los Angeles, amidst its sea of mini-golf courses and Camelot-style decor. Almost immediately, the game became a sequel sensation. Fans loved it for its fresh take on *Pac-Man*, increased challenge, and new character. The new game built on the inherent cuteness of the original, with added allure and a clever bit of storytelling. The game's intermissions revealed the tale of Ms. Pac-Man and her love, Pac-Man. GCC's new gameplay, moving fruits, and unpredictable ghost behavior breathed new life into the Pac-craze. Barely a month later, Jarocki told an industry magazine that the game was "already selling like the original."[175] He also emphasized the look of the new character he helped create: "We glamorized the little yellow, glowing dot on the screen by putting a little ribbon in her hair, and fluttering eyelashes, and ruby red lips, and a Marilyn Monroe beauty mark. Even when she's caught by the monsters, rather than being deflated as Pac-Man is, she sort of goes into a spinning swoon. We thought we had a winner in this particular game."[176]

Ms. Pac-Man became the first video game sequel to eclipse its predecessor—a significant feat, since *Pac-Man* had been the best-selling arcade game of all-time. Midway sold 116,000 *Ms. Pac-Man* cabinets—though Kevin Curran believes the final number was closer to 132,000. Nevertheless, the official number was nearly 20,000 more than *Pac-Man* had sold—and *Ms. Pac-Man* did it in less than a year. (*Pac-Man* needed 21 months to reach its 96,000 sales mark.) GCC was not anticipating sales of that magnitude. Curran felt that selling 30,000 cabinets would have been "a home run." Golson said, "It was so much more than we expected it to be. We thought, 'Oh, if we could get 10% of the install base of *Pac-Man* machines converted over to *Crazy Otto*, or 20%—wow!'" Jim Jarocki, Midway's advertising and sales promotion manager, summed up the company's reaction in the fall of 1982, "We knew *Ms. Pac-Man* would attract more women, but we never dreamed how many. We planned on 20,000 machines; now we have 100,000. The women and men love it."[177]

Incredibly, Midway struck gold a second time while also striking a chord with the coveted female audience. *Pac-Man* proved that women would connect with a less aggressive, more approachable video game, and *Ms. Pac-Man* seemed to be even more tailor-made for female players. The game was not just pandering to a desired demographic, either. It proved even more challenging than the first game, while also championing a strong, positive, female lead character.

The press also found a welcome "human interest" hook in the story of *Ms. Pac-Man*'s release. Midway dubbed her "The new femme fatale of the game world" in its materials, and articles called her "the first lady of video games." In a story titled "Pac-Man meets its match" a *Los Angeles Times* writer began this way: "No man is an island—Adam had Eve, Antony his Cleopatra, Batman his Batwoman, and now the king of the video games, Pac-Man, has a queen, Ms. Pac-Man."[178] She also became a central hub of the nuclear Pac-family, with even greater prominence as a wife and mother, "Pepper," in the *Pac-Man* TV cartoon from Hanna-Barbera.

The attract screen was the first thing Midway saw when GCC presented the enhancement kit to them, October 9, 1981. For trademark reasons GCC avoided using Pac-Man icons and names, picking famous scientists' names for the ghosts.

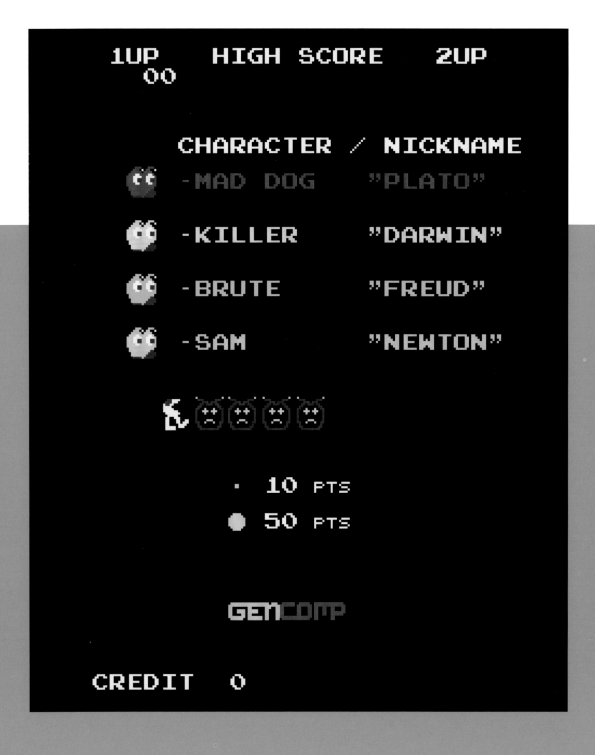

The triumph of *Ms. Pac-Man* worked out well for everyone involved. Midway kept their production lines near capacity, churning out bright blue cabinets festooned with bold pink and yellow graphics. Their assembly line also required very little retooling, since each cabinet basically contained the guts of a *Pac-Man* machine, with an added *Ms. Pac-Man* "daughter board" and new ROM chips. GCC planned to combine all the elements into a single board for the game that would make production simpler, but sales and manufacturing moved at such a rapid pace that the idea was never executed. By November of 1982, Midway was wrapping up its production run of *Ms. Pac-Man*, ready to kick off manufacturing of the first 10,000 cabinets of the Namco-created sequel, *Super Pac-Man*.[179] From nearly 6,000 miles away, Namco was able to observe the proceedings and continue collecting the same royalty bonanza it enjoyed with *Pac-Man*'s U.S. success. Namco received an identical percentage for *Ms. Pac-Man* without expending any additional resources or development time in the game. For its part, GCC coupled their newfound revenue stream with the already-lucrative Atari development deal, and started growing the company in earnest.

"The real innovators here were the guys who did Pac-Man. They made this amazing, amazing game out of nothing."

Mike Horowitz, GCC engineer

But amidst all of the praise for the sequel, Mike Horowitz felt it necessary to acknowledge the original, groundbreaking game. "The real innovators here were the guys who did *Pac-Man*," he said. "They made this amazing, amazing game out of nothing. They did the heavy lifting. We just did some polishing. Ninety-five percent of it is the original *Pac-Man*, and then we added the five percent [to make it] better." Curran also mused that *Ms. Pac-Man*'s success pointed back to the original and "reinforced the vision of the founder and the original developer of *Pac-Man*."

Ms. Pac-Man might have been received as little more than a clever "hack" of *Pac-Man* if not for the branding savvy of Midway's Stan Jarocki. He and Dave Marofske helped sculpt the Pac-Man characters into assets that were ripe for licensing and sequels in the larger world. "They were strong marketing people that looked at it and said, 'Okay, we have to figure out how to make the most out of this property,'" Macrae said. "Remember, Pac-Man started off as a yellow blob eating dots. It was not a Saturday morning cartoon. In the United States, the credit goes partly to Stan and Dave for taking a yellow, pie-shaped thing, marrying it together with a female character, and starting to merchandise it." Their shrewd marketing added dimensions and popularity to the Pac-Man brand that were crucial to the franchise's growth in the decades that followed. The sequel, with its storyline and expanded character set, served as the catalyst for a universe where Ms. Pac-Man, Jr. Pac-Man, Baby Pac-Man, Professor Pac-Man, and others populated new games. This larger family helped turn Ms. Pac-Man and Pac-Man from a pair of video game stars into an iconic pop culture couple.

In the end, Macrae felt it was the combined effort of several different video game makers that made the Pac-Man franchise robust and popular in that era. "What makes the whole Pac-family interesting is the fact that there were four major companies all helping with its direction—that Namco, Midway, Atari, and General Computer all contributed to creating a direction for this character, and it came out better than anybody could have done on their own."

Intriguingly, for all of *Ms. Pac-Man*'s American success, the original game cabinet was never released in Japan.[180] Perhaps its release was limited by the geographic boundaries of Midway's licensing deal. Or maybe equivalent demand didn't exist in Japan, as its game market had seemingly already moved on to other titles and new styles of play. It's also conceivable that the American market was its own sort of unicorn—a rare market already primed for *Ms. Pac-Man* success by a wave of media and merchandising, creating a greater appetite for sequels than anywhere else in the world.

No Copies Accepted

The stratospheric sales of *Ms. Pac-Man* were not just the result of its engaging gameplay. The game also benefited from some clever engineering by GCC, who made it far more difficult to copy (and sell) bootleg cabinets. GCC created a scheme that utilized four custom programmable array logic (PAL) chips, which acted as a failsafe against would-be copiers. The chips would detect any unauthorized copying or "dumping" of the program's code, and would change the decryption algorithm, preventing anyone from reading (and copying) the encrypted program information. They were awarded a patent for this strategy in 1985.

In negotiations, GCC also convinced Midway to pay a licensing fee to utilize this proprietary technology in the *Ms. Pac-Man* and *Jr. Pac-Man* cabinets. "This was part of our idea to make our *Crazy Otto* kit not be cloned and ripped off," said Steve Golson. These protective strategies undoubtedly helped catapult *Ms. Pac-Man* beyond its predecessor's sales, as industry pundits estimated that some popular arcade games could have sold 25-30% more units if it were not for the impact of illicit manufacturing.

The four mazes and animated sequences of the original *Crazy Otto* prototype show a clear way forward to the version of the game that would later be released as the fully licensed and approved *Ms. Pac-Man*.

A close-up view of the *Ms. Pac-Man* "daughter" board that plugged into the interior of every *Ms. Pac-Man* cabinet.

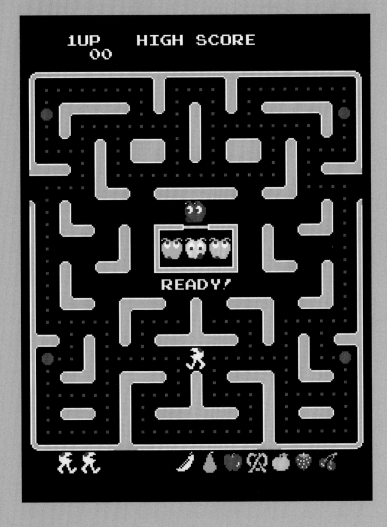

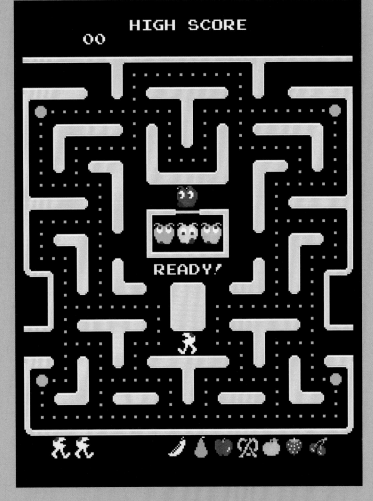

The GCC Spirit

For its part, Midway never acknowledged GCC by name, which wasn't unusual for the video game industry at the time, both in the U.S. and Japan. Many companies subcontracted game design and development to other firms, with no requirement that the relationships be made public. And GCC was happy with that. Unlike their peers at third-party developers like Activision or Imagic, the group was content to stand in the shadows and collect their paychecks. While some high-profile game designers abandoned their corporate masters in pursuit of greater publicity and royalties, GCC never sought the spotlight, shying away from industry notoriety or self-promotion. "The *Ms. Pac-Man* story was hidden away for 30 years and nobody knew it," said Steve Golson. "We were not keen on tooting our horn, because basically we were getting paid. We didn't care. It was kind of amusing to see internet speculation."

A group portrait of the GCC team in August 1983, which had grown substantially since its humble beginnings designing *Super Missile Attack*.

While their Boston location wasn't considered the center of the video game universe, it made perfect sense for GCC and the company's future. Instead of pulling up stakes and moving to Silicon Valley or Chicago, the GCC team was happy to remain in that area, where engineering talent flowed freely from MIT. To Golson, it seemed a natural fit. "This is what MIT students did," he said. "You started up a company and you stayed close. We were already living in Boston. We had our little bubble of people in Cambridge who came out of this MIT philosophy of 'Work hard, solve the engineering problem, get your work done, and maybe we can play later.' It was fun. The joy of solving the difficult problem was a reward in and of itself. The fact that you were designing games while you solved the problem? Well, that just made it even more joyful." Macrae recalled that in 1983, GCC was the largest recruiter of talent from MIT. "We passed IBM and Hewlett Packard in recruiting because our pitch was very easy," he said. The group's allure was simple: "'Do you want to come work on video games? Do you want to make a lot of money? And would you like to stay living in your frat? Because we're right around the corner.'"

GCC grew to become a trusted Atari partner, diving deep into both game development and hardware design, eventually engineering the company's Atari 7800 console. Their initial two-year contract with Atari was extended to four years, and they eventually developed 72 games for the company—many of them coin-op conversions for home consoles, including ports of their own *Ms. Pac-Man* game for the Atari 2600, 5200, and 7800 consoles, Atari 400/800 computers, and the Commodore 64. In 1983, *Electronic Games* magazine awarded GCC's Atari 2600 version of *Ms. Pac-Man* the Videogame of the Year award for console games with less than 16K of memory. GCC had discovered a sweet spot of taking popular arcade games and translating them to the day's home consoles, with the final products both delighting home game fans and pleasing Atari executives. "In some ways it suited us much, much better than when we were trying to develop video games from scratch," said Macrae. "We were calculating engineers who could code very, very well. We were not necessarily extremely creative people who could create lots of new video games from scratch and create a whole new storyline and characters."

The formula proved to be a lucrative one. From 1981 to 1984, games and products GCC designed grossed $750 million for Atari and Midway, with nearly $250 million coming from *Ms. Pac-Man*-related sources. GCC's take was also substantial, by design. Golson recalled something that Curran had told them during the company's peak: "'We're not in this to make a living—we're in it to make a killing.'"

All in the Family

Like Midas, Midway seemed to have the golden touch (or yellow, at least), when it came to Pac-Man. Then, they proved that lightning could indeed strike twice, when teaming up with GCC for *Ms. Pac-Man*. The two games kicked off a slew of licensed products and spinoffs that turned the growing Pac-Man stable of characters into a full-fledged nuclear family. Following that, both Midway and Namco created additional arcade games that were variations on the Pac-theme, some of which were oddly bizarre.

Unlike today's modern video game industry, where global coordination and intellectual property drive game releases, the early '80s market was more separated—with each geographical market an island unto itself. There was little creative collaboration between Namco's Japanese releases and Midway's *Pac-Man* sequels, and the idea of worldwide brand synergy was still a long way off. In total, six of the 10 Pac-Man arcade sequels came from Midway, which is surprising, considering that the company didn't create the original. But the fact speaks to the hunger in the U.S. market for more Pac-Man games, as well as the freedom afforded to Midway in their license with Namco.

In the intervening decades, rumors persisted that Namco was unhappy with Midway's *Pac-Man* follow-ups, or that subsequent games were somehow unauthorized. Some of these legends have even been repeated—and reprinted—as facts. But Stan Jarocki called those stories completely false. Namco had no issues with the sequels in the U.S. market— or their associated revenue streams—a flat, per-game royalty. Every game was reviewed with Namco leadership. "As ideas came up," Jarocki said, "we would always run them through Namco. Mr. Nakamura and [Hideyuki] Nakajima were always involved, and they were always alerted to what we were doing." Namco offered opinions and were involved in the process, Jarocki said.

Most importantly, Namco trusted their U.S. partners to make good decisions on behalf of the Pac-Man brand, both for arcade games and licensed products. This trust rested on the relationship—not just between companies, but between friends. In their day-to-day work, Jarocki and Namco's president Masaya Nakamura became close. "I would travel to Japan and we would have breakfast with Nakamura in his office and chit-chat," he said. "He was a great guy. He did so many things in the arcade and amusement industry, it makes your head spin. He was a great thinker. Our relationship was fantastic. Mr. Nakamura and I were very, very good friends." Jarocki and Dave Marofske even attended the wedding of Nakamura's daughter, Kyoko, in 1981.[181]

However, none of the original Midway-created arcade sequels (including the incredibly popular *Ms. Pac-Man*) were released in Japan. (Though all of Namco's own follow-up games were either released—or planned for release—in the United States.) Some whispered stories have suggested that Midway's sequels were perceived as second-rate in Japan. Midway alum and game designer George Gomez believed there might have been other reasons why Namco didn't import Midway's American *Pac-Man* sequels. "The initial [Japanese] reaction was skepticism because there was a lot of the 'not invented here' kind of attitude," he said.

Some critics have painted this as a quality issue—as none of the games came close to duplicating the success of *Pac-Man* or *Ms. Pac-Man*. But the decisions were more likely based on the needs of each market. While *Puck Man* was successful in Japan, both the game and brand were never as popular there as *Pac-Man* was in the U.S. Video game culture in Japan had quickly moved on to other titles—so it made sense that Namco would have less interest overall in additional Pac-Man games, since its audience didn't share the same appetite for the character. Also, the U.S. explosion of licensed merchandise, television, and toys further propelled interest in Pac-Man, undoubtedly feeding the desire for new games in that market. Regardless, both Namco and Midway combined to release 10 different arcade sequels to *Pac-Man* in the seven years that followed the first game's arrival, each of which brought their own stories and additions to the Pac-Man mythos.

At Namco, *Pac-Man* creator Toru Iwatani moved on to other projects within the company, eventually taking on a producer role. Perhaps that void explained the delays in a Japanese follow-up game. Iwatani would not be heavily involved in another *Pac-Man* game until *Pac-Land* in 1984, and he later returned again to help lead the team creating *Pac-Mania*, released in 1987—both games representing significant departures from the look and feel of *Puck Man*. He told an interviewer, "I'm getting away from the design process and am more involved in administration. That's nice, because I can have my staff do things I don't like to do very much and avoid the frustrations I had before. Also, I'm able to do the things I want to do—no one tells me not to, and that's very comfortable."[182] Still, the Pac-Man franchise moved forward, birthing a wide variety of iterations and interpretations.

The three intermissions created for *Crazy Otto* would prove instrumental in the development of *Ms. Pac-Man*, both as a game and a property. The rudimentary storylines created by GCC eventually grew to become a family of characters and sequels that underpinned the Pac-Man franchise for years to come.

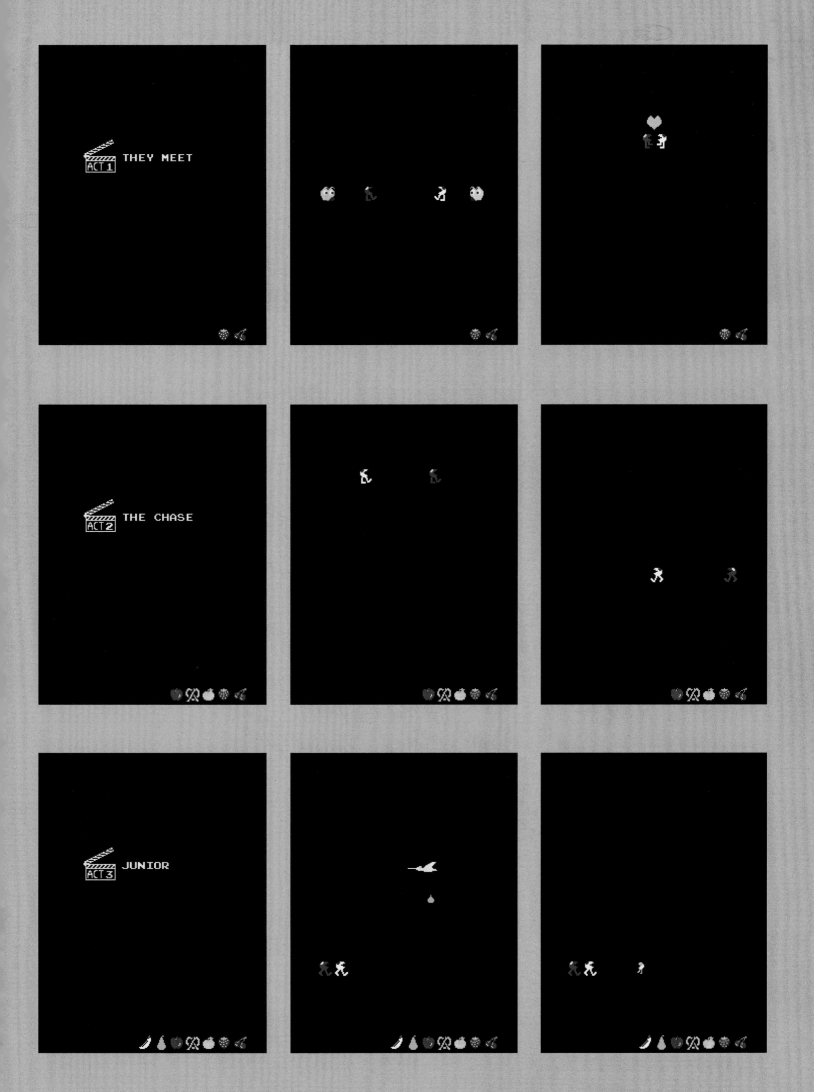

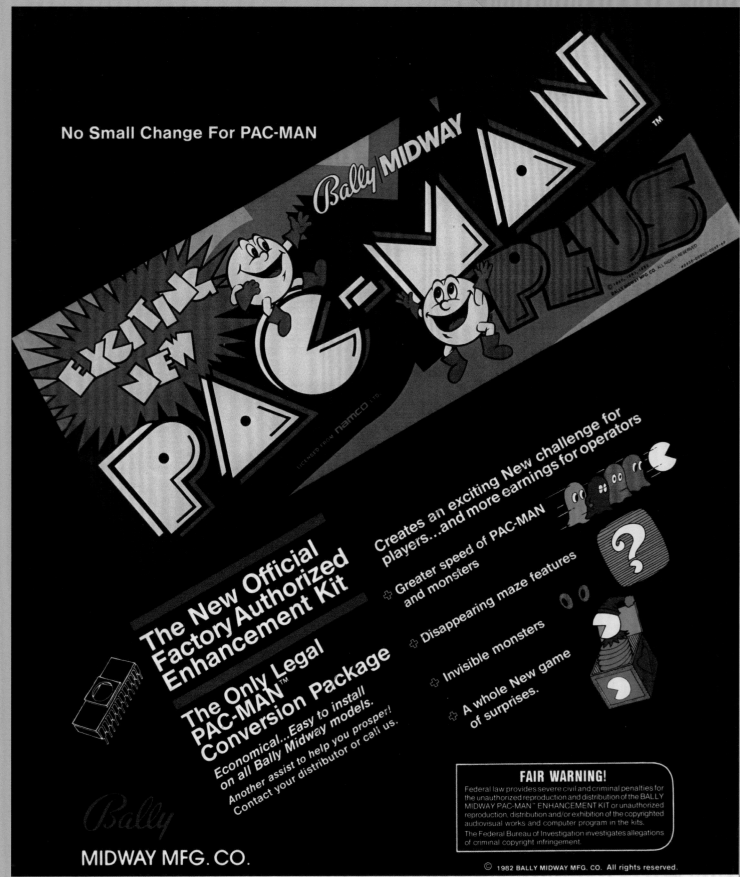

No Small Change For PAC-MAN

MIDWAY MFG. CO.

10601 West Belmont Avenue
Franklin Park, Illinois 60131
Telephone: (312) 451-9200

ROYAL DISTRIBUTING CORP.

1210 GLENDALE MILFORD RD (Bypass 50) CINCINNATI, OH. 45215
TELEPHONE: (513) 771-4250

Other Pac-Man Arcade Sequels

Pac-Man Plus (March, 1982)

Pac-Man Plus was the second sequel to *Pac-Man*, though it was technically a licensed expansion kit, created in order to stem the tide of unauthorized arcade conversion boards that had crept into the U.S. market. Advertised by Midway as "the only legal *Pac-Man* conversion package," this release was the company's attempt to cut off this grey market of bootleg add-ons. The *Plus* expansion changed the color of graphics, the look of the ghosts, and added novel bonus items. *Pac-Man Plus* also plays differently, as ghosts turn invisible when bonus items are eaten, and their behaviors are both faster and more aggressive.

Mr. & Mrs. Pac-Man (May, 1982)

At nearly the same time, Bally/Midway sought another avenue to bring Pac-Man to gamers. While it was clear that video games had eclipsed pinball, Bally hoped to bring those games back into the conversation, utilizing Pac-Man. "We were trying our damnedest to compete with the whole video thing," said Bally art director Greg Freres. "Then obviously once *Pac-Man* became the phenomenon that it was, then it was, 'Okay, we might as well ride that coattail.' Believe me, we felt the crush of video." Even so, this unique pinball game wasn't intended as a quick cash grab, Freres explained. "We put so much more creative energy into it," he said. "Once everybody knew [*Pac-Man*] was a blockbuster, we felt doing a *Mr. & Mrs. Pac-Man* pinball could be a nice shot in the arm for pinball. We wanted to give it the treatment that we knew how to give."

Pac-Man Plus was a licensed expansion kit made by Midway in order to halt the flow of illegal, unauthorized enhancement kits for their American *Pac-Man* arcade game.

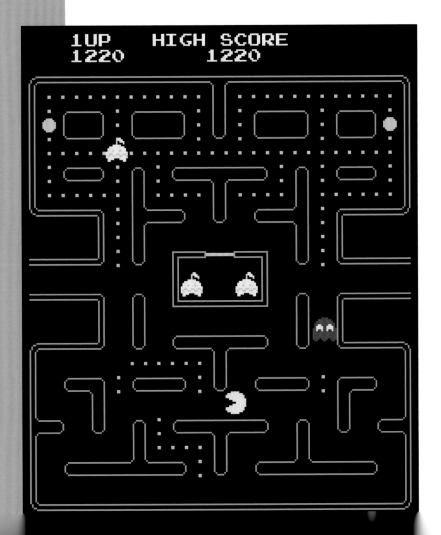

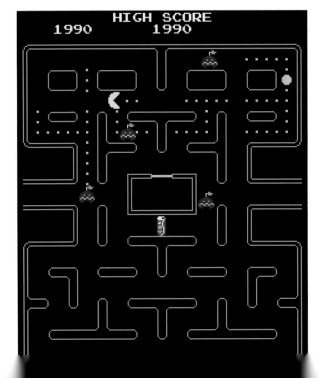

The game is a classic pinball game with a twist, sporting a kind of video game screen in the center of the playfield. By landing the ball in a specific hole, a player could light up each space in a 5x5 pixel grid, while avoiding the red ghost dot—all controlled by the left and right flippers. The game was successful enough that it spawned another Pac-Man-related pinball game later that same year, though it was never explained why Ms. Pac-Man finally made the couple's marriage official on this game, temporarily taking her "Mrs." honorific.

Super Pac-Man **(August, 1982 in Japan and October, 1982 in North America)**
This Namco-created game was the first *Pac-Man* sequel where original creator Toru Iwatani was directly involved. *Super Pac-Man* introduced new gameplay elements that allowed players to move through a series of unlocking maze doors by eating bonus keys and special power pellets that turn Pac-Man "super" for a short time—where he grows larger and can "fly" over ghosts and utilize super-speed. In a talk he gave at the 2011 Game Developers Conference in San Francisco, however, Iwatani called the game "boring."[183]

The U.S. flyer for *Super Pac-Man* relied on imagery and costume colors generally associated with another high-flying hero.

Disguised as our mild-mannered Pac-Man, Super Pac-Man fights a never ending battle to eat rows of fruit and objects, destroy enemy monsters and rack up scores that are out of this world.

Super Pac-Man was the first Namco-created sequel to *Pac-Man*, introducing several new gameplay elements, including a "super" mode where Pac-Man can grow larger and "fly" over ghosts.

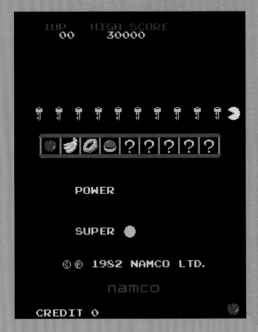

Baby Pac-Man (November, 1982)

Midway and the Bally pinball division pooled their strengths in this sequel, creating a unique, hybrid machine that combined both a pinball platform and arcade game in one cabinet. This game also contributed to the ongoing Pac-Man world-building by introducing a storyline detailed in marketing materials: "In the beginning there was Pac-Man, the chomping champion that spent his bachelorhood revolutionizing the video world. Into his life came Ms. Pac-Man, the irresistible femme fatale who lured our hero into a state of marital bliss. They lived happily, chomping away and doing all the things Pac-People do, when one day a stork delivered a bouncing bundle of joystick joy—BABY PAC-MAN—the brand new addition to the Pac-Clan!"

The game action began on the video screen, where Baby moved through a recognizable Pac-Man maze, albeit without power pellets. But players could use escape tunnels to journey to the pinball playfield, continuing the game there. After losing a ball, gameplay would resume back on the video screen. Pac-Man creator Toru Iwatani, who got his start as a pinball devotee, played the game and commented on it. "I thought Baby Pac-Man was depicted nice and cute," he recalled to an interviewer. "That being said, I wasn't too keen on the playfield because it was a bit too small for my playing comfort."[184]

Bally art director Greg Freres said that the popularity of Pac-Man "forced the issue to come up with a completely new platform, and combine video and pinball for the first time. Now we have full screens on pinball games, but that was groundbreaking to actually incorporate both genres into one platform. The amount of R&D investment that went into that—to go from a standard pinball or a standard video and to marry the two together— was obviously huge."

Details of the fold-out *Professor Pac-Man* arcade game flyer, made to look like a grade school report card.

Subject	Grade	Comments
Earnings	A+	Professor Pac-Man has the potential for being one of the greatest earners ever—anyone can play it—everyone will love it! Two player competition makes your profits even greater!
Flexibility	A+	This game is right for all locations! Great for arcades and bars, street locations and almost anywhere you can imagine!
Educational	A+	A new concept for video game play! Prof. Pac-Man challenges its players to answer a variety of questions requiring thought and logic. It's what's best—it's FUN to learn from Professor Pac-Man!
Graphics	A+	Professor Pac-Man is a brilliantly animated machine with players response producing an array of entertaining visual effects! And, the famous Pac-Man character provides both recognition and response!
Entertainment	A+	A uniquely challenging game for players of all ages. Professor Pac-Man presents puzzles and problems, questions and quips in a "quiz-show" type package. Two players make the games even more fun!

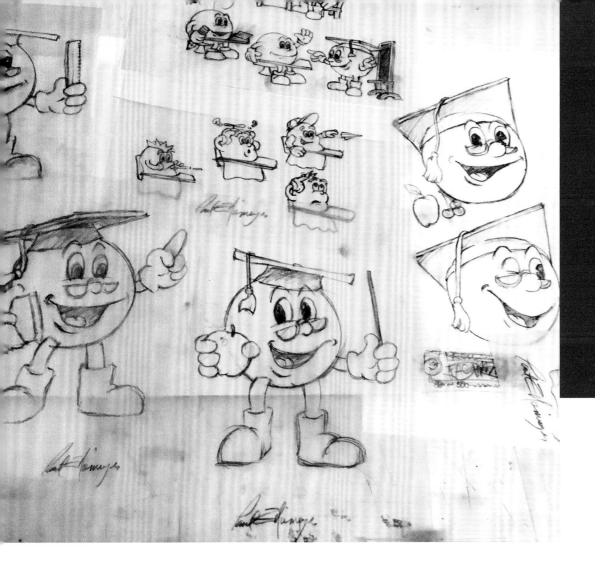

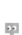

Early sketches of Professor Pac-Man by Midway artist Paul Niemeyer, for use on the game's marquee artwork and marketing materials.

Professor Pac-Man (August, 1983)

This game diverged greatly from previous Pac-Man maze games, and instead focused on the quiz game genre. It was envisioned as a counterpoint to outspoken parent groups concerned about the effect of video games on children. Artist Paul Niemeyer, who created the game's marquee artwork, recalled that some parents believed their kids' "brains were turning into mush playing these video games." Eddie Adlum, publisher of industry magazine *RePlay*, and co-creator of the game, thought that such a game concept "might stimulate a little positive public relations."

Adlum was part of the game's unusual genesis. The *RePlay* publisher and editor, already very close with many of the industry's top executives, approached Dave Marofske with the idea for a new Pac-Man game. Adlum had teamed up with Johnny Lott, an early organizer of video game competitions and professional foosball player, to create a game where Pac-Man would traverse the maze, eating dots and power ups. When he reached a particular power-up, a quiz question would appear. If answered correctly, the points won would be added to the player's final score. Midway made a deal with the pair for the game, but enlisted Dave Nutting Associates to program the game, and they altered the gameplay significantly before release, without notifying either Lott or Adlum.

In the revised game, the basic Pac-Man maze play was completely removed. Instead, the Professor presents simple visual puzzles that players ("pupils") must solve within a set time limit, more akin to a visual IQ test. Midway planned to release different game questions for a variety of venues to broaden its appeal ("Family" for younger players, "Public" for arcades and bars, and "Prizes" for casinos), but the game only ended up shipping with one set of questions. It did not sell well, and many of the cabinets were reportedly returned and later converted to *Pac-Land* arcade games.

PAC & PAL
パック＆パル

きょうも
リゾート気分

©1983 NAMCO, ALL RIGHTS RESERVED

Pac & Pal was a Namco-made game that introduced a new, helper character named Miru, who collects fruits alongside Pac-Man. She is reportedly another ghost who has defected from the quartet in order to help Pac-Man, though this is not explained in the game itself.

「遊び」をクリエイトする───
株式会社 ナムコ
本　　社　〒144　東京都大田区蒲田5－38－3　朝日ビル　☎03(736)1211（大代）

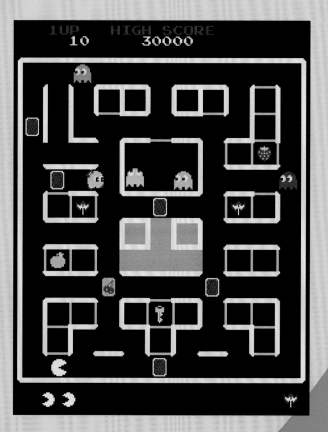

Pac & Pal (Pac-Man & Chomp Chomp) (July, 1983)

In some ways this game builds on the gameplay changes introduced in *Super Pac-Man*. Created by Namco in Japan, *Pac & Pal* employs a similar game mechanic of locking and unlocking maze doors, and power ups that give Pac-Man powers that allow him to stun the ghosts while also simultaneously referencing other games in the Namco library, like *Galaga* and *Rally-X*.

A revised version of the game was created for Western markets, planned to be distributed by Midway under the title *Pac-Man & Chomp Chomp*, but was never released in North America. In this version, (which did see a limited release in Europe), the Pal character, Miru, was replaced with Chomp Chomp, the Pac-family dog from the popular Pac-Man Saturday morning cartoon by Hanna-Barbera.

Jr. Pac-Man (August, 1983)

In an interview on Feb 8, 1982, Stan Jarocki teased, "Sometimes we do sit around kidding each other about a possible 'Son of Pac-Man.'"[185] It wasn't just a lark, either. The GCC team started work on this game in mid-1982, and was originally titled *Pac-Baby*. Delayed because of legal issues between Namco, Midway, and GCC, it was finally completed and released—with a name change, so as not to be confused with *Baby Pac-Man*, the pinball/video hybrid game released the previous year.

Jr. Pac-Man was the first Pac-sequel to utilize a multi-screen, scrolling maze—long before it became a feature in modern Pac-Man re-imaginings. The game continued the tradition of "coffee break" storylines, where Junior is delivered by a stork to the Pac-residence, and then later falls in love with the young ghost named Yum-Yum, the daughter of Blinky the ghost. *Jr. Pac-Man* also introduced the novel idea of "juiced up" dots that slow down the player while yielding extra points. Moving bonus items could also destroy power pellets upon touching them. Even though the game performed well, selling about 30,000 cabinets,[186] it was the last Pac-Man arcade game created by Midway (with the same development team that helped create *Ms. Pac-Man*), though Midway would still distribute future Namco-created Pac-Man releases.

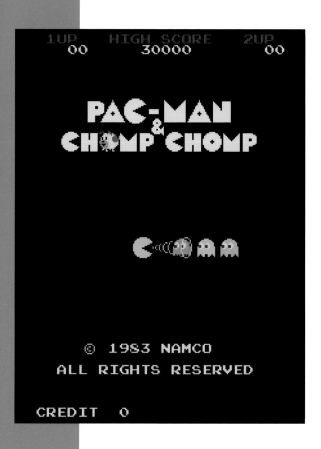

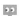

Pac-Man & Chomp Chomp was a localized version of *Pac & Pal* intended for American audiences, swapping the Japanese Miru character with Pac-Man's dog, Chomp Chomp, who originally appeared in the Pac-Man Saturday morning cartoon. The game was never released in the U.S., but some cabinets were released in Europe.

Pac-Land (October, 1984)

This game might be the greatest departure for a *Pac-Man* sequel, as the yellow dot-muncher escaped the maze and roamed the streets of Pac-Land. Original *Pac-Man* creator Toru Iwatani returned to his creation to be involved in this game, which was one of his favorites. "It pioneered action video games in which the scene flows horizontally, he said."[187] This side-scrolling "platformer" was an early, significant version of the genre; *Super Mario Bros.* creator Shigeru Miyamoto told Iwatani that *Pac-Land* influenced his creation of that breakthrough game for the Nintendo Famicom and Nintendo Entertainment System.[188]

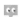

Midway artist Rich Scafidi's daughter, Katherine, was the child featured in the back of their family car on this arcade flyer. In this photo, her father is in the driver's seat, and the two were joined by the dog of Scafidi's boss at Midway.

Pac-Land was a significant shift for *Pac-Man*, transporting the character from maze-based games and into a side-scrolling platformer. Original Pac-Man creator Toru Iwatani was involved in this game, which influenced later side-scrolling adventure games. Worth noting is a slight shift in graphics. In the Japanese release of the game, Pac-Man sports a Bavarian-style Alpine hat, complete with jaunty feather. But in the U.S. Midway version, his headwear has changed to the familiar fedora worn in the American Pac-Man cartoon, undoubtedly to better connect with the popular show.

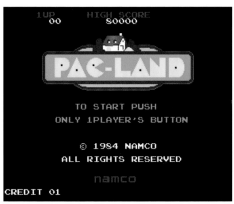

PAC-LAND™
A GREAT PLACE TO VISIT

Illinois Land of Lincoln
AXS 495

PAC-LAND

HE'S OUT OF THE MAZE AND ON THE ROAD

Pac-Man's headed for the wide open spaces and the scenery couldn't be better! The dot-chomping star of his own Saturday morning cartoon show leads the way through 19 magical adventures en route to Fairyland. Pac-Man's exploits are his most entertaining yet as he hikes through unexpected obstacles from treacherous terrain to menacing monsters. With first-class features . . . non-stop action . . . and spectacular graphics . . . Bally Midway is about to put PAC-LAND on the video map!

Bally **MIDWAY**™

Pac-Mania (November, 1987)

Pac-Mania places Pac-Man in a multi-screen, three-dimensional, isometric maze, to great effect. Even though the game returned Pac-Man to the core gameplay of traversing the maze and eating dots, it added another dimension of strategy by introducing jumping for both Pac-Man and a larger group of ghosts. This was the first Pac-Man arcade game released in the U.S. without Midway's participation. *Pac-Mania* was instead licensed to the newly-reconfigured Atari Games, which was owned in part by Namco, Atari Games employees, and Warner Communications.

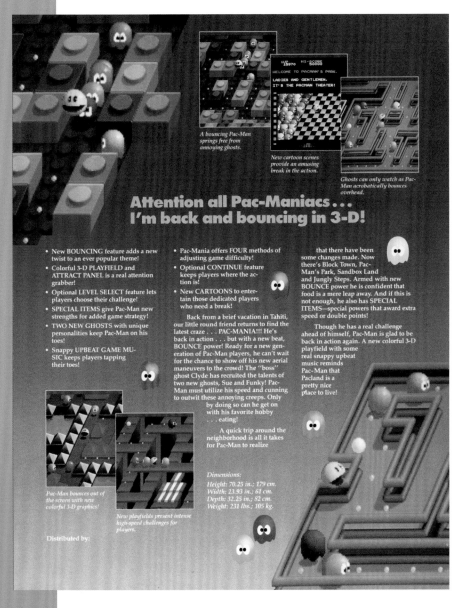

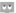

The *Pac-Mania* sequel added a new dimension to Pac-Man, placing the player in a 3D, isometric maze, and introduced gameplay that allowed Pac-Man and the ghosts to jump vertically as well. This was the first Pac-Man arcade game released in the U.S. without Midway's participation.

Count Pacula (Unreleased)

One Midway Pac-Man spinoff never made it past the conceptual stage. In December of 1983, designer Jim Patla and a team presented a design concept for a new Pac-Man game. *Count Pacula* would have been a hybrid pinball/video game by Bally-Midway, in the same vein as *Baby Pac-Man*. The game's premise was based on a minor character from the Hanna-Barbera cartoon, a vampiric Pac-Man villain with fangs and a cape. In the proposal, Count Pacula starred as the game's protagonist, racing through the pseudo-3D maze of his Pacsylvanian mansion, eating red dots and being chased—not by ghosts, but by the Pac-family, carrying wooden stakes! Pacula would have been pursued by Pac-Man, Ms. Pac-Man, Baby Pac-Man, and long-lost, beer-swilling Cousin Six Pac.

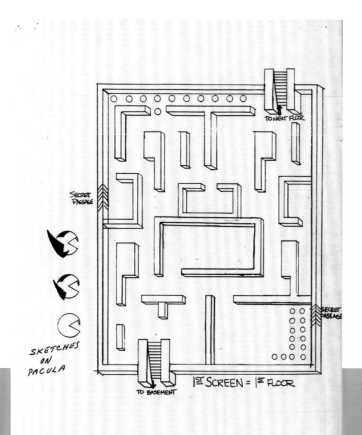

Midway attempted to turn the tables on the traditional Pac-Man gameplay in a game concept, *Count Pacula*, which never came to life. In the proposed hybrid video/pinball game, players would control the vampiric Count Pacula, who was being chased by members of the Pac-Man family, rather than ghosts!

The only details of the game proposal that remain are initial design documents describing the characters involved, and early ideas on the layout and gameplay of the multi-level title.

COUNT PACULA

BACKGROUND — The player assumes the role of Count Pacula, who is a blight on the good Pac family name. All of the Pac family members have assembled at the ancient Pac mansion, located in Pacsylvania. Their intention is to rid the country side of this embarrassing pest once and for all, and to clear the good Pac name. The family members include Pac-Man, Mrs. Pac-Man, Baby Pac-Man, and long lost cousin Six Pac. Cousin Six Pac has returned from one of his many wild adventures to aid the Pac family. Former movie stunt man (mostly westerns, he was chief of indian training, sometimes known as Pac of wild indians) and mountain guide (riding a Pac horse), Six Pacs name came from his known affection for a certain beverage started by his Great Grand Pac. Great Grand Pac entered his new brew in a local contest and won 1st prize. The brew became known as... Pac's Blue Ribbon. Six Pac is an adventuresome and rambling kind of guy.

The action starts at night fall, when Count Pacula leaves his coffin to enter the mansion. When in the mansion, he eats all the red dots that appear on each floor and returns to his coffin before daybreak. He has done this every night for centuries. But not tonight. Tonight is different. Tonight when he enters the mansion, he is startled by the members of the Pac family carrying wooden stakes. He runs frantically through the mansion, eating red dots and fleeing the Pac family. Occasionally a ghost will appear that scares the Pac family, but only momentarily. The ghost soon tires of this diversion and disappears. If Count Pacula is skillful and can find a large red energy pill, the Pac family will become frightened, drop their stakes and flee. Count Pacula now chases them to bite their necks. He remains aggressive until the Pacs find more stakes. Count Pacula may also find a special bat pill which will enable him to escape danger by turning into a bat and flying to another part of the mansion. He may want to save this pill until the threat of sunrise when he could quickly fly back to this coffin. He must eat all the red dots or return to his coffin before daybreak.

The game would have showcased some intriguing features, including power pills that turned Pacula into a bat, secret passages, and Bloody Mary bonus items. Patla explained the thinking behind the hybrid game: "At that point in time, pinball was in a downward spiral and so the whole video-pin thing was trying to breathe some new life into it. We were having a lot of fun with it." The bizarre and intriguing game was certainly a departure from other Pac-Man games, and might have brought a breath of fresh air to the franchise, but the game was mothballed and its pinball platform was repurposed for a game called *Granny and the Gators*.

Midway's creation of new Pac-Man games was an effort to capitalize on a known quantity, but it was also a practical concern. Midway marketing and promotions manager Jim Jarocki explained the commercial side of persistent Pac-sequels. "We had a factory that we had to feed. It was like a furnace," he said. "Once you build a factory that's big enough to put out 1,500 games a day, you want to keep putting out 1,500 games a day or you're going to lay off your force. Your supply chain is going to be different. Your costs and materials to build are going to be different as you lower the quantity of games coming out every day, or every year. So, that's why there were so many Pac-Man variations." While none of the sequels equaled the sales of the first two Pac-Man titles, the wide range of games traveled down some intriguing gameplay paths.

While the *Count Pacula* game never saw daylight, the character was resurrected and redesigned for an appearance in the Hannah-Barbera TV show. A slightly different iteration of the character also makes a cameo in the game *Pac-Man World Rally*.

CHAPTER 8

Pac-Man Fever

パックマン・フィーバー

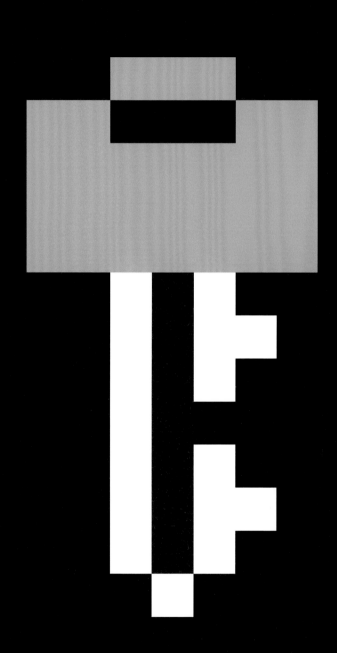

Connecting the Dots

While the incredible success of *Pac-Man* was a surprise to both Midway and parent company Namco, the excitement and interest ignited by the game couldn't be confined to an arcade cabinet. Pac-Man might have kicked off the craze, and players fanned the flames—but merchandise kept the fever burning. As with any mega-trend, from Hollywood Westerns to superhero films, the merchandising of popular characters was nothing new; kids flocked to products from shows ranging from *The Mickey Mouse Club* to *Howdy Doody* as far back as the 1950s. But it found another gear with the popularity of *Star Wars* in the late '70s, and reached a fever pitch when the FCC (the U.S. Federal Communications Commission) deregulated television airwaves, which allowed toy companies to sponsor cartoons featuring versions of their products. Hanna-Barbera's *Pac-Man* show led this charge in 1982, as the very first of the Saturday morning cartoons based on a popular character.

Some audiences—especially younger fans—had less awareness of the arcade game, but connected with Pac-Man through other outlets like the popular cartoon, toys, home video games, and more. This gave fans another way to relate to the character, fleshing out the overall Pac-Man experience in a multi-dimensional way. Unlike earlier licensing efforts to capitalize on properties like The Beatles, *Star Wars*, or *The Six Million Dollar Man*, Pac-Man came from a relatively new medium, video games, that had few licensing examples. In the modern era, where many games depend on recognizable characters, it can be hard to recall a time when they were the exception; before *Pac-Man*, most arcade experiences were centered around translations of sports or carnival-esque shooters. But *Pac-Man*'s arrival and popularity revolutionized the way people play video games. The game set the standard for all other hit video game characters to follow, with a cute, personable, spirited protagonist who could have a life beyond the confines of his cathode-ray tube world.

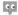

This staged photo shoot for *Popular Computing Weekly* magazine in December 1982 might have seemed like a dream bedroom—or an exercise in Pac-Man obsession. But it also highlighted the breadth and depth of licensed products available for Pac-Man fans by the end of 1982. Games, records, books, wrapping paper, bedding, and more could be purchased complete with Pac-Man characters and logos.

MIDWAY MANUFACTURING COMPANY

Trademark License List

Company	Product
Aladdin Industries 703 Murfreesboro Road Nashville, TN 37210 (615) 748-3322	Pac-Man Lunch Kits
Amusement Mktg. Concepts, Ltd. P.O. Box 3002 Springfield, MA 01101 (413) 781-1220	Pac-Man Bumper Stickers, License Plates, Labels, and T-Shirts
M.Z. Berger 20 West 37th Street New York, N.Y. 10018 (212) 594-4880	Pac-Man Game Watch, Juvenile LCD Watches
(CBS) The Buie/Geller Organization 3297 North Crest Road Suite 203 Doraville, GA 30340 (404) 491-0950	Pac-Man Fever Record Album
Colorforms 133 Williams Dr. Ramsey, N.J. 07446 (201) 327-2600	Pac-Man Colorform™ Stick-Ons and Shrinky Dinks
Brookfield Athletic Shoe Co., Inc. P.O. Box "A" East Brookfield, MA 01515	Pac-Man Ice Skates and Roller Skates

-1-

FORM – 00154-8204

Product

Pac-Man and Galaxian Table Top Games	
Pac-Man and Ms. Pac-Man Rack Toys	
Pac-Man and Ms. Pac-Man Slumberbags, Pillows, Tote Bags, Knapsacks, Backpacks, and Stadium Cushions	
Pac-Man and Ms. Pac-Man Ceramic Mugs and Glassware	
Pac-Man and Ms. Pac-Man and Wizard of Wor Towels, Bath Sets, Quilted Kitchen Accessories, Pac-Man and Ms. Pac-Man Blanket	
Hallmark Cards, Inc. Kansas City, MO 64108 (816) 274-5417	Pac-Man Greeting Cards, Gift Wrap, Posters, Puzzles, Seals, Lapel Pins
Joy Insignia, Inc. P.O. Box 68 320-69th Street Guttenberg, N.J. 07093 (201) 863-5774	Pac-Man, Ms. Pac-Man, and Galaxian Embroidered Emblems
Key Ring Supplies, Inc. 631 Fargo Avenue Buffalo, N.Y. 14213 (716) 883-1110	Pac-Man, Gorf, Wizard of Wor and Galaxian Leather Key Fobs

-2-

Product

Pac-Man and Ms. Pac-Man Plush Toys	
Pac-Man and Ms. Pac-Man Juvenile Shelving, Tray Tables and TV Tables	
Pac-Man Costume Jewelry	
Pac-Man Board Game, Puzzle, and Card Game	
Pac-Man Paper Table Goods	
Pac-Man and Ms. Pac-Man Junior Missy Sleepwear	
Pac-Man Metal Waste Baskets and Lamps	
Pac-Man and Ms. Pac-Man Stationary and School Supplies	

-3-

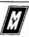

Midway's roster of licensees ran the gamut from shoe makers to toy manufacturers, ensuring that Pac-Man and associated characters found their way onto a plethora of licensed products. Portions of a listing from May, 1982 are shown here.

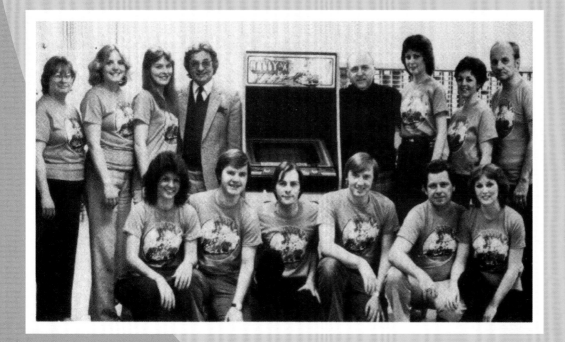

Midway's marketing team was an essential part of the company's success both in *Pac-Man*, and in other games like *Rally-X*, which was also licensed from Namco. Top row, left to right: Pat Jones, Kathy Novak, Betty Purcell, Stan Jarocki, Larry Berke, Pati Crane, Pat Richter, Andy Ducay. Bottom row: Donna Crivolio, Fred Brickman, Bob Norton, Brian Osowski, Dick Konopa, Cindy Modrzejewski.

Once Midway tasted success in sub-licensing the Pac-Man character, name, and likeness to other companies, the video game maker made it known that their popular, adopted son was available for other opportunities beyond the screen. This is clear in this advertisement that ran in an industry toy magazine, which also served as a warning to manufacturers who might try to illicitly cash in on the Pac-Man craze.

Wild West Licensing

Because of Midway's shrewd marketing (and a bit of luck), Pac-Man's image appeared nearly everywhere. Over the years, his likeness has graced waves of merchandise, including lunch boxes, bumper stickers, license plates, playable watches, analog watches, stickers, record albums, Colorforms, Shrinky Dinks, ice skates, roller skates, tabletop games, board games, figurines, plush animals, sleeping bags, backpacks, ceramic mugs, glasses, bath towels, quilts, blankets, greeting cards, gift wrap, posters, lapel pins, embroidered patches, key fobs, TV trays, costume jewelry, puzzles, paper cups and napkins, pajamas, garbage cans, notebooks, pencils, pens, pillows, t-shirts, baseball caps, suits, dresses, breakfast cereal, vitamins, canned spaghetti, puppets, telephones, bar soap, Halloween masks, wind-up toys, buttons, robes, air fresheners, bowls, stools, belts, suspenders, swimsuits, bubble gum, markers, jackets, squeeze toys, ashtrays, panties, drink pitchers, balloons, rubber balls, yo-yos, slippers, gumball machines, cross stitch sets, drapes, bedspreads, jeans, recipe boxes, liquid soap, children's storybooks, coin purses, wallets, cigarette cases, cork boards, scrapbooks, autograph books, sun catchers, wallpaper, shoelaces, shoes, lamps, rugs, globes, combs, toothbrushes, bookends, paperweights, leg warmers, trophies, night lights, electrical switch plates, pennants, scarves, gloves, frisbees, and a hot air popcorn popper. But it all began with the insight that Pac-Man could have legs beyond merely chasing ghosts across the screen.

During early negotiations between Midway and Namco in 1980, Midway lawyer A. Sidney Katz traveled to Japan and met Namco president Masaya Nakamura and his daughter, Kyoko, at Namco's Tokyo plant. Nakamura advised the Midway team that they would have to fight any counterfeit games if they were to license and sell *Pac-Man*—because Nakamura didn't want Namco entangled in U.S. litigation. "Don't involve me," he told Katz. Was Nakamura gun-shy after being sued by Atari for making unauthorized *Breakout* cabinets? Or just tired of the drain on resources that came with defending intellectual property in the video game industry? Either way, Katz reportedly offered a solution to Nakamura. "That's easy," he recalls saying. "All you have to do is assign all your rights to Midway, and then they can defend it." They came up with a simple agreement that Katz hand wrote, and Nakamura's daughter typed the final version. The deal was a "simple assignment of all rights, title, and interest in every aspect of the 'Pac-Man' game in the so-called Western Hemisphere," Katz said.[189]

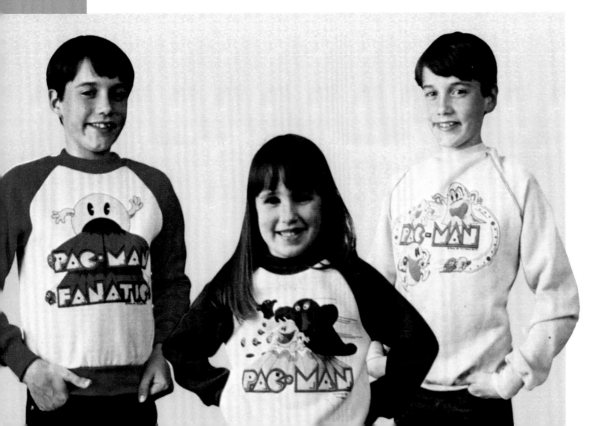

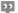

Manufacturers wasted no time creating a variety of Pac-Man-themed fashion, which typically consisted of t-shirts. However, many other wearable items were released, including "fashionable" pajamas, underwear, and other soft goods.

This sort of complete and total licensing agreement was somewhat unique for the time, but would never happen in today's video game industry, with its heavy focus on protecting and exploiting intellectual property. Present-day brands are more willing to control their own licensing—with a much tighter grip on how each piece is utilized. But in the earliest days of the licensing industry, things were less complicated. Video games were also rarely involved in licensing at all. Added together, these elements formed an unprecedented result. Being able to freely sub-license Pac-Man allowed Midway to exploit that character with an independence (and magnitude) that was crucial to Pac-Man's wider spread into popular culture.

"I can't believe the deals we cut and what we got away with! There were some amazing ones."

Tom Nieman, Bally Marketing VP

Stan Jarocki described the genesis of Midway's Pac-Man licensing when it became clear the game would be more than just an arcade hit. "A company that manufactured t-shirts came to us and asked if they could license the logo and trademark, which we did," Jarocki said in 1982. "Little did we realize at that time that it would grow to the proportions that it has grown today. This will generate a tremendous amount of income for our company in the coming year. The items that are covered! I said to a person that was in the office just the other day—we can dress you from the skin out! And I'm not kidding you. We have socks that have been licensed, sport shoes, shoelaces, belts, jackets, caps—any imaginable item."

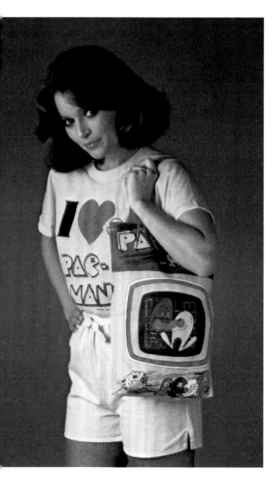
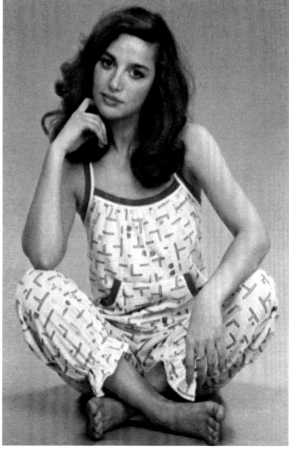

Tom Nieman, VP of marketing at Bally, explained the company's unusual arrangement with Namco. "The deal we had with Namco was total and complete in North America, meaning we could then re-license it," he said. "It took us a while to realize that, but it didn't take long to see that there was a demand. People were calling, saying, 'Hey, I've got this kind of a product and it would be perfect.' It really was a pop culture phenomenon. Magazines wanted it on the cover! Music on the radio! It was total and complete, so we turned around—and instead of just being a licensee, we became a licensor. I can't believe the deals we cut and what we got away with! There were some amazing ones."

This was a unique opportunity for Midway, a chance to capitalize on the Pac-Man craze and seize a (potentially) brief cultural moment—because video game character licensing had never been done at any scale before. No game had ever penetrated popular culture to a degree that would warrant such an effort. But *Pac-Man* had captured hearts and minds, so when the market opportunity presented itself, Namco wasn't necessarily equipped to execute a worldwide licensing program. (Pac-Man creator Toru Iwantai reportedly designed prototypes of some of his own t-shirts and stuffed toys, to help sell Namco on the potential for licensing.[190]) Midway was open to the opportunity, aided by the close relationship between Midway's duo of Stan Jarocki and Dave Marofske and Namco president Masaya Nakamura.

Licensing manager Patrice Paglia got thrown into the deep end of Pac-Man licensing when she began at Midway in 1983. While large corporations, toy makers, and other industries had been implementing licensing and branding programs for years—style guides, master agreements, product approvals, and other tools of the trade—the video game industry of the early '80s was still in its infancy in that regard.

This meant growing pains for Midway, which ventured into uncharted territory with its inherited characters and intellectual property. Paglia took over management of the licensing team in the program's second year, just as demand was peaking for Pac-Man merchandise. Just a few years out of school, she tried to strategically reverse-engineer the programs of larger companies to decipher how to best capitalize on the success of Pac-Man and Midway's unusual position as both licensor and licensee.

In the beginning, Paglia had to develop her own approach. "I don't think there was a lot of strategy," she said. In the kid-oriented marketplace, Midway and Pac-Man were competing against companies that had longer track records marketing to kids, with properties like Barbie, Hot Wheels, G.I. Joe, Strawberry Shortcake, and more. But despite their experience, these toy stalwarts were now facing a different kind of competition—a brand-new character emerging from an infant industry. Video games were suddenly a commercial force to be reckoned with.

Still, Paglia knew she had lessons to learn from these veteran brands: "I caught on very quickly that there was more to a successful licensing program than just accepting every deal that knocks on your door." So, Paglia looked at these other big-budget brands for inspiration and benchmarking. "I mapped out—here's our competition and here is what they are doing to support their brands. They have Macy's Thanksgiving Day Parade balloons. They have television shows. They advertise in trade journals with retailers. We weren't there. We were a video game manufacturer first, and licensing was second. So, I absolutely immersed myself to learn everything I could about the fundamentals of licensing, contract negotiation, structure, agreements, territorial rights, and working with agents in foreign countries."

Licensed to Drive

"It was fun," Paglia recalled. "I think I'm a merchandiser at heart, and the opportunity to work with manufacturers from all over the world in a variety of product categories is the most exciting—to see how you can translate a character like Pac-Man, which is pretty flat, into three dimensions—toys and plush and children's pajamas, and then into a cereal or a vitamin. It was exhilarating, and it was great to see your product on shelf and to see the sell-through and the results."

Nieman also explained that Midway's approach was open-minded, to say the least: "If you called and were breathing, and had a product that didn't overtly offend us—and believe me, we weren't offended by anything—we probably said yes. Someone wanted to do a Pac-Man doughnut! We'd sit around the office and laugh our asses off about who was calling us." At one point, Midway even considered licensing a Pac-Man toilet seat that would open its "mouth" to "eat" bodily waste. Bally-Midway artist Greg Freres took the unused prototype home. "Our kids were toilet trained on a Pac-Man toilet seat!" he said. Overall, licensing demand grew so great that Midway started holding an annual convention for licensees—focused solely on opportunities to license the Pac-Man characters.

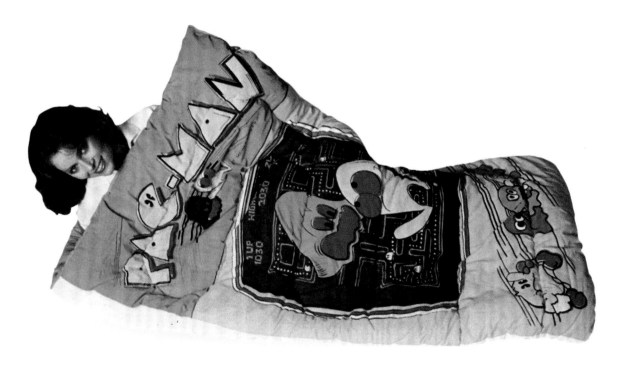

This bounty wasn't slowed down by Midway's relationship with Namco, or any approval issues. Paglia explained that Namco was not involved in product approvals or sign-offs, and Midway was the full representative for the brand in the United States and outside of Japan. Jarocki also confirmed that Midway had final approval rights as long as the marketing uses wouldn't depict Pac-Man in a violent manner. "When we started to become the licensor, we never got any resistance," Nieman confirmed. "Out of respect [for Namco] we always discussed it, reviewed it, and showed them what we were going to do. There was never any push-back from them. They loved everything we did. Of course, we paid a royalty on all of them, so, I guess that's the motivation for why they loved everything!" The interest in Pac-Man was so great that Jarocki said initial development work had been done on a feature film, which never made it into production—mostly due to the technological limits of the era in depicting a moving, talking sphere against live-action actors. "How do you show a big, round ball in a movie for an hour?" Jarocki mused. "You could get away with it in the cartoons, but when you got to the movies it became a little bit difficult."

In fact, the popularity and success of the cartoon represented an opportunity for an additional wave of licensed toys, sticker albums, shirts, and more, by providing a new set of visual characters, assets, and storylines to mine. But why was Pac-Man primed for licensing in a way that other popular video games weren't? Tom Nieman believes that the *Pac-Man* game—and by extension, the character—had a crossover appeal that meant it could work in nearly any situation. "What were the elements that made it so amazing?" he wondered. "I think it crossed the gender line, where arcades and coin-op amusement had been primarily male-driven. I think this game had that unique ability to cross over and draw in females without alienating males."

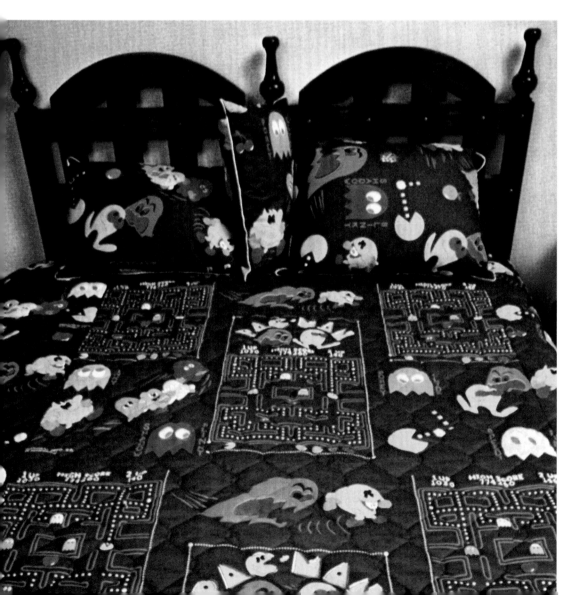

At the end of the day, even Pac-Man fans had to give it a rest. But licensed makers didn't sleep on an assortment of Pac-Man comforters, pillowcases, or adult-sized sleeping bags carrying the Pac-Man name and graphics.

Polaroid photos of a department
store POP (point-of-purchase) display
showcase an array of Pac-Man
merchandise available to retailers.

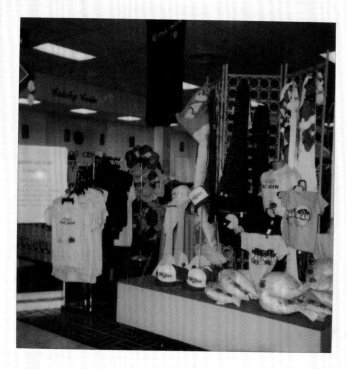

Pac-Man's cheerful, positive (and relatively benign) personality made the character easier to license, where a more polarizing character might disqualify itself from some licensing opportunities. Also, the game's design elements were unmistakable and visual—the maze, Pac-Man himself (both as a visual icon and as a character), the ghosts, and fruit bonuses —all provided many opportunities for use in product design and licensing.

"The Bally-Midway licensing program was an anomaly. You don't get programs like that many times in your lifetime."

Patrice Paglia, Midway licensing manager

The merchandising of Pac-Man put the brand and characters on the map in ways that the video game could not, but there was never a doubt that making video games was Midway's primary concern. This focus ultimately limited the depth and breadth of licensing they could execute, though the ride was fun while it lasted. Paglia went on to an extensive career in licensing, but even decades later, understands that the chance to work with a property like Pac-Man is exceedingly rare. "The Bally-Midway licensing program with Pac-Man was an anomaly," she said. "You don't get programs like that many times in your lifetime, in terms of licensing opportunities with the pitch and fever that it had."

Midway game designer George Gomez—now chief creative officer of Stern Pinball— surmises that Midway's licensing success might have given Namco's executives second thoughts. "I think it was a deal that the Japanese maybe regretted," he said. "And they got wiser about the deal a little bit further down the road. But those sorts of exclusive rights for certain markets came with the license, and you know Midway took advantage of it. I mean, the Japanese were getting royalties on their own products for all these different revenue streams. It wasn't just all Midway money."

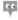

An assortment of Pac-Man merchandise photographed in a single department store (Gimbels in downtown Milwaukee, WI) illustrated the reach of Pac-Man interest in 1982.

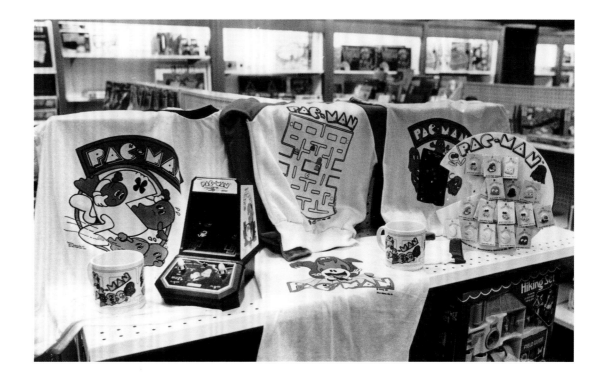

Pac-Man and Beyond

The small screen also played a significant part in Pac-Man's continued success. Premiering on ABC in September 1982, the *Pac-Man* show was a popular Saturday morning cartoon produced by Hanna-Barbera, and the first licensed kids' TV show to air after the FCC deregulated children's programming content. The Reagan administration and newly appointed FCC chairman Mark S. Fowler relaxed regulations around shows aimed at kids, which opened the door to all kinds of toy and game-based programming—and Pac-Man bowed at the perfect time to capitalize on this. *Pac-Man*'s pioneering success was the first salvo in a wave of cartoons with explicit ties to children's toys and merchandise, paving the way for TV-toy licensing juggernauts like He-Man and the Masters of the Universe, Transformers, My Little Pony, and more. The impact on children's programming was staggering, with cartoons featuring licensed characters increasing by nearly 300% between 1984 and 1985. By the close of '85, more than 40 animated shows were airing concurrently with licensed products and marketing campaigns—but *Pac-Man* was the first.[191]

Sandwiched between commercials for toys and sugary breakfast cereals, *Pac-Man* also spawned a raft of video game imitators and also-rans. Other arcade properties soon joined the rush to television adaptation, with characters like Donkey Kong, Frogger, Q*Bert, Pitfall Harry, and more featured in the 1983 *Saturday Supercade* cartoon produced by Ruby-Spears Productions for CBS. These shows also set the stage for more video game cartoons later in the decade and into the 1990s, like Nintendo's *Captain N: The Game Master, Adventures* of *Sonic the Hedgehog*, and *The Super Mario Bros. Super Show!*.

Ads in industry magazine *Cash Box* first teased the television series in April 1982, some five months before the animated show aired.

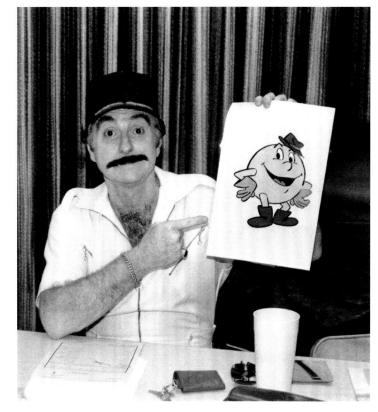

Promotional image showing the Pac-family, and the five (!) ghosts Blinky, Pinky, Inky, Clyde, and (in purple) Sue.

Actor Marty Ingels shows the character he lent his voice to in this undated picture.

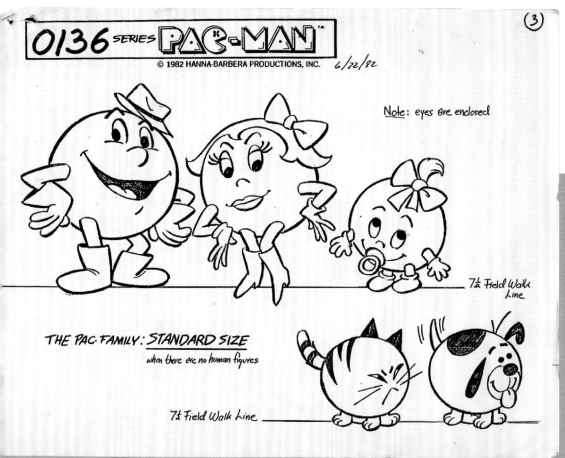

Production sheet for the Hanna-Barbera *Pac-Man* cartoon series, dated June 1982. Pages like this one were part of a "bible" used by animators when drawing and inking characters for the show's production.

Hanna-Barbera's designs and music for the Pac-Man television show echoed the studio's signature look. The show also expanded upon the meager plotlines of the arcade games, explaining that Pac-Man (voiced by Marty Ingels) lived in the Pac-Village of Pac-Land, with his wife, Ms. Pac-Man (nicknamed Pepper in the show), Pac-Baby, and a pair of pets, Chomp Chomp the dog and Sour Puss the cat. The show also featured the familiar ghosts and a new villain, Mezmeron. More fascinating than any single episode of the show was how it influenced future arcade games—both by Namco and Midway. *Pac-Land*, Namco's first arcade platformer in the series, was based on the show's animation.[192] The cancelled *Pac-Man & Chomp Chomp* (a re-skinned *Pac & Pal*) and *Count Pacula* would have featured elements and characters taken directly from the show. This extended Pac-family from the show continued to work its way into the Pac-Man video game canon, expanding both the cast of characters and the marketability of the once-lone Pac-Man.

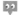

In this still from the Hanna-Barbera *Pac-Man* cartoon episode, "The Great Pac-Quake," villain Mezmaron literally dresses down the incompetent ghosts for their ongoing failures. Seen in the background were additional ghost "costumes" the characters would change into after being chomped by Pac-Man. This odd construction was used to get around the fact that censors (and Namco, reportedly) didn't want to suggest that any actual devouring was happening. Instead, it was explained visually that the ghosts would lose their clothing, with only eyes remaining, until making a wardrobe change.

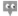

While its storylines were predictably thin, the background artwork for the Hanna-Barbera cartoon proved to be clever and memorable, with most elements containing circular references to Pac-Man and the ever-present dots and power-pellets. This animation frame comes from the first episode of the series, "Picnic in Pacland."

PAC-MAN™

FIGURINE PANINI

Cover of a Panini sticker book showing the Hanna-Barbera Pac-family. The company sold both empty sticker books and randomly-inserted packs of stickers that collectors could put into their books, trying to fill all of the predetermined spaces inside. The televised series would yield various new opportunities to expand Pac-Man's appeal.

With success came imitation, and sometimes downright theft. Because of the game's popularity, *Pac-Man* got an extra helping of both. With nearly overwhelming demand, some arcade owners and operators had a difficult time ordering *Pac-Man* cabinets. Even with significant production increases, Midway was still often playing catch-up. At different points, the backlog of games was anywhere from six to ten weeks long. "It is just unbelievable," said Midway director of sales Larry Berke in mid-1981. "Right now, I'm sitting on the largest number of *Pac-Man* back orders ever."[193] These shortages might have led some operators to explore other illicit avenues to secure their *Pac-Man* games. Some undoubtedly wanted *Pac-Man*-esque gameplay at a discount, and took a seedier route. Bootlegs and knock-off alerts became a regular occurrence at Midway, just part of daily life in their American parentage of Pac-Man.

 The *K.C. Munchkin!* game for the Magnavox Odyssey 2 home console (1982) generated a heated legal battle with Midway and Atari on the one side, and North American Philips Consumer Corp. and Park Magnavox Home Entertainment Center on the other. While Atari had exclusively licensed *Pac-Man* from Namco to produce a home version of the game, Magnavox's *K.C. Munchkin!* game cartridges hit store shelves months before Atari's version was ready, potentially eating away Atari's market for a *Pac-Man* home version. Judges eventually ruled that the game's makers "not only adopted the same basic characters but also portrayed them in a manner which made K.C. Munchkin appear substantially similar to PAC-MAN." *K.C. Munchkin!* was later pulled from store shelves. Cases like these would do much to establish benchmarks for U.S. copyright law in video games, particular in the arena of game look and feel.

Stan Jarocki called *Pac-Man* "the most infringed-upon game in the U.S." That claim might have been true, considering that increased demand for *Pac-Man* served as a clarion call for shady characters looking to capitalize on the *Pac-Man* arcade craze. Ed Adlum, publisher of *RePlay* Magazine, spared no vitriol when describing the situation to a reporter in 1982: "When you have a hit this outrageous, the vermin come out of the woodwork. We call them knockoff artists, a kinder word for thief. These people have stolen legitimate game inventions to the point where factories could have sold 25 to 30 percent more had it not been for illegal versions."[194]

"You've got to pick your battles. Some of them weren't making two dimes, and you don't want to go to the trouble to sue them."

Tom Nieman, Bally Marketing VP

The industry responded, in part, by forming the Amusement Device Manufacturing Association, a trade group that sought to deal with the issue. David Maher, an attorney who represented the ADMA, said, "It's a serious problem. Every manufacturer has this litigation going on constantly."[195] But Midway wouldn't—and couldn't—avoid these constant confrontations, as they were responsible for stewarding the brand and intellectual property licensed from Namco. Midway had registered its copyright of Pac-Man in October, 1980.[196] So, the lawyers went to work. As of March, 1982, Midway had filed at least 20 copyright lawsuits in federal courts and two in Canadian courts against counterfeit makers and distributors.[197]

The company even took out industry ads challenging companies who would traffic in unlicensed Pac-Man goods. The tone of one print advertisement was unmistakable. It featured a defiant Pac-Man in boxing gloves with a headline that read "Don't Trifle With A Heavyweight." The text promised strong action in response to bootleg merchandise or games: "We have acted forcefully to halt production, distribution & sale of unlicensed products and will continue to pursue any manufacturer, distributor or retailer who tries to infringe on our rights." Midway helped lead the way in this area, and soon other manufacturers were diligent in registering copyrights and trademarks, running confrontational ads, and fighting illicit makers, as Midway had done with Pac-Man.

"There was a lot of stuff ripped off," said Tom Nieman, VP of marketing for Bally. "You've got to pick your battles. Some of them weren't making two dimes, and you don't want to go to the trouble to sue them. But if anybody got a product off the ground that looked like it was making money, then we'd go file suit and chase them. It was not just the Pac-Man license, but they ripped off the artwork too." Larry Berke also mentioned that, at the time, Midway employed a team of six lawyers to deal with ongoing copyright litigation.

Patrice Paglia, Pac-Man licensing manager from 1983-1985, noted that combating piracy and unauthorized products was—and is—a standard part of licensing. "We had a lot of significant knockoffs in different product categories that we were pursuing," she said. "So Legal had a good hold on what was going on in terms of the licensees' products. Our licensees were really good eyes and ears out in the marketplace for knock-offs, particularly when they were over in Asia in a factory. We had raids on factories, I remember."

Jarocki also opened up on the ongoing issue to *Cash Box* magazine, when discussing the bright future of licensing in video games, a practice he helped popularize: "One of the biggest problems we've had has been in licensing infringements, which seems to be as large an issue as the actual copyright infringement of the games," he said. "There are as many infringements on stuffed animals bearing Bally-Midway characters as there are bogus coin-op games, and we have a full-time staff member who actively pursues these cases. In fact, we've spent about $100,000 over the last couple of months to track down and prosecute people who use our trademarks without licenses."[198]

"Our licensees were really good eyes and ears out in the marketplace for knock-offs. We had raids on factories, I remember."

Patrice Paglia, Midway licensing manager

Midway also coupled legal action with raids closer to home. In July, 1981, the United States Marshals Service (USMS) seized 36 video game cabinets and other PCBs from the Starship Fantasy Arcade, as well as other *Pac-Man* and *Rally-X* materials found in a warehouse in Tempe, Arizona. The company also sued the Sutra Import Corporation for importing a bootleg version of *Pac-Man*, called *Gobbler,* for $130,800.[199] Knockoff *Packman* games were found and confiscated in Providence, Rhode Island. Midway issued restraining orders, filed civil actions, and saw law enforcement impound all varieties of bootleg goods on their behalf.

Paglia also mentioned that "in a good licensing program you have to have surveillance. There should be surveillance in place with Customs, so when they bring their merchandise into the States, it gets cleared at Customs because Customs is aware that they are an authorized licensee. There's a whole legal part of licensing that we have to dot our i's and cross our t's."

Another issue that cropped up in parallel to the incredible demand for *Pac-Man* cabinets was outright theft. Conscientious law enforcement agencies and trade associations teamed up to track down games with serial numbers to find the stolen games. "This business of picking up a *Pac-Man* at 2:00 in the morning and heading south is commonplace and we believe it's going interstate, so we put our emergency newsletter into effect," said Paul Corey, the president of the Ohio Music and Amusement Association (OMAA).[200]

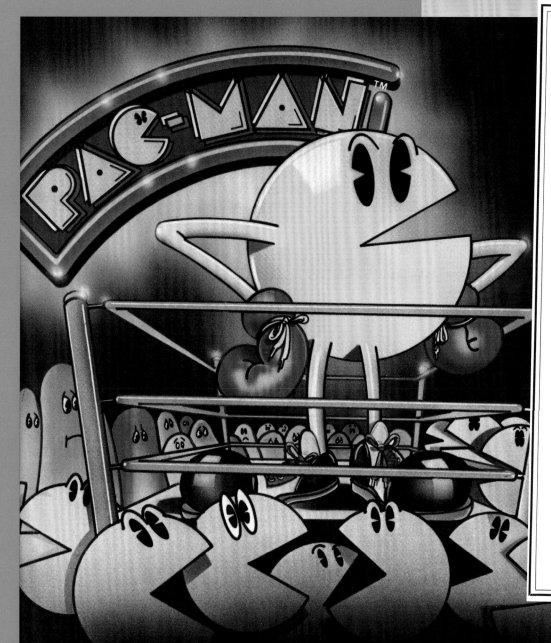

Don't Trifle With A Heavyweight

The Visual Evolution of Pac-Man

Midway felt it was important to adapt the look and feel of Pac-Man—the arcade cabinet, glowing marquee, and design of marketing materials—to appeal to its American audience. This was not an unusual occurrence in an era of imported Japanese video games, but the freedom and flexibility Midway's artists and designers enjoyed was unusual. They had nearly free rein to re-interpret the character, adding additional layers of visual identity and meaning onto the canvas of Pac-Man in popular culture.

But they didn't respond well to Tadashi Yamashita's original *Puck Man* artwork and its kawaii-inspired style. "When they brought [the *Pac-Man* art] over, we were like, 'This is it?!'" said Bally art director and pinball artist Greg Freres. "It was just so minimal compared to what we had known in pinball, and it just seemed crude. This was going to be a big hit game? Really?! We just couldn't believe it. We just all laughed, and we hadn't played the game yet either, so we didn't know the addictive properties of the game yet." The artists at Midway had grown up on a diet of American animation and artistry, and their output reflected that. Midway arcade cabinets were characterized by flat, solid-color illustrations, with a more realistic bent, and Bally pinball machines sported elaborate, multi-color imagery that was as detailed as it was elaborate. The U.S. had yet to experience the full force of imported Japanese design and style that would come later in the decade.

The art departments at both Bally and Midway were both well-respected in the industry, known for their beautiful backglass artwork in pinball and strong cabinet designs in arcade games. While the company was decidedly more engineering-driven, the art department was relaxed and laid-back, with artists and designers in t-shirts as they toiled away over art tables or lightboxes.

But deadlines were immutable, as they were a crucial point in a complex, multi-stage manufacturing process. Artists still had the power to influence the process and make their mark. Paul Faris, group art director first at Bally (and then the combined Bally-Midway) came to the company in 1976 to help develop a more art-driven, realistic style for Bally's pinball cabinets. He believed that illustration should be the focal point of a pinball game. "It should attract someone to come up and play the game," he said. "It should be like a movie poster." However, re-envisioning *Pac-Man* would require a different creative approach and a team of many hands, both inside and outside the company.

An Artistic Mystery

The iconic artwork for Midway's *Pac-Man* game strayed significantly from the designs created for *Puck Man* cabinets, arcade flyers, and advertising in Japan. Midway's first rendition of the character had no arms or nose. Instead of the black, pie-shaped eyes of Puck Man, this Pac-Man sported bulging red eyes and gigantic feet—the legs of a creature built for running, almost like a cartoon jackrabbit. And instead of the wide grin of Puck Man, Midway's creature had a knowing smirk, what Midway artist and production designer Rich Scafidi called his "sh*t-eating grin."

But who created this singular version of Pac-Man, the character design that graced more than 96,000 arcade cabinets and countless pieces of merchandise? Clues point to one possibility. From 1978-1982, Rich Scafidi essentially served as a one-man art department at Midway—but when his workload ballooned, Scafidi would call on outside help. The months surrounding *Pac-Man*'s arrival were particularly busy, and it seems likely Midway tapped its network of freelancers again in order to launch *Pac-Man*.

"To be honest, we were a little ashamed of the work, and were sorry we weren't working in advertising agencies."

Gordon Morrison, pinball and arcade artist

Artist Gordon Morison was a fan of comic books and Western animation like Hanna-Barbera's *Scooby-Doo*. He worked as a commercial artist for advertising agencies and had a healthy solo client roster as well. But Morison was best known for his work as the signature artist for pinball maker Gottlieb, just down the road from Midway. He served as artist and art director for a company called Advertising Posters Co. Ad Posters, as it was known in the industry, did contract art and silkscreen printing for pinball and arcade companies across the Midwest. At the company, Morison was subcontracted to create art for more than 137 pinball games including *Buck Rogers*, *Sinbad*, *The Incredible Hulk*, and more. His style combined comic books, pop art, and art deco, and he reportedly did artwork for Bally in that era. He left Ad Posters in 1980, finding new projects at places like Stern Electronics and NOW Comics, where he later drew the comic book *Slimer!* based on the popular *Ghostbusters* franchise.

The side artwork on Midway's Pac-Man arcade cabinet is something of an anomaly, since it bears little resemblance to either the on-screen version or Namco's original character drawings. Artist Gordon Morison might have created this memorable (but unusual) image.

Even in his 60s, Morison carried a heavy workload, often working 70 hours a week. He passed away in 2000. It seems likely that Morison did the character artwork for *Pac-Man*, while Scafidi did the compositing and logo design for the cabinet. The original *Pac-Man* cabinet artwork has a cartoony, wry sensibility and linework that seems to fit Morison's style. Nuggets of information from former Bally and Midway employees connect like puzzle pieces to potentially add up to Morison as the artist.

But if he created such iconic art, why didn't Morison share that fact with the world? Was *Pac-Man* just one job in a career of hundreds of pieces? Was it outside his wheelhouse of pinball backglasses? Or maybe just not Morison's favorite commission? Perhaps there was a clue to his feelings about pinball and video games in the foreword he penned for Keith Temple's 1991 book, *Pinball Art*. "Pinball was then just a job," Morison wrote. "Now it's got a strong element of nostalgia. In fact, to be honest, we were a little ashamed of the work, and were sorry we weren't working in advertising agencies."[201] This sentiment came from a man who illustrated almost 150 games over nearly two decades.

Maybe this cartoony art style was, in fact, "kid stuff," as Scafidi reportedly called it, but Midway's version of Pac-Man left a lasting impression on millions of video game players across the decades. It tied the addictive gameplay to a striking visual, emblazoned on the side of the bright, yellow arcade cabinet. But that red-eyed rendition of the character would shortly be dethroned as the dominant marketing image of Pac-Man in the 1980s.

Veteran pinball and video game artist Gordon Morison seems like the likeliest candidate to have created the original *Pac-Man* cabinet artwork while freelancing for Midway. Morison created the artwork for dozens of pinball games, mostly for manufacturer Gottlieb, as well as art for comics company NOW Comics.

Right: Updated digital recreation of the original stenciled side art from Midway's Pac-Man arcade machine.

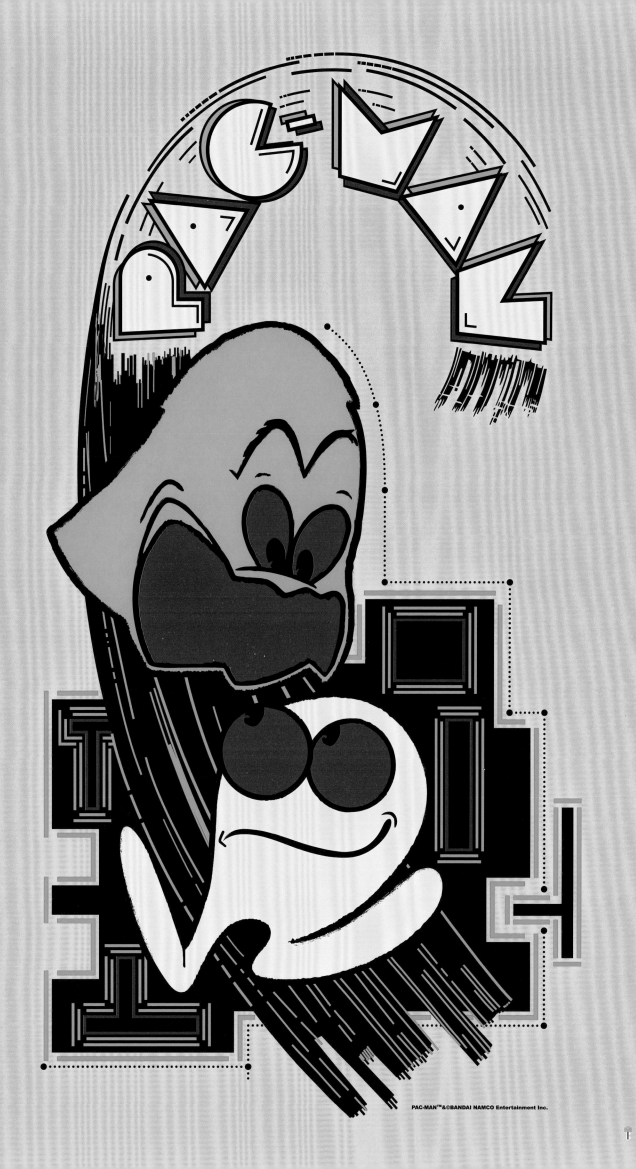

PAC-MAN™&©BANDAI NAMCO Entertainment Inc.

Artistic Mastri

Don Mastri was an independent graphic designer and illustrator in Chicago, best known for his package design and illustration work, with extensive credits for Kraft, Hormel, and other big grocery brands. Mastri was hired through a third party roughly six months before *Pac-Man*'s release, tapped to create a promotional poster for "Midway's Amazing New Video Game," as it was described in the advertising copy. Whether by specific art direction or his own instincts, Mastri eschewed the American cabinet art (which might not have been finished at the time) and seemingly returned to the Japanese *Puck Man* art for inspiration. His poster art is almost an American homage to the broken-line illustration of Puck Man created by Namco artist Tadashi Yamashita. But Mastri's work still manages to underscore the idea that Pac-Man was strangely two-dimensional, a flat graphic chomping his way across the video game screen. His Pac-Man seems less expressive as he stoically grabs ghosts and stuffs them into his gaping maw. This image's power rests in its ability to capture the chief confrontation of the game in a single panel—though that distillation might have been lost on Mastri himself.

"He didn't understand what an arcade was, and it didn't interest him enough to be excited about it," said his son, Don Mastri Jr. But the younger Mastri did say his father was proud of the finished art, and that the *Pac-Man* poster hung prominently in his downtown design office. The elder Mastri, who passed away in 2018, might not have grasped the power of *Pac-Man* in the '80s, but his son certainly did.

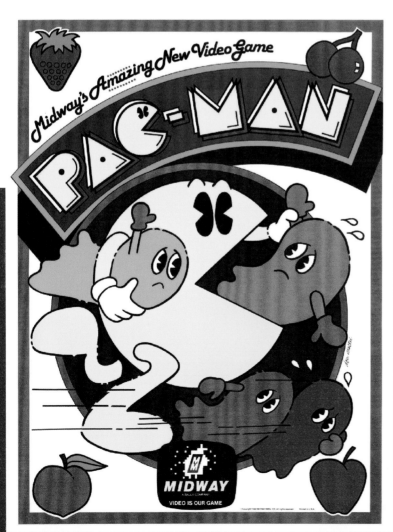

Artist Don Mastri created one of the more recognizable versions of Pac-Man in this promotional poster for Midway's arcade game. This image would go on to be used in a variety of licensed goods, from t-shirts to board games, ash trays, and arcade tokens.

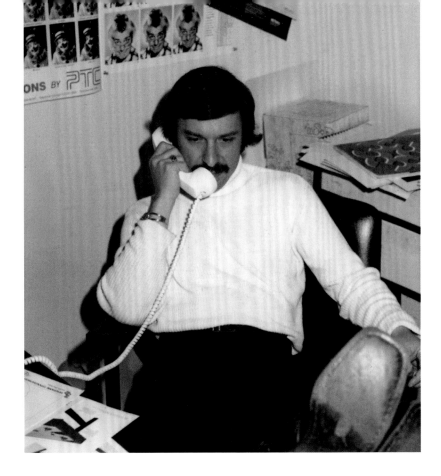

Don Mastri Jr. explained his trouble convincing kids at school that his father was behind the Pac-Man art. He finally did so—by wearing a t-shirt with the graphics emblazoned on it. Mastri's art on the shirt and other early products bore a small copy of his signature—an unusual sight in an industry that rarely gave public credit to artists.

Mastri's art graced the poster and then quickly spread to all sorts of licensed items, from TV trays, to board games and bed sheets, appearing both in its original form and a reworked version for other Midway Pac-Man products. Because of its frequent use on toys and games, Mastri's design would become one of the era's most iconic Pac-Man images, assuring him a sliver of video game fame, even if he never set foot in an arcade.

Creativity Inside Midway

Inside Midway, the art department continued to develop the look of Pac-Man used in marketing, licensing, and the array of arcade sequels that followed from 1982-1984. A group of artists at Bally-Midway quietly evolved the design of Pac-Man on arcade cabinets, posters, and more.

One artist in particular had a huge influence on the look of Pac-Man during that period. Pat McMahon's cartoony, whimsical art style telegraphed humor and personality, which was just the formula needed for Midway's Pac-Man games. McMahon created art for *Baby Pac-Man, Jr. Pac-Man, Mr. and Mrs. Pac-Man,* and illustrations for licensed products like calendars, storybooks, and LP records. Dubbed "PAC McMahon" by his co-workers, McMahon was the go-to artist at Midway when the Pac-style was needed. "He was sort of our in-house cartoonist," said art director Paul Faris. "He could paint and draw realistically, but he had a really good knack for caricature and cartoons. We felt pretty highly about his talent. This was an opportunity to kind of evolve, instead of rubber-stamping Pac-Man. It was a chance to flesh out the Pac-Man characters more, to give them a more human quality. So, I intentionally brought Pat in to be the comic relief kind of guy, when you had to have more whimsical kinds of things rather than heroic fantasy. He was the one that you'd sit down and tell him to sketch a bunch of new characters for a comic book or something and he'd do it. He'd be that good and just had that instinct."

Fellow Midway artist Paul Niemeyer praised McMahon's artwork. "His characters always had so much personality and they were just brimming with character—very, very 3-D and expressive," Niemeyer said. "His characters were so fluid and multi-dimensional. Just looking at them, you saw a backstory." Most of Midway's Pac-family iterations grew out of McMahon's style, which referenced early American animation of the 1930s, like the cartoon characters coming out of Fleischer Studios—Koko the Clown, Betty Boop, Bimbo, and Popeye the Sailor. Those characters had knobby knees and stringy, elastic arms and legs, as well as "pie eyes," the cutout eyes that pre-dated Pac-Man—but cleverly fit the character's modus operandi.

McMahon and other artists were moving in one direction with the Pac-Man artwork, but television success deemed to push them in another. Once the 1982 Hanna-Barbera cartoon became a hit, its designs became a de facto art style for the artists, who were directed to move towards that look created by the television animation house.[202] In fact, it also drove some of the design decisions for some of the later video games, including Namco's *Pac-Land* and the re-branded *Pac & Pal* arcade game, *Pac-Man and Chomp Chomp*.

McMahon also worked on licensed Pac-Man materials, a Christmas-themed feature for *Good Housekeeping*, and a slew of record albums and storybooks for the children's record label Kid Stuff—all in addition to his normal video game artwork. He helped establish the look of Pac-Man at Midway, while also adding a bit of world-building at a time when very little Pac-Man "canon" existed. Even though he recalls that the art was done under deadlines and "really down and dirty," McMahon tried to keep the designs interesting for himself and others. "I was always trying to tell a story," he said. "I was just trying to put characters in there to fill up the space with something interesting for the eye. I used to throw something in there that was irreverent or to pay homage to someone I knew or something I was into at the time," he said. "I didn't know what I was doing. I was a kid fresh out of school. So, I was having a blast. Anything they wanted to throw me, I'd say, 'Let me take a look and I'll see what I can do.'" McMahon's art was the gravitational force behind Midway's Pac-Man style, holding the designs together even as the look evolved.

Many of the artists found ways to bring their own signature styles into the art—sometimes literally. Though it was against official company policy, some illustrators (both in pinball and video games) hid their signatures in obscure parts of the finished game or pinball artwork. The trick was to keep from getting caught. Paul Niemeyer hid his initials, "PEN," in the art for *Pac-Man Plus*.

Midway artists could take those sorts of liberties in that era because they weren't beholden to a set Pac-Man style yet. In today's world of global licensing and strict policing of intellectual property, brands develop and issue strict guidelines for how their signature characters should be rendered. But that wasn't the case when Pac-Man arrived on U.S. shores. The Midway Pac-Man style "went a lot of different directions before they figured out what they wanted, or which way they were going to go with it," McMahon said. "I don't think anybody thought it was going to be an earth-shattering thing until it really, really took off."

Artist Paul Niemeyer, hired right out of college, was a self-described "pinball addict." He would skip his classes after roll call, then sneak back to the school's student center for some games. "I think that's where the real college education came," he said. Niemeyer arrived at Midway in 1982, and was immediately sent to the art department, which was situated amidst engineers and test equipment. Their work area was surrounded by machines that performed stress tests on triggers, pulling them thousands of times a day. But the cramped quarters and deafening noise were temporary, a by-product of growing pains brought on by the phenomenal success of *Pac-Man* and *Ms. Pac-Man*. After joining Midway, Niemeyer was initially disappointed that he wasn't part of the pinball department. "This video game thing is a craze," he thought. "It won't last." But that didn't prove to be the case.

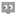

From left to right: artist Margaret Hudson, artist Greg Freres, director of Creative Services Paul Faris (posing with artwork for the 1981 pinball game *Centaur*), and artist Paul Niemeyer.

Niemeyer was responsible for the artwork gracing video games like *Satan's Hollow*, and worked on three Pac-Man sequels, as well as contributing to *Tron*, *Tapper*, and *Spy Hunter*. The work experience was nearly unmatched in his professional life. "It was going to work with some really, really awesome people who were phenomenally talented beyond your wildest imagination," he recalled. "It was a very cool place—especially when they combined the art departments and we had one huge art department. I learned more in that two years than I probably learned in all the years before that. Those two years that I worked with all those great people shaped me into the illustrator I became."

Presiding over the blended Bally-Midway art department was Paul Faris, an artist in his own right, who brought other experiences to the task of managing the company's creative flow. A former school art teacher, Faris was an even hand for the stable of creatives. Bally VP of marketing Tom Nieman recalled that when Faris joined Bally, "all of the sudden [he] was the heart of the department. I think that being a teacher—that ability—made him a great manager of that department. He was mentoring all those guys." Greg Freres saw the merger with Midway's video game team as an opportunity. "It was awkward at first, but we tried to act as one big, happy family," he said. "Because video was booming and we were here to make video games even better looking—the cabinets, the marquees—everything that went with it. We wanted to make sure we would take what we knew from pinball and enhance the experience on video games as well."

Artist Margaret Hudson arrived at Bally by answering a help wanted ad in the *Chicago Tribune*. "I pretty much wanted to do any job that was in an art department," she said. "I had a fine arts degree, but nothing in technical drawing, which was Rapidograph [pens] and cutting Amberlith [film] for color separations and doing logos. Back then we didn't have computers you could do anything with." Faris hired her for the detailed, precise artwork in her portfolio—the kind of patient attention to minutiae that would serve the art department well.

Pat McMahon created this piece of Pac-Man art to be used to promote licensing of the character. It appeared both in a calendar as well as trade advertising under the headline, "Our License Is Special."

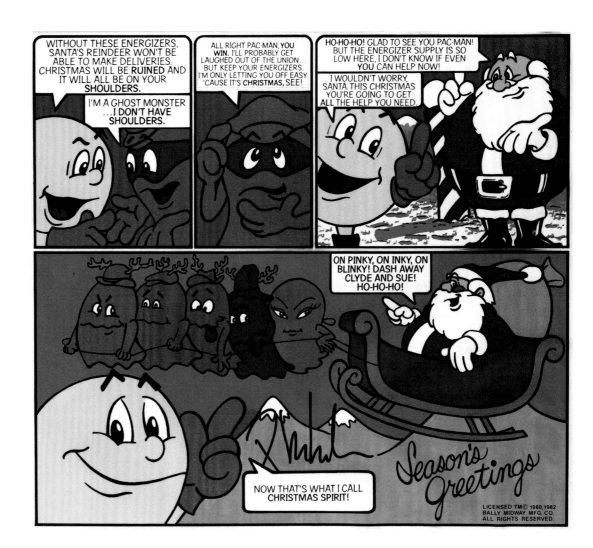

Detail from a four-page Pac-Man mini-comic that ran in *Woman's Day* magazine during the 1983 holiday, with all art by Midway's Pat McMahon. The character designs were loosely based on the cartoon style, but also echoed some of Midway's own looks for the Pac-family.

Left: Artist Pat McMahon in 1981.

Below: Advertising graphics team members Mike Springer, Mari Beth Bush, and Dave Wittekind.

She continued and developed as a production artist while also taking over art duties on her own games, like *Eight Ball Deluxe* and *Spectrum*. She also often crafted art layouts, inks, color separations, and airbrushed colors—like she did on the *Mr. and Mrs. Pac-Man* pinball game with Pat McMahon. Even in the male-dominated industry, Hudson found a way to make her mark, create great artwork, and have fun. "We would call it 'Bally High,'" she said. "It was kind of like high school. We were all friends in the art department." The success of *Pac-Man* allowed additional freedom for the creative teams. "*Pac-Man* was the crowning glory," said Niemeyer. "That was certainly the cash cow. It was fun because it let [Midway] do fun, crazy, wild stuff and not have to worry too much if it made a lot of money or not—because they were already making a lot of money. You can be a little more daring, a little more dangerous." Without a brand style guide for Pac-Man and its sequel characters, creating artwork for the games "was really shooting from the hip," Niemeyer said. "But the thing is, everybody trusted each other because we all knew our job. There was no hand holding. You could just say, 'Hey, this needs to be done,' and put in on their desk and then it would be done. And it would be done well, probably better than you even thought. That was cool because there was always this creative energy in that department. That's how things were done. We were reinventing the wheel every time we sat down, and we didn't mind it."

Artist Tony Ramunni came to Bally from Williams Manufacturing in 1980 to create pinball artwork, and was thrilled to make the move. Bally had made technical breakthroughs with 4-color process silkscreen printing, which made production much easier, while also giving artists the freedom to craft more realistic renderings and art reproduction. He also knew Bally-Midway by reputation and wanted to go "where the art was the best in the industry," he said. "I wanted to be part of it, and I wanted to get better too. With those guys I got better too, I think." He credited Paul Faris and the team for creating an atmosphere of growth. "We would help each other a lot. Or, I should say, they would help me a lot."

In the bevy of Pac-Man sequels there was always some new aspect to be considered. Paul Niemeyer worked out new lettering because the team needed to render the word "Professor" for the quiz game, *Professor Pac-Man*. His hand-lettering experience paid off, because he ended up creating a whole Pac-Man-styled alphabet. Looking back on his experiences contributing to the Pac-Man games, Niemeyer was taken aback. "Wow, how lucky I was to have been even just a small part of it—such a unique thing, this perfect little place in time. I wish I could just put a frame around it and hang it on the wall because boy, it was an amazing time."

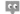

Kevin O'Connor, graphics manager, alongside the artwork for *Flash Gordon*.

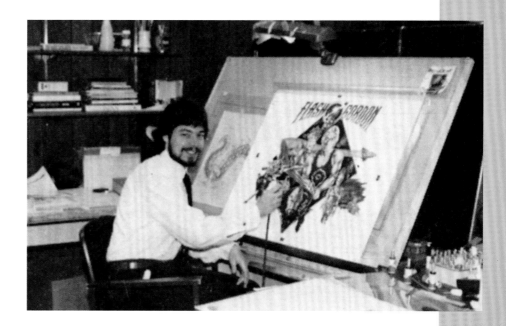

The production graphics team of Paul Niemeyer, Laurence Dabek, and Rick Scafidi.

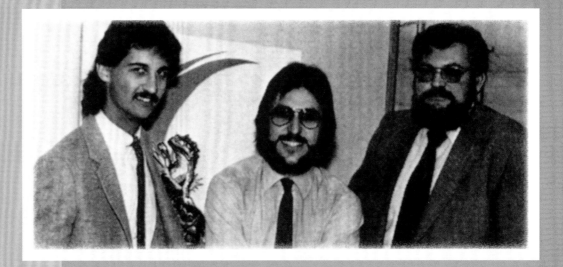

Artists Pat McMahon, Tony Ramunni, Margaret Hudson, Doug Watson, and Greg Freres.

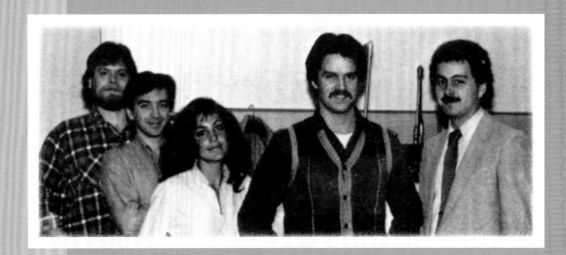

Illustrator Tony Ramunni was known for his stylish art for many pinball machines, and also contributed to Midway's original art for the *Ms. Pac-Man* arcade game. Here he is seen working on the backglass artwork for the 1981 Bally pinball game, *Elektra*.

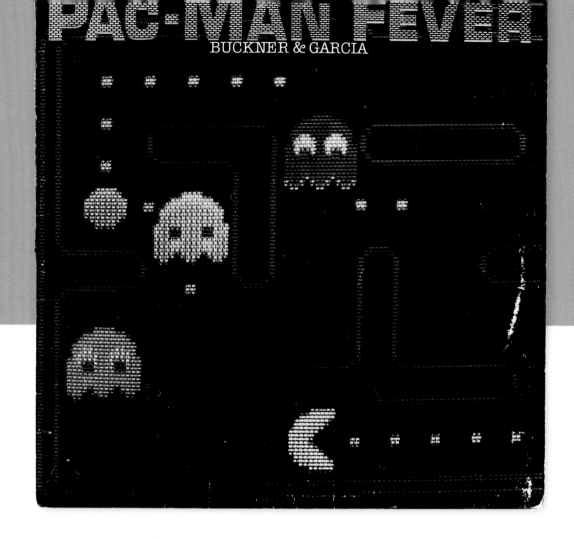

BUCKNER & GARCIA

A Pocket Full of Quarters

In 1981, songwriters Gary Garcia and Jerry Buckner were sitting in a restaurant called Shillings in Marietta, a suburb of Atlanta. After spending the evening in a nearby recording studio, the duo broke for dinner. That's when they noticed the *Pac-Man* arcade game. During the day, the duo worked as songwriters, crafting jingles and catchy ear worms for businesses and advertising agencies. At night they played together in bands in small, smoky clubs, hoping to attract the attention of record labels. But that night, they noticed a crowd around this particular video game. "We'd never seen one before," Buckner recalled. "And we saw it and people playing it, and so we tried to play. Well, just like everybody, we got hooked on it and started coming in there all the time, playing the darn thing." Garcia told a reporter, "We put $15 to $20 in it before we figured out how to play it. Then every day we'd go and try to beat the machine."[203]

The two grew up together in Akron, OH, and had later reunited as a songwriting duo, finding some success. They produced a full-length version of the theme song for the popular television show *WKRP In Cincinnati* which charted on the *Billboard* Hot 100 in 1981. But they had yet to truly break through while juggling both writing pop jingles and their bigger aspirations as rock musicians. After playing *Pac-Man*, an idea started to take root. "'I wonder if we could do a song about this game that would help our jingle business?'" Buckner asked his collaborator.

On the suggestion of their manager, Arnie Geller, Garcia and Buckner did just that. They wrote a song in short order, and called it "Pac-Man Fever," recording a demo in Buckner's apartment. The duo brought it back to their management company, the Buie/Geller Organization (BGO). "We sat down and wrote the song in about two hours," Garcia said. "We both had a couple of ideas. We went into it to write a good pop song and to make the sound effects of the machine operating kind of secondary to the writing. We are pop songwriters. Our first priority was to have something that would be a hit song regardless of what it was about. It would be a good song."[204]

Geller liked the sound of the demo, so they went back into the studio to record a full track. Garcia sang vocals and played guitar, with Buckner on keyboard and backing vocals, along with a raft of session musicians they knew. Soon, BGO sent the single out to the major labels. "And nobody wanted it," Buckner said. "They didn't know what it was. They had no idea. These people especially were like ivory towers—they weren't out playing, going to clubs, or playing video games—so they didn't know anything about it." But BGO had a local record label they occasionally used to release material, so the company pressed a record in the hopes of getting some local airplay in December of 1981. And sure enough, Jim Morrison, the program director of 94Q, a popular Atlanta radio station, played the song one morning while regular host Gary McKee was on vacation.

A promotional flyer for Buckner & Garcia's single, *"Pac-Man Fever."*

This sales flyer bills *Pac-Man Fever* as "the one and only album for a video-crazed America," and explains the marketing hook of video games to a potentially ignorant sales audience.

"He plays the song and the phones explode!" Buckner said of the deluge of calls to 94Q that followed. Because of the immediate and unusual response, Morrison played the song again in the same hour, which was unheard of. BGO sold 12,000 copies of the record in Atlanta within one week—after just three plays of the song.[205]

"They pressed out some records real quick, and by the end of the week the sucker is just flying out the door. And so, everybody's excited."

Jerry Buckner, Songwriter

This drew the attention of CBS Records/Columbia. Buckner heard a story that Columbia's head of A&R, Mickey Eichner, brought the song home and his young son, a *Pac-Man* player, went crazy for it. CBS moved quickly to ink a deal with Buckner & Garcia, but they still had to work out the Pac-Man rights with Midway, who held the exclusive license from Namco. "We had done some licensing with Columbia," said Tom Nieman, Bally's VP of marketing, who ended up handling the licensing arrangement. "We knew the people at Columbia, so we cut the deal and we got 45 cents—or whatever it was—per album. But those checks started rolling in!" After the deal was finalized, things moved quickly. "They pressed out some records real quick, and by the end of the week the sucker is just flying out the door. And so, everybody's excited," Buckner said.

The lyrics, written mostly by Garcia, spelled out a pattern familiar to *Pac-Man* players:

I got a pocket full of quarters,
and I'm headed to the arcade.
I don't have a lot of money,
but I'm bringing everything I made.
I've got a callus on my finger,
and my shoulder's hurting too.
I'm gonna eat them all up,
just as soon as they turn blue.

'Cause I've got Pac-Man fever;
Pac-Man fever.
It's driving me crazy.
Driving me crazy.
I've got Pac-Man fever;
Pac-Man fever.
I'm going out of my mind.
Going out of my mind.
I've got Pac-Man fever;
Pac-Man fever.
I'm going out of my mind.
Going out of my mind.

I've got all the patterns down,
up until the ninth key.
I've got Speedy on my tail,
and I know it's either him or me.
So I'm heading out the back door
and in the other side;
Gonna eat the cherries up
and take them all for a ride.

I'm gonna fake to the left,
and move to the right;
'Cause Pokey's too slow,
and Blinky's out of sight.

Now I've got em' on the run,
and I'm looking for the high score;
So it's once around the block,
And I'll slide back out the side door.

I'm really cookin' now,
eating everything in sight.
All my money's gone,
so I'll be back tomorrow night.

'Cause I've got Pac-Man fever;
Pac-Man fever.
It's driving me crazy.
Driving me crazy.
I've got Pac-Man fever;
Pac-Man fever.
I'm going out of my mind.
Going out of my mind.
I've got Pac-Man fever;
Pac-Man fever.
I'm going out of my mind.
Going out of my mind.

But just as the records started shipping out, the holiday season began, and things went quiet. Perhaps the early enthusiasm was premature, and the single would die on the vine. Instead, several Florida radio stations played the song to great effect during the Christmas break, and vacationing East coasters heard it, bringing their demand back home to places like Philadelphia, Cleveland, and New York. Radio DJs in Philadelphia reported being swamped with requests to play the song.[206] The single sold more than 100,000 units in its first week of release![207] With that incredible response confirmed, CBS clamored for an entire album, mere weeks later. Buckner and Garcia rushed back into the studio in a whirlwind of songwriting and recording, to flesh out a whole album's worth of songs—in just three weeks. But CBS wanted an entire album—of video game songs. The duo acquiesced, even though it meant abandoning some of their other non-video game songs, which they felt were just as strong.

Buckner and Garcia visited several arcades, conducting first-hand research on the most popular games they saw, writing new songs like "Do the Donkey Kong," "Ode to a Centipede," and "Goin' Berzerk." They would record one song in the studio during daylight hours and then stay up half the night writing the next song to record. In that era, none of the video game companies had audio recordings of their games available, so the group sent engineers to local haunts to record the sounds from actual arcade machines. The game sounds of "Pac-Man Fever" were captured in a deli near their recording studio.

Buckner & Garcia in a live show
at The Moon Shadow, Fall 1982.

07SP 598

パックマン・フィーバー
PUC-MAN FEVER ・ BUCKNER & GARCIA
バックナー&ガルシア
C W マウストラップ/MOUSETRAP

¥700

The single was also released in Japan as "Puc-Man Fever," with lines and background vocals being re-recorded to reflect the Puck Man name most recognized in Japan in 1982. This version shipped with wildly colorful, arcade-inspired album art.

German Singer Gerald Mann created a cover version of the hit song, and called his "Pac-Man Fieber." He posed with an incredible, furry version of the titular character on the single's cover. The song was also accompanied by a charming, low-budget video shot in an arcade, with costumed Pac-Man and ghosts dancing about in a park.

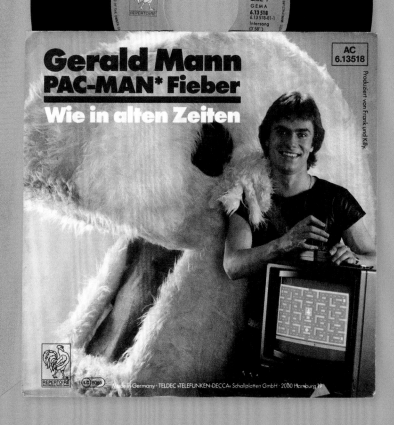

When asked if the two worried about being written off as one-hit wonders, Garcia replied, "To be honest, we do worry about that—about being considered a novelty. But if you remember, The Beatles were considered a novelty, and so were The [Rolling] Stones. We feel the music business is really a way of communicating with people and touching a responsive chord in their lives. When you've sold a million albums it proves you've done just that—so who cares what they label you?"[208]

CBS worked hard to tie the record tightly to the popular game market. One ad promoting the album read: "'Pac-Man Fever,' the single inspired by the most popular video game in America, is a huge hit! Its driving rhythms have inspired even championship players to new heights!" The record's inner sleeve included "five winning *Pac-Man* patterns." Buckner and Garcia also benefited from some of Midway's own vertical synergy to promote the record. Midway would fly the duo to the crowded grand openings of its Aladdin's Castle arcades for personal appearances in malls and shopping centers.[209]

The record rocketed up the charts, eventually settling at number nine on the *Billboard* Hot 100 chart in March of 1982, and was certified gold by the RIAA for selling one million albums. The single eventually sold 1.2 million copies by the end of 1982, and had sold 2.5 million copies as of 2008. VH1 ranked it at number 98 on their list of 100 Greatest One Hit Wonders of the '80s. "I knew it was really good and I felt it was magical," Buckner said. "I thought you could just feel it. But I never dreamed it would do what it did. I mean, that record went around the world."

The song, with its catchy lyrics and beat, wasn't just a merchandising tie-in. It captured the reigning zeitgeist—not only of *Pac-Man*, but also of the larger "video craze" infiltrating popular culture. Its opening line ("I got a pocket full of quarters and I'm heading to the arcade") served as a kind of anthem for the rise of arcades and the '80s pop culture that followed. "Pac-Man Fever" sprang from the minds of a talented songwriting duo who had gotten a taste of the video game future.

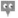

The "Pac-Man Fever" single was certified gold by the RIAA for selling more than one million copies, and had sold 2.5 million copies as of 2008.

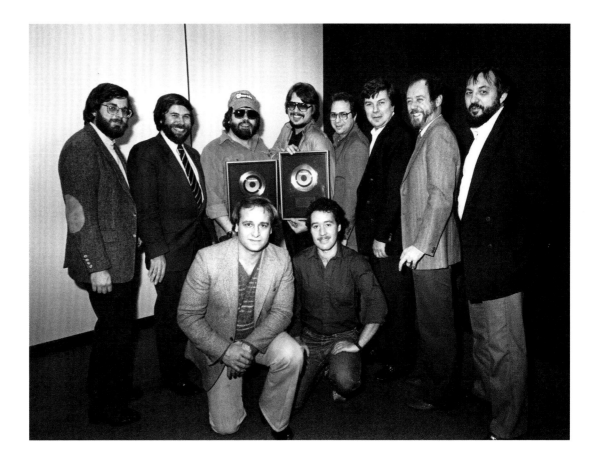

Conquering the Home with Atari

In 1981, Atari was at the top of the home video game market. After staking a claim as a pioneer of coin-op arcade games with the success of their game, *Pong*, the company later aimed at the living room. The company released the Atari VCS (Video Computer System) in 1977, and sought to sell a video game experience directly to American consumers. The console—with its signature faux woodgrain, black, ribbed styling, and single-button joysticks, initially emerged with tepid sales. But Atari's fortunes turned when they released the first home console version of the hit arcade game, *Space Invaders*. This exclusive Atari cartridge version caught fire and catapulted the Atari VCS (later renamed the Atari 2600) to "must-have" status for video game fans. The console continued its stratospheric success, as Atari churned out dozens of hit cartridges, broadening the video game market beyond a player's neighborhood quarter-swallowing arcade.

The company, owned by media conglomerate Warner Communications, hoped lightning would strike twice. Joe Robbins, former president of Bally's Empire Distributing and current Atari Coin-Op president, brokered a deal with Namco's Masaya Nakamura that granted Atari rights to bring *Pac-Man* to Atari home consoles. The agreement was initiated by Robbins and Nakamura in 1980, and formally approved on April 27, 1981.[210] The initial deal was costly for Atari, but the payoff would be worth it if Atari could deliver the yellow dot muncher to millions of *Pac-Man* fans.

In early 1981, Atari assigned 23-year-old programmer Tod Frye to the task of bringing *Pac-Man* to the Atari 2600. The huge fan interest in a home version meant that Frye would shoulder some lofty expectation. Even amidst a cast of quirky characters at the famously free-wheeling Atari headquarters in California, Frye stood out.

Atari launched a sizable campaign for the introduction of their Atari 2600 *Pac-Man* game, even while their advertising diverged significantly from both Namco's and Midway's depictions of the Pac-Man.

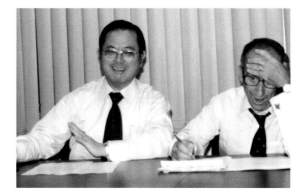

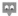
Namco president Masaya Nakamura and Atari's Joe Robbins signed an initial agreement in 1980 for the rights to bring *Pac-Man* to Atari's home consoles.

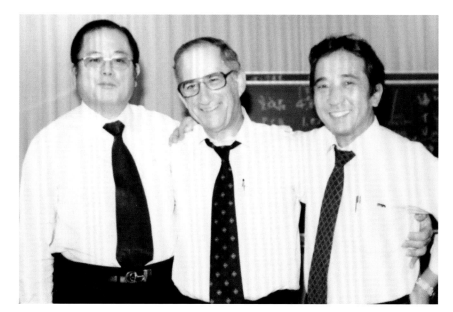
Nakamura, Robbins, and Namco's Hideyuki Nakajima embrace after signing the deal that paved the way to Atari's eventual Atari 2600 *Pac-Man* game.

LOVE AT FIRST BITE.

Quick-witted, his hair already receding in his 20s, Frye was infamous for barking like a dog and scaling Atari's narrow halls—planting a foot on each of the hallway walls—to amble down the corridor high off the ground. (A close encounter with a sprinkler head left him with 23 stitches in his forehead and ended his wall-crawling days.) Inside the company, Frye was considered talented but undisciplined, and his earlier game, a version of *Asteroids* for Atari's 8-bit computers, was a solid (if unspectacular) effort.

"The effort was to catch the essential feeling, the ethos, the spirit—the soul of Pac-Man."

Tod Frye, Atari programmer

Shortly before beginning the *Pac-Man* translation, Frye had a candid conversation with his boss, Dennis Koble, that made it clear he needed to live up to expectations or consider looking for work elsewhere.

So, Frye took on the challenge of *Pac-Man*, attempting to execute it on the 2600's much simpler hardware. Already more than four years old, the 2600's technology was behind the times. The hardware of the *Pac-Man* arcade game had 100 times the capability of the 2600—a console designed to play *Pong*-style games. It was unable to create complex backgrounds, using only chunky, blockier playfield graphics. Needless to say, the feat was daunting—and Frye accepted the mission as his first game for the console. Faced with severe technical limitations and necessary compromises, Frye considered his options for the first-ever home console version of *Pac-Man*. He likened it to the condensed adaptation of a classic novel like *Treasure Island*—retold in a single comic book. In Frye's mind, the Atari 2600 Pac-Man would have to be different. "So, when I was doing *Pac-Man*," he said, "I was thinking of it as an abridged adaptation."

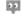

Programmer Tod Frye working on his 2600 development system at Atari in 1983. The monitor displays an experimental game kernel for a 2600 version of *Ballblazer* which was never completed.

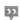

In this industry flyer, Atari teased many of the promotions they planned for the release of Atari 2600 *Pac-Man*, including a "National Pac-Man Day."

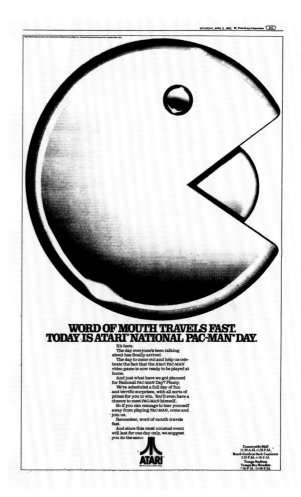

Atari kicked off the bulk of its marketing for its *Pac-Man* game with a series of ads that ran in newspapers across the country.

"The effort was to catch the essential feeling, the ethos, the spirit—the soul of Pac-Man. *Pac-Man* was known to be a repeated pattern game. So, I worked out a very precise, repeatable logic for how the ghosts worked—not the one Iwatani used, but that wasn't computationally possible for me. What that actually means is, like coin-op *Pac-Man*, my *Pac-Man* produces completely reproducible patterns. If you do the same thing every game, it will do the same thing every game. And that's actually the level at which I understood the spirit of *Pac-Man*. It's a fundamental." He also utilized available game space to preserve the two-player, turn-based system of the original, believing that was also a core aspect of the arcade game.

Frye later told a reporter, "I think we're more involved in a brand-new art form that is evolving itself and that, I believe, is here to stay."[211] As he toiled away on the game, Atari's marketing machine had kicked into high gear. Its 2600 *Pac-Man* was announced with much fanfare and attention—far more than the original arcade game or its sequels. Pac-Man's popularity as a whole had gathered steam since the successful release of *Pac-Man* and *Ms. Pac-Man*, and now Frye's home *Pac-Man* would have the white-hot spotlight trained upon it, along with a $1.5 million dollar marketing campaign: A week of full-page advertisements in the New York Times and TV commercials.

Pre-orders were in the millions. An event Atari called "National Pac-Man Day" would be held in 25 cities across the country on April 3, 1982, with "personal appearances" by Pac-Man. More than a month before the game's release, Atari spokesman Jeff Hoff said, "Without a doubt, it will be our best-selling cartridge. I won't give any numbers, but I'll go as far to say it could account for up to 25% of everything done in the home game industry this year."[212]

Frye buckled down and committed to the project with grit, completing *Pac-Man* in six months of grueling 80-hour weeks. Inside Atari, other programmers congratulated him for the work and the final product. Outside, success seemed guaranteed. *Pac-Man* flew off the shelves, selling an estimated 7.7 million cartridges and earning almost $200 million for Atari. By every metric, it was an incredible triumph. In fact, it would go on to be the best-selling game of all-time for the Atari 2600. For his part, Frye was unaware of the media blitz surrounding the game, but its success did not leave him untouched. Under Atari's new system of profit sharing, Frye was awarded 10 cents for every cartridge sold. Within a matter of months, he was a millionaire, eventually earning more than $1.3 million dollars. "It was overwhelming. It's like winning the lottery," he said. "You don't deal with that as a 26-year-old. A lot of marijuana and cocaine. It completely changed my life. There are things I would do differently if I could have."

But shortly, negative press began cropping up. *Electronic Games* magazine panned the game: "Considering the anticipation and considerable time the Atari designers had to work on it, it's astonishing to see a home version of a classic arcade contest so devoid of what gave the original its charm." *Softline* computer magazine said it looked "less like Midway's original than any of the pack of imitators."

What were the issues? Die-hard *Pac-Man* arcade fans could see the differences, even if they didn't understand why changes were made. The game's colors were different, swapping the thin blue maze lines and black background for a bright blue background and chunky, orange maze—reportedly because Atari had a policy of avoiding black backgrounds for fear of phosphor burn-in on television sets.

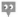
Atari's *Pac-Man* version looked markedly different from the arcade original.

It was also said that inside the company, only space-themed games were to have black backgrounds. For his part, Frye saw other Atari 2600 arcade translations taking liberty with their color palettes, and decided to do the same. "I wanted to add more color to the maze instead of black and blue, so I chose the colors," he said.[213] Each of the ghosts were the same color, and flickered often as they traversed the screen. The familiar maze shape and proportions had been changed to fit the more horizontal TV dimensions. Overall, the game looked, played, and sounded markedly different than the arcade game so many knew.

Pockets of fan criticism and reviews passed Frye without notice, while he worked on his ambitious *Swordquest* series of games for the Atari 2600. Perhaps Atari's high-intensity marketing heightened expectations to an unreasonable level, amplifying the backlash when the game wasn't a pixel-perfect rendition. To some, it didn't seem to matter that Frye's *Pac-Man* was created as one of the earlier arcade game translations for a much simpler system. Over the years, negative reviews, internet commentary, and the calcification of ideas have given the game a reputation as a cash-in or a half-hearted programming effort.

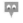
An Atari promotional photo used for in-person Pac-Man events like signings and appearances, 1982.

Frye disagrees. "*Pac-Man* was very, very credible," he said. "The things the press doesn't like were just the fact that it was the first. The idea of what it meant to be a faithful representation of *Pac-Man* was not established. It did not exist at the time I wrote *Pac-Man*. There is a direct connection between 2600 *Pac-Man* and arcade *Pac-Man*, and I was influenced by arcade *Pac-Man* when I made mine. We would have fixed the obvious, easy-to-fix things that people harp on if anyone, anywhere in the human species, had known at that point. History was being made. We were just finding out what the rules were. That's what it is to be a pioneer."

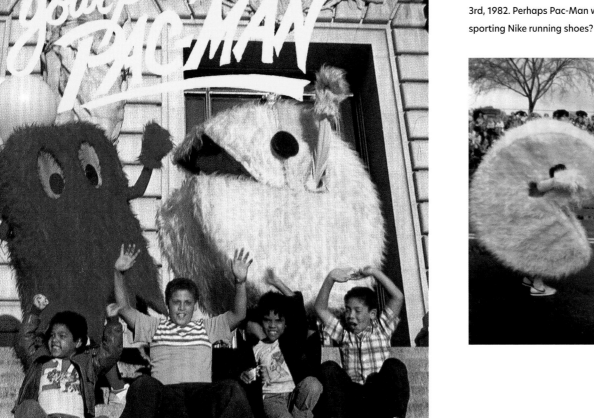

Pac-Man chases a playful ghost at a "National Pac-Man Day" event in Washington, D.C., on April 3rd, 1982. Perhaps Pac-Man was faster while sporting Nike running shoes?

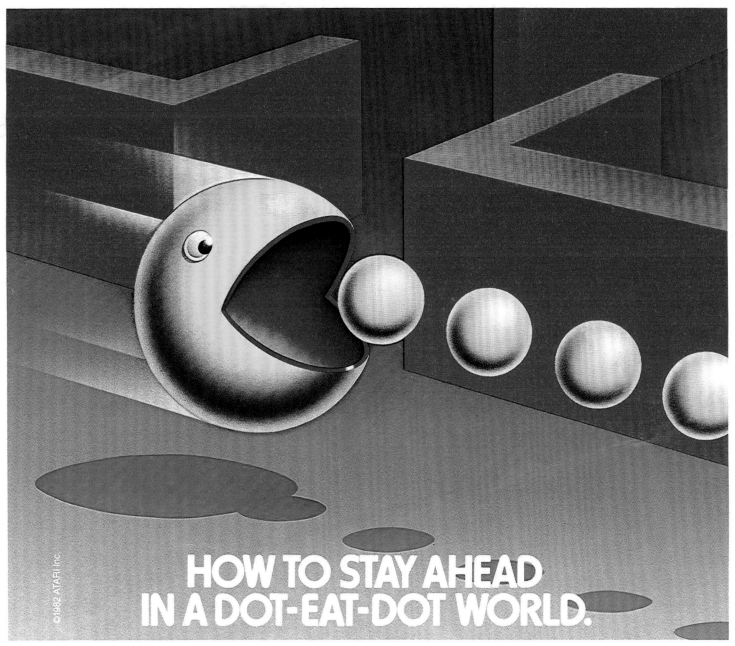

© 1982 ATARI Inc.

HOW TO STAY AHEAD
IN A DOT-EAT-DOT WORLD.

The way ATARI stays ahead is simple: we just give America a steady diet of the most exciting, challenging home video games we can come up with.

Like PacMan.* It is now the most popular arcade game in the world. After all, how many other games let you steer a hungry, dot-like character around in a maze, where it eats up other, smaller dots and an occasional Power Pill? And how many other games let you chase little blue ghosts around until they change color and start pursuing you?

The most important question is, how many other companies will offer a home video game

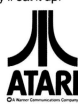

program of PacMan*? Again the answer is obvious. Because only ATARI consistently brings the world's most popular arcade games into the home. We did it with Space Invaders,** we did it with Asteroids,™ and this spring, we'll be doing it with PacMan.*

We'll also have many other new games coming out in 1982—including Defender† and Berzerk††—and we'll be supporting them with the biggest advertising and promotional program in our entire history.

All of which is sure to be appreciated by consumers everywhere. In fact, we're certain they'll eat it up.

*Indicates trademark of Midway Mfg. Co.
**Indicates trademark of Taito America Corp.
†Indicates trademark of Williams Electronics Inc.
††Indicates trademark of Stern Electronics Inc.
™Indicates trademark of Atari Inc. © 1982

ATARI
◎A Warner Communications Company

He believes that *Pac-Man* was a wake-up call for both programmers and fans. The unstated goal of future home translations would be strict fidelity. It seems that some fans wanted the 2600 version to mirror the beloved arcade game, even if that wasn't possible given both the technical and time constraints of the day. "A lot of people who played it were disappointed, and a lot of critics hated it," Frye explains, almost 40 years later. "I characterize it as the first major critical flop, which, bizarrely enough, was a commercial success—and I have no good data around how people actually thought about it."

But Frye has also asked himself another question. "Should I have loved *Pac-Man*?" he wondered. "Was that my job? Would it have been better? I honestly do not know. I was a *Defender* player, not a *Pac-Man* player. I loved *Missile Command* and *Defender* and *Robotron*, but I played *Pac-Man* as a professional. I have always thought that I very diligently overcame the astonishing obstacles and challenges of the Atari 2600 to deliver a really solid idea of the ideal *Pac-Man*—the essence of *Pac-Man*."

Regardless, Frye had high praise for the original arcade *Pac-Man*. "*Pac-Man* is just a brilliant freaking product," he said. "The guys in Japan just pulled together this human experience into this interactive device for the *Pac-Man* coin-ops that just tugs at the human heartstrings in a very specific way that had never been possible before." While he lauded the original game, Frye also pointed out that the Atari 2600 *Pac-Man* also played a part in bringing complex video game technology into American homes. "*Pac-Man* [2600] brought algorithmic media, computed media—computation into the living room," he said. "There's a lot of moving parts to it. I would have never come up with the design of the *Pac-Man* game myself, but I was capable of midwifing it into the living room. I delivered it into the mainstream." For better or worse, the Atari 2600 *Pac-Man* impacted the legacy of the brand and its characters, cementing it as a pop culture juggernaut.

Far left: In this advertisement, Atari touted its huge game library of arcade translations, including the smash-hit *Pac-Man*. Designed by advertising agency Doyle Dane Bernbach (DDB) in 1982, this piece once again showcases a Pac-Man illustration that did not match Atari's package design, nor the marketing of Namco and Midway. Atari seemingly had the freedom to create different versions of the character's look, in stark contrast to the tightly controlled world of licensed intellectual property that exists today.

Pac-Man does some light reading, holding a copy of *How to Win at Pac-Man* during festivities for "National Pac-Man Day" in 1982.

OF GHOSTS AND MONSTERS

Quick quiz—what do *you* call Pac-Man's four pursuers? Most English-speaking players know the Americanized Blinky, Pinky, Inky, and Clyde as the colorful quartet of ghosts in *Pac-Man*. They seem to float through mazes and tunnels and (mostly) disappear after being chomped. But the original spirit (pun intended) of Pac-Man's adversaries, created in Japan, is somewhat different. In fact, based on some specific word translation and shades of meaning, Japanese audiences might see their adversaries more akin to the legendary monsters Godzilla and Mothra.

LOST IN TRANSLATION

A minor debate rages among the arcade faithful about what to call these creatures, and the true answer is more opaque than the monsters themselves. In the end, the correct name depends greatly on which era *Pac-Man* players remember best. Toru Iwatani said that the Japanese manga *Little Ghost Q-Taro* (*Obake no Kyutarō*) was his chief inspiration for the four enemies, and the eponymous star of that comic series, a shape-shifting blob with big anime eyes, does bear a certain resemblance to the creatures in the game. But the official *Puck Man* cabinet designs didn't use the Japanese term "obake" for ghost.

Instead, its arcade instructions read: "When the Puck Man powers up, the Monsters [Monsutaa] start to run away." And this wasn't an isolated incident, either. Namco's advertisements and flyers also use the same language. "Controlling Puck Man with just the 4-directional lever, you go along the course," a September 1980 ad in *Game Machine* magazine read, "And by erasing the dots and counter attacking the monsters, you aim for the high score."

Thus, most original Japanese players would have considered them "monsters," especially since the Western idea of a stereotypical ghost—a floating entity with a bed sheet draped over its head—is very different from the Japanese conception of spirits. Matt Alt, an American writer and translator living in Japan, who has written extensively about Japanese pop culture, explained: "In Japanese folklore, a ghost is a 'someone'—the often angry soul of a dead person—and they can be very scary," he said. "The word for them is 'yurei,' and those are the things that curse you." These would not be confused with the "obake" in Japan, Alt said. "Obake, also known as yokai, aren't 'someone,' but 'something.' The basic concept is similar to that of our Cookie Monster: he who eats cookies. What he does is who he is; he's a personification of that behavior. The creatures in *Pac-Man* are closer to that lineage than 'ghosts' as Americans think of them."

Still, this original "monster" designation generally remained when Pac-Man first crossed the Pacific. Midway called the creatures monsters in most of its subsequent arcade sequels besides *Ms. Pac-Man and Jr. Pac-Man*. But today these four colorful characters are almost universally known as "ghosts" in the West. How did that happen?

MY FRIEND FLICKER

Some point a finger at the Atari 2600 home version of *Pac-Man*, the game that utilized a programming technique of "flicker" to display all four opponents on the screen at once. Programmer Tod Frye used the 2600's limited hardware to draw the four pursuers in a sequence of successive frames, alternating which ghosts got drawn on each frame, leaving players with an impression of semi-transparent characters, easily interpreted as "ghosts."

Atari's marketing supported this idea, as they were called ghosts in the game's manual and promotional materials when the game launched in 1982. But while Atari certainly helped popularize the spectral idea of "ghosts," the American public was probably most responsible for the name change over time. Early newspaper and magazine features often mentioned ghosts when describing the game, like *Commercial West* magazine did in 1981: "*Pac-Man*… involves a mischievous character who dashes through a video maze gobbling energy cookies and destroying pursuing ghosts."

The name change speaks to American cultural sensibilities: to U.S. players, Blinky, Pinky, Inky, and Clyde looked and felt more like ghosts. Their visual specificity as apparitions made more sense than the broader idea of "monsters," which, to Westerners, could look like anything from Bigfoot to the Creature From the Black Lagoon.

The original *Pac-Man* arcade game itself submits a final, confusing piece of evidence. In the second and third game intermissions, players get a possible peek behind the curtain—or clothing—of one of the creatures. In the second act, while chasing Pac-Man across the screen, Blinky snags himself on an exposed nail, and some of his clothing tears away to reveal a bare leg. He stops and rolls his eyes in embarrassment, and the intermission ends. But the third act intermission has him return, sporting a patch on his repaired outfit. But after exiting the screen at the left, Blinky returns naked, dragging what is left of his clothes behind him. Is he just a monster in ghost's clothing after all?

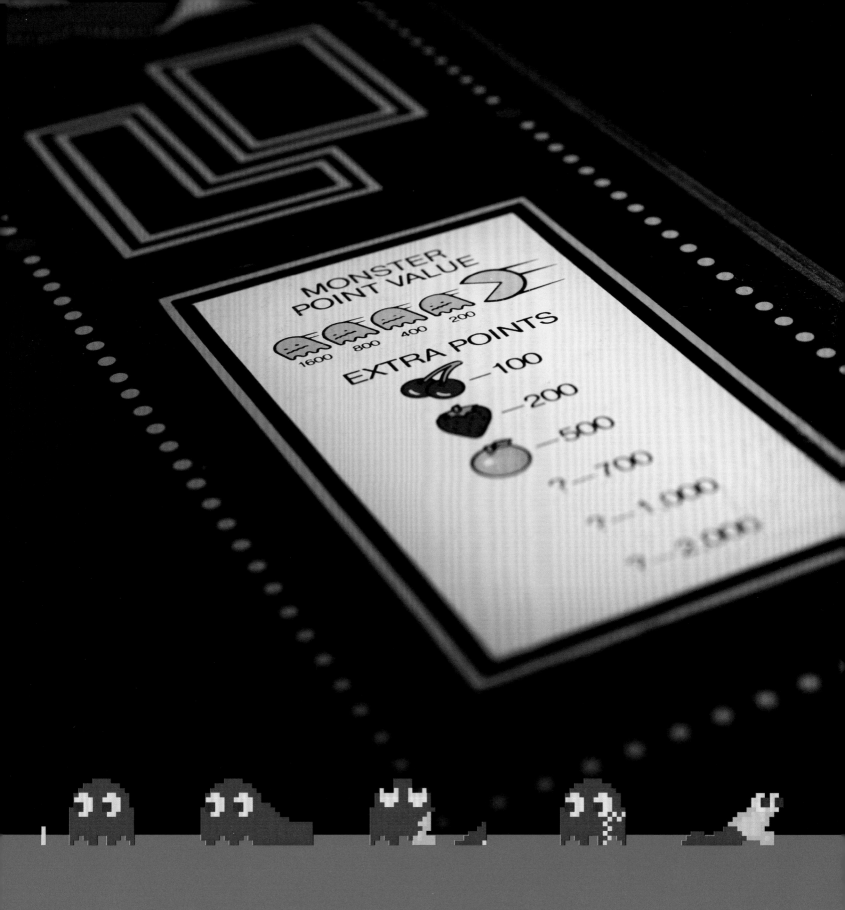

MONSTER
POINT VALUE

1600 800 400 200

EXTRA POINTS

—100

—200

—500

?—700

?—1,000

?—3,000

This "wardrobe malfunction" depicts a brief progression of Blinky's costume troubles, and suggests what lies beneath. In the second and third intermissions of the *Pac-Man* arcade game, players get a possible peek behind the curtain—or clothing—of one of the ghosts. Amusing, but it does little to clarify what exactly the ghosts/monsters are!

At Home with Pac-Man

While Tod Frye developed *Pac-Man* for the 2600, Atari staff artist Hiro Kimura was trying to capture the game's flavor and energy—for the game's packaging.

Kimura was born in a Buddhist temple in Kyoto, Japan, and studied both in Hawaii and at the Art Center College of Design in Los Angeles. Recruited right out of school by Atari, Kimura accepted a staff illustrator position after meeting with art directors Jim Kelly and Steve Hendricks. Initially, Kimura wasn't sure if he could create the bold marketing images needed to sell video games. He remembered being anxious and unsure about the opportunity. "What really helped me was my childhood love of superhero comic books," Kimura said. "Thinking I'd outgrown the phase, I sort of put it aside as a past passion. Unleashing it helped me get into the video game mindset."

"I believe they assigned me to Pac-Man because my style was a bit whimsical, which sort of matched the game."

Hiro Kimura, *Atari artist*

As one of the Atari artists tasked with working on console game art, Kimura had a standard approach to designing the packaging art for a release. After playing and studying the relevant game, he "tried to get into the game world itself and function as a photographer, capturing scenes that best represented the game. I tried to visualize that and sketch out the most effective scenes."

While not all of Atari's artists did so, Kimura made a point of talking with the game programmers, to better understand the mechanics and to see which features they wanted to focus on. The typical turnaround for a single game box art was three weeks. "The first week was spent on concept sketches," he said. "My challenge was how to capture and communicate to possible purchasers the essence of the game within the given package space. Sketches were usually done in pencil, and once it was narrowed down to a few at the sketch meeting, I worked on colored pencil sketches. Upon final sketch approval, I researched any necessary references and drew a full-sized line drawing during the second week. After it was approved, I took it to the final version and completed the illustration by the end of the third week."

Kimura had created compelling art for *Yars' Revenge*, one of Atari's most successful original games for the Atari 2600, so *Pac-Man* was only his second full game package project. "I believe they assigned me to *Pac-Man* because my style was more whimsical," he said, "which sort of matched the game." But Kimura felt no pressure, despite being handed such an important game—one the company was counting on to be a success. In fact, he was unaware of how popular *Pac-Man* was. "I had absolutely no idea how eagerly awaited the home video game version was."

Kimura initially had free rein to re-interpret Pac-Man, and didn't have to fashion his work after Namco's cabinet art or that of Midway. "I was handed a blank slate for *Pac-Man*," he said. "I wasn't given any reference materials, character design, or any restrictions— and was totally oblivious to its burgeoning popularity. After watching the arcade version of the game, I started my first *Pac-Man* image."

But his first effort at capturing *Pac-Man* didn't go as planned. This original piece was an offbeat take on Pac-Man, which diverged significantly from the classic look used in other media. His Pac-Man had shiny, silver skin, with more angular features and long limbs. Kimura drew on the trend of ultra-reflective chrome, which was a very popular visual style in the '80s. He also incorporated a surfwear look for Pac-Man's clothes, including an icon of the character himself in the clothing. In the scene, Pac-Man was shown being chased by savage, colored monsters, a more literal interpretation of the original Pac-Man name translations. "In my childhood, I had this recurring nightmare of being chased by a huge cat monster. It may have crept into the image," Kimura said. He was close to completing the piece when Atari management asked him to change direction. "They were concerned that the 'ghosts' in it were too ferocious," he said. The piece was left unused by the company, and went unseen by the public until 2016, when it was showcased in the book, *Art of Atari*. For his part, Kimura returned to the literal drawing board for a fresh take. "I went back to play the arcade version and decided to take a cuter, gentler approach, to try and be more faithful to the graphics on screen."

After getting a deeper sense of the game, he took a different visual route—depicting the visceral moments of the game. "I was fascinated by the gameplay in which Pac-Man, usually chased by the ghosts, can turn and gobble them up once he takes the pill," Kimura recalled. "I really wanted to capture the thrill of that moment of 'eat or be eaten.'"

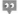
Kimura working on his initial vision of Pac-Man for the Atari 2600.

Artist Hiro Kimura conceived this first version of
packaging artwork for Atari's home *Pac-Man*
game. His offbeat take was very different than the
character's classic look.

Kimura adapted his approach and created an updated design for Pac-Man, borrowing heavily from the 2600 game's maze style and colors, and depicting the character in a unique way, with more sophisticated pie-eyes and shiny, rubbery limbs and running sneakers. While this version would be shelved at the 11th hour for a more literal rendering of the character (see left), this spherical one was still released on most *Pac-Man* cartridge labels and other iterations of the box packaging.

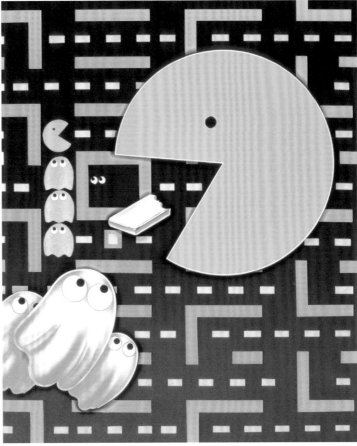

While Kimura had already created an approved version of Pac-Man art that was more spherical and true to the 2600 game left. Atari management asked him to revise it again. This final version of Pac-Man artwork was created with the idea that audiences might prefer a more literal, one-dimensional version of the character. This iteration was used for many advertisements and packaging of the game.

This new artwork featured Pac-Man in a lighter shade of yellow (to better match the game graphics), with a more spherical shape and subtle airbrush shading. The updated Pac-Man still wore sneakers and bore shiny, elastic limbs like in vintage cartoons. The ghosts had their own shared, pale pink color, and the dots were flattened, looking more like ice cream bars, after being transformed into "video wafers" to echo the 2600's blocky playfield graphics. This rendition of Pac-Man was used on cartridge labels, catalogs, advertising, sell sheets, and most boxes—becoming a familiar sight, tied to the best-selling game cartridge.

But still another change would be made. Late in the production process, a marketing executive at Atari felt that the box needed a more literal interpretation of Pac-Man, and the spherical character was replaced somewhat awkwardly by a two-dimensional depiction more closely resembling the game icon on-screen. This version of the box was produced alongside the previous one, with consumers receiving one variant or the other depending on game bundles, location, and sales outlet.

But Kimura wasn't finished with Pac-Man yet. He revived his initial approach for another adaptation of *Pac-Man*, this time for the version on Atari's 8-bit computer line. "When John Haag, the art director at the home computer division, asked me to illustrate the 400/800 *Pac-Man* package, I suggested bringing back the very first Pac-Man image, as they were under less restrictions. He approved the idea but suggested I give Pac-Man a yellow body this time. Since we seemed to have more visual freedom, I then proposed the idea of making the maze like a castle labyrinth, as it'd be visually more intriguing and John liked the idea." This iteration is quirky and energetic, though less well-known because this Atari computer line wasn't nearly as popular as the 2600, its signature console.

Hiro Kimura was allowed more flexibility in his designs for Atari's 400/800 computer version of *Pac-Man*. He playfully re-imagined the maze as a set of castle walls, and Pac-Man as a buck-toothed sprinter.

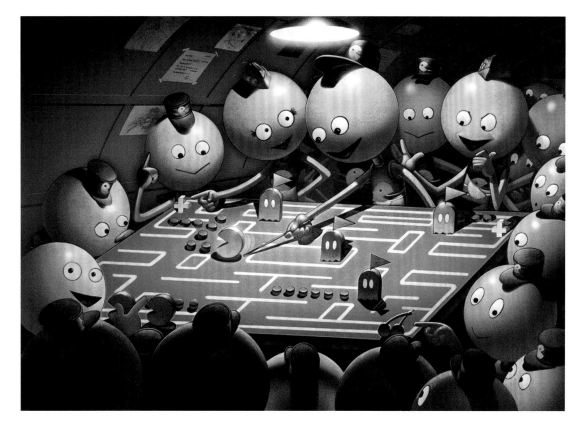

In this illustration for the manual interior for the Atari 400/800 release of *Pac-Man*, Kimura created a kind of strategic "war room" environment for the Pac-Man army and its gameplay. Eagle-eyed viewers will notice the female Pac-pinups gracing the walls behind the crowd of characters.

One of the more obscure pieces of Pac-Man art was Kimura's manual illustration for that same Atari computer version. In this piece, a group of Pac-Men and women are seen huddled around a military-style strategy table. For reference, Kimura photographed a scene from the TV show *McHale's Navy*. He also worked in some slightly racy details in the background that went relatively unnoticed by art directors, since they were approved without change. "I'd noticed G.I.s always had pinups on the wall," Kimura said, "so I thought, 'Why not with Pac-Men soldiers, too?'" Kimura spent three years at Atari and left just before the company was sold to Jack Tramiel in 1984. At that time, he was the last remaining staff illustrator. "I felt I'd done all I wanted to do within the game package limitations," he said. "I thought it was the perfect time for me to move on to pursue my dream of freelancing in New York City." He contributed a substantial chapter to the visual legacy of Pac-Man in the character's Atari home games.

This French advertisement for *Pac-Man* by Doyle Dane Bernbach (DDB) proves that ghosts exist, and once again touts the popular game translation to showcase the Atari 2600 to consumers.

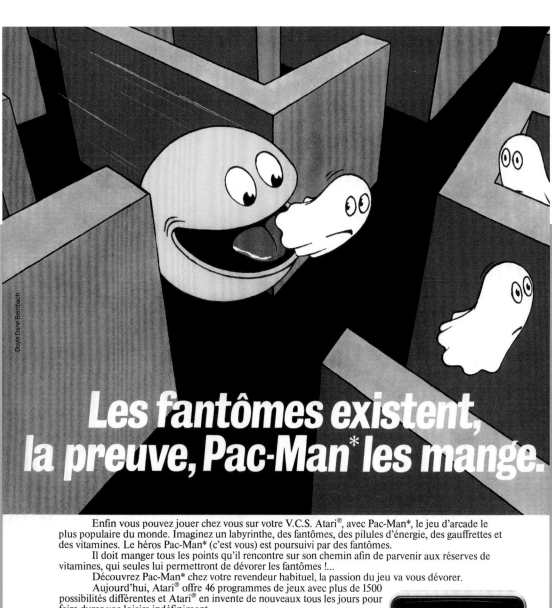

251

Pac-Man in Culture

More than four decades after the release of the original arcade game, Pac-Man continues to be relevant, influencing pop culture realms like fashion, advertising, film, and beyond. The signature shapes, visuals, and color palettes associated with Pac-Man and the ghosts have now become a canvas for a litany of willing creatives working in many disciplines. Whether in the service of nostalgia, beauty, or social commentary, Pac-Man continues to provide a cultural touchstone to millions around the world.

British designer Giles Deacon did his part to keep the yellow dot muncher in fashion. His 2009 Spring/Summer runway show focused on the '80s style icon, dressing the venue and runway in familiar images. Models donned ghost-colored dresses and bags (many with embroidered Pac-Men on them) or the spectacular candy-colored fiberglass Pac-Man and ghost helmets, designed by Stephen Jones.

This custom Pac-Man hot rod was originally designed by Larry Wood and built at Rod Powell's Custom Shop in Salinas, California. The car contained a Buick V6 engine, Volkswagen panels and Peterbilt truck fenders, taking three months to build. It debuted in October, 1982, and toured auto shows extensively in the '80s.

Pac-Man made its way into the political discourse. This 1982 cartoon by Kate Saley Palmer likened the hungry arcade machine to Ronald Reagan's ballooning budget.

The *Pac-Man* arcade game makes a cameo appearance in this promotional photo for the popular '80s sitcom, *Silver Spoons*. In it, child actor Ricky Schroder plays a boy who moves into a mansion filled with his father's toys, trains, and naturally, arcade games.

With *MAD* magazine parodying American institutions throughout its 67-year run, lampooning both Pac-Man and *TIME*'s famous 'Man of the Year' covers was an obvious choice. The surly Pac-Man was drawn by illustrator Robert (Bob) Clarke.

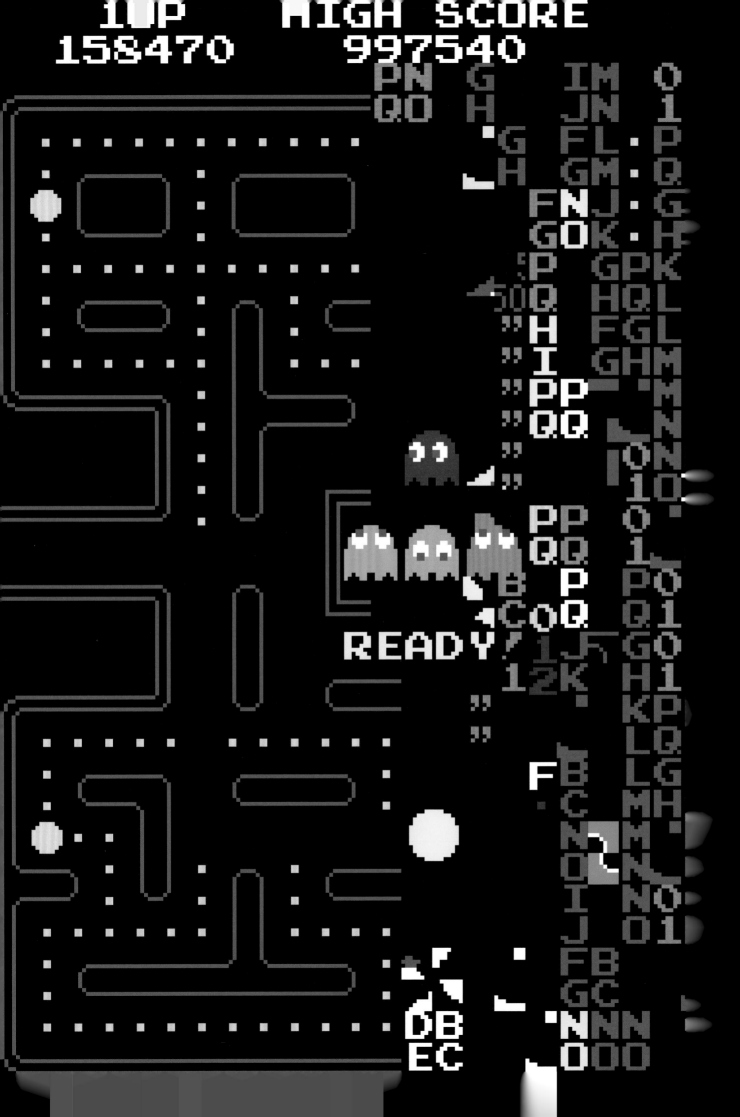

THE INFAMOUS LEVEL 256 GLITCH IN

You need to be an expert *Pac-Man* player to see it for yourself, but there's actually an end to the iconic game. And it's not a celebratory finale that Mario or Link might enjoy, but an inglorious, unintentional ending caused by a programming bug that initially went undiscovered by its programmers.

This conclusion occurs when a player reaches level 256, managing to survive that many mazes and the nefarious ghosts. As this new screen loads, the right side of the maze devolves into a jumbled mess of seemingly random colors, patterns, and portions of the game's characters. While it's still possible to navigate and eat dots on the left side of the maze, the other half blocks some of Pac-Man's passage, preventing him from eating the 244 dots needed to move on to the next level, effectively ending the game in a glitchy mess of color and frustration.

As early as 1982, video game players were discovering this screen. Teen gamer Paul Reynolds experienced the glitchy screen on his way to 3,157,000 points in a pizza place on August 17, 1982. And another player, 15-year-old Tim Balderramos, discovered it after scoring 3,187,360 points. He had read about others experiencing the same broken screen effect. "When you reach the end of the program, the thing starts freaking out and does odd things. All of a sudden my strategies didn't work, which made it almost impossible to play. So my last two men died," he told a reporter. Midway Manufacturing, the U.S. licensee of *Pac-Man*, was aware of the issue by this time. The company's advertising and sales promotion manager Jim Jarocki stated that "the game was never intended to be played that long." Others theorized that playing the game for that long had overheated or "frustrated" the machine, but that's not quite the case.

So why does this happen in a game lauded for its innovative programming? The reason behind this "split screen level" is based on the structure of the level counter, and its visual representation at the bottom right of the screen. For every level cleared, the game adds a symbol on-screen—first a cherry, then a strawberry, followed by an orange, and on and on.

This level counter is stored as a so-called "8-bit integer," a set of eight bits (ones and zeroes) able to represent 2⁸ or 256 different possible values. From level 1 to level 255, the computer has no problem visually representing the level counter as intended (carefully selecting a maximum of seven symbols).

Internally, the computer begins counting with "level 0," but then adds one number to show the player the symbol for level 1. So, the player's level 13 is actually level 12 for the computer.

Once a player reaches the 256th level, something dramatic happens. Adding "1" to the "255" within the program causes it to overflow back to "0." This shouldn't be a problem, but the computer also knows it has to show the player the new level symbols and reads its marching orders as "draw 256 level symbols, starting from symbol 1, until you reach 0." This causes the computer to draw 256 symbols on the screen all at once. The symbols start filling in the level counter bar, but since there's not enough space there, the computer overwrites the maze, from top right to the bottom of the screen.

Line by line, it draws fruits, keys, Galaxians, and other elements—but they appear garbled and incomplete. When the computer runs out of symbol tilesets to pull from, it uses sets meant for other things, like the game music. Eventually, the computer reaches "0," and stops drawing at the center of the maze. In the end, the screen immediately fills up with pieces and parts of the game's graphics and programming that are normally hidden or correctly displayed. The unintended chaos is beautiful, but nearly unplayable and 100% impassable.

One intriguing side effect of this infamous level 256 glitch is its effect on *Pac-Man* high scores. Iwatani and programmer Shigeo Funaki never intended for the game to end before players lost all their lives, but the herculean task is possible. And even then, there is a world of difference between arriving safely at level 256 and executing what players call a "perfect game." This second feat is even more difficult than the first: if a player can clear every pellet, energizer, fruit, and blue ghost without losing a single life on the way to level 256, and then use all their remaining lives to collect the maximum amount of pellets within that broken level, it leads to the ultimate high score, a perfect game of 3,333,360 points.

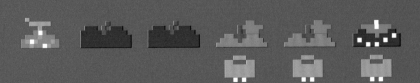

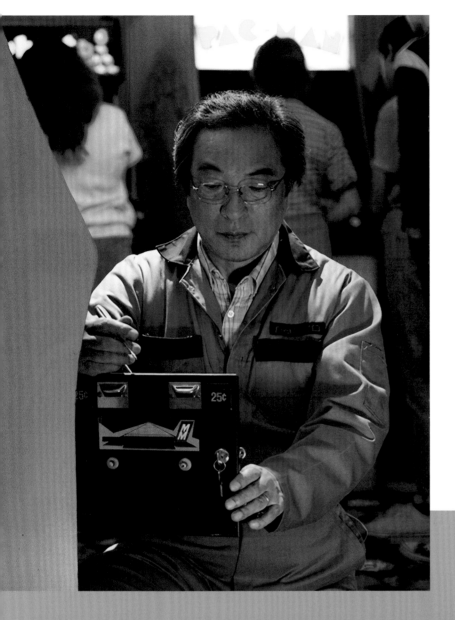

A variety of stills from the 2015 film, *Pixels*, directed by Chris Columbus. Pac-Man is rendered in spectacular fashion with special effects, and the character appears as the avatar of an invading alien force, who eventually bites off the arm of creator Toru Iwatani (played by Denis Akiyama). The real Iwatani also has a brief cameo in the film, working as a humble arcade repairman.

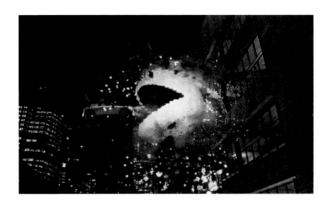

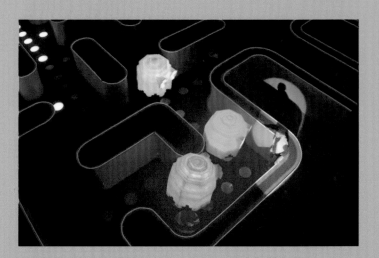

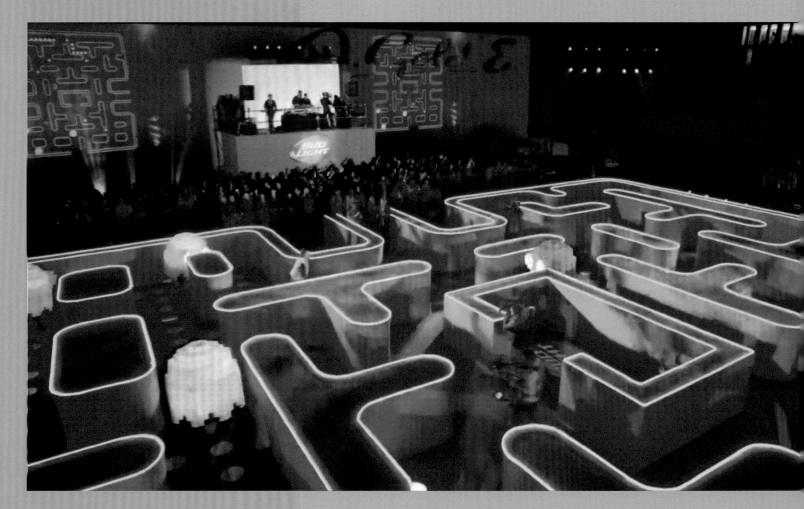

In 2015, Bud Light launched a Super Bowl commercial that featured a couple of friends stumbling upon a life-sized *Pac-Man* maze. One of them runs through the maze, avoiding ghosts. The spot was a continuation of the brand's "The Perfect Beer for Whatever Happens" campaign, created by ad agency Energy BBDO in Chicago. It generated a lot of buzz and more than a little bit of nostalgia. The ambitious set took place in a huge open area in downtown Los Angeles, and the elaborate production was expensive, coming in at a price that could "buy a few nice houses or one in L.A.," said executive producer Rob Tripas.

Pac-Merch

While Pac-Man was a huge success in video games, the character also conquered worlds beyond the screen. Nurtured by Midway's efforts in the U.S., the Pac-Man family grew into a licensing bonanza. Pac-Man (and his associated imagery) made its way onto hundreds of products, from the obvious to the bizarre. These licensed toys, food, and collectibles produced a huge variety of visual expressions of the character and his video game world. Blessed with surprising freedom in how Pac-Man could be depicted, creative marketers and product designers contributed their own unique iterations of the character, which led to a great variety of products. The following pages include just a sample of the hundreds of Pac-Man products released across the globe, providing just a taste of the smorgasbord available to Pac-fans over the years.

Pac-Man sneakers by Keds, complete with shoelaces printed with Pac-Man and an extensive row of dots for him to eat. Intriguingly, the shoes and packaging utilize artwork from Namco's Pac-Man marketing materials, which was unusual for most licensed Pac-Man products in the United States.

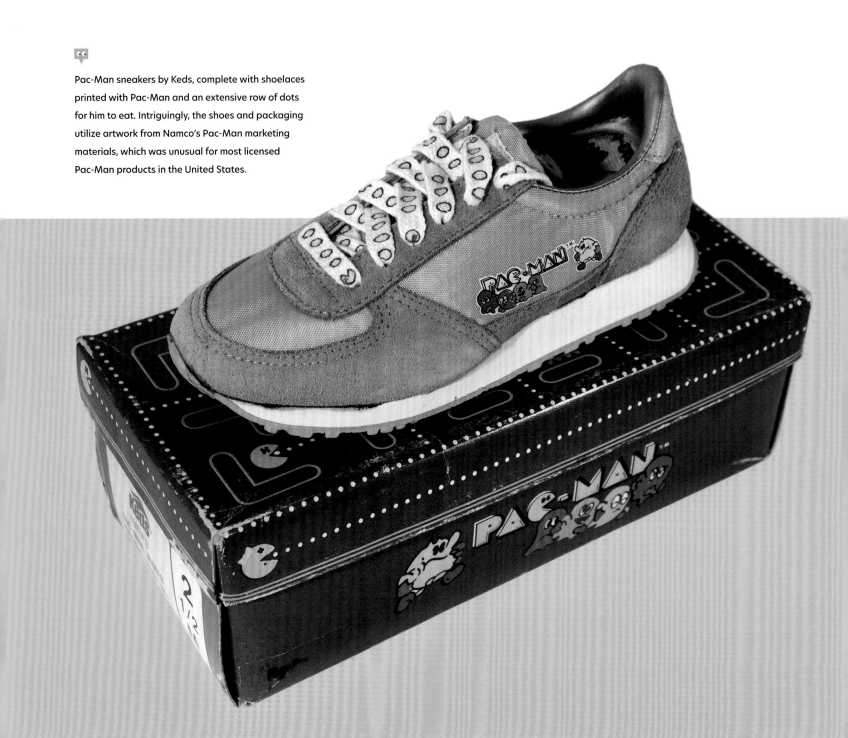

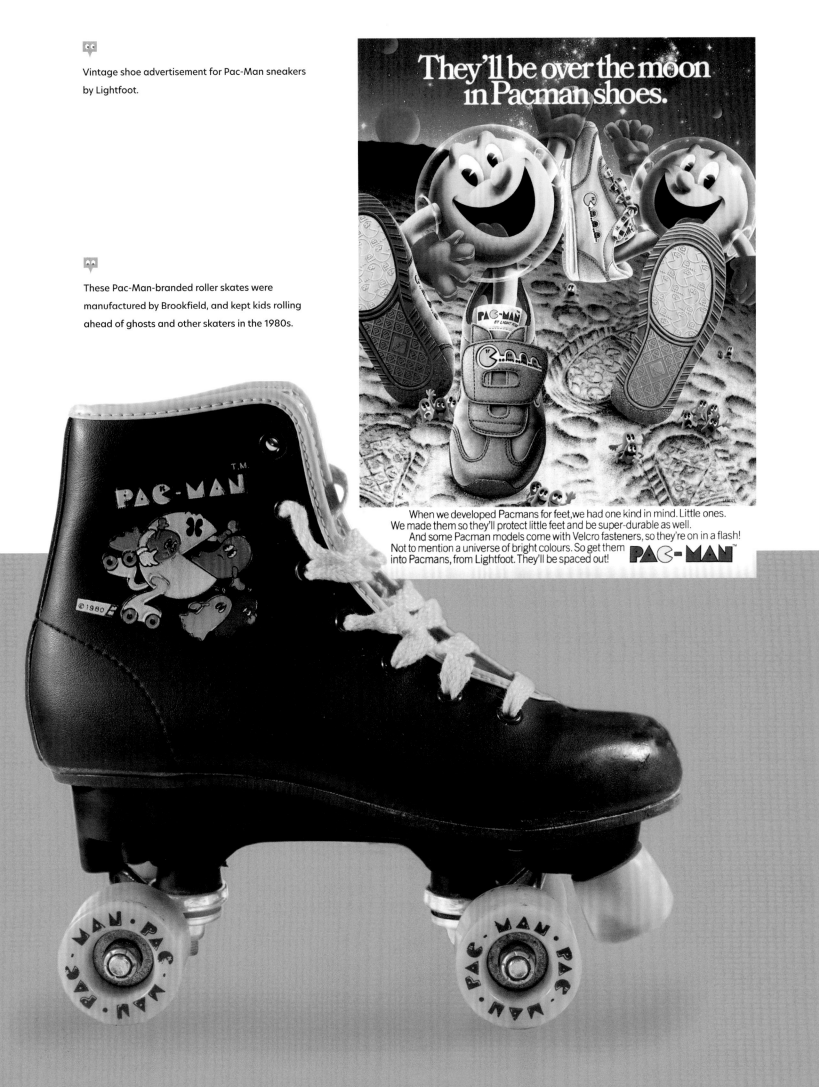

Vintage shoe advertisement for Pac-Man sneakers by Lightfoot.

These Pac-Man-branded roller skates were manufactured by Brookfield, and kept kids rolling ahead of ghosts and other skaters in the 1980s.

They'll be over the moon in Pacman shoes.

When we developed Pacmans for feet, we had one kind in mind. Little ones. We made them so they'll protect little feet and be super-durable as well. And some Pacman models come with Velcro fasteners, so they're on in a flash! Not to mention a universe of bright colours. So get them into Pacmans, from Lightfoot. They'll be spaced out! **PAC-MAN**

Pac-Man card game by Milton Bradley that uses addition and multiplication to simulate some of the game's interactions.

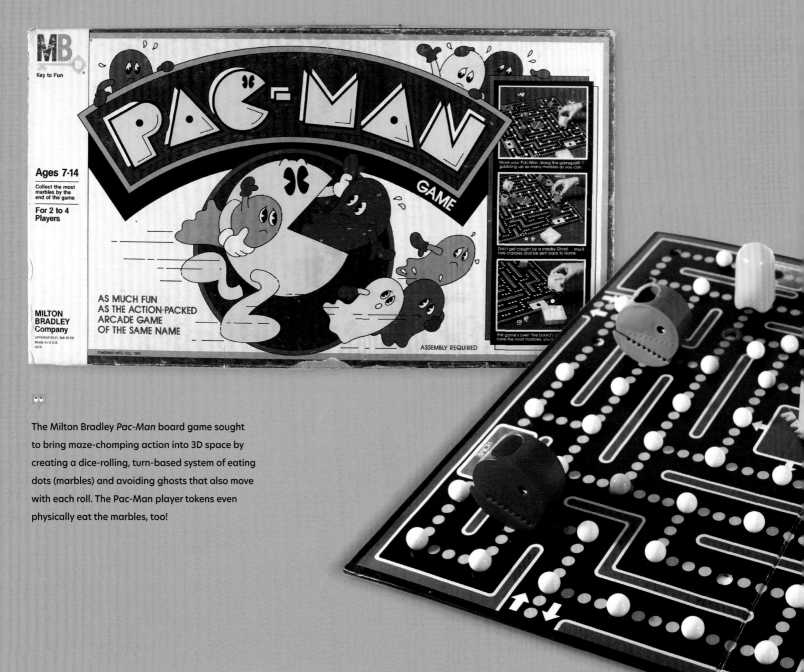

The Milton Bradley *Pac-Man* board game sought to bring maze-chomping action into 3D space by creating a dice-rolling, turn-based system of eating dots (marbles) and avoiding ghosts that also move with each roll. The Pac-Man player tokens even physically eat the marbles, too!

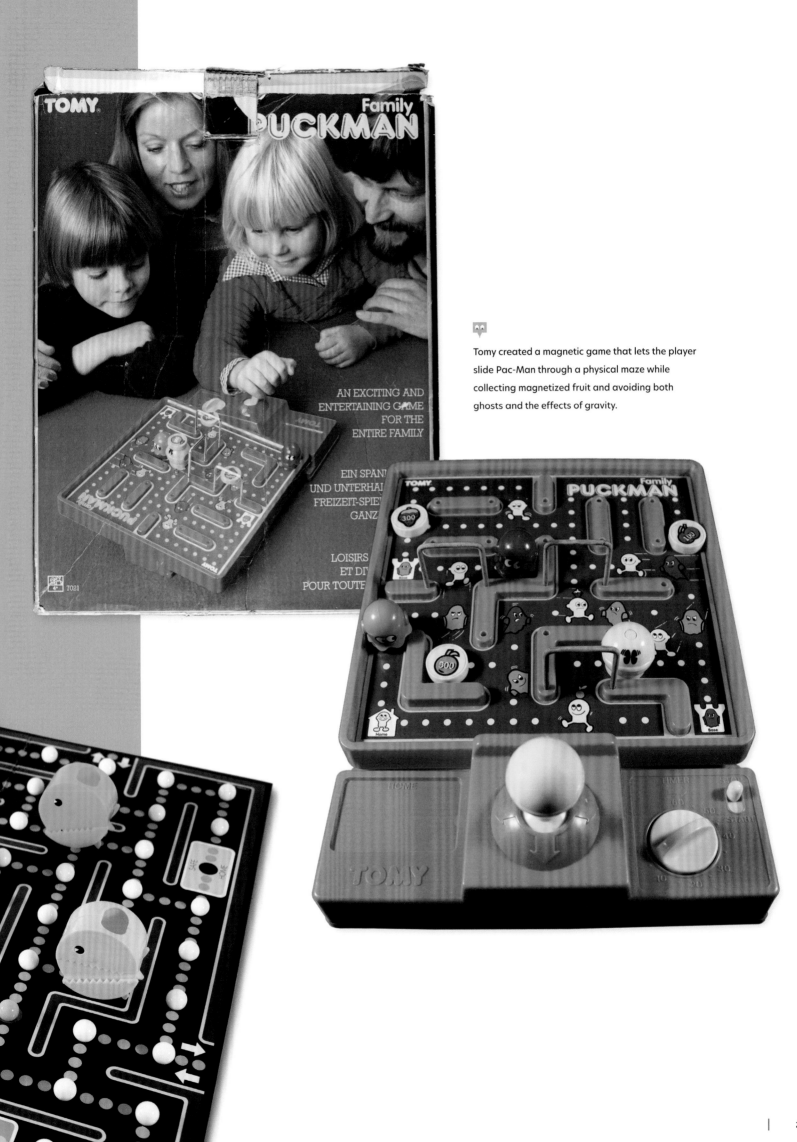

Tomy created a magnetic game that lets the player slide Pac-Man through a physical maze while collecting magnetized fruit and avoiding both ghosts and the effects of gravity.

"Good-bye, Fred Hello, PAC-MAN™"

In addition to producing basketball and baseball cards, trading card maker Fleer dove into pop culture subjects like Pac-Man, releasing multiple series related to the character. These came packed with scratch-off games, stickers, and the infamous, nearly inedible pink bubble gum.

BETTER: NO SUGAR. Because new PAC-MAN has absolutely no sugar. And studies show that too much sugar can be harmful to young children. Flintstones® has over 70% sugar.

BETTER: NOTHING ARTIFICIAL. Because new PAC-MAN has no artificial flavors or colors. Flintstones does.

BETTER: COMPLETE NUTRITION. New PAC-MAN comes in two formulas...for kids under 4 and kids 4 and over. Each has 100% of the U.S. Recommended Daily Allowance of the 10 essential vitamins and iron. Flintstones doesn't.

SAVE 35¢ on either formula.
PAC-MAN™ CHILDREN'S CHEWABLE MULTI-VITAMINS plus Iron.

DEAR RETAILER: For payment of face value plus 7¢ handling, send to Rexall Corporation, P.O. Box 1212, Clinton, Iowa 52734. Coupon will be paid only if presented by a retailer of our merchandise or a clearing house approved by us and acting for and at the risk of the retailer. Retailer must submit on request invoices proving purchases of sufficient stock within normal redemption cycle to cover the merchandising program represented by coupons presented for redemption. This coupon is nontransferable, nonassignable, nonreproducible and any sales tax must be paid by customer. Offer good only in U.S.A., APO's, FPO's and void where prohibited, taxed or otherwise restricted. Cash redemption value, 1/20th of one cent. This coupon good only on brand specified. Any other use constitutes fraud.

Limit One Coupon Per Purchase. Coupon Expires 12/31/83.

BETTER
THE **BETTER** CHOICE
BETTER ™

00122 107790

© 1980 Bally Midway Mfg. Co. Trademark of Bally Midway Mfg. Co. All rights reserved. © 1983 Rexall Corporation

These vintage wind-up Pac-Man toys were some of the more distinctive plastic toys created by Tomy. When Pac-Man opens his mouth, a scared ghost can be found there, suspended in perpetual mid-chomp.

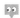

This vintage Pac-Man soap set (or "bathing arcade!") contains molded soap ghosts with unique designs and a Pac-Man-shaped sponge. Made by Ben Rickert Co., it might have over-hyped the product, with marketing copy claiming that bath time would be "as much fun as playing your favorite video game."

A clever bit of packaging for this Fleer Pac-Man candy let the small, ghost and Pac-Man shaped pieces roll around a maze-shaped blister pack, echoing the game's play mechanics.

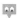

Promotional collector's Pac-Man glasses were available for $0.59 (with a medium soft drink purchase) from Arby's fast food restaurants in 1982.

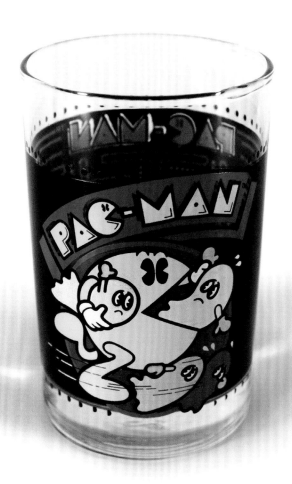

👀

Collectible Pac-Man action figures made by Coleco, 1982. The toy line also included additional wedding style versions of "Mr. Pac-Man" and "Mrs. Pac-Man," complete with top hat, wedding veil, and a bouquet! This was another rare instance where Ms. Pac-Man took on the Mrs. honorific.

👀

A promotional sticker for Midway's arcade release of *Pac-Man*.

💬

Box, playset, and repositionable vinyl characters for a Colorforms set, 1982. While the limited color palette (probably due to production costs) was not arcade accurate, the backgrounds and depictions of the Pac-Man world were some of the earliest.

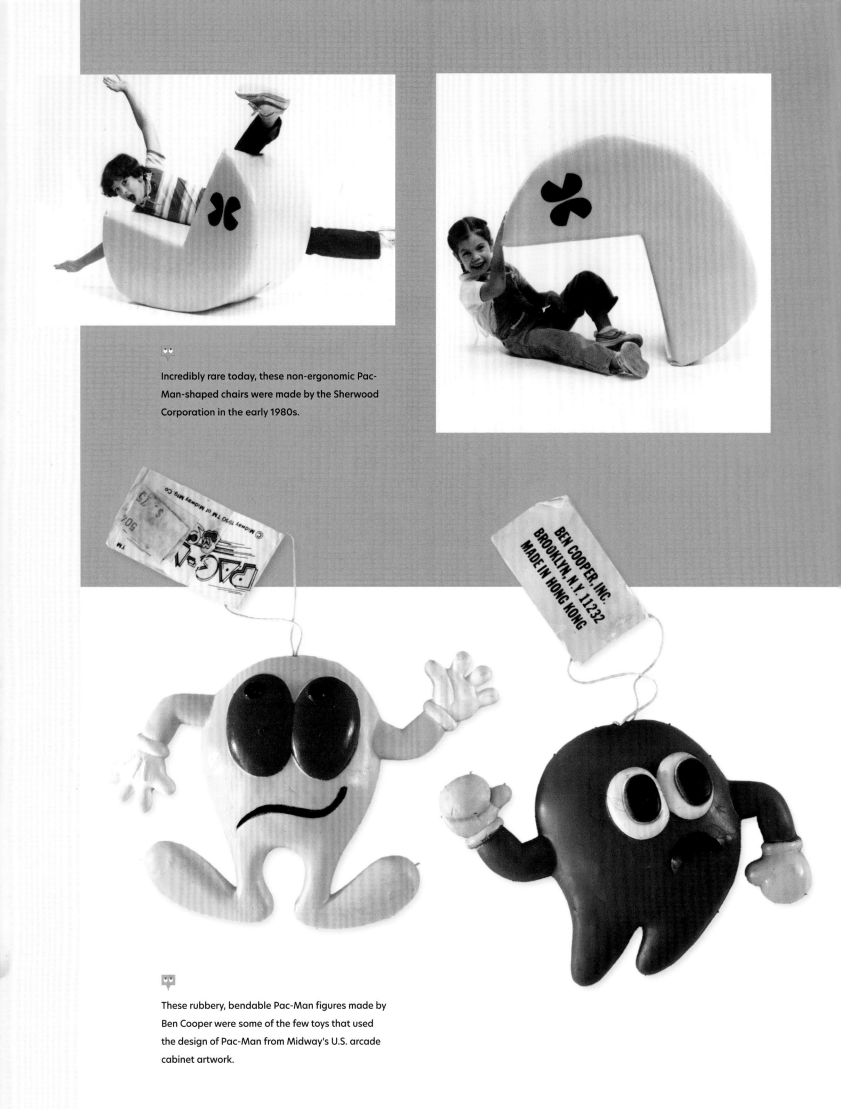

Incredibly rare today, these non-ergonomic Pac-Man-shaped chairs were made by the Sherwood Corporation in the early 1980s.

These rubbery, bendable Pac-Man figures made by Ben Cooper were some of the few toys that used the design of Pac-Man from Midway's U.S. arcade cabinet artwork.

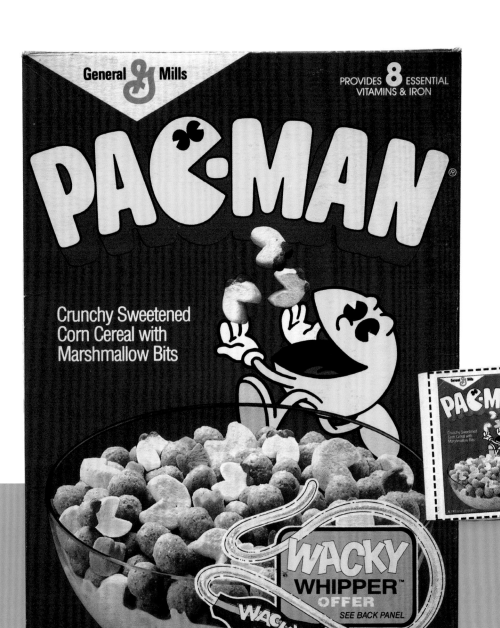

General Mills

PROVIDES 8 ESSENTIAL VITAMINS & IRON

PAC-MAN®

Crunchy Sweetened
Corn Cereal with
Marshmallow Bits

WACKY WHIPPER™ OFFER
SEE BACK PANEL

NET WT 13 OZ (368 grams)

General Mills' Pac-Man cereal with character-shaped "marshmallow bits" was launched in 1983, intending to capitalize on the video game's popularity. A later version was released with its own commercials, hyping the new Ms. Pac-Man-shaped marshmallows with a "shocking pink bow."

MFR COUPON | NO EXPIRATION DATE **M517**

PAC-MAN

Crunchy Sweetened
Corn Cereal with
Marshmallow Bits

Save 40¢
when you buy any size PacMan® cereal

Consumer: Limit one coupon per purchase, no other coupon may be used in conjunction with this coupon. **Retailer:** You are authorized to act as our agent and redeem this coupon at face value plus 8¢ handling, in accordance with our redemption policy, copies available upon request. Send coupons to: GMI COUPON REDEMPTION, P.O. Box 900, MPLS., MN 55460, or our authorized clearing houses. **Void if copied, and where prohibited, licensed, or regulated. Good only in U.S.A., A.P.O's, F.P.O's. Cash value 1/100 cent upon presentation for payment.**

General Mills 5

16000 72540

0686

Midway's Amazing New Video Game

Pac-Man placemat set, using re-drawn versions of both Midway and Namco marketing artwork.

Three Aladdin lunch boxes. The company created metal, plastic and soft-cushion versions, with some including a matching Thermos flask.

As part of a tasty licensing bonanza in the early 1980s, Chef Boyardee joined the fray by releasing Pac-Man versions of its canned pasta, including spaghetti with Mini-Meat Balls, Cheese flavor, and Golden Chicken flavored sauce.

The Pac-Man art of Midway artist Pat McMahon graced many licensed products, including these records by Kid Stuff. McMahon brought a unique, American feel to Pac-Man and the family of characters before the style evolved to more closely match Hanna-Barbera's Saturday morning cartoon character designs. The stories contained in these 45-rpm records didn't match any existing Pac-Man mythos, but still kept the character in front of young audiences.

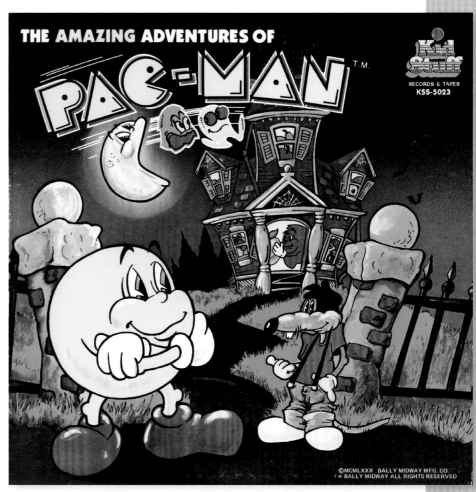

MASTERING PACMAN™

SIGNET•451-AJ1758•$1.95

KEN USTON
PATTERNS, TIPS, AND STRATEGIES
FOR DOUBLING, TRIPLING, EVEN
QUADRUPLING YOUR SCORE
IN THE GAME THAT'S
SWEEPING THE COUNTRY!

FULLY
ILLUSTRATED

PAC-MAN™ IS A TRADEMARK OF THE MIDWAY MANUFACTURING
COMPANY. THIS BOOK HAS NEITHER BEEN AUTHORIZED NOR
ENDORSED BY THE MIDWAY MANUFACTURING COMPANY.

Scoring BIG at PAC-MAN

How to Munch the Monsters

by
Craig Kubey
Author of *The Winners' Book of Video Games*

..... Expert advice that can
...... make you a winner at
...both coin-op and.........
......home video.....
.......versions! .

WARNER BOOKS 30-507 $1.25

Once *Pac-Man* took over arcades, a slew of books were published with strategies and hints for serious players looking to take their game to the next level (literally). One of the most well-known of these is *Mastering Pac-Man*, written by champion Blackjack player Ken Uston. Uston himself was a fascinating character who won loads of money and was eventually kicked out of most major casinos. He sued the casinos and later turned his pattern-recognition genius to video games.

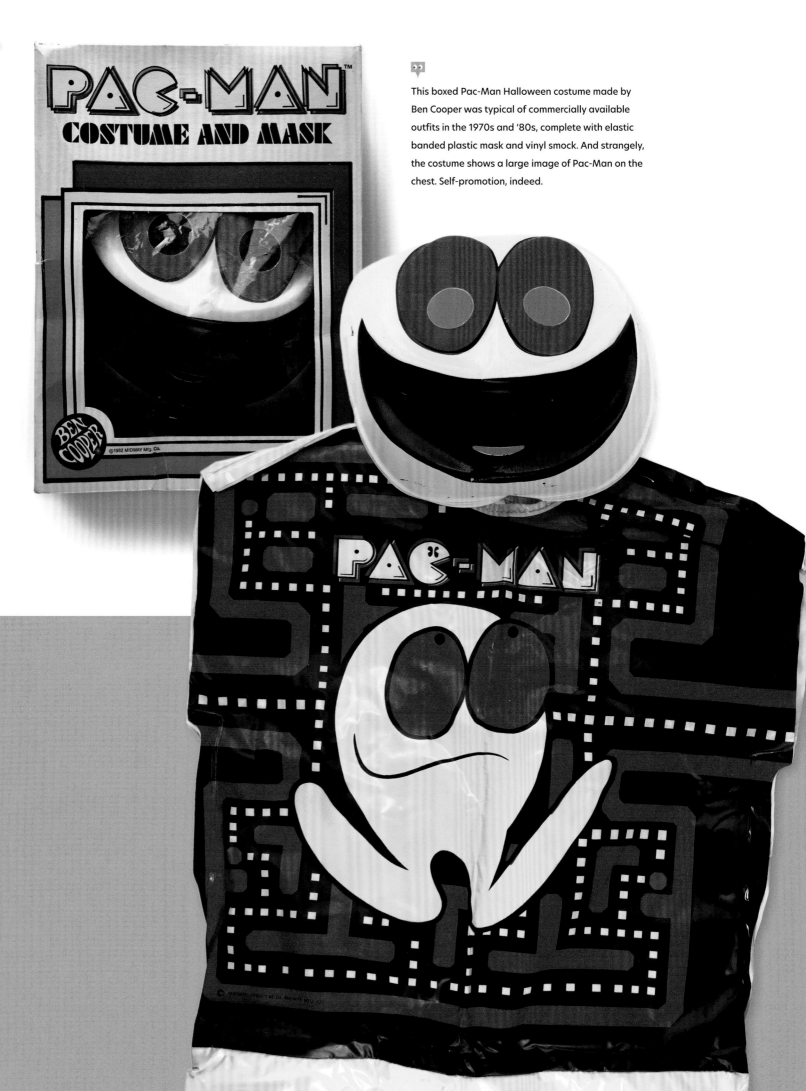

PAC-MAN™
COSTUME AND MASK

BEN COOPER® ©1982 MIDWAY Mfg. Co.

This boxed Pac-Man Halloween costume made by Ben Cooper was typical of commercially available outfits in the 1970s and '80s, complete with elastic banded plastic mask and vinyl smock. And strangely, the costume shows a large image of Pac-Man on the chest. Self-promotion, indeed.

PAC-MAN™

Pac-Man yo-yo made by Duncan, with a lenticular center that displayed rudimentary action of Pac-Man chomping, which the packaging generously calls "Video Action."

This simple and adorable Pac-Man bubble set comes complete with powdered soap. Oddly, the package suggests how to keep blowing bubbles once the original soap ran out: "For more bubble fun, use your mom's dishwashing liquid mixed with water."

Commonwealth toy and novelty company created a variety of plush puppets, stuffed animals, and slippers tied into their Pac-Man license. This one is seemingly designed to match Midway's arcade artwork, and comes complete with an attached, blue ghost he can "swallow", too.

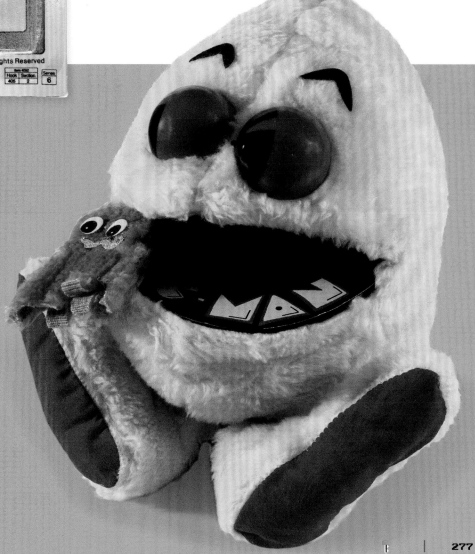

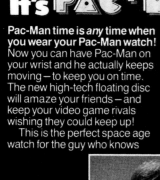
It's PAC-MAN Time.

Pac-Man time is *any* time when you wear your Pac-Man watch! Now you can have Pac-Man on your wrist and he actually keeps moving—to keep you on time. The new high-tech floating disc will amaze your friends—and keep your video game rivals wishing they could keep up!

This is the perfect space age watch for the guy who knows

every video game character—and even wears one! You can trust the Swiss jeweled movement and the tough plastic case and band. And for your room—the Pac-Man clock, with battery operated quartz mechanism. Get yours at your favorite toy, hobby, or video game store.

For all ages!

See Pac-Man gobble ghosts and power dots as it turns and tells time.

New! Floating Disc Technology! Swiss Jeweled Movement Watches.

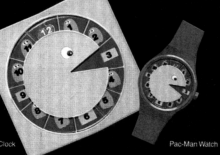

9" Pac-Man Wall Clock Pac-Man Watch

PAXXON CORP

A Subsidiary of Diversified Greyhound
8052 N.W. 14th Street, Miami, Florida 33126 • (305) 592-6460
Licensed TM © 1980, 1981 Bally Midway Mfg. Co. All rights reserved. Disc licensed by Chromachron.

Advertisement for the colorful Pac-Man-themed wrist watches and wall clocks made by Paxxon. Worth noting is the marketing that suggests, "this is the perfect space age watch for the guy who knows every video game character."

Pac-Man AM radio and headphones created by Tiger Electronics, best known for their miniature, liquid crystal display (LCD) handheld video games.

This iconic phone was designed in the shape of Pac-Man, allowing the user to flip open Pac-Man's mouth and dial a number or talk.

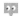

This TomyTronic electronic *Pac-Man* handheld game with a three-color display echoes the character with its oblong, rounded product design. Released in multiple countries, first in 1981.

The handheld *Pac-Man* game made by Entex was released as *PacMan 2*. It was not a sequel, but instead was named for its two-player mode: Player one would control Pac-Man, and the second player guides a single ghost in the game's head-to-head mode. This VFD (Vacuum Fluorescent Display) game made the most of its design, situating a player on each side of the device. Another version of *PacMan 2* was also sold as an included cartridge in Entex's Select-A-Game machine console.

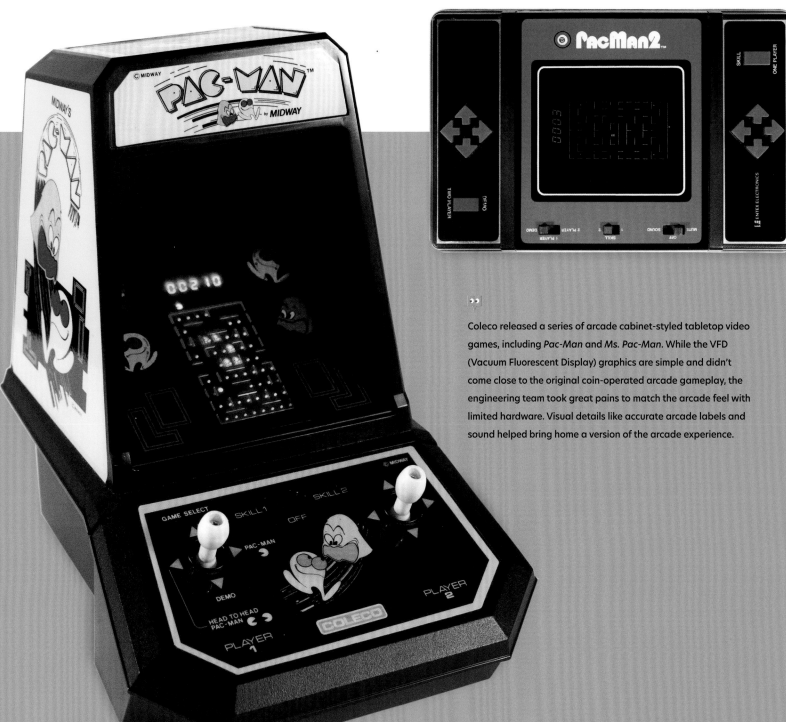

Coleco released a series of arcade cabinet-styled tabletop video games, including *Pac-Man* and *Ms. Pac-Man*. While the VFD (Vacuum Fluorescent Display) graphics are simple and didn't come close to the original coin-operated arcade gameplay, the engineering team took great pains to match the arcade feel with limited hardware. Visual details like accurate arcade labels and sound helped bring home a version of the arcade experience.

Legacy & Evolution

パックマンの伝説と進化

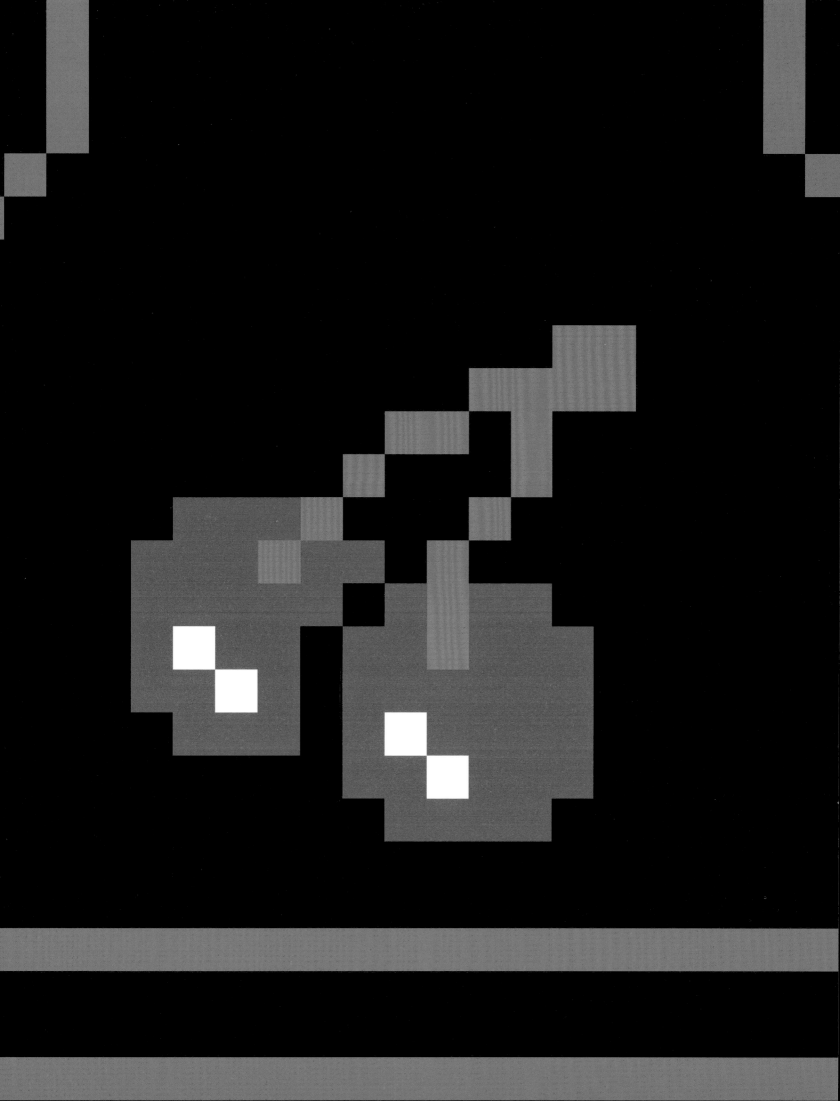

The Video Game Crash

The popularity of *Pac-Man* came near the apex of what is now considered the Golden Age of arcade games, when a swell of interest met a slew of companies creating games for both arcades and the home markets. But this rapid rise eventually led to a glut of games at home and in arcades. While consumers were spending more money in arcades, there were many more games available, lessening the final take for each game, which meant trouble for the swelling ranks of operators. One arcade operator explained it this way: "If you figure each block has $100 to spend on games, there are now 20 machines per block instead of two."[214]

Operators had a tougher time making back their investments in new games, and eventually bought fewer new arcade cabinets, which affected the manufacturers. In home consoles, consumers struggled to distinguish the quality games amidst so many available options, and prices plummeted as retailers sought to cut their losses. In the arcade ecosystem, operators wrestled with affording new games, including some of the cutting-edge, expensive cabinets in a shrinking market during an economic downturn. Atari's well-publicized underperformance sent Wall Street into a panic and cooled off the video game market. Companies who had jumped into the fray without extensive programming or electronics experience were the first to seek shelter, and others who had overextended themselves in competition found their positions compromised.

"We had the sense that it was a very good game, but I had no idea it was going to be a great game that would change everything."

Dave Marofske, Bally/Midway president

After out-earning both the American film industry ($2.7 billion in revenue) and music industry ($2.7 billion) in 1981[215], the video game market peaked in 1983. Total sales that year amounted to between $5 and 6 billion dollars.[216] Some believed that video games were a passing fad, as teens and others moved onto other popular media, like music or the growing home video game market. The industry seemed to have imploded—but instead, it contracted when the market bubble burst. The economics of the video game industry's peak were unsustainable, and now the market seemed to be correcting itself.

But the industry moved on, and *Pac-Man*'s original popularity waned as Midway's sequels faded in the rear-view mirror. The arcade industry itself changed after the crash. Some smaller arcade owners and operators were forced out as technology improved and more elaborate arcade games became the must-have attractions. This led to more expensive cabinets—laser-disc games with complex internal drives, and simulators utilizing sophisticated displays and costly cabinet builds. This winner-take-all scenario hastened the death of independent arcades and meant that mostly chain arcades and extravagant "destination venues" were likely to survive.

Coupled with the rise of home consoles, these factors put traditional arcades on life support. The Pac-Man franchise would morph, finding new audiences in nearly all of the home consoles released, as Namco and other partners continued to adapt *Pac-Man* and its sequels for the changing video game environment.

NINTENDO PUTS NEW LIFE INTO PAC-MAN GAMES.

Now you can turn your Pac-Man' and Ms. Pac-Man' games into a money-making VS. System." Because Nintendo's VS. UniKit is now available for both games.

Nintendo's VS. UniKit allows you to convert your Pac-Man' and Ms. Pac-Man' cabinets into high earning VS. UniSystems" that are compatible with any number of our exciting VS.-Paks. Games like

VS. Hogan's Alley," VS. Duck Hunt," VS. Excitebike," VS. Golf," VS. Ice Climber," and future VS.-Paks.

Contact your local Nintendo Distributor or Nintendo of America Inc, at (206) 882-2040.

Nintendo

WE'LL GIVE YOUR GAMES A WHOLE NEW PERSONALITY.

*TM of Bally Midway Mfg. Co.

*TM of Bally Midway Mfg. Co.

How to rejuvenate your Pac-Man™ and MS. Pac-Man™ games?

$395

Put new life into your tired Pac-Man and Ms. Pac-Man cabinets with the exciting new Pac Pack conversions from Bally Midway. **ONLY $395** . . . complete conversions includes everything you need! **HIGH EARNINGS** . . . assured by one-on-one, and two-player competition. **QUICK EASY CONVERSION** . . . in less than one hour. Engineered by the people who brought you the originals. **STREET LOCATIONS** . . . games designed with your needs in mind. **QUALITY** . . . designed and built in the U.S.A. by Bally Midway.

Pac Pack ™·M·

The most profitable $395* investment you can make.

AVAILABLE NOW . . . Jump Shot™
New releases available by mid-January and mid-April.

Bally **MIDWAY** ™
© 1985 Bally Midway Mfg. Co.

*395 manufacturers suggested price to operators.

Arcade owners and operators had a challenge before them in the second half of the 1980s. As games became more sophisticated, and players clamored for newer arcade experiences, many older games were left behind. The incredible popularity and ubiquity of *Pac-Man* arcade games meant that many of these once-popular cabinets were no longer making enough money for their owners. So, operators turned to conversion kits that would transform the games into newer, more profitable titles, and provide new revenue streams for manufacturers like Midway itself, or even Nintendo, as seen in this pair of advertisements.

Midway itself would evolve beyond *Pac-Man*, maintaining its influence and reinvigorating arcade games in the 1990s, with new talent and popular games like *Mortal Kombat*, *NBA Jam*, *Cruis'n USA*. Some of the architects of *Pac-Man*'s American success moved on to other parts of the video game industry. Stan Jarocki left Midway in July of 1985, and helped inaugurate Grand Products, Inc. not long after, joining his former collaborators and Midway alums Dave Marofske and Hank Ross, who had both resigned from Midway that year.

Despite the industry's struggles at the time, the three believed it would go on. Marofske said, "There are a lot of people here in the Midwest and here in Chicago who are out of the industry now but still have their hearts in it. I'd like to pull some of these people back, and I think it can be done as the industry gets back on its feet."[217] Jarocki worked there until retiring to New Mexico in 1991, though Grand Products would continue for two more decades, later with second-generation David Marofske Jr. at the helm. Not one to remain on the sidelines, Jarocki began riding rodeo bulls at age 61. After four months of "retirement," Jarocki brought his red, eel-skin cowboy boots back to the coin-op industry. He threw his lot in with a startup game company called American Laser Games in Albuquerque, as VP of marketing and sales in 1991.[218] He finally retired from an advisory position in 1995 when his son, Jim Jarocki, took over as VP of sales and marketing of Coin-Op at ALG.[219]

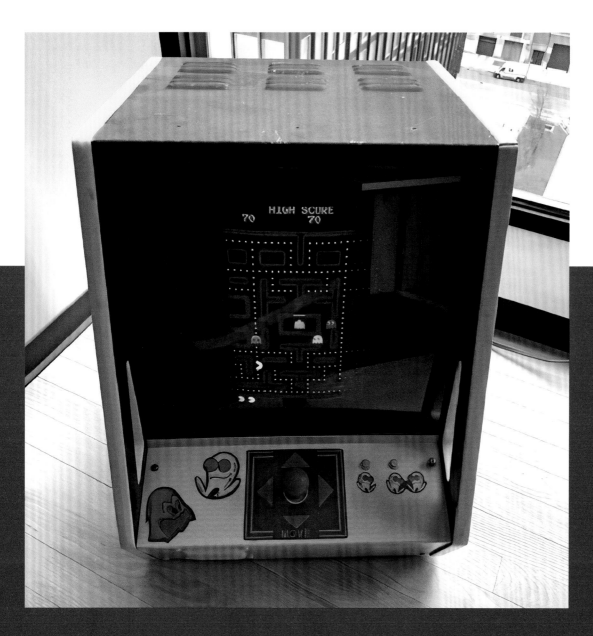

This proposed home arcade version of *Pac-Man* was designed by Midway's George Gomez, with the intent of bringing actual, authentic *Pac-Man* arcade play into the home. Inside Midway, Gomez commissioned this prototype, but it was never commercially produced.

Marofske also retired in 2012 after more than 25 years at Grand Products. Midway alum Patrice Paglia recalled, "David was an amazing leader and visionary—but extraordinarily humble. He truly did what he did for the well-being of the people he worked with at Midway. He drove the business to new heights but never stopped taking care of the people from the factory to the office to the global partners." Jarocki also remembered his business partner fondly, spending so many years alongside each other in video games, both at Midway and Grand Products. "Dave and I worked very closely together. We were almost like brothers," he said.

"Pac-Man was endless. As long as you kept eating energy, you could play forever."

Dave Marofske, Bally/Midway president

Marofske took some time to reflect on the rise of *Pac-Man* with journalist Chuck Klosterman in 1999: "We had the sense that it was a very good game, but I had no idea it was going to be a *great* game that would change everything," he said. "So much of marketing is just timing, and *Pac-Man* had a lot of ingredients that were in step with where players in 1980 were going. Most video games were built around a fixed time, and if you were good, you earned a little extra time. But *Pac-Man* was endless. As long as you kept eating energy, you could play forever."[220] Marofske passed away in 2014.

Namco went through its own changes, and the company eventually merged with toymaker Bandai which led to the formation of a new company in 2006, BANDAI NAMCO Games Inc. (currently BANDAI NAMCO Entertainment Inc.).

Masaya Nakamura remained president of Namco until 1990, when he stepped down, and assumed a role as company chairman. But after his successor, Tadashi Manabe, resigned in 1992, Nakamura returned to his previous role until 2002, when he took a ceremonial role in the company's management. He finally retired at 80 years old, one of the wealthiest men in Japan.[221] He was awarded the "Order of the Rising Sun, Gold Rays with Rosette" by the Japanese government in 2007, recognizing his contributions to the Japanese entertainment industry. He was also inducted into the International Video Game Hall of Fame in 2010. He passed away in 2017.

Toru Iwatani continued to intertwine his love of video games and play, serving as an elder statesman and producer within Namco, producing more than 50 games.[222] In 2005 he started teaching at the Character Creative Arts Department at the Osaka University of Arts as a visiting professor. He designed his final game, *Pac-Man Championship Edition*, in 2007 for Microsoft's Xbox 360 console, calling it his favorite *Pac-Man* sequel.[223]

He left Namco to become a full-time instructor at Tokyo Polytechnic University, sharing his experience with the next generation of game designers. Since then, he has become a locus for all things Pac-Man, from documentaries to events and interviews. Iwatani even had a brief on-screen cameo as an arcade repairman in the 2015 film, *Pixels*. The video game-inspired movie featured Pac-Man as a central element in the film and its marketing. Ironically, a "Professor Iwatani" (played by actor Denis Akiyama) also appeared as a character in the film—as the creator of Pac-Man who battles an evil version of his famous creation.

Irreducible Simplicity

"Good design is as little as possible. Less, but better, because it concentrates on the essential aspects, and the products are not burdened with non-essentials. Back to purity, back to simplicity," said industrial designer Dieter Rams, who made a name for himself crafting furniture and electronics, objects that demand intimate interaction. Rams was instrumental in helping designers and technologists understand the intrinsic link between form and function. Less design often means more freedom, and greater constraints in the design process often lead to the greatest creativity.

Pac-Man's development illustrated these ideas, and the game's longevity has affirmed how simplicity can help a design to transcend its time period and original context. With its simple, pixelated sprites and flat environs, *Pac-Man* remains nearly as fresh and playable as it was in 1980. While many gameplay trends, rendering styles, and technologies have come and gone in 40 years, *Pac-Man* has survived and preserved its relevance by remaining above such layers of decoration and ornamentation. Iwatani has explained how, in the long gestation process for the original *Pac-Man*, the team avoided the trap of addition—of adding features, complexity, and design details that would bog down the game. "Good design is as little as possible." Iwatani might not have known of Rams, but their aims ended up being very similar. The technological and aesthetic constraints the Namco team encountered drove them to solutions that were visually simple, and thus, even more powerful.

Abstract design signals to our eyes that there is opportunity for connection. Studies of the "uncanny valley" of computer graphics and character design show that people emotionally connect to things that are either essentially human, or those that are so abstract as to remain approachable—while avoiding the off-putting likeness of things "not quite human."

Pac-Man's simplicity let the character serve as a canvas, allowing audiences to project their own feelings, excitement, and energy onto it—whether in the midst of gameplay, or in reference to the universal act of eating. Video game players around the world can easily relate to the functional, necessary chomping that defines Pac-Man's two-dimensional existence. He is both affable and good-natured, reminding us of our best moments. Creator Toru Iwatani put it well. Pac-Man "is an innocent character," he said. "He hasn't been educated to discern between good and evil. He's indiscriminate because he's naïve."[224]

In the rear-view mirror of history, it's hard to overstate *Pac-Man*'s influence on popular media and electronic games and technology. The game democratized video games, ushered computing power into living rooms, and helped give a voice to game players who would grow up to be a bridge generation—a junction between the analog and digital worlds.

Pac-Man Lives On

Pac-Man has endured the decades because of its inherent playability and an ongoing appeal to people of all ages and cultures. The original *Pac-Man* and its maze of 240 dots have been transferred, adapted, and remixed on dozens of different video game consoles and platforms across the generations. Despite the rapid march and evolution of gaming technology, Pac-Man persists to this day, on video game consoles, handhelds, and even smartphones and mobile devices.

Pac-Man has grossed an estimated 10 billion quarters ($2.5 billion) during the 20th century.[225] It reminds both video game players and game industry denizens that simplicity is transmutable, and great gameplay is universal. *Pac-Man* and the extended family of characters live on in ways that Toru Iwatani could never have imagined in 1979. The games have been used to improve artificial intelligence algorithms[226] and have set A.I. world records[227] and Guinness World Records (for most coin-operated machines installed worldwide: 293,822[228]), becoming a touchstone experience for millions.

At its heart, the basic gameplay of *Pac-Man* is a great equalizer. It is timeless. In an industry that expends so much energy embracing technological advancement, Pac-Man still prevails. It is almost comforting to know that Pac-Man will outlast the latest and greatest, ready to be translated time and again, finding his home with us in each new era and platform.

A young woman poses in front of a large Pac-Man mural in Hong Kong, made by street artist Invader.

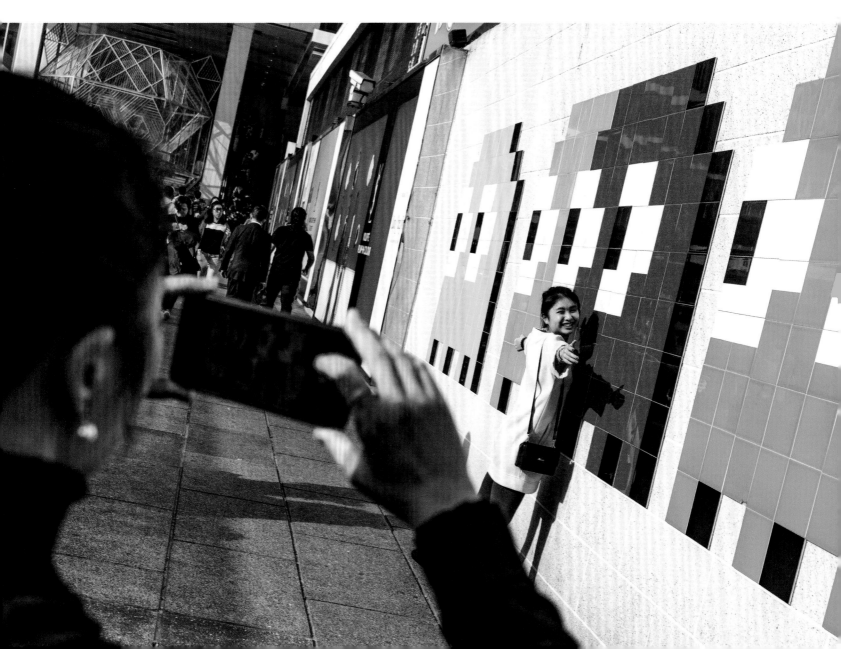

Endnotes

CHAPTER 1: The Story of Pac-Man

1. Hirohiko Niizumi, 'Pac-Man Chomps Into Record Books,' CNET, June 1 2005.

CHAPTER 2: Japan & the Rise of Video Games

2. Toru Iwatani, Pac-Man's Game Study Manual (Pac-Man's Method), 2005. An English translation of sections relevant to Pac-Man is included in this book.

3. Pac-Man's Method, pg 19.

4. Pac-Man's Method, pg 16.

5. Pac-Man's Method, pg 21.

6. After merging with Bandai in 2006, Namco would be part of BANDAI NAMCO Entertainment Ltd, the Japanese multinational video game developer and publisher.

7. Quoted in Steven L. Kent, The Ultimate History of Video Games: From Pong to Pokémon and Beyond, 2001, pg 1448 (Kindle edition).

8. Nakamura followed the example of Nintendo here. The Kyoto toy company bought Disney image rights for their playing cards in 1959, and advertised them on TV—a first for the company—leading to a threefold rise in revenue that year and a record 600,000 packs sold. See Florent Gorges, The History of Nintendo, 2012; and David Scheff, Game Over: How Nintendo Conquered the World, 1993.

9. Quoted in Fumio Kurokawa, Narratives of Video Games Pt.4, 2018; translated from the Japanese (online) original.

10. A thorough introduction to Japan's pre-video games entertainment industries can be found in Alexander Smith, They Create Worlds: The Story of the People and Companies That Shaped the Video Game Industry. Volume I: 1971-1982, 2020, specifically the chapter 'Rising Sun'.

11. Interview with Akira Osugi, Bandai Namco Entertainment (asobimotto.bandainamcoent.co.jp/436/, 2019).

12. For the full story on the start of the Japanese video game industry and the endless range of Pong clones, read Martin Picard, The Foundation of Geemu: A Brief History of Early Japanese video games, 2013; Game Studies.org, volume 13 issue 2.

13. For the full and fascinating story on Atari Japan and Namco's involvement in Atari imports, see Alexander Smith, They Create Worlds (chapter 18, 'Breaking Out in Japan'); Marty Goldberg and Curt Vendel, Atari Inc.: Business is Fun, 2012; and Steven Kent, The Ultimate History of Video Games, 2001.

14. The Development of Pac-Man, 2003. English translation of Japanese original at Glitterberri.com.

15. Alistair Wong, 'Pac-Man Creator Toru Iwatani On Namco's Atari Influences And Overseas Popularity,' Siliconera.com, 2019.

16. Pac-Man's Method, pg 29.

17. Iwatani most likely refers to the June 29, 1977 'Two the Hard Way Tour' show the Gregg Allman Band performed with singer Cher at the Nippon Budokan, as The Allman Brothers Band were engaged in a bitter breakup at the time.

18. Pac-Man's Method, pg 32. In his book, Iwatani wrote he spent a night in jail, but in our 2020 interviews he corrected his earlier statements: his mother picked him up at the police station in the late afternoon. "This was actually only two or three months after I joined the company, so my mother told me: 'What kind of Yakuza-company did you join?!' Haha."

19. Kent, 2001.

20. Kent, 2001.

21. Kent, 2001.

22. Wong, 2019.

23. Kurokawa, 2018.

24. All About Namco volume 1, 1985.

25. The Development of Pac-Man, 2003. English translation of Japanese original at Glitterberri.com.

26. Kurokawa, 2018.

27. Pac-Man's Method, pg 21.

28. Susan Lammers, Programmers at Work, 1986. Programmersatwork.wordpress.com.

29. Kazuhisa Maeno, 'Namco, Maker of the Video Age,' Journal of Japanese Trade & Industry, no.4, 1985.

30. Pac-Man's Method, pg 34.

31. High score tables would be new to video games when Space Invaders launched, yet were a regular feature in pinball and other electro-mechanical games. Pinball tables in the 1950s sometimes had a box in the backglass artwork where the Highest Score To Date could be written with a grease pencil. These crude tables would evolve to mechanical score reels, and finally to digital score tables.

32. It is often claimed the Space Invaders craze led to a national shortage of 100-yen coins, but these claims have long been debunked. Another rumor from those days had 'six trucks full of 100-yen coins' entering Taito's headquarters in Kawada-cho. Both claims are unsubstantiated, but fact is a lot of yen flowed to Taito's coffers, necessitating custom-made bags for Taito's many coin collectors doing the rounds.

33. Electronic Games, Winter 1981, pg 31.

34. Kurokawa, 2018.

35. The name Cutie Q was a riff on the Creedence Clearwater Revival song, 'Suzie Q'. In his memoir, Iwatani reflects on the naming history: "'Suzie Q' was deeply memorable as in high school we took a trip to Hiroshima, and in the night train I recall the song playing, transforming it into a disco train. Due to this, the song left a lasting impression, plus the song name also felt quite sensible. I arranged the title to my liking and decided on the name, Cutie Q." Pac-Man's Method, pg 40.

CHAPTER 3: Finding Puck Man

36. Frank Lantz, 'Hearts and Minds' talk held at the Game Developers Conference, 2014. See gdcvault.com.

37. Numbers based on estimates by interviewees, 2020.

38. Japanese industry pundits held varying views on copying games around this time. Nintendo president Hiroshi Yamauchi even went on record in a televised interview in 1979, stating: "There's no such thing as patenting a way of playing. Look, if someone has the inclination and the time, they can copy anything. There's no way around that. So we should abandon that way of thinking, and everyone should release their software openly, for the growth of the amusement industry as a whole."

39. Sawano cites the movie Admiral Yamamoto and the Allied Fleets, 1959, as inspiration, featuring specific airplane dive maneuvers in the climactic end scene.

40. Quoted in TV Game: denshi yuugi taizen, 1987; English translation from Japanese original retrieved from schmupulations.com

41. Pac-Man's Method, pg 30.

42. For more Space Invaders history, see Alexander Smith, They Create Worlds, 2020; and Masumi Akagi, It Started From Pong, 2005.

43. Toru Iwatani, 'Post-Mortem: Designing Pac-Man,' Game Developer Magazine, 2005.

44. Chris Kohler, 'Q&A: Pac-Man's Creator Reflects on 30 Years of Dot-Eating,' Wired, 2010.

45. Lammers, 1986.

46. Kohler, 2010.

47. The Development of Pac-Man, 2003.

48. Lammers, 1986.

49. The Development of Pac-Man, 2003.

50. Lammers, 1986.

51. 'Interview With Pac-Man Creator Toru Iwatani,' Pacman.com, 2010.

52. This feature would show up later, in Namco's 1983 sequel, Pac & Pal, where Pac-Man has the ability to shoot and stun ghosts after eating a power-up.

53. Lammers, 1986.

54. Pacman.com, 2010

55. The 'three heads high' aesthetic predates the 1970s and Hello Kitty. Early examples can be found in advertising mascots like Kero-Chan, a frog character

touted by the pharmaceutical company Kowa.

56. See Matt Alt, Pure Invention: How Japan's Pop Culture Conquered The World, 2020 for a thorough introduction to the history and impact of kawaii design and the impact of Hello Kitty and Sanrio.

57. The 3 channel 4-bit WSG or Waveform Sound Generator sound chip.

58. NG Community Magazine, issue 5, March 1987, pg 5.

59. 'This Is What *Pac-Man*'s Creator Thinks 35 Years Later,' Time, 2015.

60. Lammers, 1986.

61. Pac-Man's Method, pg 43.

62. See Jamey Pittman's 'The Pac-Man Dossier,' an extensive breakdown of *Pac-Man*'s coding wizardry, Gamasutra.com, 2009.

63. Pac-Man's Method, pg 45. *Popeye* was broadcast on Japanese television from the late 1950s onwards, well before Japan's first domestic TV anime aired—Osamu Tezuka's *Astro Boy* (1963). Popular with children of that age, it influenced other Japanese creators. The outstanding example is Nintendo's Shigeru Miyamoto, who built an arcade game featuring Popeye, Olive and Bluto, only to find Nintendo could not secure a license to the property with King Features Syndicate. The game was reimagined with a plumber, a princess and a giant ape in the starring roles, and released as *Donkey Kong* in 1981.

64. It has been discussed if the ghost behavior in *Pac-Man* can be seen as the first use of Artificial Intelligence in games, but that's not the case: the ghosts follow strict protocols and don't learn new patterns to defeat the player. However, the team was advanced in thinking about how the system should behave vis-a-vis a player, discussing complex features like 'auto-difficulty'—a concept where the game would evaluate a player's skill and adjust the difficulty in turn. Later, this idea was implemented in Namco games like 1983's *Xevious*, a game that replaced enemies with more advanced types once the player's score met a certain threshold. However, those behaviors were still largely hard coded and not 'learned' by the computer in any real sense.

65. One fascinating feature was the so-called 'miss-bypass sequence' Funaki programmed. When Pac-Man gets defeated, the speed of the game—and hence the difficulty—doesn't remain the same when you respawn. Iwatani: "We thought that, since the player just died at a certain difficulty, making them start from the same point would not be a good idea, so the difficulty goes down a bit." Interviews, 2020.

66. Pacman.com, 2010.

67. The situation would be repeated when, in 1981, a dispute arose between Midway and Tomy over the use of the name Pac-Man, to which Tomy also claimed trademark rights. This was settled in a formal agreement, with Tomy assigning to Midway all of its trademark rights, and Midway paying Tomy $175,000 in return, also granting them a royalty-free license to use Tomy's Pac-Man designs for toys. See: 'Final Summary of the case Midway and Atari v North American Philips et al, consolidated case number 81 C 6434 appeals number 81-2920 dated December 18, 1984,' pg 11.

68. Tadashi Yamashita, San Diego Comic Con Pac-Man Hall of Fame induction interview, December 2020.

69. Yamashita, Hall of Fame induction interview.

70. Lammers, 1986.

71. 'The Man Who Gave Us Pac-Fever,' International Herald Tribune, June 26-27 1982.

72. Pac-Man's Method, pg 46.

73. Kai remembers his early efforts were "somewhat bland. Up until then, there had never been such a thing as a 'groove' in video game music, where the melody sits a little behind the beat [of a song]. The music I wrote didn't have what musicians call 'syncopation,' and thus sounded very mechanical (with notes hitting the exact pulse of the beat). At one point, I called the office from a crowded train station, and was told (programmer) Ishimura-kun had 'fixed it a bit for me.' I next heard the interlude songs played over the phone, now with syncopation, right in that crowded space! That's why it left such an impression on me." Interviews, 2020.

74. Pac-Man's Method, pg 49.

75. idem.

76. BEEP! Magazine, 1985. English translation of Japanese original retrieved from Schmuplations.com.

77. Pac-Man's Method, pg 50.

78. Steve Bloom, Video Invaders, 1982.

79. Kurokawa, 2018.

80. At the time of writing in 2021, the Hikarie building in Shibuya. The Tokyo Bunka Kaikan building does not exist anymore.

81. Kohler, 2010.

CHAPTER 4: Hitting the Market

82. At the time, this roughly translated to $6,000 for the cocktail version and $7,000 for the upright.

83. Game Machine 147, August 01 1980.

84. Cash Box, October 11 1980. For a full account of the exhibitors, floor impressions and photography, see (Japanese magazine) Game Machine 152, October 15 1980.

CHAPTER 5: Coming to America

85. 'Keynote Address by Sega Chairman David Rosen,' Cash Box, July 4 1981, pg 41. In his keynote, Rosen said he used "our studies" for these figures, presumably using Sega/Gremlin's internal documents, and warned his audience: "precise figures are impossible to come by."

86. Idem.

87. Alexander Smith, 'Historical Interlude: The History of Coin-Op Part 4, From Sportlands to Playlands,' videogamehistorian.wordpress.com, 2015.

88. 'Form Midway Mfg. Company,' Cash Box, Nov 15 1958, pg 68.

89. 'Bally To Acquire Midway; Also Lenc-Smith Cabinets,' Cash Box, August 2 1969, pg 52.

90. 'Pong Into National Distribution; Success For Atari, Inc.,' Cash Box, April 7 1973, pg 104.

91. Ryan Smith, 'Chicago once waged a 40-year war on pinball,' Chicago Reader, 2018.

92. Video Games magazine, December 1982.

93. 'Midway To Pop Hockey & TV Games,' Cash Box, March 10 1973.

94. This game had no relation to Atari's arcade machine, *Asteroids*.

95. There was no *Winner III* game, because *Winner IV* was named thusly because of its four-person gameplay feature, not because of its release sequence.

96. Nutting was the brother of Bill Nutting, whose own company helped launch the groundbreaking game, *Computer Space*, with Nolan Bushnell and Ted Dabney, who would later form Atari.

97. Electronic Games magazine, Winter 1981, pg 31.

98. They Create Worlds, pg 441; and Casey Minter, 'Passings: Paul Moriarty,' RePlay Magazine, October 31 2015.

99. Cash Box, December 23 1978.

100. Cash Box, Dec 29 1979, pg 114.

101. Cash Box, Dec 22 1979, pg 43.

102. A curious example is Nintendo's *Radar Scope*, created in the mold of *Space Invaders* and *Galaxian*, which was a commercial failure. Thousands of unsold cabinets were converted into another game more recognizable to modern audiences: *Donkey Kong*.

103. Cash Box, August 23 1980, page 46.

104. 'Mittel Named President And CEO of Taito America Corp,' Cash Box, July 19 1980, pg 36.

105. Kent, 2001, pg 138.

106. 'Midway Debuts 'Galaxian' Video,' Cash Box, April 5 1980, pg 40.

107. Jarocki Wired In interview, https://mediaburn.org/video/wired-in-raw-29/.

108. They Create Worlds, pg 512.

109. 'Video Game Mythbusters— Was Rally-X the Hit of the 1980 AMOA?,' Allincolorforaquarter.blogspot.com, 2014.

110. Kent, 2001, pg 2542 (Kindle edition).

111. 'Chicago Chatter,' Cash Box, July 15 1978, pg 50.

112. Anderson also told an intriguing story about this division of games to historian Keith Smith, and it has circulated because of its audacity: "Namco had four games and they were going to give Game Plan two and Bally/Midway two. [It came down to] T*ank Battalion* and *Pac-Man*. We flipped a coin. I won and I turned down *Pac-Man* because I thought *Tank Battalion* was the better game. So I turned down *Pac-Man* for *Tank Battalion*." However, this story by Anderson was debunked by Stan Jarocki. When asked about it, he said: "That's totally untrue. I was there, I saw it first, I brought it back." And Anderson himself seemed to cast doubt on his own story, when pressed: "I don't even know how accurate that is. We were just screwing around more than anything. But it made a good story, so Stan and I just held to it. We didn't deny it. Why would we? It was a good story." Interviews, May 2020.

113. Cash Box, Sept 23 1978.

114. Cash Box, Feb 19 1980, pg 40.

115. Charles Storch, 'Bally's 'silly Pac-Man boosts profits, fuels expansion plans,' Chicago Tribune, Oct 28 1981.

116. Video Games Magazine, Issue 3, Dec 1982.

117. idem.

118. Bloom, 1982, pg 41.

CHAPTER 6: The Rise of Pac-Man

119. 'Bally Midway: The Next 25 Years,' Cash Box, December 17 1983, pg 36.

120. Maurice Molyneaux Interview, 2018; official Namco translation of original Pac-Man design document, 10/18/2012.

121. Jim Jarocki interview.

122. Stan Jarocki interview.

123. George Gomez interview.

124. Cash Box, Nov 22 1980, pg 42.

125. Cash Box, Jan 31 1981, pg 36.

126. Cash Box, Feb 7 1981, pg 36.

127. Cash Box, March 7 1981, pg 40.

128. Cash Box, November 20 1982, pg 56.

129. Cash Box, October 31 1981.

130. The Manhattan Mercury (Manhattan, Kansas), 8 Feb 1981, pg 33.

131. Napa Valley Register, March 20 1981, pg 1.

132. 'It's a Pacmen-Eat-Pacmen World,' Independent Network News, 1982.

133. 'Celebrity Pac-Mania,' Oui magazine, April 1982.

134. Cash Box, August 22 1981.

135. Bloom, 1982, pg 37. In this interview, Bailey uses a poorly disguised pseudonym, as Atari had a policy of not crediting or naming its game designers, for fear of other companies poaching their talent.

136. Gene Policinski, 'Manual helps us all survive the video craze,' Lafayette Journal and Courier, May 2

1982, pg D-5.

137. Dinah Prince, 'Pac-Mania,' New York Daily News, August 12 1982.

138. 'Video Arcade "Addiction": When Pac-Man was King', CBS Evening News, January 29 1982.

139. Cash Box, April 10 1982.

140. 'Chicagofest '81,' WMAQ Channel 5 - NewsCenter5, 1981.

141. Stan Jarocki interview.

142. Ken Anderson interview.

143. Christian Marfels, Bally: The World's Game Maker, 2007, pg 128.

144. WFLD Channel 32—PM Magazine Chicago, 1981.

145. Marfels, 2007, pg 128.

146. 'Pac-Man Sublicenses Extend Bally's Profits,' New York Times, Feb 16 1982, Section D, pg 1.

147. Charles Storch, 'Bally suffers from own success,' Chicago Tribune, March 2 1983, pg 7.

148. Time Magazine, April 5 1982, pg 1.

149. 'A healthy helping of profits,' Louisville Kentucky Courier Journal, Feb 21 1982, pg 58.

150. Bally Who internal newsletter, Bally, 1982.

151. The Coin Slot magazine, Jan 1983, pg 21.

152. Cash Box, March 20, 1982.

153. Bally Arcadian newsletter, June 1983.

154. Marfels, 2007, pg 76.

155. Video Games Magazine, June 1983, pg 18.

156. Marfels, 2007, pg 73.

157. From Midway Bally Arcadian November 1983, Vol 4, issue 5.

158. Years later, Jarocki felt ready to move on from Pac-Man and had the custom ring melted down into another piece of jewelry. But after later retiring, he considered reviving the gold memento, and asked an artisan in New Mexico to do the work. Ironically, the jeweler declined to make a new Pac-Man ring, concerned about possible copyright infringement.

159. Marion Cutler and Jane Petersson, 'Videos: Differences between Male and Female Players,' PlayMeter, Jan 1 1982, pgs 37-38.

160. Willis David Hoover, 'Pac Man: King of the Arcade,' Des Moines Register, May 30 1981.

161. Cash Box, Oct 21 1981, pg C-6.

162. Cash Box, Dec 26 1981, pg 89.

163. 'Atari Concludes First Decade Of Record-Breaking Growth,' Cash Box, Nov 20 1982, pg 66.

164. 'Operators Slash Overhead To Maintain Profitability In '82,' Cash Box, Feb 20 1982, pg 40.

165. Joyce Worley, 'Women Join the Arcade Revolution,' Electronic Games Magazine, May 1982.

166. 'Celebrity Pac-Mania,' Oui magazine, April 1982.

167. Wired Media Burn TV interview.

168. InfoWorld, August 30 1982.

169. This relationship with a character might sound familiar, as it's also the concept at the heart of

another similarly cute (and massively successful) Japanese entertainment product: Tamagotchi.

CHAPTER 7: We Are (Pac) Family

170. Alex Rubens, 8-Bit Apocalypse: The Untold Story of Atari's Missile Command, 2018, pg 159.

171. 'Boston Electronics Team Likes The Coinbiz,' RePlay magazine, July 1981.

172. https://www.ipeg.com/_UPLOAD%20BLOG/BabeRuthofPatentTrolls.pdf.

173. Raw interview footage from WIRED interview series.

174. Benj Edwards, 'The MIT Dropouts Who Created Ms. Pac-Man: A 35th Anniversary Oral History,' Fastcompany.com, 2017.

175. Cash Box, March 6 1982.

176. Wired In Raw unaired TV interview.

177. Jory Farr, 'Ms. Pac-Man: Is it a new feminist issue?' Baltimore Sun, October 3 1982.

178. Patrick Goldstein, 'Why is Pac-Man grinning? He's sharing his quarters,' Los Angeles Times, Feb 4 1982.

179. Cash Box, Nov 20 1982, pg 56.

180. Though it did make an appearance as part of the 'Class of '81' arcade cabinet re-release in 2001, which featured both *Ms. Pac-Man* and *Galaga*.

181. Cash Box, May 2 1981, pg 42.

182. Lammers, 1986.

183. 'GDC Panel: Classic Postmortem—Pac-Man,' GDC Vault, 2011.

184. Samuel Claiborn, 'Pac-Man Creator Toru Iwatani on the 40th Anniversary of the First Video Game Blockbuster,' IGN.com, June 2 2020.

185. 'The adventures of Pac-Man...,' The Boston Globe, Feb 8 1982, pg 30.

186. Doug Macrae presentation, California Extreme, 2010.

187. Retro Gamer magazine, issue 61, pg 30.

188. 'Exclusive: Interview with Toru Iwatani, creator of Pac-Man,' Geek Culture, May 22 2015.

CHAPTER 8: Pac-Man Fever

189. 'The father and daughter lawyers behind Pac-Man and Beanie Babies,' Robertloerzel.com, 2010.

190. Alejandro Arbona, Awesome Minds: Video Game Creators, 2018, pg 40.

191. Martin Goodman, 'Dr. Toon: When Reagan Met Optimus Prime,' Animation World Network, 2010.

192. John Szczepaniak, 'The Untold History of Japanese Game Developers, Vol 2.,' Interview with Yoshihiro Kishimoto, pg 207.

193. Willis David Hoover, 'Pac Man: King of the arcade,' Des Moines Register, May 30 1981.

194. Shelagh Kealy (UPI by Shelagh Kealy), The Daily Journal, March 10 1982.

195. Paul Merrior, 'Nothing's jolly about pirating video games,' Crain's Chicago Business, Nov 2 1981, pg 3.

196. Allan Jalon, 'The new world of video games leaves the law gasping,' Philadelphia Inquirer, Dec 15 **1981,** pg 27.

197. Milwaukee Sentinel, March 16 1982.

198. 'Around the Route,' Cash Box, Sept 18 1982, pg 43.

199. 'Games Impounded By Midway Mfg. In Arizona Action,' Cash Box, July 25 1981, pg 35.

200. 'State Associations Mobilize to Oppose Adverse Legislation,' Cash Box, September 19 1981, pg 36.

201. Gordon Morison's foreword for Keith Temple, Pinball Art, 1991.

202. The show's credits list character designers Sandra Berez, Deborah Hayes, and Takashi as having worked on the series.

203. Dennis Hunt, 'Double Dose of Pac-Man Fever,' LA Times, March 21 1982.

204. Mary Campbell, 'Buckner and Garcia: Pop not novelty,' The Daily Register (Red Bank, NJ), April 18 1982, pg 56.

205. Recorded interview with Gary Garcia, for Pac-Man Fever 30 Year Anniversary, Spotify interview track.

206. Philadelphia Inquirer, Dec 24 1981, The Scene, 2-B.

207. 'Around the Route,' Cash Box, December 26 1981, pg 86.

208. Video Games, August 1982, pg 10.

209. Tom Nieman interview with author.

210. Alexander Smith, pg 518.

211. 'Playing Video Games for Fun and Profit,' New York Times, March 29 1982, D4.

212. Joe Urschel, 'Pac-Man goes home,' Detroit Free Press, Feb 21 1982.

213. Marty Goldberg and Curt Vendel, 'What are the real facts behind Pac-Man's development?,' Ataribook.com.

CHAPTER 9: Legacy & Evolution

214. Michael Schrage, 'Video Arcade Industry Is Suffering a Glut,' Washington Post, November 23 1982.

215. 'Keynote Address By Sega Chairman David Rosen,' Cash Box, July 4 1981, pg 41.

216. Michael Schrage, 'When Pac Man died, vid kids met reality,' Dayton Daily News, Washington Post, Dec 29 1985.

217. Cash Box, May 10 1986, pg 34.

218. Albuquerque Journal, Sept 12 1994.

219. Albuquerque Journal, Aug 14 1995.

220. The Beacon Journal, Akron, Ohio, Oct 17 1999, pg F3.

221. Jonathan Soble, 'Masaya Nakamura, Whose Company Created Pac-Man, Dies at 91,' New York Times, Jan 30 2017.

222. Leo Lewis, 'Toru Iwatani: Pac-Man and the real life of games design,' Financial Times, June 10 2015.

223. Claiborn, 2020.

224. Lammers, 1986.

225. 'Six odd facts about Pac-Man, who turns 35 today,' CNBC.com, May 22 2015.

226. Simon Parkin, 'Could Ms. Pac-Man train the next generation of military drones?,' The New Yorker, March 29 2017.

227. Syl Kacapyr, 'Engineers eat away at Ms. Pac-Man score with artificial player,' News.cornell.edu, January 17 2017.

228. Hirohiko Niizumi, 'Pac-Man Chomps Into Record Books,' CNET, June 1 2005.

Pac-Man Gameology

⋮ 1980s

Puck Man (1980, Namco, currently BANDAI NAMCO Entertainment Inc.)
The original arcade game helped popularize maze games and brought new audiences and play styles into video games. (Arcade)

Pac-Man (1980, Midway)
The phenomenon that started it all! (Arcade)

PacMan2 (1981, Entex)
An electronic handheld game by Entex under the license of Midway. Like Coleco's handheld Pac-Man units, two people can cooperatively play on the same device. (Handheld)

Kick (1981, Midway)
A clown on a unicycle catches falling balloons and Pac-Man characters on his head. The game is sometimes known as *Kick-Man* due to its association with Pac-Man. (Arcade)

Ms. Pac-Man (1982, Midway)
The wildly popular sequel expanded upon the foundations of the original Pac-Man with new mazes, tougher challenge, and an overarching narrative exploring the relationship between Ms. Pac-Man and Pac-Man. (Arcade)

Pac-Man Plus (1982, Midway)
Midway's official modification kit adapts Pac-Man, changing the maze to green. Power Pellets and fruit can cause surprising side-effects like briefly turning the maze invisible or only affecting a few ghosts at a time. (Arcade)

Mr. and Mrs. Pac-Man (1982, Bally)
Intended to capitalize on Pac-Man's popularity, Midway sub-licensed the character to its Bally Pinball division, creating a unique pinball game. (Pinball)

Super Pac-Man (1982, Namco, Midway)
Namco's first sequel to *Pac-Man*, where the player collects keys to unlock maze doors, and green pellets grant Pac-Man the ability to fly over ghosts. (Arcade)

Baby Pac-Man (1982, Bally)
The video / pinball hybrid game was a novel move by Midway's parent company, combining both game styles in one cabinet, but ultimately failed to satisfy either type of fan. (Arcade / Pinball)

Professor Pac-Man (1983, Midway)
This visual quiz game served as Midway's response to parents concerned that video games lacked educational value. While a planned multi-edition rollout never came to pass, the character has since appeared in many subsequent Pac-Man games. (Arcade)

Pac & Pal (1983, Namco)
Pac-Man finds a new friend in Miru, and the pair team up to gather fruit and flip over cards to unlock power-ups. Some of these reference other Namco games like *Galaga* and *Rally-X*. (Arcade)

Pac-Man & Chomp Chomp (1983, Midway)
The game is a modified version of *Pac & Pal*, with characters altered to more closely tie into the popular Pac-Man Saturday morning cartoon. The show's family dog, Chomp Chomp, headlines the game. Few got the chance to play the game, as it only had a limited release in Europe after its U.S. launch was cancelled.

Jr. Pac-Man (1983, Midway)
This horizontal maze scrolling version extends the width of the maze, and continues the Pac-family storyline begun in *Ms. Pac-Man*. Its intermissions tell a Romeo & Juliet-esque story of Jr. Pac-Man falling in love with a ghost named Yum-Yum, the daughter of Blinky. (Arcade)

Count Pacula (1983, Bally)
A scrapped Midway-era *Pac-Man* pinball / video game hybrid where players would reverse roles, playing as Count Pacula, running from the Pac-Man family members instead of ghosts. (Arcade / Pinball)

Pac-Land (1984, Namco, Midway)
Inspired by the Hanna-Barbera animated series, Pac-Land is an early side-scroller where Pac-Man travels through cities, deserts, forests, and abandoned castles. (Arcade)

Pac-Mania (1987, Namco, Atari Games)
Boasting colorful pseudo-3D graphics and a jumping Pac-Man, *Pac-Mania* provides a challenging fresh spin on the classic arcade formula. (Arcade)

Carnival (1987, Namco)
This Japanese mechanical medal game allows players to bet on which number the wheels will land on, and also stars Pac-Man and his family. Other versions were produced featuring characters from *Mappy* and *Dig Dug*. (Arcade Redemption)

Family Pinball (1989, Namcot)
This video pinball game features a Pac-Man table, as well as Pac-Man himself as a playable character. Sadly, these elements were cut when the game was released in the USA as *Rock n Ball*. (Nintendo Famicom)

1990s

Puzzle Club (1990, Namco)

In this puzzle game, players move and shift tiles around a game board to align and clear rows. There are two modes of play: *Pac-Man Story* (aimed at younger audiences) and Floor Exercise (for adult audiences). Although nearly complete, the game never saw an official release. (Arcade)

Ms. Pac-Man (1990, Tengen)

Tengen's NES *Ms. Pac-Man* contains a plethora of mazes and customizable options not seen in other versions, including the Namco release for the same platform. The game features two- player competitive and cooperative play for the first time in the Pac-Man franchise. (NES, SEGA Genesis / Mega Drive, SEGA Master System)

Pac-Attack / Pac-Panic (February, 1993, Namco)

This conversion of Namco's arcade game, *Cosmo Gang the Puzzle*, brings *Tetris* to mind, as falling blocks and clearing lines are part of the gameplay. However, ghosts will also drop down with most of the blocks; it takes summoning Pac-Man himself to chomp through them. (SNES, SEGA Genesis / Mega Drive, Nintendo Game Boy, SEGA Game Gear)

Pac-Man 2: The New Adventures / Hello! Pac-Man (1994, Namco)

In a game that was billed as "the world's first interactive cartoon," the player does not actually control Pac-Man, but instead helps to steer him through a world whose gameplay feels more akin to a point-and-click affair. Using a slingshot, the player can shoot at objects in view, fling Power Pellets to aid Pac-Man during a ghost attack, or annoy Pac-Man by striking him repeatedly. (SNES, SEGA Genesis / Mega Drive)

Pac-in-Time (1995, Namco)

The Ghost Witch villainess from *Pac-Man 2: The New Adventures* returns to send Pac-Man back to the year 1975 in this multi-level platformer. While the DOS and Game Boy games are conversions of 1993's *Fury and the Furries*, the SNES version features all-new levels and gameplay mechanics. (SNES, DOS, Nintendo Game Boy)

Pac-Man (1995, Life Fitness)

A *Pac-Man* game was once in development for the SNES Life Cycle 3500 Extertainment Bike, a fitness bike peripheral designed to connect to the console. The game featured 3D-rendered graphics and gameplay driven by pedaling the bike. Although the $800 peripheral was released, this game was not.(SNES)

Pac-Man Arrangement (1996, Namco)

This high-energy Pac-Man game features a variety of worlds to chomp through, as well as a ghost named Kinky who can merge with other ghosts to grant them additional abilities. (Arcade)

Arcade Classics (1996, Namco)

This arcade game compilation for the Philips CD-i includes a version of *Ms. Pac-Man* that boasts its own unique mazes. (Philips CD-i)

Pac-Man VR (1996, Virtuality)

Virtuality reimagined Pac-Man...in virtual reality! This first-person point-of-view game was never officially released for the short-lived 1990s VR platform, but is notable for being very much ahead of its time. (Arcade)

Pac-Slot (1996, Namco)

A Pac-Man themed video slot machine. (Slot Machine)

Pac-Eight (1996, Namco)

Similar to *Pac-Slot*, but this game also utilizes vertical rows to win. (Slot Machine)

Pac-Cap (1996, Namco)

Players mechanically push a capsule through a maze-like layout to receive the prize inside. (Arcade Redemption)

Pac-Carnival (1996, Namco)

A video revision of *Carnival* where Pac-Man is shown running across a circular board. Four numbered buttons are used to bet on what tiles he can land on. (Arcade Redemption)

Pac-Man Ghost Zone (1997, Namco)

This early platformer was intended to serve as Pac-Man's first foray into 3D console gaming. In it, the story's player character was transformed into Pac-Man and sucked into an arcade machine. The game was shelved (reportedly by Masaya Nakamura), but its concepts and gameplay would later evolve into *Pac-Man World*. (Sony PlayStation)

Pac-Adventure (1997, Namco)

Medals fall onto the playfield as the gondola sways, and Pac-Man and his family serve as big win targets in this redemption outing. (Arcade Redemption)

Pac-Junior (1997, Bandai)

An electronic handheld LCD Pac-Man game that features three difficulty levels of play. (Handheld)

Anna Kournikova's Smash Court Tennis (1998, Namco)

Pac-Man is a playable character in this video tennis game; he also makes playable appearances in *Smash Court 3* and *Family Tennis Advance*. (Sony PlayStation)

Pac-Man World (1999, Namco)

Pac-Man celebrated his 20th Anniversary with a leap into the 3D console gaming space. In the game he runs, jumps, and Butt Bounces through Ghost Island to save friends and family from his villainous imposter, Toc-Man. (Sony PlayStation)

パックマンのデスクトップ大作戦 / Pac-Man's Desktop Operation (1999, Namco)

This desktop pet depicts Pac-Man running around with a ghost on the computer screen. Players can feed Pac-Man, read his diary, and let him compete against the ghosts in a series of events called the Pac-Athlon. (PC)

2000s

Pac-Man: Adventures in Time (2000, Infogrames)

In a game that re-envisions the classic arcade gameplay in 3D, Pac-Man is sent back in time by Professor Pac to recover pieces of a shattered amulet in prehistoric times, the Wild West, and other eras. (PC)

Ms. Pac-Man: Maze Madness (2000, Namco)

Ms. Pac-Man enters 3D game territory with a puzzle-oriented maze exploration game. She must retrieve the Gems of Virtue and take back control of the Enchanted Castle from the evil witch Mesmerelda. (Sony PlayStation, Nintendo 64, SEGA Dreamcast)

L'il Pac-Man (2000, Playskool)

An electronic handheld game from Playskool that only made it to the test-marketing stage. Pac-Man moves left and right to catch ghosts moving towards him. (Handheld)

Pac-It (2000, Namco)

This VMU (Visual Memory Unit) minigame was released exclusively with the SEGA Dreamcast version of *Namco Museum*. In this simple monochrome game, the player moves Pac-Man up and down to catch waves of moving dots at increasing speeds. (SEGA Dreamcast)

Pac'n Party (2000, Namco)

The third entry in Namco's *Shooting Medal* series (following *Galaxian Fever* and *Shooting Paradise*) lets players use a light-gun to fire medals at ghosts to clear stages and protect Pac-Man. The game was only released in Japan. (Arcade)

Ridge Racer V (2000, Namco)

After 1998's *R4: Ridge Racer Type 4* paid homage to Pac-Man with a car taking his form, Pac-Man himself has since made appearances throughout the series in which he drives a vehicle starting with *Ridge Racer V*. (Sony PlayStation 2)

Pac-Match (2001, Namco)

Also known as *Chain Shot*, this early mobile puzzle game lets players clear tiles depicting Pac-Man characters by selecting groups of the same character. (Mobile)

Super GPS Pac-Man (2001, Namco)

This early experiment incombining *Pac-Man* gameplay and real-world streets was axed alongside a GPS accessory for the Japanese WonderSwan handheld console. (Bandai WonderSwan Color)

Pac-Man's Ticket Factory (2001, Namco)

A ticket redemption arcade machine with a spinning wheel; stopping it at the right time dispenses tickets. (Arcade Redemption)

Ms. Pac-Man: Quest for the Golden Maze (2001, Infogrames)

Ms. Pac-Man gets into some classic ghost-chomping antics within the depths of Cleopactra. This was the last original game headlined by Ms. Pac-Man. (PC)

CR Fever Pac-World SP (2001, Sankyo)

A Pac-Man pachinko machine with an LCD monitor serving as a slots game. (Pachinko)

Pac-Man World 2 (2002, Namco)

In this *Pac-Man World* sequel, Pac-Land falls victim to a new ghost freed from the grasp of the Pac-Village's famed Golden Fruit Tree. In between adventures, Pac-Man can use tokens collected in the game's levels to unlock playable arcade games. (Sony PlayStation 2, Nintendo GameCube, Microsoft Xbox)

Tree Top Token Game (2002, Namco)

All Pac-Man wants to do is dance! In this minigame featured on the *Pac-Man World 2* website, Pac-Man must ricochet across a row of bouncy B-Doing pads collecting dots to score enough points for a token to put in the jukebox. (Web Browser)

Pac-Man All-Stars (2002, Infogrames)

Free-form levels and gameplay allow players to venture throughout the environment eating dots as Pac-Man, Ms. Pac-Man, Professor Pac, or Pac-Jr. A variety of items and obstacles turn the feeding frenzy into a chaotic party game. (PC)

Pac-Man Fever (2002, Namco)

Pac-Man and a group of Namco all-stars come together to compete in minigames on a *Mario Party*-style board game race to the finish. (Sony PlayStation 2, Nintendo GameCube)

Pac-Man Fever Flash Games (2002, Namco)

These two Flash-based browser games were created to promote the console release of *Pac-Man Fever*. One finds Pac-Man protecting an island's trees from being burnt up by the ghosts, and the other lets the player navigate a house to collect trading cards. (Web Browser)

Pac-Man Crisis (2002, Namco)

Much like *Whac-a-Mole*, in this game players must eliminate ghosts as they pop up to score points. A boss battle occurs after reaching 5,000 points. (Mobile)

Pac-Man Pinball (2003, Namco)

The virtual pinball table in this game pays visual homage to *Pac-Land*. (Mobile)

Pac-Man Casino (2003, Namco)

Pac-Man Casino: Slots Pack and *Pac-Man Casino: Card Game Park* were both released under this mobile game banner. (Mobile)

パックマンのことばdeパズル / **Pac-Man's Word Puzzle** (2003, Namco)

A puzzle game that involved lining up three letters to form words. This was only released for the Japanese PLUS e, a line of touchscreen machines installed in many chain restaurants. (PLUS e Entertainment System)

Pac-Man Ball (2003, Namco)

In this coin pusher style medal game, players match fruits and create chains in an attempt to win big. (Coin Pusher Medal Game)

ゴルフの達人DX / **Golf Master DX** (2003, Namco)

This 3D golfing game features Pac-Man as one of the playable golfers. (Mobile)

Capsule Factory (2003, Namco America)

In this Pac-Man-themed redemption machine, the player balances a capsule containing merchandise via robot arm as it slowly moves up. (Arcade Redemption)

Pac-Man Vs. (2003, Nintendo & Namco)

This clever multiplayer game re-imagines Pac-Man in head-to-head action, with one player guiding the titular character while the others control the ghosts tasked with catching him. The first player to capture Pac-Man gets to control him next. The game was designed by Shigeru Miyamoto, creator of Nintendo's *The Legend of Zelda* and *Super Mario Bros*. It was also released as part of *Namco Museum DS* in 2007. (Nintendo GameCube)

Pac-Man Puzzle (2004, Namco)

Players strategically place blocks to help Pac-Man navigate his way to the dots in each level. (Mobile)

Pac-Man Bowling (2004, Namco)

A bowling video game featuring Pac-Man, Ms. Pac-Man, Pac-Baby, and Inky as playable characters. (Mobile)

Ms. Pac-Man for Prizes (2004, Namco)

This mobile version of *Ms. Pac-Man* allowed players to compete in tournaments for real prizes. (Mobile)

Pac-Man Adventures (2004, Namco)

Namco recruited legendary animator Don Bluth to design and consult on this Pac-Man game. Though the title was eventually canceled before release, some of the design remnants eventually made their way into *Pac-Man World 3*.

Pac-Man Pinball Advance (2005, Namco)

In this round of virtual pinball, Pac-Man becomes the pinball itself; dots are scattered across the table for him to eat. Ms. Pac-Man can even join the fun during multiball events. (Nintendo Game Boy Advance)

Pac-Man Arrangement (2005, Namco)

Although bearing the same name as the 1996 title, this venture features its own set of levels, mechanics, and visual presentation. (Sony PlayStation Portable)

Mario Kart Arcade GP (2005, Nintendo / Namco)

In an unexpected twist, *Mario Kart* made its arcade debut with Pac-Man, Ms. Pac-Man, and Blinky along for the ride as playable characters! (Arcade)

Pac-Man World 2 (GBA) (2005, Namco)

While the GBA versions of *Pac-Man World* and *Ms. Pac-Man Maze Madness* resemble their console counterparts, this handheld console take on *Pac-Man World 2* plays more like a de-make of its console counterpart. (Nintendo Game Boy Advance)

Pac-Pix (2005, Namco)

When Pac-Man gets trapped in a magic storybook, players utilize the DS's touchscreen and stylus to draw versions of Pac-Man that come to life to chomp ghosts. (Nintendo DS)

Pac'n Roll (2005, Namco)

Also making heavy use of the DS's touchscreen features, players use the stylus to roll Pac-Man around like a ball to explore the ghost-infested, 3D Pac-Land. (Nintendo DS)

Space Invaders x Pac-Man (2005, Taito / Namco)

A special variation of Pac-Man where the aliens from *Space Invaders* replace the four ghosts. (Mobile)

Pac-Man x Space Invaders (2005, Taito / Namco)

This game is the reverse of *Space Invaders x Pac-Man*, where Pac-Man characters make an appearance in *Space Invaders*! (Mobile)

Pac-Man World 3 (2005, Namco)

The third game in this series includes new character attacks like punching, and is notable for featuring a speaking Pac-Man (voiced by actor Martin T. Sherman). Pac-Man even teams up with ghosts to take down a greater threat to their world. (Sony PlayStation 2, Sony PlayStation Portable, Nintendo GameCube, Nintendo DS, Microsoft Xbox, PC)

Ms. Pac-Man Maze Madness 2 (2005, Namco)

A sequel to *Maze Madness* was once in development by TKO Software, but the studio closed before the game could be completed..

Super Pac-Man Pinball (2005, Namco)

This video pinball game was once in development for the Nintendo DS by Rubik Interactive (now Zen Studios); however, the game was canceled shortly after its announcement. (Nintendo DS)

The final title to bear the *Pac-Man World* moniker, this kart racing game boasts Pac-Man characters from all three platformers, plus some Namco favorites and entirely unique entities. (Sony Play-Station 2, Sony PlayStation Portable, Nintendo GameCube, PC)

Pac-Man Arrangement+ (2006, Bandai Namco)
This updated version of 2005's *Pac-Man Arrangement* features a dose of Namco fan service, including levels designed in homage to games like *Dig Dug*, *Mappy*, and *Toy Pop*. The game is part of the Japan-only *Namco Museum Vol. 2* for the PSP. (Sony PlayStation Portable)

Namco Museum Remix (2007, Bandai Namco)
Over the decades, classic Namco arcade games have been re-released through Namco Museum compilations. However, this Wii outing cleverly features modern "re-mixed" versions of games all starring Pac-Man, optimized for the Wii's control scheme. The array of games includes *Gator Panic Remix*, *Pac-Motos*, *Galaga Remix*, *Rally-X Remix*, and *Pac'n Roll Remix*. (Nintendo Wii)

Namco Museum DS (2007, Bandai Namco)
This classic arcade compilation was released for Nintendo's popular DS handheld console, and also included a version of *Pac-Man Vs.* that allowed players to go head-to-head on separate devices via the Download Play feature. (Nintendo DS)

Namco Arcade Golf (2007, Bandai Namco)
This mini-golf video game contains a twist: collectible tokens that players can use for minigames by hitting the ball into arcade machines. Pac-Man plays a major role in the game as the announcer. it wasn't until *2008's Pac-Man Arcade Golf* that he would get to be a playable golfer. (Mobile)

Pac-Man (2007, I.C.E.)
Sharing the same name as the original game, this bright yellow coin-pusher game accommodates up to eight players. (Coin Pusher)

Pac-Man Championship Edition (2007, Bandai Namco)
Designed by original Pac-Man creator Toru Iwatani, this rebirth of classic Pac-Man features a slick neon look and intense, timed high score challenges. *Pac-Man Championship Edition* was a pioneer in modern video gaming, proving the power and relevance of arcade-like experiences on home consoles. (Microsoft Xbox 360)

Pac-Man (2008, Bandai Namco)
The original arcade game made its smartphone debut! While it started out as a straightforward port, the game received a major overhaul in 2013; to this day, Pac-Man continues to receive new mazes and content. (iOS, Android)

Pac-Man Pinball 2 (2008, Bandai Namco Networks)
The sequel to 2003's *Pac-Man Pinball*, *Pinball 2* features music, unlockable tables, and more refined graphics and ball physics. A game of Pac-Man even serves as the tables' video mode. (Mobile)

Mario Kart Arcade GP 2 (2008, Nintendo / Bandai Namco)
This update to the original arcade racing game adds two new cups, an enthusiastic announcer, and Waluigi and Tamagotchi's Mametchi as playable racers. (Arcade)

Pac-Man Remix (2009, Bandai Namco Networks)
In this isometric mobile release, Pac-Man moves through stages that contain added features like opening and closing doors, and unique power-ups. Among those are the Dash Boots (allowing Pac-Man to run fast), and the Jump Feather (letting Pac-Man hop over ghosts and walls). (Mobile)

2010s

Google Pac-Man (2010, Google)
For Pac-Man's 30th Anniversary, the Google home-page featured its logo transformed into a playable game of Pac-Man. This popular "Google Doodle" let players indulge in a game (or three) of Pac-Man, and caused a significant productivity crisis. A software firm estimated that the game's release led to 4.82 million wasted work hours! (Web Browser)

Pac-Man Reborn (2010, Bandai Namco)
This iOS game lets players raise their own Pac-Man character, allowing it to evolve in hundreds of different ways. Players could also connect the game to Twitter in a way that allowed them to feed Pac-Man their followers. (iOS)

Pac-Chain (2010, Bandai Namco)

A mobile puzzler where players clear groups of ghosts of the same color. Pac-Man can also eat them all up if he comes into contact with a Power Pellet. (iOS)

Pac-Man Kart Rally (2010, Bandai Namco)

Pac-Man and friends revisit kart-racing in this 3D mobile affair, with a 2D iteration available for phones not powerful enough to run the 3D version. (Mobile)

Letter Labyrinth (2010, Bandai Namco)

This anagram game stars Pac-Man and lets players connect letter panels to solve puzzles ranging from words to sentences. (Mobile)

Pac-Man Party (2010, Bandai Namco)

Mario Party meets *Monopoly* in this Pac-Man blend of minigames and board gaming. Players try to overtake each other's castles while also establishing and building their own. (Nintendo Wii, Mobile)

Pac-Man Championship Edition DX (2010, Bandai Namco)

The sequel to *Championship Edition* ups the ante with a barrage of fast-paced levels, a pumped-up techno soundtrack, and all the ghosts a player can handle! (PlayStation 3, Microsoft Xbox 360, PC)

Pac-Match Party (2010, Bandai Namco)

Pac-Match Party is a match-3 puzzle game where players match ghosts to clear designated tiles in each level. (Web Browser, iOS)

Pac-Man Pizza Parlor (2010, Bandai Namco)

In this casual game (in the "food serving" sub-genre), Pac-Man leaps out of an arcade machine to help a woman run her father's diner while he is in the hospital with amnesia. (PC)

Pac-Man x Bomberman (2010, Hudson Soft / Bandai Namco)

A *Bomberman* game where a special power-up turns the characters and arena into a session of Pac-Man. (Mobile)

Namco Museum Megamix (2010, Bandai Namco)

This updated version of *Namco Museum Remix* features a beefed-up selection of classic arcade games as well as the new "Remix" game, *Grobda Remix*. (Nintendo Wii)

Pac-Man World (2010, Bandai Namco)

Only known as Pac-Man World, this scrapped 3D platformer was once in the works along with titles like Pac-Man Party.

Pac-Man Battle Royale (2011, Bandai Namco)

Pac-Man's return to the arcade turns the classic formula into a four-player smackdown. Although ghosts move around the maze, players are actually focused on chomping each other! (Arcade)

Pac-Chomp (2011, Bandai Namco)

A vibrant match-3 puzzler where players progress through levels by matching three ghosts of the same color. (iOS, Android)

Pac-Man E1 Grand Prix (2011, Bandai Namco)

A driving game where Pac-Man must follow traffic laws. (Arcade)

Pac-Man Party Scramble (2011, Bandai Namco)

In this match-three Flash game themed after *Pac-Man Party*, players score as many points as possible within a time limit of three minutes and twenty seconds. (Web Browser)

Pac-Man SP (2011, Bandai Namco)

This mobile Pac-Man experience utilizes elements from both *Pac-Man Arrangement* games. (Mobile)

Pac'n Jump (2011, Bandai Namco)

Similarly to *Doodle Jump*, Pac-Man bounces on platforms to go as high as he can while eating dots, ghosts, and fruit. Unlockable levels pit Pac-Man against enemies with designs based on other Namco games. (iOS, Android)

Pac-Man Facebook Games (2011, Bandai Namco)

Along with the original Pac-Man, three other Pac-Man games were also made available through the Facebook platform, including *Pac-Man S*, *Pac-Man Casino*, and *Pac-Man Social*. (Web Browser)

World's Biggest Pac-Man (2011, Microsoft / Bandai Namco)

Players all around the world can create their own Pac-Man mazes for others to play in this massive online game. The gameplay is classic Pac-Man, but the tunnels can be used to explore the vastly interconnected map of user-created levels. (Web Browser)

Pac-Man Tilt (2011, Bandai Namco)

Exclusively featured in *Pac-Man & Galaga Dimensions* for the Nintendo 3DS, *Pac-Man Tilt* is a platformer that uses the system's gyroscopic sensor for control. The player tilts the handheld to help Pac-Man gain speed to roll quickly, spinning up ramps or moving obstacles. Switches, cannons, and pinball flippers are also used to help Pac-Man navigate the levels. (Nintendo 3DS)

Pac-Man Games (2012, Bandai Namco)

An iOS app featuring a collection of "S" editions of *Pac-Man, Galaga, Dig Dig, Rally-X, Gator Panic*, and *Pac-Chain*. Items can be bought with in-game currency via Facebook integration to use during gameplay. (iOS)

PAC-MAN™ Pizza Parlor & ©1980-2010 NAMCO BANDAI Games Inc.

Pac-Man Smash (2012, Bandai Namco)

What starts off as a typical game of real-world air hockey quickly becomes a frenzy as numerous pucks spill onto the playfield at once. The game birthed a pair of follow-ups: *Pac-Man Smash: Slim Line* in 2016 and *Pac-Man Smash Mini* in 2018. (Arcade)

Pac-Man Ghost Bowling (2012, Bandai Namco)

Classic Skee-Ball-style gameplay with Pac-Man. A sequel, P*ac-Man Alley Ball,* was released in 2015. (Arcade Redemption)

Street Fighter x Tekken (2012, Capcom)

Pac-Man makes a surprise appearance as a downloadable character in this crossover fighting game. He pilots a mech based on Tekken's Mokujin to make his power levels more comparable to the rest of the game's cast. Pac-Man's design in this game is based on the visual style of *Street Fighter IV.* (Sony PlayStation 3, Sony PlayStation Vita)

Pac-Man and the Ghostly Adventures (2013, Bandai Namco)

Based on the animated series of the same name, this 3D platformer sends Pac-Man through the levels of Pac-World, collecting all sorts of Power Berries to save his home from the evil Lord Betrayus and his ghost minions. (Sony PlayStation 3, Microsoft Xbox 360, Nintendo Wii U, PC)

Pac-Man and the Ghostly Adventures (3DS) (2013, Bandai Namco)

Unlike the console version, *Pac-Man and the Ghostly Adventures* for 3DS is a 2D platformer with its own set of level designs and gameplay mechanics. (Nintendo 3DS)

Pac-Man Dash (2013, Bandai Namco)

In this fast-paced auto-runner game, Pac-Man must eat as much as he can within the given amount of time. The game's visuals come directly from the *Pac-Man and the Ghostly Adventures* television show (iOS, Android)

Pac-Man Championship Edition DX+ (2013, Bandai Namco)

This update to *Championship Edition DX* adds new stages, music, and skins. (Sony PlayStation 3, Microsoft Xbox 360, PC)

みんなのGOLF 6 / Everybody's Golf 6 (2013, Sony)

Known as *Hot Shots Golf: World Invitational* in the USA, Pac-Man makes a guest appearance as a playable golfer in a Japan-only DLC pack. (Sony PlayStation 3, Sony PlayStation Vita)

Mario Kart Arcade GP DX (2013, Nintendo / Bandai Namco)

The third Mario Kart Arcade GP installment marks Pac-Man's last appearance in the series; the game differs from its predecessors with the addition of kart combinations, gliding, and underwater driving. (Arcade)

Pac-Man Chomp Mania (2013, Raw Thrills / Bandai Namco)

Bandai Namco and Raw Thrills teamed up to turn the original Pac-Man into a ticket redemption game. When the maze is cleared, Pac-Man must enter the ghosts' base to go for the jackpot. Also known as *Pac-Man Ticket Mania.* (Arcade Redemption)

Pac-Man Award / סרפ ןמקפ (Good Humor)

A Flash variation of Pac-Man made as part of a collaboration with ice cream maker Good Humor for Hebrew-speaking audiences. (Web Browser)

Pac-Man Monsters (2014, Bandai Namco)

A puzzle-RPG with a distinctive art style, Pac-Man characters and ghosts alike venture off in search of missing treasure. (iOS, Android)

Pac-Man Swirl (2014, Bandai Namco)

A ticket game where a ball rolls down a spiraling rail into a spot on a rotating wheel. Each hole in the wheel marks an amount of tickets that the player can win. (Arcade Redemption)

Pac-Man Feast (2014, Bandai Namco)

Players use a fan to blow red balls towards Pac-Man as he mechanically moves side to side in the arcade cabinet. Pac-Man must collect as many of these balls as he can before the time runs out. (Arcade Redemption)

Pac-Man Basket (2014, Bandai Namco)

This arcade free-throw basketball game is visually themed with Pac-Man graphics and design, as well as custom yellow basketballs. (Arcade Redemption)

Pac-Man and the Ghostly Adventures 2 (2014, Bandai Namco)

In this sequel, Pac-Man's friends Cylindria and Spiral join in with their own levels in which players shoot waves of ghosts as they move towards the screen. (Sony PlayStation 3, Microsoft Xbox 360, Nintendo Wii U, Nintendo 3DS, PC)

być jak Pac-Man and the Ghostly Adventures / Be Like Pac-Man and the Ghostly Adventures (2014, Katila)

A Flash maze game created for Teletoon+, the Polish TV station that broadcast the associated Pac-Man show. (Web Browser)

Pac-Man Friends (2014, Bandai Namco)

In this puzzle game, the player controls a group of multicolored Pac-Men simultaneously. Each colored version has its own distinct ability, like attracting dots or emitting light in the darkness. (iOS, Android)

Super Smash Bros. for Wii U and Nintendo 3DS (2014, Nintendo)

Pac-Man makes his debut in Nintendo's crossover fighting game alongside a variety of iconic video game characters. (Nintendo Wii U, Nintendo 3DS)

Pac-Man Bounce (2015, Bandai Namco Entertainment)

In this puzzle game, players must place arrows and turn them in ways that help Pac-Man navigate each level. (iOS, Android)

パックマンでモバイルeスポーツ / Mobile eSports with Pac-Man (2015, WonderLeague Corp.)

A competitive variation of Pac-Man where players compete for high scores in the WonderLeague mobile app. (iOS, Android)

Action Pac-Man (2015, Krobon Station)

An action-platformer starring Pac-Man based on Krobon Station's *Action Mogura* game. (PC)

ナムナム / NamNam (2015, Profire Co., Ltd)

A shoot 'em up where players use their fingers to fire at neon sprites that resemble Namco characters. (Browser, iOS, Android)

激ムズ！ドッヂアンドダッシュver.パックマン / Intense! Dodge & Dash ver. Pac-Man (2015, az&co)

An endless runner game in which Pac-Man travels as far as he can without running into ghosts or falling off of the terrain. (iOS, Android)

Pixel Dash (2015, Sat-Box)

Based on Sat-Box's *Chalk Dash DX* game, Pac-Man and Wagan Land characters run on chalk lines. (iOS, Android)

ピクセルスーパースターズ / Pixel Super Stars (2015, Sat-Box)

Players fling sprites against each other with the intention of knocking opponents off the playfield. The sprites themselves are based on Pac-Man and other Namco properties. (iOS, Android)

Pac-Man Slots (2015, Bandai Namco Entertainment)

An app dedicated to Pac-Man themed virtual slot machines. (iOS, Android)

Super Mario Maker (2015, Nintendo)

In this game players can transform Mario into Pac-Man with the help of a specific Mystery Mushroom or by utilizing a Pac-Man amiibo figurine. (Nintendo Wii U)

Outcast Odyssey (2015, Bandai Namco)

For a limited time, this virtual card battling game allowed players to collect and use highly stylized cards featuring Pac-Man and the ghosts. (iOS, Android)

Pac-Man 256 (2015, Bandai Namco Entertainment)

From the makers of *Crossy Road*, this endless maze game makes the infamous Level 256 glitch a core part of the experience. While high scores are still the main objective, players must also beware of the descending glitchy mess. Notably, *Pac-Man 256* was the first ever mobile Pac-Man game to be ported to home consoles. (iOS, Android)

Crossy Road (2015, Hipster Whale)

Tying in with the release of *Pac-Man 256*, Pac-Man makes a playable appearance in this smash hit mobile game. (iOS, Android)

Pac-Man Championship Edition 2 (2016, Bandai Namco Entertainment)

This entry in the series tests players' reflexes as ghosts perform evasive maneuvers even as they turn blue. The game also introduces an Adventure mode topped with walloping boss battles. (Sony PlayStation 4, Microsoft Xbox One, PC)

Pac-Man Pop! (2016, Bandai Namco Entertainment)

A puzzle game that utilizes the bubble-shooting gameplay formula popularized by Taito's *Bust-A-Move* series. Players shoots bubbles with Pac-Man to win fruits and "pop!" the ghosts. (iOS, Android)

激ムズ！ パックマンムゲンタワー / Intense! Pac-Man Fantasy Tower (2016, KIT, Inc.)

In this puzzler, Pac-Man moves back and forth while the player builds a path for him to climb with *Tetris*-like pieces. (iOS, Android)

World's Largest Pac-Man (2016, Bandai Namco)

Not to be confused with the browser-based *World's Biggest Pac-Man*, this variation of Pac-Man utilizes a huge standing LED screen or giant projection screen. The 678 lb. game adds new features like co-op play and includes a playable version of *Galaga*. (Arcade)

Pac-Man Air Hockey (2016, Bandai Namco Entertainment)

Unlike the multi-puck frenzy of *Pac-Man Smash*, this game delivers no-frills air hockey action. (Arcade)

Skill Ball Pac-Man (2016, Bandai Namco Entertainment)

A skill ball bingo cabinet with Pac-Man elements; ghosts can play the role of numbers to discard, but if they turn blue, they can be used to the player's advantage. Also known as *Pac-Man Zingy*. (Casino)

Pac-Man Wild Edition (2017, Ainsworth)

The first in a series of Pac-Man slot machines by Ainsworth. It was followed by *Pac-Man Dynamic Edition* in 2018 and *Pac-Man Link* in 2019. (Casino)

Pac-Man Puzzle Tour (2016, Bandai Namco Entertainment)

A match-3 puzzle game where Pac-Man must recapture stolen fruit from the devious ghosts. (iOS, Android)

MilboxTouch VR Pac-Man (2016, Milbox)

This game revisited the concept of VR Pac-Man for smartphones, requiring a portable headset to play. (iOS, Android)

Trace-It Pac-Man (2016, Think-a Ltd)

Players identify a path Pac-Man must take through the entire maze without running into ghosts. (iOS, Android)

Mega Run Meets Pac-Man (2016, Kecmo)

Based on 2012's *Mega Run*, this 2D auto-running platform game stars Pac-Man. (iOS, Android)

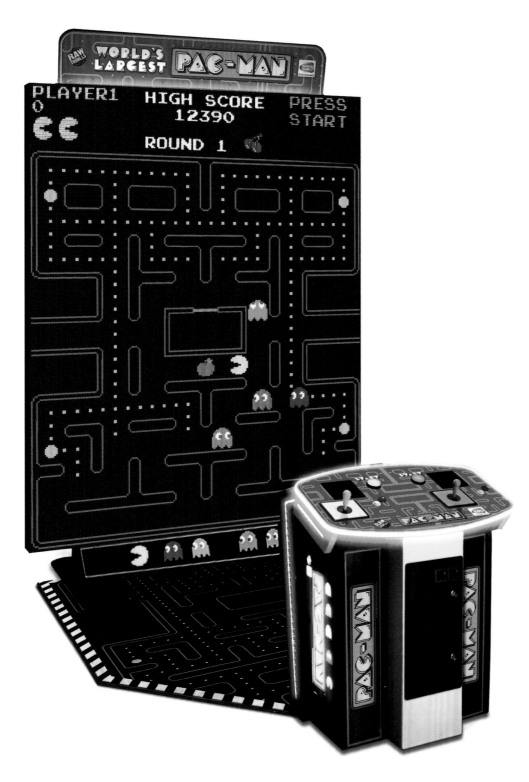

WORLD'S LARGEST PAC-MAN

PLAYER1
0
HIGH SCORE
12390
PRESS START
ROUND 1

もぐもぐパックマン"にやりゴーストの逆襲 / Mogpac (2016, Defide Inc.)
Pac-Man must follow a path while avoiding cookie-cutter ghosts and meeting the criteria to beat each level. (iOS, Android)

パックチューン / Pac-Tune (2016, enqueue)
This unique stage creator game turns Pac-Man mazes into playable music tracks. (iOS, Android)

VAMPIRE HOLMES 星屑の救世主 / Vampire Holmes: The Stardust Messiah (2016, Cucuri Co., Ltd)
Pac-Man makes a major appearance in the 10th installment of the Vampire Holmes series of apps, in which he pleads with Holmes to save his home planet from ghosts. (iOS, Android)

とびだせ/ Pac-Man Run (2016, CoolGames)
An auto-runner where Pac-Man runs and jumps across linear levels to reach the finish while avoiding obstacles in his way. Mission types involve eating enough dots or ghosts, collecting cherries, and racing against time. (Browser)

One-Way Pac-Man (2016, Shinkyo Gakuto)
Created with Pac-Man assets released for RPG Maker MV, this puzzle game has Pac-Man leave wall tiles behind as he moves around the playfield. (PC)

Pac-Man Hats (2016, Bandai Namco Entertainment America)
An open beta version of the Pac-Man app in which players progress through levels using special powers that come from Pac-Man's different hats. While the beta lasted less than a year, the *Pac-Man Hats 2* beta opened in 2017, and that structure later served as the basis for the Pac-Man app's Adventure mode in 2020. (iOS, Android)

Pac-Man Powered by Moff (2016, Moff, Inc.)
This version of Pac-Man is powered by the Moff Band wearable technology; players move their arms up, down, left, and right to control Pac-Man. (iOS, Android)

Pac-Man Ghost & Stage Maker (2016, Bandai Namco Entertainment)
Not only could players design their own Pac-Man mazes and share them in this game, but they could also accessorize ghosts and use them in those mazes. (Web Browser)

Family Guy: The Quest for Stuff (2016, Jam City)
In the game based on the popular animated show, Pac-Man was part of an event called Quahog's Not So Silent Night. Unlocking the character requires players to complete the questline appropriately named Chomping at the 8-Bit. (iOS, Android)

The Sandbox Evolution (2017, Pixowl)
A 2017 game update let players create and share levels with Pac-Man elements. In addition, the game's developers released a campaign mode that included premade Pac-Man levels. (PC, iOS, Android)

Pac-Man Maker (2017, Pixowl and Bandai Namco Entertainment)
An iOS-exclusive app composed of the Pac-Man elements from *The Sandbox Evolution*. (iOS)

Pac-Man Hammer (2017, Matic Entertainment)
A Whac-a-Mole-style cabinet; it is also known as *Pac-Man Against Ghosts Hammer*. (Arcade Redemption)

ザカード-Respectable Pac-Man / The Card: Respectable Pac-Man (2017, BlueRadioGames)
In this game, cards flip over to randomly determine how Pac-Man and the ghosts move. (iOS, Android)

PAC-MAN パックマン麻雀パズル / Pac-Man Shanghai Mahjong (2017, CoolGames)
A mahjong tiles web game with Pac-Man characters and objects (and those from other Namco games too) occupying the tile graphics. (Web Browser)

Pac-Man Note ページからの脱出 / Pac-Man Note: Escape from the Page (2017, DreamFactory)
A physics puzzle game where Pac-Man is trapped in a notebook and has to break free. (iOS, Android)

Pac-Pong (2017, SolidSeed)
A Pac-Man blend of SolidSeed's GlassPong series of virtual beer pong app games. (iOS, Android)

ガチ逃げ・マジ逃げパックマン / Gachi Escape: Serious Escape Pac-Man (2017, Nobuyuki Miyamoto)
Pac-Man is able to lead ghosts to clear them and create scoring chains in this match-3 puzzler. (iOS, Android)

Pac-Run (2017, Rakuten)
An auto-running platformer based on *Pac-Land* that was featured on Rakuten's short-lived webgames portal. (Browser)

Resse's Pac-Man (2017, The Hershey Company)
This web game version of Pac-Man replaced game characters and dots with Resse's candies. It was also playable on the Snapchat app for a limited time. (Web Browser, Snapchat)

Pac-Man Mini (2017, Bandai Namco)
This version of Pac-Man is hosted on a Bandai Namco Mobile website dedicated to webgaming. The game is akin to the original, but extra lives are rewarded every level after netting 10,000 points. (Web Browser)

Pac-Man Championship Edition 2 Plus (2018, Bandai Namco Entertainment)
New to this version of the game is a co-op Score Attack mode where a pair of players can gobble through six levels for the highest scores. A CPU ally can also be used in place of a second player. (Nintendo Switch)

PA-3 x Pac-Man Special Game (2018, Meiji Dairies)
In this short web game variation, Pac-Man slows down the more he eats. But chomping on PA-3 yogurt products will restore his stamina. The game was launched to promote PA-3, a yogurt released by the company Meiji Dairies. (Web Browser)

Retro Wonder Park (2018, Bandai Namco)
Pac-Man appears in this tycoon-style game where players can build their own Namco-themed amusement park. While the game was available as an open beta, it was never released. (iOS, Android)

Pac-Man Red Bull (2018, Bandai Namco)
As part of the promotional collaboration with Red Bull, Bandai Namco released a playable arcade machine featuring branded, custom mazes from the Pac-Man app. The exclusive arcade machine, found in convenience stores and gas stations, also contained a refrigerator with Pac-Man branded cans of Red Bull for sale. (Arcade)

Pac-Man.io (2018, Miniclip)
Swiss game website Miniclip's collaboration with Bandai Namco yielded a browser-based, multiplayer game where a player's Pac-Man could eat dots to grow larger in order to eat smaller Pac-Men. (Web Browser)

Pac in Town (2018, Bandai Namco Amusement)
A mixed reality attraction using Microsoft's HoloLens smartglasses held in Namjatown, an indoor theme park at the Sunshine City mall in Ikebukuro, Tokyo. (Augmented Reality attraction)

Pixel Runner (2018, M2K Co., Ltd)
A 2D auto-runner game starring a variety of Namco characters. (iOS, Android)

Pac-Man Stories (2018, Bandai Namco Entertainment Europe)
This Amazon Alexa app tells stories about Pac-Man and friends, and allows the listener to select story actions and branching paths in each. (Amazon Alexa)

Pac-Man Jackpot Power (2018, Big Fish Games)
A virtual Pac-Man slot machine available in the Big Fish Casino app. (Big Fish Casino)

"Alexa, open PAC-MAN™ Stories."

迷ったときのパックマンおみくじ / Hesitating Pac-Man's Fortune (2018, SFSoft)

A collection of games of chance; also includes a pseudo-3D maze for players to explore. (iOS, Android)

Sonic Dash (2018, SEGA)

In 2018, Pac-Man and SEGA's popular Sonic the Hedgehog participated in a mobile game crossover, allowing players to unlock Pac-Man and Ms. Pac-Man characters in this game. (iOS, Android)

Pac-Man: Ralph Breaks the Maze (2018, Bandai Namco Entertainment)

Released in conjunction with the film *Ralph Breaks the Internet*, the movie's characters assist the player progressing through the mazes as Pac-Man. Additional maze packs could be purchased or redeemed after buying movie tie-in toys. (iOS, Android)

トレジャー発掘！/ Treasure-Dig! Diggers! (2018, Radiuthree)

Players tap the screen in order to dig up sprites from various Namco games. (iOS, Android)

パックマンの旅めしニッポン / Pac-Man's Journey to Japan (2018, Fantec)

In another title created with RPG Maker MV, Pac-Man visits the prefecture of Okinawa to enjoy gourmet food and tour Japan. (iOS, Android)

Super Smash Bros. Ultimate (2018, Nintendo)

Pac-Man returns in this updated version of the cross-company battle game, along with every previous fighter in this game franchise. (Nintendo Switch)

/ アスレチックVR Pac-Man Challenge (2019, Bandai Namco)

A modern VR *Pac-Man* game occupying an entire room's worth of space; it served as an attraction for the now-defunct Mazaria entertainment center. (VR Attraction)

ディグ・ドル・パックじゃんけん王 / Dig Dug-Drauga-Pac-Man: Janken King (2019, SFSoft)

Characters from *Dig Dug*, *The Tower of Druaga,* and *Pac-Man* appear in this Rock, Paper, Scissors-style standoff. (iOS, Android)

Pac-Man Party Royale (2019, Bandai Namco Entertainment)

The multiplayer gameplay of *Pac-Man Battle Royale* comes home via Apple Arcade with an updated take on the popular gameplay. Players can play the game locally or online. (Apple Arcade)

Million x Pac-Man (2019, Paco Rabanne)

In this online *Pac-Man* version promoting Paco Rabanne's Million fragrance brand, dots re-spawn in the maze even after being eaten, but eating them fills up a meter that, when activated, triggers a power-up. (Web Browser)

Pac-Man Battle Casino (2019, Bandai Namco)

This variation of *Pac-Man Battle Royale* was designed for play in casinos. This game was succeeded by *Pac-Man Cash Chase* in 2019. (Casino)

One Piece Pac-Man Stampede Ver. (2019, Bandai Namco)

To promote the movie, One Piece: Stampede, Bandai Namco released a Pac-Man webgame featuring characters from the franchise. The game was accessible to theatergoers who received a special art print drawn by the original manga author Eiichiro Oda. (Web Browser)

Disney Tsum Tsum Festival (2019, Bandai Namco)

For a limited time, Pac-Man became a guest character in this party game based on Disney's lineup of Tsum Tsum plush toys. (Nintendo Switch)

Pac-Man Panic (2019, Bandai Namco Amusement)

A competitive pinball game where players go head-to-head on opposing sides of the cabinet with multiple pinballs in play. (Pinball)

2020s

Pac-Man Tamagotchi (2020, Bandai)

In this version of the Tamagotchi virtual pet, keepers can call on Pac-Man to scare off ghosts or eat glitchy messes. The Pac-Man styled toy also contains two mini-games, called *Pac Game* and *Catch Game*. (Handheld)

Kipling x Pac-Man (2020, Kipling)

Luggage maker Kipling launched an Instagram web game in connection with their 40th anniversary Pac-Man collection. In it, players open and close their own mouths on video in time with a matching Pac-Man game, opening the character's mouth to catch dots and closing it to avoid incoming ghosts. (Instagram)

Morinaga Pac-Man Mini (2020, Morinaga)

A short game of *Pac-Man* where Instead of turning blue, the ghosts turn into Morinaga candies. Some candy packages contained a code that players could enter to access a special game mode. (Browser)

Minecraft Pac-Man (2020, Microsoft)

In a digital add-on to the popular *Minecraft*, gameplay has been reimagined to fit the blocky, three-dimensional world-building game! The game includes ten *3D Pac-Man* boards, a maze editor, and unlockable characters from throughout Pac-Man's history. (Microsoft Xbox One, Sony PlayStation 4, Nintendo Switch, iOS, Android, Amazon Fire TV)

TenSura x Pac-Man (2020, 川上泰樹)

A webgame crossover with the Japanese "light novel" series, *That Time I Got Reincarnated as a Slime* (also known as *TenSura*). Players control Satoru Mikami like Pac-Man as they navigate five levels. Accompanying the game is a short story written by TenSura's creator, Fuse, where its characters interact with a Pac-Man cabinet. (Web Browser)

Pac-Man Championship Edition "De-Make" version (2020, Bandai Namco)

This "de-make" of Championship Edition recreated the modern game using the technical limitations and visual style of the Nintendo Entertainment System. It began life as a fan-created demo and eventually received an improved official release as part of Namco Museum Archives Volume 1. (Sony PlayStation 4, Microsoft Xbox One, Nintendo Switch, PC)

プロ野球 ファミスタ 2020 / Pro Yakyuu Famista 2020 (2020, Bandai Namco)

Although Pac-Man has made frequent appearances in Bandai Namco's Japanese Famista series of baseball video games, the latest installment includes his biggest role yet. As the leading protagonist of the brand new story mode, Pac-Man must build a team of Namco all-stars to fend off baseball-loving aliens. (Nintendo Switch)

スピード錯覚アトラクション *Pac-Man Racer* (2020, Bandai Namco)

The latest of Pac-Man's VR offerings, a location test was held in the Mazaria entertainment center until its closing. (VR Attraction)

Sabritas Pac-Man (2020, Sabritas)

Created for a contest by Mexican snack company Sabritas, this version of Pac-Man lasts three levels. Participants joined the game via specially marked product codes. (Web Browser)

Cooking Craze (2020, Big Fish Games)

Pac-Man appeared in this mobile cooking game as part of an event level called Pac-Man Surf City. A paid bundle pack was also available. (iOS, Android)

Hello Kitty Pac-Man (2020, Super Impulse Toys)

This game began as a collaboration with Sanrio for the Pac-Man app in 2017, but eventually was transformed into a standalone Tiny Arcade handheld game. (Handheld)

Pac-Man Geo (2020, Bandai Namco)

In a concept previously explored in Google Maps, *Pac-Man Geo* allows players to turn real-world locations into Pac-Man mazes. Players can also compete for high scores in Tour mode. (iOS, Android)

Pac-Man Mega Tunnel Battle (2020, Bandai Namco)

This battle royale-style game pits 64 players against each other in connected mazes. Players can enter other mazes, gain wild powerups, select costumes for their characters, and fight to become the final remaining player. (Google Stadia)

Pac-Man: Waka Waka (2020, Bandai Namco)

In this voice-controlled game, players speak "Wakanese" to guide Pac-Man through the levels. An audio version also allows players to interact with Pac-Man using their voice without a screen-based device. (Amazon Alexa)

Pac-Man Pizza Fly Game (2020, Pizza Marzano)

This webgame was playable via the WeChat app as part of a promotion with the Chinese restaurant chain, Pizza Marzano. (WeChat)

Project ABC パックマン スクワットチャレンジ / Project ABC Pac-Man Squat Challenge (2021, Astellas Pharma Inc. / Bandai Namco Entertainment)

In collaboration with Japanese Astellas Pharma, this fitness training web game encouraged players to squat while holding their mobile device to compete online in head-to-head teams as Pac-Man or a ghost. (Web Browser)

Pac-Man Wheel (2021, Ainsworth)

Ainsworth's latest slot machine features a digital wheel players can spin to win one of several bonus rewards. (Slot Machine)

Pizza Hut Arcade Presents Pac-Man (2021, Pizza Hut)

Specially marked Pac-Man Pizza Hut boxes could serve as the playfield of this Augmented Reality (AR) version of *Pac-Man* developed by Tool Experience. (Web Browser)

Pac-Man 99 (2021, Bandai Namco Entertainment)

This battle royale take on the classic arcade game pits a whopping 99 players against each other by turning one's ghost-chomping antics into obstacles on competing screens. (Nintendo Switch)

Image Credits

Images used are courtesy of the following individuals and organizations, with photography credits following where appropriate.

■ ■ ■ ■ ■ ■

Acknowledgements

No book is the work of a single person. *Pac-Man: Birth of an Icon* is the fruit of dozens of researchers, fans, and creators who gave generously of their time, talent, and opinions to help craft this volume devoted to Pac-Man and video game history.

The authors would especially like to thank the team at Cook and Becker, Maarten and Ruben Brands, Pascale Brand, and Eric Bartelson, for making this incredibly fun and insanely complex project possible and seeing us through to the end.

Full credit to everyone at BANDAI NAMCO Entertainment Ltd., with special thanks to Kioko Farinatti and Aâdil Tayouga at BANDAI NAMCO Entertainment (Lyon, France) for their patient liaison between their company and Cook and Becker.

We are exceptionally grateful to Mr. Toru Iwatani and Enterbrain Publishing for permitting the first English translation of Mr. Iwatani's book *Pac-Man's Method* in this volume.

TIM LAPETINO

A heartfelt thank you to more than four dozen people who helped me by participating in the making of this book, including special thanks to the following:

The alums who shared their stories of Midway's *Pac-Man* American midwifery: Greg Freres, for his invaluable memories and connections; to George Gomez, for his legacy of amazing games and patience to answer all my stupid questions; to Pat McMahon, for humbly sharing his original art and memories; to John and Sandy Werner, Frank Cosentino, David Bishop, Kevin Hayes, Brian Smolik, Jim Patla, Margaret Hudson, the late Rich Scafidi, and Stan Jarocki;

To the GCC crew who gave generously of their time and recollections of those halcyon days: to Steve Golson, who graciously spent many hours with me over several years to help shepherd the Ms. Pac-Man story into a book, to Kevin Curran, Doug Macrae, and Mike Horowitz for their razor recollections and openness;

To the team at the Strong Museum of Play, for archival and research support on what will be our third book together;

To Christine Bonheim for her life-saving transcription help; to Don Mastri Jr., for letting me share a sliver of his father's creative legacy; to Hiro Kimura, Dave Marofske Jr., Jeff Pickles (can you find your score?!), Lee K. Seitz (for constant help and encouragement); to all of the @365ofPac crew who kept me diving deeper and deeper into Pac-Man lore in 2020; to Dan Hower, for sharing his epic flyer archive; to Van Burnham for her encouragement and inspiration; to Frank Cifaldi and Kelsey Lewin for tirelessly championing video game history and preservation; to Ryan Silberman for going above and beyond for our Gameology; to Ethan Johnson for keen eyes and tireless archival/research help; to all those who provided crucial background and context, including David Greenspan, Billy Mitchell, Jennell Jacquays, KJ McClain, Marcin Wichary, Michelle van Schouwen, Jeff Scheer, Rob Wanenchak, Kevin Williams, Peter Hirschberg, Richard Robbins, Walter Day, Cat DeSpira, and Whitey Karr, and to anyone else I forgot to mention.

And most of all, my eternal thanks to the Lord; to my sweet and encouraging kids Max and Paige, who created their own Pac-Man memories with me this year; and finally, to my wife, Emily, who has lovingly endured far more than her share of Pac-Man geekery these last couple years: You've supported me through crazy times and projects as we've sailed together through uncharted career waters, both wonderful and raucous. My admiration, love, and appreciation for you have no high score limit.

ARJAN TERPSTRA

Writing this book was a journey above and beyond the ordinary perils of constructing a narrative, and it is safe to say I could not have done it without the help of all the great individuals I met along the way.

A very special thank you to Katsuaki Kato for the Tokyo interviews, done under very challenging pandemic circumstances, and to our translators Michiko Sueishi, Niek Jonker, and Kaori Kishimoto, for much more than mere translations. Additional thanks to Rica Matsumura, Masumi Akagi, Yasushi Takeda, Luite Douma, Matt Alt, and Ken Kawashima for your guidance in all matters in Japan;

In the U.S., I am eternally grateful for the support, small and big, from Ethan Johnson, Alexander Smith, Jonathan Kinkley at Chicago Gamespace, and the good people at the The Strong Museum of Play and other archives we worked with. Hats off to Julia Novakovic who first brought Tim's Pac-Man projects to our attention;

Special thanks to Joost Honig, who stepped up when it was needed most, and to my wife Patricia, whom I can rely on to make fun of me whenever I take things too seriously.

About the Authors

ARJAN TERPSTRA is a video games writer, historian and curator, and author of the books *Sonic the Hedgehog 25th Anniversary Art and Design*, *FINAL FANTASY XV Art tand Design*, and *Killzone Visual Design*. As a curator, he is involved in games curation for the Storyworld Museum in Groningen (The Netherlands), and programmed the exhibition Wakawaka! 40 Years of PAC-MAN there in 2020. He lives in Alkmaar, the Netherlands, with his wife and two children.

TIM LAPETINO is a writer, creative director, and pop culture historian. He is the author of the best-selling book *Art of Atari*, as well as co-author of *Damn Good: Top Designers Discuss Their All-Time Favorite Projects*, and editor of *Undisputed Street Fighter* and *Sky Captain and the Art of Tomorrow*. His award-winning design work has been published in more than a dozen books and magazines, and he continues to investigate the intersection of design and geek culture. He lives in Chicago, IL, with his wife and two kids.

Toru Iwatani

Pac-Man's Game Study Manual
(Pac-Man's Method)

The following pages contain the first-ever translation of Toru Iwatani's book '*Pac-Man's game study manual*," subtitled *"Pac-Man's method*."

In this book, originally published in Japan in 2005, Iwatani reflects on his career at Namco and his involvement in designing *Pac-Man* and other Namco games. He also shares precious insights into video game design, both of the era, and in general.

Both Mr. Iwatani and his publisher, Enterbrain, kindly agreed to let us publish this translation, supporting our effort to make key Japanese texts on video game design and history accessible to a wider audience.

Our team opted for a translation of the text that remains true to Iwatani's original writing, without embellishments that might improve the readability but perhaps obfuscate his intent. To aid researchers we added the original page numbers within the text.

Introduction

PAGE 4 There was a period in 1980, where I wished that gaming would reach a wider audience, to be played by more people. This is when the concept of something "females can also enjoy" came to mind. Utilizing "eating" as a theme, I thought of Pac-Man.

Pac-Man chomps through the cookies in each stage, while the enemy monsters interchangeably "chase" and "whimsically" move. The introduction of the colorful user interface and animation – inclusion of things that did not exist in games of that time resulted in the big hit Pac-Man was.

Across the ocean in America, it surpassed the widespread momentum in Japan. When turning the property into TV animation, the viewership was recorded at over 50%, creating a Pac-Man bonanza. Just like that it becomes a song, "Pac-Man Fever," became a hit topic and reached #9 on the Billboard charts.

Pac-Man merchandise surpassed over 400 items. Moving forward, this flow impacts and influences the management and sales strategy of games.

PAGE 5 25 years went by – the game industry showed rapid progress. Japanese games now hold an important position in the gaming market. Gaming centers went from places to simply play games to an amusement park where all generations can enjoy themselves. Gaming consoles in households were popularized — and now that people play mobile phone games in the trains, the "universalization of gaming era" has arrived.

Two or three years ago I personally began to teach the making of games in schools. I often have an opportunity to interact with students in class that love and have been influenced by games. Unfortunately, it seems to me that some of the younger people focus too much on only what they know, they tend to limit themselves within their world.

As they enjoy games, they obviously get better but to create games for this generation, not only does coming up with new game ideas matter, reality is that it is difficult to attract more gamers.

PAGE 6 For those who have interest in games or strive to become a creator, it is important to remember the excitement and anticipation from the curiosity and the playful nature of childhood. That feeling is the origin of game making and gives an opportunity that will help you notice various things. I want it to broaden your perspectives and develop a personal measure not only for games, but towards other things as well. In games, you can see a creator's experience and personality. If the creator themselves has a wide array of experiences, more ideas will be born. Will the next generation that will be responsible for the game industry carry such thoughts, exercise this knowledge when making games? This was the beginning of this book project.

In CHAPTER 1, I highlight my childhood experiences, episodes that became important factors for myself as a game designer, pinball which sparked my entry into Namco, and destiny introducing me to videogames once I started working for the company, and to the story that leads to the birth of "Pac-Man." Chapter 2, 3 will introduce "what is game creation?" We will take notice of the roots of game creation, currently at "Tokyo Daigakuin (University of Tokyo)" the university I teach a course in "collaborative science industry - creative content

creation program" and game developer seminar, what was popular at the CEDEC (CESA DEVELOPERS CONFERENCE) "development method of fun games and games that sell" curriculum, and the knowledge of what I have learned through the many years of producing approximately fifty games.

PAGE 7 CHAPTER 4-8*, is an extra lesson in this book, we will gather how ideas were born from various industry experts/celebrities through current games and its production, to how games should be approached and the state of the gaming market; also we broaden our perspectives to how we play games, which is essential. From there we will find qualities we seek from planners and producers and their roles to see many stories that will be helpful to those who are working to create something.

We will look at Namco which marks its 50th anniversary this year, we hear Chairman Nakamura's ideas, the origin of "Namco-ism" and the path that Namco should take moving forward.

I am extremely fortunate to be a part of a historical game like Pac-Man in my younger years. In addition, Pac-Man was influential to not only gaming, but to my life thereafter. It is just games, but games... game making teaches many life lessons.

I wish for those who picked up this book to use this as an opportunity to look at game making to feel something, and it would be great if it would be put into practice.

* (Omitted for brevity in this translation)

Chapter 1
Pac-Man's Method

1955-1980 **Affection toward "Commencement"** → **Analog and Digital Sense** → **"Fun of Make Believe" and "Devising Fun"** → **In the Pendulum of Selfishness** → **Commuting to Work (without transfer)** → **A Company that Creates Fun** → **The Birth of Video Games and 1977** → **The Birth of the Video Game Industry in Japan** → **Cultivation of Gaming Power, Atari's Blessing** → **An Age Where Copies are Rampant** → **Namco's First Shot - Video Game "Gee Bee"** → **What I learned from "Gee Bee"** → **"Bomby," seeking a game with more Intensity** → **"Cutie Q" Changes from Geometric Patterns to Characters** → **"Pac-Man," Born from Eating a Pizza** → **Behavior Algorithms Become the Monster's Personality** → **Elements of Popeye in Pac-Man** → **The Creation of "Coffee Break" From a Film Director's Perspective** → **Akabei (Blinky the Red Ghost) - They were at one point only Red Ghosts** → **Final Discovery of Balance from One Single Paper** → **Pac-Man, Born on May 22nd, 1980 in Shibuya, Tokyo** → **Pac-Man Fever in America** → **Pacman's 25th Anniversary** → **The Dawn of Japanese Game Development** → **Namco's 1980's Era Masterpieces** → **Created with Freedom in the Production Environment** → **Rivals Acknowledge Namco's Culture** → **Libble Rabble - Born at the Disco** → **Too Early of a Game Advertisement** → **Future Product Development Project** → **The Search for Online Gaming Potential in 1984** → **Migrating to Producer Work**

PAGE 10 Affection for "Gimmicks"

In 1955, I was born in Meguro, Tokyo as the youngest child following an age gap between my older brother and sister. Ten years post war, people slowly became richer. A society of mass consumption had not yet arrived, but we could sense the signs, like the end period of an era. The Tokyo Olympics had not been held, and there was no mass economic growth. I spent my youth in Tokyo before the crazy land speculation, before the economic boom. Roads were still gravel, utility poles were merely logs coated with asphalt, during that time it really felt like war had just ended and things were just starting to recover.

Till the middle of Kindergarten, I lived in Meguro. Apparently, I was a kid with a blank stare. I would experiment by riding my tricycle with my eyes closed and try to find out how far I could go downhill. Maybe I was a bit too wild.

*PAGE 11 As you can imagine, I fell into a ditch about the height of an adult and injured myself. It was not a big deal but the scar I got from it still exists, and every time I look at it, it makes me think "I was a kid who didn't think about the future." Perhaps, I was a kid who could not see my surroundings. In kindergarten, due to my father's work I had to move all around; from Akita, Morioka, and Sendai all around the Tohoku area while still attending school. My father worked in a broadcasting studio as an Engineer, so in those times we had a TV in our home which was quite unusual at the time, but I do not recall watching television at the time. No matter where I went, I leaned towards being that kid that played around alleys and hillsides. I interacted with nature the most while living in Akita. This period I experienced the most within nature, learning many things by observation.

For example, I learned to read the opponent's movements before throwing a snowball during a snowball fight, or when catching crawfish I gained the knowledge to draw in the creature by putting some squid on the tip of the hook, moving the string with a very subtle touch. I would tinker around with how to droop the string and how to put on the bait. I liked to prank as well. I would set booby traps imagining the moment when my friends would laugh out loud as they fell for my pranks.

*PAGE 12 I would make pitfalls covered with grass. Silly pranking was what I really enjoyed. A game designer is about gimmicks, and this may have been the origin of where my love of gimmicks began.

It snowed in winter and when playing in the house, I crafted a horse race game by putting together imagery I knew from a week known dice game, "Sugoroku." We would all play the game I created together. I enjoyed thinking of these ideas and making them. During this time, I believe that I unconsciously mastered an understanding about the relationship between playing and rules.

Also, since we lived in Akita, I made a snow igloo. I ate ramen in there, so I remember that I went as far as ordering delivery. It was like a cave, or a base so that is why it probably gave a sense of amusement.

During the Akita era, there was an intense experience that I still cannot forget. It was one day when the snow piled up, we played hide and go seek. Now that I think of it, this was a rare experience where I fell into a pile of fertilizer. This pile of fertilizer was an area where fertilizer was infused into manure, and if living normally you would not fall into this mixture. At the time we were playing hide and go seek, I jumped into the fertilizer and manure mixture.

*PAGE 13 Fortunately, it was good that I called an adult to help me out, but the fear of falling into a swamp with manure still traumatizes me to this day. It is like a skill that you develop when you endure a near death experience, this element of surprise when experiencing a "trap." When I am thinking of a game system, the focus on "traps" might be derived from this experience of my childhood. Probably, the painful treatments encountered as a child are brought into video games.

It is a bit of a smelly story that by falling into fertilizer, it became something useful in this world. The peaceful laid-back days in the countryside are important experiences even now.

Analog Sense and Digital Sense

Until elementary school I stayed around North Eastern Japan, and once in middle school I would return to Tokyo. In 1967, post the ANPO treaty and the Tokyo Olympics, urbanization quickly picked up, bringing Tokyo to its current state. Gradually, old Tokyo was destroyed as new Tokyo began to appear. Areas like Shinjuku and Shibuya saw prosperity through urbanization as a downtown emerged. Through television and magazines, the "younger generation culture" strongly claimed its existence.

PAGE 14 Group sounds, student movement, rock, pop art, the origin of present day "subculture" came into shape. Lifestyle in North Eastern Japan surrounded in nature was different from Tokyo where sudden modernization progressed. Until then, I lived a very laid-back life on the fields so everything to me was a complete 180-degree shift in transition.

When I was in middle school, I happened to come across a short film by Andy Warhol that was airing on television. It has left a memory of me thinking, "wow, there's a different world out there."

As for music, I was exclusively listening to hard rock, Western music. I started with Cream, then Led Zeppelin, Deep Purple, and loud head-banging music. Pitfalls, dice games, Warhol became pop art superstars (in motion picture) and the forefront of western music of the current time. The transition into Hard rock seems different, but the one thing that was clear when I returned to Tokyo was that I drastically changed to consciously take in the information represented by the mass media in my everyday life. Maybe the neural circuits responded to what I was seeking, this city-like sense is what I call the "digital sense."

PAGE 15 Come to think of it, my life experience of living in the countryside as a child was a good thing as well. What I went through as an elementary student in the fields, that "analog sense" and what I experienced after middle school in Tokyo, the "digital sense" are both what fuels me.

"Fun of Make Believe" and "Devising Fun"
The first time that I experienced "Fun in creation" was in middle school. My first memory item was a small rocket I made with a pencil cap. This so-called rocket was simple, made with tiny pieces of the celluloid collar on the student uniform shoved into a mechanical pencil cap and lit on fire, but seeing the aluminum cap with white smoke zoom towards the sky was a fun memory.

Just by itself it flew flimsily, I wanted it to fly more swiftly into the air like a rocket, so I kept adding more to it. I ended up cutting and utilizing the end of the match with a knife, as a substitute for the celluloid. I also made the body of the rocket slimmer with the reduction of air resistance.

PAGE 16 One day while doing an experiment in class the rocket suddenly popped with a bang and shot through and made a hole in the black board. I personally was making the rocket for fun, but upon excessive improvement, it resulted in making "a gun." After this, as you would guess my teacher got mad at me. However, this experience opened my eyes to "the fun in creation."

In my middle school era, I came across pinball which later triggered me into this industry. Pinball is a game machine consisting of a contained stand with inclined glass in which a rolling ball (silver iron sphere) is bounced by the flippers to hit the target to accumulate points. Pachinko in Japan is said to be a changed version of pinball. At this time, I unknowingly got sucked into the "structure of fun" in pinball and became crazed about it. There were no established Game Centers, so game machines were limited to the rooftop bowling centers.

PAGE 17 I was fascinated when I first saw pinball with its American pop design at the bowling alley. The peculiar art design on the large glass in front made me think of a painting exhibition, with all the various targets on the playfield molding together. I was drawn to the sophistication and underground vibe of the machine.

Once I played, I was addicted to the sharp movements, the speed of the ball, the fun in the various features and the depth of the game. The more I played, I would be able to manipulate the ball better. As I took my stance, I learned to embrace the machine with both hands, with an illusion as if I were dancing with the machine.

This was the beginning of my introduction to pinball as a young boy. Its "attractive type of play" reeled me into its world, and I continued to embrace this relationship today. Now that I think of it, in the experience from young boy to adult, it likely led the way of my mental growth.

In the Pendulum of Selfishness
1970, I enrolled in Tokyo Metropolitan University high school.

PAGE 18 Social passion at this time had a strong influence from the 1967 University of Tokyo Yasuda Auditorium case, an era with thriving student movements. The high school that I went to was heavily influenced by student movements, where if the entrance ceremony did not occur due to a boycott (at the start of each semester), we would show up to a class that does not exist. Some long-haired senior students holding the protest would then show up to organize the new students. I remember watching them smoking and really think, "this is where you are allowed to smoke."

In high school, the Marx principle and Communist principle ideologies were spreading, and they influenced the school culture but barely reformed it. Putting a stance to repel from the system, with a sense of opposition made it seem like the right thing for the world to go in the right direction. That is the type of influence I saw. At the time I did not think of it as "Equal Socialism" but looking back at it now it was likely more of a "opposition based on feeling."

In other words, it was not a "opposition" based on a thought, more so an opposition preference that "we want to show that we are different from others and stand out, also an opposition in fashion." I think even now, the root of "wanting to do things differently from others," this sense of selfishness comes from being raised in this era.

PAGE 19 High school and college students of Japanese society during that time seriously believed that their movement would 'make the world a better place.' I believed that too. So I joined student movements and attended demonstration marches, but aside from whether that was thought of as the cool thing to do, I participated in them like a festival, a place for the young to divert their energy. When classes were on lockout due to student strikes, we would go to the rock cafe in Shibuya at 1AM and drink while listening to loud rock. At night we would say, "should we play some Mahjong?"

Upon graduating high school, I entered the Tokyo University Faculty of Engineering living a life different from the freedom I previously enjoyed. I put time into my studies, working hard for the next four years. With the way I approached this extreme difference from high school, this influenced my life following those years. In the world of creating things, "bringing thoughts into fruition with self-assertion energy" is needed. In other words, sometimes I was called selfish and self-centered. I do often think creators are self-centered beings but being selfish for a creative job is importantly needed.

PAGE 20 During my college years, not having freedom I began to painfully understand how necessary freedom is. Every day consisted of experiments and turning in reports in a time where personal computers did not exist, I really struggled with handwriting reports. The struggle eventually aided me in the strength of will in creating games, but the energy I accumulated in college became the momentum for me to join this industry. That is me, but there was still something I continued through high school and college. This was pinball. In my youth, as I sought a place to exert my energy my passion toward pinball gave me an opportunity to blossom.

Commuting to Work (without transfer) - A Company that Creates Fun
During my job-hunting period in my 4th year of college, I got a hold of a recruitment book. As I flipped through it, the catchphrase "Creation of Play" caught my eye.

PAGE 21 Honestly, this was the first page in which I felt something. To be exact, at that moment I felt an antenna react within me. When I saw the "Creation of Play" phrase it dawned on me that this is a place where I can do something, a place where I may be able to make pinball machines. It is embarrassing to talk about it now, but at the time when Namco (Nakamura factory) was in the Ota ward, Yaguchi no Watashi station, one of the reasons I chose this job was because I was able to take one train line to commute to work. The entrance exam emphasized the interview more than a writing exam. I remember that the president Masaya Nakamura (current Chairman) and Yusuke Yokomizo were the interviewers. My direct boss Yokomizo later mentioned, "this kid is really different from the others."

When I joined Namco, they were recruiting new talent who would be responsible for the upcoming domestic video game market. Therefore, they took out a large budget toward advertising in the recruitment book to look for talent who emphasized both individuality and originality with intention to become a creator. The phrase that caught my eye "Creation of Play" was just that, an ad I saw through the efforts of recruiting the right talent. During this period, Namco received recruitment ad awards for consecutive years.

PAGE 22 Thinking back, the members who joined the company at the time of the ad awards included Masanobu Endo (Designer of "Xevious," "The Tower of Druaga") and Eiji Sato (Director of "Mappy" and Designer of "Dragon Buster"), who were part of the talent behind the initial golden era of Namco. In 1977 I joined during the golden era of Namco (Nakamura Factory). I wanted to create a pinball machine, so when I was assigned to the development team like I hoped, my expectations were on the rise. I was thrusted into reality and I thought to myself "finally, the time has come."

Soon after joining, I was at the new employee welcome party and introduced myself, "my dream is to design a pinball machine that will make the world proud." It was then, my senior stated one thing, "we don't make pinball machines here." I answered back, "then let us make them," in which he kicked back, "there are many patents, so it is pretty hard to make." Ruthlessly, just a few days upon starting, my brittle dream crumbled. Still, my dreams of wanting to create a pinball machine continued to grow within me until there was the right moment.

PAGE 23 The Birth of Video Games and 1977
In current times in the game industry, any time new hardware is announced in the news it is something major. It has grown to become a topic that never loses

interest, but back in 1977 when I joined it was a time far different from the current scene when video games finally opened the doors commercially in Japan. In 1972, after many twists and turns, when "Pong" gained commercial attention in North America, Japan followed to receive its blessing. Let us follow and unravel the birth of computer games chronologically.

There are various theories to how video games were born. The world's first video game is said to be created in 1958 in Appleton, New York in a Brookhaven National Lab by physicist Willy Higinbotham. Physicist Higinbotham also participated in the North America nuclear bomb project during World War II. The atomic bomb he was involved in was dropped on Hiroshima. After the war, they say that the physicist felt remorse and joined the nuclear abolition movement.

PAGE 24 The game that Higinbotham developed made tennis its theme, "Tennis for Two." "Tennis for Two" used a measuring instrument called an oscilloscope which the voltage was controlled through an analog circuit to draw onto the screen. Therefore, it was a game that used a monitor, but did not go far enough to call it a computer game.

In 1962, Steven Russell, a student of Massachusetts Institute of Technology (MIT), used a computer called a PDP-1 to develop "Spacewar!" This was the world's first game created using a computer. Steven Russell was a Sci-Fi fan so the Sci-Fi novel "Lensman" and its concept of space combat was used toward the creation of "Spacewar!" This software used a general-purpose type computer that then spread to the universities and experimental labs across the United States. It also gave great influence on Nolan Bushnell, who was a student at Utah State University at the time (one of the founding fathers of video games).

In 1972, the world's very first home video game console arrived. The prototype was built in New Hampshire by Ralph Bear, an engineer who worked in munition making. In 1968, he developed a home gaming system called the Brown Box.

PAGE 25 A large characteristic of the Brown Box was that you can use it with your home television to play. However, the Brown Box was not for sale commercially and several years later a home gaming console with improvements from the Brown Box," the "Odyssey" was released. The world's first video game software for sale was in 1971, Nolan Bushnell's "Computer Space." At this stage, games were too complex and failed commercially but the following year in 1972, Nolan Bushnell developed "Pong." Though it is a simple game, it is one with great depth that in a blink of an eye it became a big hit that triggered new life into the video game industry. In other words, 1972 is the first year for video games. At the time, Japan did not have a video game in existence. However, in less than a ten-year span, Japan moved on up as a leading developer of video games.

PAGE 26 The Birth of the Video Game Industry in Japan
Post 1972, video games became widely popular due to Atari's "Pong." As a result, Japanese makers also emerged. The Japanese pioneers were Daito Trading Company (present day Taito) and Sega Enterprises (present day Sega). In 1973, "Elepong" from Daito Trading and "Pong Tron" from Sega Enterprises were released. Since these games were direct influences from "Pong," they could not be called fully original.

Following a couple years, in 1975 a wonderful driving game "Speed Race" from Taito was announced. It was a racing game that utilized a wheel shaped controller where you see the car and the course from a top down birds-eye view

and can vertically scroll up and down to control the moving car. The sense of speed felt as you pass up cars was unique to this game, and there was nothing like it. "Speed Race" was a starting point for Japanese games to show promise alongside the USA in game development.

PAGE 27 Another title release by Taito, "Western Gun" (1976) also received positive reviews due to its excellent workmanship. "Speed Race" and "Western Gun" were both created by Tomohiro Nishikado who later was known as the one who brought "Space Invaders" (1978) to life. Nishikado and I have known one another for more than a dozen years. He worked in electronics as an electrical engineer and is also the game designer for "Space Invaders."

In 1976, new video game concepts started to be announced one after another. "Blockade" (1976) by Gremlin Industries was one of the games of this time. It was a four-player multiplayer game where you out survive other players on a cylindrical stand-up gaming structure.

Exidy's "Death Race" (1976) is a game where you run over and kill people. I remember that it was banned for sale in Japan due to the unethical content. As the level of technology improved, we began to see gaming diversification around this time. For Atari who made "Pong" a success, they had a video game research institute, and there were many great individuals who made a name for themself in the computer industry who enrolled there. To name a few — Alan Kay who came up with the Dynabook concept, those who worked on the concept of virtual reality, Eric Hulteen and Scott Fisher who later transferred to NASA, the microprocessor development leader Ted Hoff are among a few from Atari's video game research institute.

PAGE 28 Globally, games were becoming an extremely hot industry, as original games developed out of Japan accomplished a breakthrough in development. American developed games centered around Atari had a few steps ahead of Japan in all aspects of technology, idea, market achieving results. However, through a game that arrived in 1978, Japan too sees a turning point. It is the arrival of "Space Invaders." Post "Space Invaders," the Japanese game market welcomed a dramatic change.

Cultivation of Gaming Power, Atari's Blessing
When I joined Namco in 1977, "Speed Race" (1975) released by Taito was a big hit in the US and the Japanese domestic video game markets were amid excitement. Namco, who had gained popularity in electromechanical markets like "F-1," acquired Atari Japan in 1974. As the video game approached a new era, anticipation in market entry in the years ahead steadily moved Namco forward.

PAGE 29 The fact that Namco had the ability to sell Atari's exciting game when it had momentum made it possible to open up the video game market in Japan. This meant developer staff like me saw great possibilities in Namco. You can say that we saw the cultural influence and felt culture shocked by the nature of different games, ideas, and design.

My first job was fixing the Atari video game consoles that Namco was selling in Japan. At this time there was no service team, so the development team fixed the computer board. If new samples came from Atari USA, the development team also created the user manual while thinking of catchphrases and comments. I was the best player in the development team, and as it was before they were shipped into the marketplace I remember innocently playing against the number

"I wanted to create a pinball machine, so when I was assigned to the development team like I hoped, my expectations were on the rise."

one high scored player in Japan. Namco's development team perhaps was among the first of any game maker in Japan to experience cutting-edge video games.

Looking back now, the base plate repair job of video games was simple work but come to think of it — test play during repair, creating documents for new hardware were some of the training tasks for young development personnel like myself. Simple jobs, but come to think of it, I believe that between test play during repairs and creating documents for new hardware, I absorbed a lot of game ideas.

PAGE 30 Eventually, this prompted the arrival of "witty Namco games"... it felt like a blessing from Atari. When Atari Japan was acquired in 1974, it was a hard period to make clear what the future held for video games. However, if this acquisition did not happen, Namco would not be in existence today.

An Age Where Copies are Rampant
It is hard to believe now, but in the latter half of the 1970's there were a flood of illegal product copies in the video game marketplace. Namco was Atari's authorized distributor and was troubled by this issue. I personally was working in gaming repair as well as in intellectual property rights. It was then that I encountered events that would affect my life. This was in 1976 when Namco released the driving game machine "F-1" which became a worldwide hit but had a copied product issue. "F-1" was a car race themed electromechanical machine, one that dod not rely on cathode-ray tubes.

PAGE 31 This game at the time became a great hit. However, as soon as the game gained popularity, "F-1" and its illegal copies started to flood the market. We struggled to create this machine, but someone had an illegal copying machine and sold the games. It is something that I cannot imagine happening today.

During this time there was no practice toward illegal copies with copyright measures in place. You could only sue by presenting clear facts the unfair competition prevention law, and by means of defense. Also, to file a lawsuit, you would need evidence. There was a lead that in a warehouse in Kanagawa prefecture there were copied products so we would take pictures of the site. Of course, this was to be photographed without permission.

We quickly headed to the site and quietly with our car trespassed on site. My older colleague who accompanied me who had a physique like (actor) Yul Brynner started taking pictures. "Snap, snap," he pushed the shutter to take pictures for proof. It was in the moment that we finished taking pictures without an issue, someone yelled out to us, "hey, what are you doing?" It was the security for the warehouse. My colleague then took out and exposed the film, as on the film there was a prototype of the machine that was being developed out of Namco.

PAGE 32 It was a swift move. The warehouse security who saw this reported us to the police as an industry spy. Shortly we heard police sirens sound off and along came the patrol cars. In a couple of hours, we were being interviewed at the Isehara Police Station. We had a legitimate lawsuit regarding the copied products, but they would not listen to us. Instead we were arrested for trespassing. They secured our fingerprints and took front and side profile photos as we held on to numbered signage. That night, we slept in jail until the morning. It was the worst day of my life. Moreover, I was supposed to meet my girlfriend whom we just started dating at a concert to watch The Allman Brothers Band. She tried to match my preference for this type of music and agreed to go with me, but due to this incident I was dumped. In those days there were no cell phones, so I could not contact her.

However, I think back if that incident did not happen, I may have dated her longer, or even been married to her. Looking back, it still makes me think that this was something that influenced my life. After this, my prosecution was suspended. The "F-1" copy issue lawsuit went into settlement. At the time, slightly altered copied products were rampant, but Namco never offered that kind of product.

PAGE 33 From early on, Namco was a company that had a strong philosophy concerning intellectual property rights. I think that the driving force for their ability to come up with "games with originality" differ from other game companies come from their understanding and stance on this philosophy.

Namco's First Shot - Video Game "Gee Bee"
I mentioned it earlier but for a while upon entering the company, my main job was to repair the base plates. Day in and day out of working on the base plates was honestly not a job that was fun, but I think it was a good time to prepare since I wanted to create an original game in the future. After working at Namco for a year — in 1978 a chance arrived. The first time that I heard the request, the theme of the game had already been decided in my mind. Yes, it was pinball. Pinball was going to be the motif, the very reason I joined Namco. The reason pinball was chosen as a theme was because I believed that "pinball is filled with every game feature possible."

PAGE 34 Of course there was a personal impulse as I really wanted to make a pinball game, but in addition there was a strong conviction that pinball game features could be applied in video games as well. The technology level at the time however made pinball video games hard to produce.

This is where we came up with the idea of combining pinball and Atari's video game, "Breakout." about It is a simple game where the top screen has a series of blocks that are arranged, and you are to use a paddle that moves left and right to bounce the ball back and forth. Everyone has probably seen this game at least once as it is a vintage masterpiece. At the time "Breakout" was a major hit. That is where we took the marketplace's popularity into perspective and to take in the features of "Breakout."

Once we gathered the idea of pinball and Breaking Blocks, we quickly took it to development to start. I recall that manufacturing progressed smoothly. Shigeichi Ishimura (current President) oversaw the computer board design and programming. He accurately understood my planning intent.

When thinking back to that time, it was no comparison to now. I remember that it was an era where game development struggled with poor conditions and low budgets.

PAGE 35 It was not that Namco's equipment was bad, it was just that kind of era. During development, I remember that recording data required paper tape with holes to save the data. Current development teams would not be able to imagine this. In 1978, in sunny weather "Gee Bee" was completed. "Gee Bee," is from the English name of the "Kumanbachi" (popular name, Suzumebachi) It was named from the ball on the screen violently moving on the screen like the Carpenter Bee. My first game I worked on, "Gee bee" was Namco's first original video game. The fact that I oversaw this initial game in the long history of Namco gives me pride, as it was such an honor. In Japan, "Gee Bee" secured over 10,000 in game sales. This triggered Namco to break through into original video games.

What I learned from "Gee Bee"
Video games of that time had a relatively long product cycle and there were no preorders in the industry yet.

PAGE 36 During this time, there was one game that became so popular it was a social phenomenon and became the entire talk when discussing video game topics. Soon after "Gee Bee" was released, Taito released "Space Invaders."

"Space Invaders" got the idea and arranged the elements from the popular game of the time "Breakout." They turned the blocks to invaders, and the paddle to the tank. Even those who are not interested in games are likely familiar with this title. The popularity of "Space Invaders" during this time was crazy.

Many years have passed after the birth of video games but looking back, no other game has grabbed the attention of society the way "Space Invaders" became a pop culture sensation. The entire game industry focused their interest on "Space Invaders" - as a result "Gee Bee" did not meet Namco's expectations. With many units not selling through, they ended up staying in the warehouses. However, to me, "Gee Bee" was a product that was able to give insight into video game production.

PAGE 37 We faced pain and difficult adjustments at times, so in a sense we were lucky that we gathered and absorbed a lot of the core foundational learning ingredients to game development during this time. "Space Invaders" which swept Japan in popularity continued to be strong, where even a dedicated game center called "Invader House" was open. They faced a situation where the nation's 100-yen coins were scarce due to its reputation.

All around Japan, the focus was on this video game. "Space Invaders" spread globally and became somewhat the king of video games. According to developer Tomohiro Nishikado, development began after they applied the computer board from Midway's 1976 game, "Sea Wolf." You just really do not know what will bring on a big hit title. "Space Invaders" was the trigger on Japan's real gaming boom, as it also brought an intensification of domestic game development.

"Bomb Bee," seeking a game with more Intensity

After working on "Gee Bee," I did the game design for "Bomb Bee." "Bomb Bee" was born from the dissatisfaction of hiding in the shadow of "Space Invaders," and the fact that I could not get over the feeling of disappointment. Therefore, the basic gameplay is like "Gee Bee" and is like a sibling title to it. Speaking of improvements, just like adding "bomb" to the title, there have been changes added into gameplay. A new game screen feature included a hidden bumper on the top row that is revealed by breaking the middle area, then bumping the area with a ball so it explodes. In addition, the screen now is in color. In other words, the model changed to a game with more intensity which is a quality that games currently deserve. However, doubt arose within me. I asked, is it enough for games to just pursue what they are weak at? Even if you can satisfy a group of players one after another, we are only paying attention to one layer of specific players. This thought also connected to the challenges during the development of "Cutie Q."

PAGE 39 "Cutie Q" Changes from Geometric Patterns to Characters

To get more types of players, we decided to focus on adding new elements to "Cutie Q." The game's planner was Shigeru Yokoyama (current Managing Executive Officer CT Company President) who later became the planner for Galaga. Just like "Bomb Bee," "Cutie Q" is based on developmental planning that started post "Gee Bee." It was then where I decided to improve some things after reflecting that "Gee Bee" had a bad initial impression. "Gee Bee" and "Bomb Bee" had a 2nd screen designs. For reference, think geometric patterns. Its inorganic look gave it an awfully bad initial impression. Even if the gameplay felt fine, the game screen was scarce in its content. There I thought of the plan to, "create something that more people will play = women will want to play too."

PAGE 40 This was where the renewal of the screen image idea was born. By interchanging the geometric pattern to something that would pop- this may interest and attract girls. In other words, I decided to utilize characters.

The block was swapped with a small mushroom like rainbow blocks, who then turned into characters called "walkman." When the obstacles in the middle of the screen get hit by the ball, the expressions now change giving it a warmer feeling. To give the game title more sensibility and character, we thought of adding the Creedence Clearwater Revival's song, "Susie Q." "Susie Q" was deeply memorable as in high school we took a memorable trip to Hiroshima, and in the night train I recall the song playing, transforming it into a disco train. Due to this, the song left a lasting impression, plus the song name also felt quite sensible.
I arranged the title to my liking and decided on the name "Cutie Q." It has been over twenty years but I think that I landed a great title reminiscent of the era that will not fade over time.

PAGE 41 As a result "Cutie Q" did not become a big hit but sales surpassed the units sold for "Bomb Bee." "Cutie Q" taught me that the existence of characters can attract more players to a game.

"Pac-Man," Born from Eating a Pizza

In 1979, the state of Japan's gaming scene was pointing toward a clear direction. This was influenced through an astonishing game called "Space Invaders." Another game maker released many games that aimed to be the 2nd version of "Space Invaders" with a mechanic to shoot up aliens. Due to this, the game centers had an aura or reputation where ladies would not want to step foot into

them. I mean, game centers became a man's playground. I perceived a sense of uncomfortableness in those environments and thought to myself, "can I make a game where women and couples can enjoy together? This way the game centers will become a more peaceful environment. In addition, let us make a game that targets women."

PAGE 42 This was how the planning for Pac-Man began. Up until now when making games, I would look at people's actions and turn them into keywords to associate it to an idea. The title Pac-Man's idea came from the action of eating. I was certain that all women had an interest in eating. With "eating" as a key word, I started to look for ideas. One day, I came across an "a-ha! moment" that stemmed from that idea. It was one day when I was at lunch nonchalantly eating a pizza that I ordered. After eating a slice, the remaining pizza was shaped like a character with its mouth open. This was the exact moment Pac-Man was born.

After that, more than just working over the idea, additional ideas kept springing up, helping plans to come together. "The content you think up at your desk is not fun," is something that I think to this day since having that experience.

However, everything for Pac-Man was not fully ready during the first planning check. The enemy monsters and power treats (officially called power cookie) features were not available, and the warp tunnels on the left and right of the screens did not exist yet.

What was decided was only the four-way directional lever to make it easy for women to control, and Pac-Man to be a game based off the concept of eating.

PAGE 43 Behavior Algorithms Become the Monster's Personality

First, we added the monsters. Due to this, the next important game feature after eating, Pac-Man and the "chasing" movements were added. We requested the programmer in charge, Shigeo Funaki, "please have the monsters chase Pac-Man and surround him from every direction instead of simply following from behind like a string of beads." Mr. Funaki was able to create a fabulous algorithm from the abstract request. Let us explain how this algorithm works. The first monster chases after Pac-Man. The second monster aims a bit ahead from where Pac-Man is and anticipates its next move.

PAGE 44 The third monster targets where Pac-Man is. The fourth monster freely maneuvers wherever it pleases without thinking. The four monsters each have a different goal, so with the four working together the chasing game intensifies, creating exhilarating gameplay.

So, the algorithm can be seen and expressed as the character's personalities. The monsters that chase from behind became known as "insistently chasing characters," and the characters that roam in front of Pac-Man became "ambush characters," the seemingly unpredictable ones became the "whimsical characters," and the randomly moving monsters became the fickle characters. The game until then had no characteristic in the markers (symbol), but the moment they started to have a personality there was a renewal of unique characters. We gave the monsters a variety of colors in hopes that women too can enjoy the visual aesthetics. This also gave uniqueness to the monsters.

This was the birth of the red insistently chasing monster Akabei, pink ambush character monster Pinky, blue whimsical character monster Aosuke and orange fickle character monster Guzuta.

PAGE 45 Elements of Popeye in Pac-Man

Once the specification of the monsters was set, Pac-Man became a game where you would eat up all the cookies as you are being chased by monsters. There was a need for another factor in its game features. That is where I thought of "power treats." The origin of this idea came from a cartoon in America called Popeye. Popeye in his normal state cannot beat Bluto in strength. In the beginning, he is a delicate character who always loses to Bluto.

However, once Popeye eats a can of spinach his position turns around and he can unleash superpowers to throw the big man Bluto. Pac-Man and his power treats are basically Popeye's spinach. Here I want to clear a misconception that you may have about Pac-Man. Many people think that once Pac-Man eats a power treat, he will be able to eat the monster, but that is incorrect. The truth is that the power treat changes the position of Pac-Man and this allows him to chase and bite the monsters.

PAGE 46 This is to signify, "you are in my way, move over." By no means is Pac-Man eating the monsters. It has never been an intention to have Pac-Man eat them up. Proof of the monsters being bit was them turning into eyeballs, as they retreated to their base to revive.

The addition of the power treat, its dedicated efforts to bring Pac-Man closer to perfection. I think that –the joys of running away, chasing, strategizing, aiming for a high score – all these joys became deeper as a result. So, when all of that comes together, we get "the likeliness of Pac-Man."

The Creation of "Coffee Break" From a Film Director's Perspective

There was a proposition to make Pac-Man a game the women can enjoy, but with chasing as the base of gameplay it meant a long period of nervous moments. This type of content is somewhat hard for women to enjoy. To take away from the nerves in gameplay, as well as to open the character's view of the world we suggested to put in animations between the stages.

PAGE 47 However, Mr. Funaki, the programmer in charge strongly was against the addition. The reason was that "if it doesn't relate to the game, I don't want to program it." I did not know how to program, so there was no way I could make the demo animations.

The animations are not essential to open the character's view of the world, but we kept hearing over and over that animation demos in the marketplace were active and beneficial, so we managed to coax him into creating them. Also, I felt that Pac-Man could be a symbol not just in video games but outside of gaming as a character expansion. This was an idea that was thought of before there was ever any precedent of this. My older colleague (senpai) saw me trying to persuade him and he said jokingly, "Iwatani, you're like a film director." I remember how happy I was with him trying to cheer me up. With the simple phrase, I felt a sense of confidence where the problematic animation issue was talked about and they were able to convince Mr. Funaki to adopt this feature. The demo animation starts with light music, Pac-Man running away, and the monsters that chase him. When Pac-Man disappears from the screen, he then must have eaten a power treat as the screen changes as he returns as larger Pac-Man and chases the monsters.

PAGE 48 The animated demo became a fun and comical one where it also accurately expressed Pac-Man's gameplay. Post launch this demo was called

"coffee break" and became popular. There were players that played the game just to see the demo. This small added consideration greatly changed the way the game was perceived. Now that I think of it, "coffee break" might be the origin of animated demos.

Akabei (Blinky the Red Ghost) – They were at one point only Red Ghosts

During this time at Namco, it was customary that Masaya Nakamura (current Chairman) would do a "president announcement" or trial when the game was in development. Of course, we had him play Pac-Man. It was necessary that President Nakamura approved of the game during trial play. His firm belief in playing, along with his approval during this test play determined if the game would become a product. On the production side it was like a ceremony, with a bit of pressure.

PAGE 49 When President Nakamura started playing, he played for a few hours. I remember him getting passionate while he played. However, during this playtest he just said, "I don't know who the enemies are. Make the enemy monsters red." The separation of colors was for women to enjoy, but also to create a unique impression of each monster. I objected, "even though you mentioned this, we made the monsters colorful because we are targeting women. Expanding characters of each color is something I'm thinking about too." He still unfortunately would not hear my opinion, "No. Make it just one color, red."

As I mentioned earlier, the President held a firm belief in the process of "play." In thinking about the gameplay, it was about principle, so it was a waste to be controversial any further. I answered, "I understand. Please let me take it into consideration." For that moment I temporarily ended the discussion. I realized that in a sensitive discussion we would not reach a conclusion, so the following day I created a survey regarding the color of monsters for the development team. The details of the survey were simple. "Should the monsters in Pac-Man be colorful with four monster colors or just one color of red?"

With that, the survey results showed an overwhelming support for the colorful monsters. I took the survey data with the great difference in votes up to the President for another meeting. Once he saw the results, the President was silent for a while but said just one thing, "Got it," as he shook his head vertically.

PAGE 50 He did not say anything, but maybe my wishes towards Pac-Man finally got through to him.

Discovery of Balance in its Final Stage – A Very Fine Line

It was when the President's announcement was over, and development was in its final stages that doubt sprung up within me. Were the difficulty adjustments progressing smoothly? I personally was a little frustrated with the play speed. It did not develop into too large of a doubt or dissatisfaction, but more so I thought "I guess this is how it is." However, during an experimental verification of various work efficiencies we tried to double the speed of Pac-Man and the monsters. Suddenly, the frustration I experienced disappeared. The deployment of this faster speed brought a new sense of thrill. This is when I truly felt from my heart, "this game can make it!" This is exactly the moment when we can say that Pac-Man completed.

I still think sometimes, what would have happened if we shipped the slow version as is. During that stage both Pac-Man and the monsters were actually half the speed of what we shipped the game with.

PAGE 51 If we kept it as is, it likely would not have become a world hit. If so, Pac-Man would not have become a character that represents Namco, and even the balance of where Namco stands in the gaming industry may have been slightly different.

Sometimes a subtle difference determines if the game will become a hit. "Galaga" which arrived after Pac-Man is a great example of this. "Galaga" was designed by Mr. Yokoyama who designed "Cutie Q."

It is a shooting game that inherited the game features from "Galaxian." However, when we showcased "Galaga" at an event, the distributors gave it a harsh review. The reason was because the game was too much like "Galaxian."

After spending over six months of balance adjustments, it was a problem of appearance. The gameplay was more robust than "Galaxian" where the more you spent time playing, the depth of the game was apparent but at the show that was hard to convey. So, once we put the game out, the players became proof that Mr. Yokoyama had a good game.

PAGE 52 No matter how many months passed, the income did not drop. As a result, "Galaga" repeated production for two years becoming a super long seller that is hard to now imagine. As you can see from the example with "Galaga", just a bit of difference in detail will determine if the product would become a hit in the game world. Pac-Man too was a lucky title that made a discovery when balancing the game in its final stages of development. This fine line of balance made Pac-Man a hit title.

Pac-Man, Born on May 22nd, 1980 in Shibuya, Tokyo
A few months later, Pac-Man finally leaves the development room. Pac-Man's birthday is on May 22, 1980. This day coincides with the day that we first had a location test. Its birthplace is Shibuya. During the location test, I remember that we saw women woo-ing as they played the game, just as we tried to target them.

PAGE 53 I asked Satoshi Tajiri, the game designer of "Pocket Monster," who was also known to be a game freak about that time. He told me, "post invaders, the pioneer was Pac-Man. The fun of the demo animation screen, the comical movements of the character, and a game with a collectible gallery." He was a student at the time and was quite a gaming maniac, and afterwards he was such an intense fan that he went as far as to even purchase some printed circuit boards of Pac-Man. Also, Tajiri commented "the results once the game was fully played showed that the balance of Pac-Man and the monsters speed, the speed in relation to when the power treats were eaten were really well made. I think of its existence as a game design textbook." He praises Pac-Man from a game creator's perspective. His words make me extremely happy.

Pac-Man had high user ratings, but the sell through number in Japan was about 15,000 units. When I asked Namco's Vice President, an ally of mine named Norio Ishikawa about its release he said, "within the nation's locations some places were good, but in comparison to Galaxian sales were not outstanding." At the time Mr. Ishikawa was part of the sales business who went around selling Pac-Man stating, "I got an impression that women play games too."

PAGE 54 My personal impression was that the game was also popular amongst kids. Alongside Pac-Man, another widespread title called "Gamewatch" launched

"I think that–the joys of running away, chasing, strategizing, aiming for a high score– all these joys became deeper as a result."

video games like Pac-Man into a top hit. Many similar game types began to release as Pac-Man entered the children's market.

Just as its intended concept, Pac-Man brought in women and was recognized by children. From its release to its current state it continues to be a game that receives great recognition and love.

Pac-Man Fever in America
Pac-Man gained popularity, excelled over "Space Invaders" in Japan, then crossed the sea to North America. It provoked an excitement and fever that exceeded our expectations. After Nintendo's "Pocket Monsters" (Pokémon) hit, now more than ever we see it gaining popularity as a Japanese game. In the early 80's this was not something we thought was possible, but we somehow managed to sweep the American marketplace without any notice that it was developed in Japan.

PAGE 55 I spoke to Yoichi Haraguchi who at the time worked in the mass production design and procurement of the systems and is now the Managing Executive Officer and CT Company Vice President. When speaking to him, I was able to understand the momentum of Pac-Man and its overseas expansion. Since its location testing it was explosive in its popularity, with 20,000 to 30,000 units in its initial orders. At the time Namco's monthly production number was about 2,000 units max, so you can see that it was an extraordinary number.

According to Mr. Haraguchi, there was a time when they went around to every semiconductor maker in Japan struggling to find semiconductors, housing, and arrangement of color monitors. They were not able to reach their order numbers after all, that during production they shifted over to start production in North America, but it resulted in a shipment number of approximately 280,000 units. This number does not include the illegal copies, just the originals.

In comparison to Japan's 15,000 units, they shipped approximately 20 times more. This is tens of billions of yen (accumulation up until present day that includes character license fees) when thinking in terms of sales.It can be predicted that they could have achieved more than double the units sold if illegal versions were monitored properly as done now.

PAGE 56 At the time, the influence from North America's sales were so huge that they say Namco's general employees received a bonus of 3 million yen (almost $30,000). It was like Pac-Man fever at work. As for me, I unfortunately did not pick up a bonus.

It can also be said that Pac-Man changed Namco's profit structure. This is the origin of licensing fees. During these days, America had Atari's home console system called the "Atari 2600" which was expected to spread more than the Famicom (the official name in America is Nintendo Entertainment System). They say that Pac-Man was ported over and became a megahit reaching a breakthrough of 5 million units. To each unit, there was a suitable licensing fee that was added to it, so it is said that the amount was huge.

Famicom's "Super Mario Brothers" had a record sale of approximately 7 million units, so it is known to be Japan's highest selling title. The next game would be the Game Boy version of "Tetris" with approximately 4.5 million units in sales.

Even when comparing this number, Atari 2600 software's approximate 5 million units can be called a record. You can see from the numbers the great length of popularity Pac-Man gained in North America.

PAGE 57 During this era Japan was still weak in its ideas for a character product line release, but North America was already doing this. Namco had license agreements with about 250 companies for a release of close to 450 Pac-Man merchandised products. The range of items released was a variety that included neckties, telephones, and other various items. Japan did not air this, but a TV animated show was created as well. The production was done by the animation studio Hanna-Barbera Productions who was famous for animation shows such as "Wacky Races," "Tom and Jerry" and "Shazzan."

Hanna-Barbera Production has low awareness in Japan, but in the United States it represented a Production Studio known for big hits. The Pac-Man cartoon was a super popular cartoon which aired during prime time, and at its peak it had a 56%% viewership rating. This was when what we now call media mix rapidly began deployment. When Pac-Man and its popularity were at a climax, Pac-Man Fever released as a disco record. It became a hit as it peaked at number nine the Billboard charts on the Billboard 100. Most were not aware that across the sea, Pac-Man Fever was surpassing Japan's popularity of "Space Invaders."

PAGE 58 This unusual fever even unleashes into the art world. Pop Art master Andy Warhol added this to his artwork list as a motif, but unfortunately a piece by him ended up only as a dream. After his passing however, his apprentice carried an art piece to completion. Also, there are an assortment of coined words that are derived from Pac-Man.

They say that those who are really into Pac-Man are Pac-Maniacs and people whose wrists hurt from playing too much Pac-Man were called Pac-Wrist. At one point there was a hot topic of an economic expression called Pac-Man Defense that many people may have heard about. This is when a company is to be acquired but turns the tables by trying to acquire its would-be buyer. In any case, Pac-Man swept up popularity all over the United States, and as a creator, I could not have imagined the scale of this Pac-Man Fever. In America, it gained top class popularity being compared to Mickey Mouse of the 80's. Why was it that Pac-Man became such a hit in America? I attribute its reason to a strong first impact.

PAGE 59 Just as Japan saw an impact from novelty in "Space Invaders" with its complex attack patterns, in North America Pac-Man was amongst the first games to have character. I feel that it became a legendary hit as it captured the hearts of Americans.

Pac-Man's 25th Anniversary
Pac-Man celebrated its 25th anniversary in 2005. The number of games that I've helped develop include "Pac-Land," "Pac-Mania," recently, "Pac-Man Vs." (Nintendo), and counting the recently released "Pac-Pix" and "Pac 'n Roll" amongst others makes the series huge.

It was not an exaggeration to say that with new hardware it released on pretty much every gaming system. New hardware and new media always included a Pac-Man game. With the latest handheld device PSP, Pac-Man has ported over, and not just in Japan but in mobile devices across other territories saw a Pac-Man application.

PAGE 60 From what I hear, the Pac-Man app overseas has quite large sales. I think that Pac-Man as a game has become a gaming pronoun. In other words, like "Breakout" and "Tetris" it became a standard of gaming. Then how did it become a standard? I believe it is because Pac-Man was not arranged from another game but was created with rules that can only be played in Pac-Man. For the 25th anniversary in 2005, Pac-Man saw a success as the most successful coin-operated game in the field of business hardware that it received a certification of recognition from the Guinness Book of World Records.

In the span of seven years from 1980 to 1987, Pac-Man sold 293,822 units (this includes royalty). This astonishing accomplishment received praise, as well as deeming its number one spot.

PAGE 61 **The Dawn of Japanese Game Development**
Let us take our story back to the 1980's. After Pac-Man released in 1980, arcade games (video game systems for businesses) began to change greatly. This was the rise in original games. It was an era where a handful of titles that were the origin of gaming arrived on the scene.

"Scramble," the first side-scrolling shooter released from Konami in 1981 is what you can call the origin of side-scrolling shooter games. Another side-scrolling shooting game pedigree was inherited by a title that is in our history, "Gradius." "Gradius" released like "Scramble" through Konami in 1985. Its production is said to have received high ratings, with exciting gameplay that included a power up system with strategic options, lasers, and special sound effect settings for weapons which still to this day hold up. "Gradius" also influenced other titles like "R-Type," and "Darius" amongst others. Also, around this time PC performance increased giving it much more range to gradually increase the creation of games with unique qualities. In 1979, an electro acoustic company released "Heiankyo Alien" where you chase an enemy into a hole and bury them.

It received a lot of buzz due to its unique environment and gameplay style created by a Tokyo University student.

PAGE 62 Other games made in Japan that were released during this era are "Crazy Climber" (1980), and Nintendo's "Donkey Kong" (1981). "Space Invaders" that was released in 1978 influenced the expansion of the video game marketplace.

You can say that 1980 is when they broke away from games that imitated "Space Invaders." We can say that Japan started the road to becoming one of the world's greatest video game producing nations this year.

Namco's 1980's Era Masterpieces - Created with Freedom in the Production Environment

In the 1980's Namco saw what you can call its first golden age when video games encountered diversification. Games that released in the early 1980's and are still supported today include Pac-Man (1980), "Rally-X" (1980), "Galaga" (1981), "Pole Position" (1982) , "Dig Dug" (1982), "Mappy" (1983), "Xevious" (1983), as well as some others that will remain in videogame history.

PAGE 63 I asked about how the era was like to "Space Invader" creator Tomohiro Nishikado, and he mentioned that everyone felt that there was quite a hurdle in order to catch up to Namco's masterpieces that they were rushing to create one after another. However, Namco at the time was not listed as a company, and they were creating games without having a clear budget. In a way, for game creators this environment was an extreme blessing. It was an era where instead of thinking of deadlines and budgets, they could make anything into a game starting from a blank canvas to freely draw and knead their creation until they were completely satisfied.

It would not be called an exaggeration to say that Namco's masterpiece titles in this era were mostly created in this kind of environment. Also, compared to the current masterpieces the production scale of the games was overwhelmingly smaller, that it likely made it possible for this type of freedom in the production environment. In addition to that, the spirit to vigorously take challenges and to accept novel ideas likely existed because the game industry was in development. This dream-like reality continued post the 1980's era. With that, Namco was able to see through the creation of many masterpieces due to the steady corporate culture.

PAGE 64 Rivals Acknowledge Namco's Culture

In the 1980's Namco was part of an era filled with many masterpieces, as well as a time where they competed with its rivals. During the early 1980's its rival was Atari. Namco's company goal was to create fresh games like Atari with game ideas that did not exist anywhere. At the time, each time Atari's latest title was released we would feel motivation.

Towards the end of the 1980's there were clear rivals in Japan. Specifically, they were the three companies Sega, Taito, and Konami. When participating in shows, I would choose to first go look around to see Sega, Taito, and then Konami.

This was customary, as I was extremely curious to see what they would be showing. There were times when I would feel disappointed, like "man, they beat us!" One of our goals during this development during that era, we wanted to make games that would stand up to our rivals. Elemeka Games included "Ryori no Tetsujin" (Cooking Iron Man), "Sweetland," and videogames included "Final Furlong," "Block Cycle." Whenever they released new concept titles, we would receive high reviews saying that they were very Namco like.

PAGE 65 So, what exactly is what people claim to be "Namco like"? It is a question that is hard to answer. However, when I think of what "Namco like" means I think it is a new challenge that displays (human) warmth. At times we offered thoughtful things for the players or come up with game features that do not exist elsewhere. We were a company that while we tried new things, can still do interesting things. This flow has existed from long time ago and still exists in what is "Namco like." I think that in recent times the 2002 hit title, "Taiko no Tatsujin" takes part in this "a new challenge that displays (human) warmth."

Libble Rabble - Born at the Disco

A little after Pac-Man had its big hit, we developed "Libble Rabble" which released in 1983.

PAGE 66 "Libble Rabble" is an action game where you play as the characters Lib and Rab, controlling them at the same time with a lever to capture fairies. When the line that connects Lib and Rab gathers around the fairies, you can capture them. It is considered an unusual game within Namco's games, but the gameplay is deep. Even after about twenty years since its release, its unique game style does not fade.

In "Libble Rubble," just like how Pac-Man had eating, when thinking up its plan I gathered a hint from what the action would entail. For this, the action was to surround. I thought of surround at a very unusual place. In the early 1980's there was a disco trend and I frequently used to go out to enjoy the scene. I loved to dance intensely by taking up the entire floor. One time, it was crowded, and I felt that the people surrounding me were in the way. I thought for a second, "I wish I can round them up with a piece of rope and erase them." In that moment, it also brought up a memory of a game I played when I was a kid, where you would have nails in the ground that symbolized points and you would connect the dots to claim the territory. This is when I thought of the game concept for "Libble Rabble." In the planning phase the title was named "Potato."

PAGE 67 The initial phase of the concept came together quickly, but with the computer performance in this era it was hard to color in the area that was surrounded by a line, with this new screen processing need. Hence, we needed to start development from the board. Once the hardware completed, we then saw limited gameplay with its simple mechanic to surround the enemies and take them out. At the time, the director and producer duties started to increase, so I asked the game design to be led by Makoto Sato. With Sato being the center, we had programming lead Kazuo Kurosu, hardware design Toru Ogawa (currently CT Company Development Strategy Office) to produce "Libble Rabble." The game's feature of finding treasure and nature conservation recommended sensibility came from Sato's idea. I am appreciative that they were able to complete a game that exceeded my original plan.

Also, from the planning documents to the major specification changes on the way, Kurosu who had ability showed reluctance at first but we were able to make the changes by convincing him that they were necessary to create and deliver an exciting game. "Libble Rabble" was born after such hardship. But commercially, it was not a large hit. However, to game fans, I think that the game is deeply is rooted in their memory as a hidden masterpiece that goes down in history as a gem.

PAGE 68 Too Early of a Game Advertisement

I think that games are a type of media. To prove that, one of the outlets are game advertisements. In the latest baseball or soccer games you will see stadiums and fields with actual advertisements, which we call game advertisements. The game advertisements largely started focus during Namco's "Super Famista 4" (1995). Like the actual baseball field, the stadium banners had product logos that were placed and acted as advertisements.

Not many people may know but the Nintendo Disc System had a title called "Return of the Mario Bros" (1988). This was a tie-up with a company called Nagatanien to do an advertisement in the game.

PAGE 69 In exchange for a rewrite fee that is normally 500 yen, it would be 400 yen. This was an epochal game. This advertisement idea was something we were thinking of during "Libble Rabble."

I earlier mentioned that "Libble Rabble" during the planning phase was called "potato," so let me explain why. At the time we were thinking of a tie-up with a potato chip maker in the initial planning phase. Once that game was cleared, we were planning a potato chip product commercial. However, "Libble Rabble" planning when completed in 1983, it was too soon to do. Unfortunately, there were no companies that could work with us on the tie-up.
That resulted in "potato" changing to "Libble Rabble" when it saw the light of day. Then, a few years later game advertisements came into fruition through Sega. At the time, I remember feeling extremely disappointed. Other than game advertisements in-game, there were other development projects that took precedent during those times, so I would like to introduce those next.

PAGE 70 Future Product Development Project
Like the catch phrase that brought me to the beginning of my career, Namco was a company that strived to create the act of play. Lately, they focus on things other than games like food theme parks as a company to focus on "play" as a main component. This type of company culture existed previously, and once Pac-Man completed, I had the opportunity to be blessed in the creation of the future product development project (1981-1982). The future product development project allowed us to think of various things to experiment with.As an industry that focused on post-game projects, aside from the existing game we had an opportunity to challenge it if it had any elements of play. With the arrival of the Nintendo DS, we experimented with the touch pen that was receiving a lot of attention through touch paint. A top candidate was a Nintendo DS software where you drew Pac-Man to play the game, called "Pac-Pics."

Utilizing touch paint, we were planning around a project called "Electro Ehon" (Electro Picture Book). It was intuitive with the finger and screen, as it used the latest Liquid Crystal (LCD) technology to knead the planning of the product.

PAGE 71 We were working on a prototype software where interaction with on screen animals could make them move but unfortunately, were unable to see it to completion. One reason we did not complete the project was due to the number of games that I oversaw in development were moving rapidly alongside my full-scale producer duties. There was another reason, which was that Namco did not have a department that dealt with toys in its organization, so there was not department that could sell the potential product. The Electro Picture Book planning was an interesting idea, so it is unfortunate that we did not see it to fruition.

The Search for Online Gaming Potential in 1984
Recently, online gaming is considered a genre on its own but during the future product development project we were experimenting with games that utilized the network. When mentioning games that used the network, it was not like now where many players can access one gaming field at the same time to play in real time. It was more about accessing a menu at home to choose a game that you want to play, and then through a cable company downloading the game.

PAGE 72 The experiment was done in Nara prefecture, in Higashi-Ikoma city where a cable television's bio directional light fiber network was utilized to perform a test operation on the MSX personal computer terminal for on-demand distribution. Since the system itself was a cable company's and on demand service, the VTR was modifiedfor MSX use, and consisted of simple game data recorded on to a VTR tape that would be distributed.

According to my memory, the monthly fee (Accurately 45 days) cost about 2000 yen (approximately 20 dollars). The service had a positive reputation, but this business was not able to step into an actual service. The reason was that it was apparently too early to go into service. The MSX personal computer that was being used at the time had incredibly low specs that could not even be compared to the personal computers that are out today, so it was very tough.

Another large reason that I think this did not work was due to little progress with the spread of the fiber network, as well as the terminal for personal computers that showed little progression.

The network infrastructures that are now set up today in general households, were released around Windows XP's release 2001. Come to think of it, the fact that it this idea only made it to concept stage in the 1980's era is no surprise.

PAGE 73 Since then, games that utilized the network have been enjoyed and is certainly showing great possibilities.

Migrating to Producer Work
Once the "future product" work was done and the development of "Ribble Rabble" started to move forward, I moved from planner and producer to full-time producer. At this time Namco's initial masterpieces all came together, the director, as well as I moved over during this time to more of the producer role. Masterpieces and well known "Dragon Buster" and "Genpei Tōma Den" are among those I worked on after moving to full-time producer.

In "Dragon Buster" we took in the concept of life gauge, and it was one of the first games that used this type of damage indicator at the time. Like a fighting game, it utilized a command technique which this game was the first to do so. The director was Eiji Sato who also worked on games like "Mappy."

PAGE 74 Namco's release of "Genpei Tōma Den" in 1986 is the title that showed me pain and the difficulty of producer work. The game is a Japanese style action RPG where you play as Taira no Kagekiyo who fell in the battle of Dan-no-ura. After he is overthrown, he will be resurrected to fight Minamoto no Yoritomo. During the middle, we worked on a novel idea where in the game system depending on the stage the viewpoints would change.

Also, according to the exit you would be able to choose the route freely and without the three sacred devices collected you would not be able to move forward to the final boss; things that are now normal but at the time the game detail, graphic, sound, and everything was considered fresh. However, to me there were difficulties with the young director, programmers, and different viewpoints making it an extremely hard time working on this title. This is when I witnessed the severity and hardship of the producer world.

Since then, I have worked on over fifty titles as producer. I remember feeling fortunate that I was able to get involved in quite several games, but I have also felt the hardships. I will share my knowledge in the next chapter regarding my experience in producer work and what it took to cultivate these fifty plus titles.

PAGE 75 The Real Pleasure of Creating a Game from Zero

In 1985, Sega released a game where you straddle a motorcycle bike and drive, called "Hang On." This is the beginning of experiential gaming. An experiential game is a fusion of ele-mecha game and video game where the machine housing moves along with the game's movements. The development of the project was done by my friend, Yû Suzuki.

After this, the experiential games that released consisted of "Space Harrier" (1985), "Outrun" (1986), "After Burner" (1987), and the driving force behind the huge hit "Virtua Fighter" (1993).

At Namco, there was "Pole Position" (1982) that used a large individual type machine, and "Final Lap" where you can communicate to one another while playing. We released our games with a different approach from Sega. Then, once we entered the 1990's Namco also started to develop experiential games. Why did we focus on experiential games and enter this market as if we were chasing Sega? Since there were no controllers, this type of gaming would be able to offer novel and fun elements in comparison to regular individual games.

PAGE 76 Also, after the release of Sega's "Hang On" there were radical movements to make thematic games with sports cars, fighter machines and other experiences, whereas Namco created experiential games like "Alpine Racer" (1995) and "Prop Cycle" (1996), shifting to games where one can enjoy controlling the game with their entire body.

With experiential games, there is a difference from a fixed interface (terminal control part) used in table games. There is a need to pay attention to how a game operates during production. In the first experiential game released, Sega's "Hang on," you would have to maneuver the fixed portion left and right to control the game but at the time the idea was so novel that there were many people who were confused about it. This is a large task for experiential games with original interfaces. There was something similar with "Alpine Racer." "Alpine Racer," is an experiential game that has a ski-type controller.

Skiing is the subject matter but instead of having a controller per each side of the foot, it was designed where you would put both feet into the board so that even if you did not know how to ski you would put both feet together to enjoy skiing through parallel turns.

PAGE 77 However, prior to development we tried to create a board for each leg to reproduce a sense that operated similar to skiing. In the experiential game, we had believed that basically "the theme itself would have to be a real experience within the game." If each leg had a different controller the game controls would be extremely hard to control, making it less fun as a game. It was then that we took the two ski boards and improved it by making it one board. With this change the game became very balanced.

Although it was different from real skiing, we did feel a bit anxious whether players would accept and understand this unique way to operate the game. When we ended up doing the location test, we saw a very great income, and the only concern we had about the game's operability ended up being popular with the players. Unlike basic table games, game production for an experiential game comes with a real pleasure starting from zero but also there is a large theme of "what to do to have the customers enjoy themselves." Because we pursued this without neglecting this point, we saw happy guests during the location test.

PAGE 78 These types of experiences at the location test sites are great starting points for creators. I believe that feelings of these moments give us luck and advantage, but what do you think?

PlayStation and Namco

Today, the top home console video game PlayStation series has quite the connection with Namco. In 1992, after the arrival of Super Famicom Namco was moving to plan the creation of an original home console.

Since there were developments in hardware in the arcades, we had a hypothesis of the specs, and had an idea of the drawings and functions of the system. In other words, you can say that a hardware architecture design was completed. At the time Namco was aiming to develop what became mainstream for arcades, a machine that can express 3D. We were aiming for hardware that can reproduce "Ridge Racer."

PAGE 79 However, the integrated circuit and the design to realize this could not be achieved with just the game maker alone. This was a world where hundreds and millions of yen would be spent on the full amount to produce. This is where Namco wanted to discuss a joint development of the chip with Sony.

I discussed this with my friend that worked at Sony then, who suggested an introduction to speak with Mr. Ken Kutaragi (Current President of Sony Computer Entertainment) as this would be up his alley. Quickly, I called Mr. Kutaragi and conveyed the details and received a slightly strange reaction.

We decided at first to "meet and have a discussion." We proceeded to have a simple meeting, and there Mr. Kutaragi relayed a fact that we did not expect. It was a truly shocking statement where he conveyed, "we currently are in the middle of developing game hardware for the home television."

"Wait, Sony is?!" However, it was imaginable since this is Sony." I was able to quickly restructure my feelings about what I had heard. In that moment, Namco's hardware plan lightly disappeared. We moved discussions forward instead to have Namco cooperate with Sony in developing software for their new hardware.

PAGE 80 With the release of PlayStation, Namco also released "Ridge Racer." It was a port of the big arcade hit. It was a fact that "Ridge Racer" was able to help pull the sales of the PlayStation. Come to think of it now, for PlayStation that was looking for game software with value and potential, the conversation with Namco may have been great timing.

CHAPTER

Game Study

PAGE 82 VARIOUS CREATORS!

To achieve something, it is said that you need a wide field of view, and game creation is not an exception. Last year, in various fields there have been a plethora of people with the title of creator. It is my belief that to become a true creator, I suggest that you first take interest in things that are outside of your field to widen your field of view. When I mention it this way, the majority will think that it sounds vague and that it isn't easy to move it into motion, as I also thought. To begin it can be good to start by looking close at your surroundings.

For example, it can be in the commuter train that you nonchalantly ride every day. Is there something from your perspective that you find interesting? Try taking a simple approach to observe your surroundings. This observation is essentially the important action in creating something.

The secret to coming up with a great idea is not to think up the idea up front, but to observe is the first step into creating something. To begin, try to always take in many sights, sounds, and experiences to accumulate and enrich your brain's database.

PAGE 83 The gathered data from these observations will exquisitely choose

various things from within your mind combining them together as ideas as they come to fruition. In game creation, a creator's personal experiences and personality shows. The more experiences a creator has, there is a chance for a variety of new ideas that connect to a good game.

Also, for the various creators that deal with game creation, the hope is that the perspective will come not only from their experience in gaming, but from their individuality. It is important that over time they polish up their status and are able to is reflect their experiences in the game. With this, even if the technical environment surrounding the game changes, I think that the basic outlook of an individual must not be forgotten when creating a game.

In this chapter, I hope to take you through the "preparation in game making," to the "basics of making games, "development method" and "knowledge of game development work."

"Infinite" is Where the Game Theme Lies

It takes numerous steps for game creators to make a game product and to output it into the world.

PAGE 84 Within those steps, first we need the theme which is the nucleus and

the input of the subject matter which is essential. Without them, no game will hold up. I think that games are entertainment, also one of the things among the category of playing. This is why when I'm thinking of a game's subject matter or theme, I pursue the game content (subject matter) itself and instead of making

it more complex (equates to why my ideas aren't super mania style), I focus on the part of "Playing (Fun)" of what the game will inherently equip. What is the play factor that gaming has?

Long ago during the "Space Invader" copied product issue, a judgement was issued during the development of the trial. According to it stated: A "game" is something where rules exist to achieve a goal within the fixed space and time limits. By completing voluntary actions and activities, we aim to provide excitement and fun as a form of expression, that is part of a cultural phenomenon to be understood as a valuable existence in human society. (Tokyo Chisai Showa Gojyuyonen 1954 - Number 10867 Main Sentence of the Judgement Claim for Damages)

PAGE 85 On its own the sentence is hard to understand, but what is written

here matches the definition of how I see games. In other words, we could interpret it as "a game is all play based on certain rules." If you think about it like that, the game's subject matter and theme spans the vast world of humans. There is a possibility of expressing anything through this medium.

In other words, when generally speaking you can look to opposing fields from games like the medical care and welfare fields, restaurant business, education business, sporting business, information business, the geriatric business, among other fields when looking for subject matters for games.
I chose video games as a medium to express myself, but as mentioned earlier, it not an exaggeration to say that there is infinite possibility in the game development space.

Also, what is important is to discover themes and subject matter that are unique to oneself. By freely seeing things without being bound by time frames in the vast world that surrounds ourselves, we take a step toward moving forward as a game creator.

PAGE 86 Fun first

In the perspective of crafting something there is a way of thinking that is most important. This is "FUN FIRST" = first and foremost to have fun. If the game is not fun, there is no point to it. This is obviously for the player but applies to the creator as well.

First, we need to prioritize game making by asking what the player considers fun, and what players find to be interesting. This is something that I always thought about. Essentially, players do not welcome difficult things. However, as of late users have become geeks, so there are trends around those who seek complex games. I see situations during game creation where they fail to make proper decisions due the game creator falling within the gap between the maniacs and general players to get stuck in a dilemma.

I would like people to be mindful to make games that give an easy to join impression for beginners and people who are not familiar with games. On the other hand, what is "FUN FIRST" to a creator? This means that the creator has a goal to create a game that they want.

PAGE 87 To achieve this, it is important to first be aware of who would find their desired game to be "FUN FIRST." For this, there must be a clear reference value on the creator's side.

As an example, I will talk about my reference value as, "finding content where a craftsman that normally does not play games would be able to enjoy." In my opinion, I have an image of craftsmen = "stubborn," therefore it may represent a typical category that is difficult in providing the idea of "FUN FIRST." By visualizing the target, it helps me be mindful to design games for a wide range of users. In game production, when coming across a situation that makes you think, if we visualize the "XX type of person," clarify and make concrete who that target is, it is easier to identify and apply "FUN FIRST" for the various parties. In this flow, it is likely that the game design desired by the creators will naturally move in the right direction.

Everything is Born from Observation
I am often asked where the imagination is derived from when coming up with a fresh game idea where the game rule is original, the story is abundant in change, and one where you are completely focused in the game

PAGE 88 This is not an innate mechanism where you are able to think of something from nothing. Knowledge acquired in the brain, choosing data derived from gathered information, and the results once combined become the form of an idea is scientifically made clear to ignite a spark. If that is so, it is thought to best to collect a wide amount of information to broaden the options that will lead to many secret discoveries of fun patterns (combinations) and ideas.
Here, let us introduce an example of the game development process.

Even if we can collect information (input), to choose from it and combine it to an idea (output) starts from observing things. For example, we will say that an employee of a company was observing people in the commuter train that they go back and forth on every day. One day, they quickly glance around the train and discover a similar item that everyone has. In this moment, we gather the information of something that everyone has, the results behind the analysis of why everyone has this, the reasons and hypothesis (idea) to consider why they have this item. What happened in the mind of this employee was that at first, he was able to, "observe," and at relatively the same time he then proceeds to "analyze," "consider," and turns the wheels in his head.

PAGE 89 Then, it results in the birth of the "hypothesis." I looked at the series of the flow to "observe → analyze → consider → hypothesize" as an idea finder that I make a habit of every day. It is not an exaggeration to say that I am always interested in something.Like so, just by looking at the little things in our everyday lives it should connect into many ideas. I think that I would like to call this flow, ideas born from "observations."

The ideas that are born from everyday observation can often be an important introduction that connects easily to product development. Additionally, beyond that we can see it in the world of practice as we gather the hypothesis to "create," and to produce as we "develop' after the ideas are completed. Lastly,

we step into the product marketplace to get evaluated to complete the process. When I explain how these ideas come to mind during a lecture, I often refer to an "escalator" as an example. In comparison to an elevator, an escalator is less convenient to go to higher floors, but it is a complete tool for navigating between floors. This is because if there is a power outage, elevator functions are lost and you will be locked up during that time, resulting in trouble, whereas escalators will still properly function as stairs.

PAGE 90 That is why we can evaluate it as a complete function that serves its purpose well. This seemingly simple idea also resulted from observing an escalator to having a variety of assessments to consider. Some may say to this result, "what is this"? However, it is not the realization of the escalator turning into stairs that is of importance, but more about taking something from our everyday lives and being able to see it from a different perspective to notice things that we normally may not notice. If this type of viewpoint can be had, your daily life will likely overflow with hints toward creating games.

Game Making is a Human Experiment
Last year, sales of new titles with existing genres targeted to the various fans were sluggish. Due to this situation it is said that games are in a transition period. We can certainly say that there is no point to chase a genre after the freshness has faded. When seeing it from the user side it possibly can look like we are creating this type of situation on the creator's side.

PAGE 91 When talking to the younger producers in charge they say things like, "there is nothing more to do," or "exhausted all ideas" but I do not think so. For example, there was a time when we were digging coal and once the coal was gone, we would dig for petroleum. When the petroleum was all gone, we did not just give up. We would think of an alternative energy. I would want people to come up with ideas like that. The hardware continuously progressed and spread without a doubt, but the ideas were depleting due to limited game ideas. Seeing this I questioned what it is that people crave, as well the mechanism of people's hearts as an experimental theme to make a fun game. In other words, to make a game I have a theory that human experiments should be done.

Ethologist Desmond Morris known for "naked monkey" states, "games are a type of play rooted in human instinct." In game development, we try to find definitions by asking "what is the relationship between humans and play." I feel the need to have more discussions about this at the production site.

PAGE 92 **Motivation Behind Gameplay**
Here I would like to consider what is necessary to motivate a player to choose and play a single game amongst the many game choices. The first step is for them to pay attention to a specific game or nothing can get started. The factors to help them focus come from having the following elements.

1) Novelty - Have not experienced for a while, or never experienced
2) Uncertainty - Things that cannot be understood, questions answered after trial and error
3) Complexity - The more the number of component types and its amount, the more complicated

Let us try to increase the interest of our customers by raising these points: How interesting is something, what hidden surprises are there, how much fun can be had, and what are the sales points to encourage players?

The second step and importance behind getting people to play a game is to have "a clear gaming objective."

PAGE 93 This means, in other words what do you do in the game? Here are two examples that meet the conditions.

1) Game clearing rules (battle) is easily understood without question
2) In a glance you can understand the game features (play and depth)

Games that have become hits up to this point can be said that they basically meet these conditions. "Space Invaders" has the basic rule, "destroy the enemy while being careful to not destroy your own aircraft," for Pac-Man it is "eat the treats within the maze." It can be said that the basic rules of these two games are quite easy and can be understood by anyone.

Also, golf is a sport that has a clear-cut objective as most of you know with the rule, "with as little strokes put it in the hole." For anyone it is an obvious rule, hence it has likely become a popular sport to be enjoyed by a wide range of people.

PAGE 94 The third step is that this game needs to have an element where the player can each feel the confidence, "I can do it." Here are two points that I will raise as things that need to be emphasized.

1) Easy to understand technology of operation
2) Playable within the scope of general knowledge

A level that will guide you to the point where you feel that "I can do it" is one where they "do not ask too much of the player." For example, if there are say ten elements, there is no need to show all of them from the beginning. We should devise methods to keep the user's interest, like revealing those ten elements slowly.

The fourth step, we see lately in experiential games for a player that as the game progresses, there is a remarkable tendency to desire that others see them play. This also contributes to motivation. For this there is only one condition.

1) Receive attention, make performance possible

PAGE 95 Ever since the arrival of experiential games we start to see a trend, where in addition to gameplay, the player's performance also adds to a deeply interesting title like Konami's "Dance Dance Revolution." The game becomes even more exciting with a group observing the action like a gallery. Also, this condition seems to have nothing to do with home game consoles, but I feel that in the future of games "performance possible" becomes a key phrase with potential.

The popularization of online is inevitable now. In online games with an unspecified number of participants, showing one's uniqueness during gameplay plays an important rule. In many online RPG games, it is designed where you can express your personality depending on the costume. "Receive attention, make performance possible," in other words this all connects to the fact that "in the game there is a system in place where one's individuality can be expressed." Not only this, there are also games that have been supported before that act as a motivation by "following existing rules." These are the kind of games that most of you may know, like Baseball games and Soccer games.

Since the player already knows the actual rules of the game through experience, even if the rules of the game may be complicated it is easy to get used to quickly. When it comes to choosing which game to play with there is a high chance of a game like this being picked.

PAGE 96 Another, that is a known factor to create the maniac type player is the "evolutionary game genre" category. Currently, most games fall under this category that when a game hits and its rules are accepted then another game following this rule will be pursued continuously.

For example, the reason "Xevious" was a big hit can be said that it is because of the existence of "Space Invaders." This is because users knew the shooting game mechanics and rules of "destroying enemy ships while being careful of your own ship being destroyed," while also learning the gameplay rules that are unique to "Xevious." This resulted in the players being able to take in the setting of "Xevious."

In "Xevious" your plane vertically scrolls on the screen as it destroys enemy planes that fly alongside it to progress the game. Ideas like hidden characters popping out when blowing up secret locations, achievements when blowing up and destroying the enemy's mother ship, and other factors are added into the game to give it originality, but in most recent times we have almost too many "evolutionary games of a genre" .

PAGE 97 Wouldn't it be nice if you could make a new game that would make us say, "I want to play!"?

Elements that make Play Fun
What is necessary to have a game player think that a game is fun? First, the process leading to the end is rich in variable changes. It means that it is necessary to make changes that result in succession as opposed to minor adjustments.

Secondly, it needs to be tactical. Instead of simply progressing through the game it should urge you to take the path to the right this time, or move ahead to see what happens in this type of possibility for you to devise a strategy.

The third element is that you can take control of leadership or become the protagonist. The moment the player feels like, "I am just dancing around like a pawn piece in the game creator's hands" there is a chance that the game would not be played anymore. By giving the feeling that the program is skillfully controlled in the player's hands, even if it is for a designated amount of time it will provide them with a sense of bliss.

PAGE 98 Then, the fourth is that the setting when a player misses is something that is agreeable. There are various traps that are prepared in games. When getting stuck in a trap multiple times resulting in a game over, it needs to be clear to what mechanism is responsible for you losing the game, or you will be left with uncertainty. Did you speed too much, or were you not supposed to turn right? By making the mistake obvious, it connects to a replay. With this, the player will create a strategy and attempt to avoid it on the next try. Even if something feels like it is too hard to overcome after a quick beat down, the player will feel like they are getting better the more they play. With improvement, there is an ability to see ahead where more time can be spent playing. You also look forward to leveling up to enjoy the game.

In other words, you end up playing repeatedly just to improve. The last and fifth element is to have smooth controls. To play repeatedly and improve, it is necessary to have an interface that is easy to operate to control things very freely so that no stress builds up while playing.

PAGE 99 The above elements take the player through a series of different flows which impacts and allows them to demonstrate the result of their learnings. It can be said that an interesting game is one that guides you through such learnings.

Difficulty Settings

Game production often tends to lead to complexities. Depending on the game balance it may not gain popularity even if the subject is good. It is thought that the best game balance has "moderate difficulty." However, as developers create, they cannot help getting used to their creations making the game setting more difficult. In pursuit of finding the most responsive feeling there are cases where it exceeds the player's expectations resulting in some of the developers becoming maniacs.

Also, players do not welcome things that are too easy. The difficulty setting is something that must satisfy the user's desire. It must not be too hard, nor too easy, while maintaining the proper balance. This is the nature of difficulty setting. The following are points to remember on how to set the difficulty.

PAGE 100 When starting from a difficult setting, new players or general players do not know how the game works, nor the depth of the game, so they will label the game as not interesting.

On the contrary, beginner's relief will be experienced when starting from too easy of a difficulty. When many people start to master this another problem arises where the game feels long and extended as well as a game with no tension. From what is considered, if the difficulty curve set rises too quickly or if a player hits a wall, there will be no support from the player. If the difficulty curve is set low because of an incorrect prediction, you can see that the game becomes unresponsive to the player.

If the difficulty increases as players clear levels, this will give players a sense of intensity whether it is a beginner or advanced player. This also for the most part leads to the possibility of continuous play.

However, in the case where things are too easy until you reach an area that matches your technique there is potential of a drawback. If you continuously must clear an area in a mechanical manner, it will cause throwaway matches until the point is reached.

PAGE 101 Various technical gaps for women and beginners exist. The difficulty arises from trying to handle game technology with a single difficulty curve for both maniacs and an assortment of players. Without knowing if the player is a beginner, a general game player or a hardcore gamer, it will only offer a single type of program and cannot cover the expanding player base due to the technical gap.

A system called self-game control was introduced to this point. With this system, the game software automatically calculates the player's skills and provides game play at the level corresponding to their levels. By incorporating such a system, appropriate drills make it possible for anyone to play at a level that is

" When starting from a difficult setting, new players or general players do not know how the game works, so they will label the game as not interesting."

suitable to their ability. If you are a beginner, you will practice the drill continually and challenge yourself to the more difficult levels. If you are a hardcore gamer (maniac) you will master the lower grades as appropriate, as you will always be able to take on challenges from a grade level that suits your ability.

PAGE 102 The components that determine the deciding factor can be considered from the following:

1) Condition of operational parts such as lever buttons
2) Target Hit Rate
3) Achievement at the Point where a Mistake is Made
4) Time it takes to clear
5) How to Score

In other words, it is possible to use any phenomenon that changes according to technological differences. Obviously, the weight of the materials changes from game to game, so it is preferable to prioritize games with a wide range of necessary changes or those that are loyal to the differences in technology. You can also obtain results by understanding the technical levels and calculating the best use of the materials.

This "self-game control system" was first adopted by Namco's shooting game "Xevious" in 1982. It is now somewhat obvious to have but it was a revolutionary system at the time.

"Service Spirit" in Game Creation

Unlike other media, games connect people to the game and assume communication between them.

PAGE 103 Therefore, it is important to give the interface, the terminal operator control part a human friendly touch that tells you how to play the game. Whether it is a home video game or an arcade game, exercising constant care is necessary. The interface needs a setup that is easy for players to familiarize themselves. It also needs an easy to understand screen configuration, as well as a controller that does not interfere with the player and their enjoyment. We should simulate how a player would play, seeing how to make it fun and stress free as possible. At times we must try to optimize the gameplay environment from an ergonomic point of view.

In game production, giving attention is connected to the spirit of service. In other words, it is necessary to have a compassionate heart. In speaking of services, it sounds like a customer service business, but this is the same as setting up the customer (player) to enjoy cooking (game). For the user to enjoy the game, game makers are given a mission to pay attention and provide the utmost care. The spirit of service, and production along these lines sometimes feel negative as it takes away from the creator and their creativity.

PAGE 104 However, in my experience, having users enjoy the game results in a great deal of confidence for the creators.

Creating Games Using Verbs

In my case, there are a few games that are born through hints that come from verbs. For Pac-Man, a pizza that has been eaten suggested the word "eat." With Ribble Rabble, the idea stemmed from my past when dancing in a crowded disco when I wished to remove people who were in my way. Human behaviors and actions have hidden hints that can be applied to games. For example, let us think of the action "to lick" as a keyword. When licking, there is an object and it is the act of tracing the opponent with your tongue. Also, "to lick" is to check the flavor of something. From there, it leads you to think of the idea that you can absorb the ability of an opponent. In addition, from the action of licking, you can make judgments about the idea behind the ability to confirm safety. When you lick something, there is saliva. You may notice that the enemy can have the ability to slip or melt by licking them.

PAGE 105 To further discuss the verb lick, when compared to verbs like fighting or jumping there is somewhat of a comical impression to the word. Therefore, a character with an ability to lick gives off a cute and loving impression. You can imagine an environment or a world view with a warm atmosphere. In this way, just by taking one word like "licking," I think the image of the game can expand quite large. The point of these ideas is how we capture the verb of the theme in a wide range and drop it into an idea. Of course, some people may see this method of finding ideas is not ideal. In that case, what we introduced earlier about taking observation-derived steps daily and by looking back on them will surely be effective for you when making games.

The Idea of Reversal

At Namco, we developed many racing games that became hit titles. The first blockbuster game hit was Pole Position in 1982.

PAGE 106 This is also the title that created a pseudo 3D screen by using the method of raster scroll. With this title racing games found a new direction. The player can enjoy a type of game where they sit in the driver's seat, or the cockpit. The next racing game that became a hit was Final Lap in 1987. In the game Final Lap, we made use of many gaming machines allowing for battles to be had. However, the now commonly accepted idea of multiplayer was strongly opposed during development. The reason was because "complete strangers would not play against each other." Although when the location tests were done it surprisingly had an amazing outcome. As a result, this competitive format was adopted beyond the boundaries of racing games into many other games. The face to face style of the now popular fighting game is influenced by the battle style of Final Lap as well. Once hardware evolved, 3D expression became possible to develop Ridge Racer. In this game, we were able to make textured backgrounds from polygons for the player. We concentrated on more than the F1 style track and expanded the motif to public roads.

PAGE 107 It is also a game where one can enjoy drifting, so I daringly removed the standard battle method found in Final Lap. Then this time we were met with opposition in the planning examination stage with them asking, "Why is it different from F1? Why not a battle?" We however were able to push it through. In addition, during mid-production announcement the revenue department also questioned us, "why does it not have communicative competition"? This was because the mainstream racing games had this feature. Here too I tried to appeal to them by stating, "this driving game has drifting and enjoyment of the driving itself" but they just did not understand. Even with good results from the location test, the number of units allotted for release were lower than what the development team wished to release. In the case of competitive battles, profits will increase due to multiple units involved. It is true that this style was well received. From the creator's side who took a bet on a new challenge, it can be said that the results were poor.

However, considering the results "Ridge Racer" was a huge hit becoming a masterpiece in game history. Ironically, before competitive gaming styles were established, competitive play was uncertain. Also, single player games which were mainstream initially were denied once competitive battle play was introduced.

PAGE 108 As you can see from the examples of Final Lap and Ridge Racer, it is important to challenge the marketplace in the creative world. The success of Ridge Racer comes from the opportunities that come from the challenges when ideas are reversed. From there we need to have a strong feeling of wanting to create something interesting and not give into those who have opposing opinions. For a creator to find something interesting they need a strong opinion to push through. It must also be remembered that they need the courage to look at things objectively, which at times deny their new game creation.

New Desires and Game Design

It is said that the principle of human behavior is governed by "desire." Studying the essence of humans will surely be useful in game production. Now, what kinds of things are part of human desires? Let us borrow the words from American psychologist Abraham Maslow as we introduce them. According to Maslow, "human desires are laid out in the form of a five-step pyramid. When the needs at the lower base are fulfilled, then they will seek the desires above."

PAGE 109 Let us enumerate the five levels:

1) Physiological Desire / Desire for appetite, sleep, and primitive requests related to existence
2) Safety Desire / Clothing and housing to protect oneself necessary for living
3) Request of Affiliation / The desire to relate to others, do as they do, and group membership
4) Ego Desire/ The desire for acceptance in groups as someone with value, the cognitive desire to be respected
5) Self-Actualization Desire / The desire to demonstrate one's abilities and to pursue creative activities and personal growth.

Maslow classified these five things as human desires, and they are now widely recognized. However, are there any other human desires besides these?

I will then suggest one idea that can be applied to game design. As having the opportunity to meet many successful people through my line of work, so-called successful people are ones who have reached the "self-actualization" tier. However, hearing them speak of their stories, they seem to aspire to more. This should be called "free service desire."

It is a desire that goes beyond my ideals and is not for personal interest, but a desire to do something for society. This is close to the spirit of volunteering.

PAGE 110 In the spiritual culture of East Asia, there are many teachings to rid oneself of greed. "Find an ugly self that lurks in oblivion inside." "Loss enlightens, lust is lost." There are so many teachings that make you realize that you are unselfish, such when a person sees in themself pain and suffering that comes from greed.

My "desire to service for free" may be part of these Eastern Asian teachings. We have not yet answered how to create a game by making the "desire to offer service for free" as something that is part of the game. What we can say is that if we include "the desire for free services" elements in games, it can guide the way for new gaming possibilities. In addition, I hope that it will help improve the social status of the game.

Game and Play

Game is a form of play, but what does "play" in general mean to humans? According to Dutch historian Johan Huizinga, humans are playmates as discussed in "Homo Ludens."

In review of the relationship between bureaucratic and lazy people they found that not only was there a purpose of life human beings left behind, but within work itself was the foundation of play. Play is defined as follows:

PAGE 111 "From a certain angle we know that play is fiction, which is outside the framework of everyday life, but it is a free activity that can fully grasp the player without any interests or effects. It is completed in a clearly defined space-time, proceeds in an orderly manner according to the rule given. It is an activity in your life where you can emphasize your own sense of being green and how you see the everyday world within a group relationship."

In other words, playing itself is one of the reasons for human existence. Regarding the motive of play, there is a surplus energy theory that having excess energy necessary for survival is the cause for play.

This instinct theory says that playfulness is inherited, and play is accompanied by an idea of a reaction different from the reaction of labor and the distraction theory that it removes harmful byproducts of labor. There are compensatory theories that use play to satisfy unmet needs, and other abilities such as potency theories, purification theories, learning theories and repeat theories. Only a part of play behavior can be explained as there is no logic to make a decisive plan.

PAGE 112 It is thought that these hypotheses may serve as a reference for one in game design to derive the points that can please the fundamentals of one's self esteem. We will continue to take a closer look at play. French thinker Roger Caillois classifies play into four areas in his book, "Play and Humans" inheriting from points mentioned by Huizinga:

1. **Agōn – Greek / Competition**
 A game of competing under fixed rules and conditions
2. **Alea – Latin / Chance**
 A game where you play with something that determines the outcome of your luck like dice. It refers to a game that can be enjoyed by beating luck rather than an opponent. In casino games the elements of play are made up by Agōn and Alea.
3. **Mimicry – English / Imitation**
 This is used to imitate, and play make believe in a fictional world. There is a strong element of this in RPG games.
4. **Ilinx – Greek / Dizziness**

PAGE 113 Play that disrupts perception and stabilizes consciousness. Swings, roller coasters, disco environments with flashing laser balls are examples of this type of activity where "dizziness" is at the base of play.

According to these definitions, role-playing games have a strong element of "mimicking" and casino games have elements of play that are composed by "chance." Most game genres fall into one or a combination of these four categories. This is useful when characterizing the games that you design, as well as when coming up with a new genre of games. Here I would like to add another definition to those that are introduced. It is logic.

I decided to use the word logic as I could not find a suitable word. Meaning wise, this is a type of game where you can enjoy the story telling from the inflections and scene changes that come from transposition. Not only games, but movies and anime also do not monotonically evolve from beginning to end. I think that the series of flow itself can be felt from the mechanism of logical composition. One can enjoy the varying degrees of change which is also a component of play.

Colophon

Pac-Man: Birth of an Icon
First edition (2021)

Authors: **Arjan Terpstra, Tim Lapetino**
Editorial Contributors: **Ryan Silberman, Katsuaki Kato, Eric Bartelson**
Editorial Consultants: **Maurice Molyneaux, Christine Bonheim, Ethan Johnson,**
Matt Alt, Steve Golson, Olivier Oosterbaan
Line Editor: **Mike Diver**
Production Manager: **Pascale Brand**

Creative Direction: **Ruben Brands, Maarten Brands**
Visual Design: **Studio Moan**
Color proofing/lithography: **Marcel Salome, Re-Art.**

Cook and Becker

Toru Iwatani *Pakkuman no Gēmu Gaku Nyūmo*n (Enterbrain, 2005).
English translation published with kind permission.

Printed in Italy

The text in *Pac-Man: Birth of an Icon* is set using the New Hero typographic family, with headlines
and subheads utilizing the Balgin type family. Additional details were crafted with the
Emulogic and Clone Rounded typefaces.

Balgin references 1990s nostalgia with its dynamic, sweeping strokes and tails, designed by Cahya Sofyan
and published by Studio Sun in 2020. The geometric sans serif New Hero family was created by
Miles Newlyn, Ben Mitchell, and Riccardo Olocco and released in 2015. Clone Rounded, inspired by computer
coding and architecture, was designed by Lasko Dzurovski and published by Rosetta Type Foundry in 2015.
Emulogic captures the pixelated look of early Atari and Namco on-screen arcade game typography,
and was released in 2004 by Christian Künzer at FreakyFonts.